ELMHURST PUBLIC LIBRARY

3 1135 00894 4495

W9-AHA-966

Memorial Museums

907.5
Wil

Memorial Museums

The
Global
Rush
to
Commemorate
Atrocities

Paul Williams

BERG

Oxford • New York

ELMHURST PUBLIC LIBRARY
125 S. Prospect Avenue
Elmhurst, IL 60126-3298

English edition
First published in 2007 by
Berg
Editorial offices:
First Floor, Angel Court, 81 St Clements Street, Oxford OX4 1AW, UK
175 Fifth Avenue, New York, NY 10010, USA

© Paul Williams 2007

All rights reserved.
No part of this publication may be reproduced in any form
or by any means without the written permission of Berg.

Berg is the imprint of Oxford International Publishers Ltd.

Library of Congress Cataloging-in-Publication Data
Williams, Paul Harvey
 Memorial museums : the global rush to commemorate
atrocities / Paul Williams. — English ed.
 p. cm.
 Includes bibliographical references and index.
 ISBN-13: 978-1-84520-488-4 (hbk.)
 ISBN-10: 1-84520-488-3 (hbk.)
 ISBN-13: 978-1-84520-489-1 (pbk.)
 ISBN-10: 1-84520-489-1 (pbk.)
 1. Atrocities—Museums. 2. Terrorism—Museums. 3.
Historical museums. 4. Museum technique. I. Title.

 D2.5.W55 2007
 907.5—dc22 2007039580

British Library Cataloguing-in-Publication Data
A catalogue record for this book is available from the British Library.

ISBN 978 1 84520 488 4 (Cloth)
 978 1 84520 489 1 (Paper)

Typeset by Avocet Typeset, Chilton, Aylesbury, Bucks
Printed in the United Kingdom by Biddles Ltd, King's Lynn

www.bergpublishers.com

CONTENTS

ILLUSTRATIONS

ACKNOWLEDGMENTS

In this project I have received a good deal of useful information from the staff of memorial museums worldwide. I hope they will find this book useful. Deserving of special mention are Liz Sevcenko (The International Coalition of Historic Site Museums of Conscience), Michael Gelb (The Center for Advanced Holocaust Studies, United States Holocaust Memorial Museum), Youk Chhang (The Documentation Center of Cambodia), Fu-Tong Hsu and Ruan Mei-shu (advocates of the 2–28 Massacre Memorial Project), Romulus Rusan (The International Center for the Study of Communism), and Alice Greenwald and Jan Ramirez (The World Trade Center Memorial Foundation).

I want to thank Berg for supporting this project. I am especially thankful for the dedication to detail provided by Tristan Palmer, Emily Medcalf, and Hannah Shakespeare.

I would also like to thank Suzanne Glickstein, my love, the Duttons, and the Williams family: buoyant and caring, as always. On an academic level, I have received especially close scholarly attention and personal friendship from Haidy Geismar, Jeffrey Feldman, and Bruce Altshuler. Glenn Wharton and Miriam Basilio have also made the New York University Museum Studies program a rewarding work environment. Barbara Kirshenblatt-Gimblett and Max Gimblett have shown special generosity over the past few years. I consider Chris Healy at the University of Melbourne my most important teacher.

PROLOGUE

This book emerged out of a desire to describe and analyze what I see as a remarkable phenomenon in the field of heritage and museum studies which has received little critical attention: the seemingly unstoppable rise of memorial museums and sites. I am especially interested in those beyond the Holocaust, which are dedicated to less recognized forms of political violence and suffering that has occurred over the past few decades. State repression and imprisonment in the former Eastern bloc; nuclear disasters in Hiroshima and Chernobyl; political disappearances in Chile and Argentina; apartheid in South Africa; genocide in Armenia, Cambodia, Rwanda, and Srebrenica; terrorism in New York, Oklahoma City, and Madrid; massacres in Nanjing and Taipei … these are just some of the events that now form a key part of our historical consciousness, but whose translation into museological forms has been little explored.

1 A NOVEL HYBRID: INTRODUCING THE MEMORIAL MUSEUM

PILLARS OF SALT, PILLARS OF STONE

In the Genesis passage describing the destruction of Sodom and Gomorrah, Lot's wife was turned into a pillar of salt for daring to look back at the burning cities during her flight. She was, in a cautionary interpretation, punished for wanting to look back at what she could not forget. Pillars of stone, by contrast, have emerged as a modern symbol of our willingness to remember; sculptural pillars and monuments are one way we concretely mark places that saw destruction and loss, albeit often in a more triumphant register than that suggested by the petrified, crumbling statue that Lot's wife might have resembled. Between salt and stone, between the ephemeral and the permanent, between dissolving personal memory and hardened official histories, I will eventually situate memorial museums. Yet we will loiter, for the moment, around pillars.

In mid-2004, newspapers in New York, from where I write, reported a quarrel over the opening of a new memorial. This felt unremarkable; in current times, controversy over memorialization is a near-default expectation. Across many nations, public commemorations of warfare, political violence, terrorism, and discrimination have become a political flashpoint. What seemed odd in this particular instance, however, was that the memorial in question is situated in an uncontroversial place and is dedicated to an event now generally considered settled or resolved. Halfway down the open plaza of Washington, DC's National Mall stands a ring of fifty-six gray pillars, each inscribed with the name of one of the forty-eight states, seven territories, or one district that made up the U.S.A. during the Second World War. At the north and south ends, framing a large pool with gushing fountains, stand two 13-meter-high arched pavilions named for the Atlantic and Pacific theaters of war. Centrally plotted between the Washington Monument and Lincoln Memorial, the monument's grand neoclassical design (by Friedrich St. Florian) is uncomplicated in its symbology. It has also been critically maligned: "Imperial kitsch," said one commentator. Others called it "the worst kind of authoritarian architecture," "the architecture of 1930s-era fascism," and even "worthy of Albert Speer's Germania."[1] The problem was that, although the column and arch-based design is stylistically consistent with earlier World War memorials, it communicates little of what we now expect from structures commemorating mass death and suffering, including the experiences and conflicted memories of ordinary citizens who fought, worked and grieved. As one reviewer complained:

> Take away the written explanations, and you're left with a memorial that could be for almost anything. Columns marching in a circle, bronze wreaths, gold

stars, spurting fountains, big bronze birds of prey, sculpted reliefs of historic scenes – what martial effort couldn't be evoked by symbols like that? This is all stock celebration, not true commemoration – there's no true calling to mind of what the war meant, and then committing it to memory.[2]

Critics have drawn attention to the memorial's shortcomings by comparing it to another nearby. Diagonally across the Mall is Maya Lin's Vietnam Veterans' Memorial (1982). Its primary structure consists of two 75-meter-long black triangular granite walls that meet at a 125° angle and progressively descend into the earth. Inscribed on the walls, grouped by year, are the names of every soldier killed or missing. At the deepest point along the wall the number of the dead reaches its peak. Compared to the problem of relevance assigned to the Second World War Memorial, this (also once-controversial) memorial is now heralded as "a monument with the right problem – not how to give it character but how to let its stark character come through unfiltered to a country still unready to make a separate peace with a tragic part of its own history."[3] The memorial has been widely interpreted as symbolizing a scar across the landscape that cleaves (that is, both pulls apart and draws together) Americans.

Across the Atlantic, another memorial tied to the Second World War opened a year after the American National World War Two Memorial. Located between Berlin's Brandenburg Gate and Potsdamer Platz (a space treasured in Speer's plans for Germania!) stands a memorial which, although also based in a plaza and featuring stone pillars, could scarcely be more different. Peter Eisenman's Memorial to the Murdered Jews of Europe (2005) is a human-scale labyrinth of narrow rising and falling pathways that intersect 2,711 concrete slabs. This memorial has generally been met with thoughtful critical reflection:

> The land sways and moves beneath these pillars so that each one is some 3 degrees off vertical: we are not reassured by such memory, not reconciled to the mass murder of millions but now disoriented by it. Part of what Eisenman calls its *Unheimlichkeit*, or uncanniness, derives precisely from the sense of unease generated in such a field, the demand that we now find our own way into and out of such memory.[4]

The memorial is about moral uncertainty; it has been described as embodying "the delicate, almost imperceptible line that separates good and evil, life and death, guilt and innocence."[5] Its political reference points include the crisis of state modernity, the vulnerability of human rights, and the formation of ethnic diasporas under conditions of tragedy and renewal. By contrast, The U.S. National World War Two Memorial appears to represent a suspect, anachronistic political aesthetic that fore-grounds statesmanship over common experience, and contains shades of both nine-teenth-century nationalism and twentieth-century totalitarianism. (J. Carter Brown, chairman of the Washington Commission of Fine Arts, was unapologetic in the face of the memorial's detractors, saying: "If triumphal arches and victory wreaths don't give you the sense that we won the war, I'm sorry."[6])

Of course, these two sets of pillars commemorate converse experiences: one relates to a nation's triumph in an overseas war, the other concerns a nation's own culpability in the systematic destruction of almost an entire people. Nonetheless, the distinct critical reception each received strongly suggests that a prevailing set of ideas governing the critical evaluation of memorials has emerged. Without positing that older memorial conventions have been eclipsed or abandoned, it is clear that the critical consensus now favors minimalist and abstract design over that which is grandiose and authoritative; decentered and incommodious space over that which is central and iconic; bodily visitor experiences that are sensory and emotional rather than visual and impassive; interpretive strategies that utilize private, subjective testimony over official historical narratives; salt over stone, perhaps.

ESSENTIAL ELEMENTS: SECOND WORLD WAR AND HOLOCAUST MEMORIALS

The cases just mentioned fall into the category of monuments and memorials. I begin with these (rather than museums) since their relative simplicity of form more easily foreshadows key interpretive themes that emerge throughout this book. Further, these World War and Holocaust memorials provide the essential background for the less established examples analyzed here, dedicated to genocide, terrorism, political disappearances, nuclear incidents, and other forms of irregular conflict. While Holocaust memorials certainly relate closely to themes of atrocity, illegality, and degradation that my cases share, many Holocaust memorials were themselves shaped (positively and negatively) in response to the form and meaning of World War memorials. In the aftermath of the First World War, a common concrete appearance for monuments was established among the nations that fought. Nearly every town placed sculptural monuments in a battlefield, civic square, park, bridge, parliament building, or church. While these varied in splendor and detail, they typically featured one or several sculpted soldier figures raised on a plinth, onto which a short passage is inscribed praising their heroism. The sculpture is often set within a backing archway or in front of an obelisk, on which the names of the nation's battles may be engraved. A wreath, coat of arms, or angel figure might crown the monument. Famous examples containing some combination of these elements include the Cenotaph in Whitehall, London, the Tomb of the Unknown Soldier in Arlington Cemetery, Virginia, the Thiepval Memorial on the Somme, the Menin Gate Memorial to the Missing at Ypres, or India Gate in New Delhi (Fig. 1.1). These monuments themselves borrow neoclassical motifs from nineteenth-century war monuments such as the Arc de Triomphe in Paris, Nelson's Column in London's Trafalgar Square, or the Voelkerschlachtdenkmal (Battle of Leipzig Monument). A combination of classical and religious themes and motifs of the native landscape formed the key connection between the cult of the war dead and nationalist self-representation. While the icons, imagery, and language used varied according to the nation's prevailing political arrangements and religious and artistic traditions, they shared the motif of "war as *both* noble and uplifting *and* tragic and

unendurably sad."[7] This message contributed to a romanticization of war that, in Raphael Samuel's words, entered into "the very marrow of the national idea."[8] As this physical and thematic template was reinscribed after the Second World War, where, most commonly, further engravings and icons were added (for both practical and symbolic reasons) to the existing structures, war memorials became concretized as a sculptural genre.

While First and Second World War memorials communicated intangible values like honor, sacrifice, and spirit, the postwar period has seen an emerging expectation that ordinary and often conflicted attitudes towards a specific conflict might be

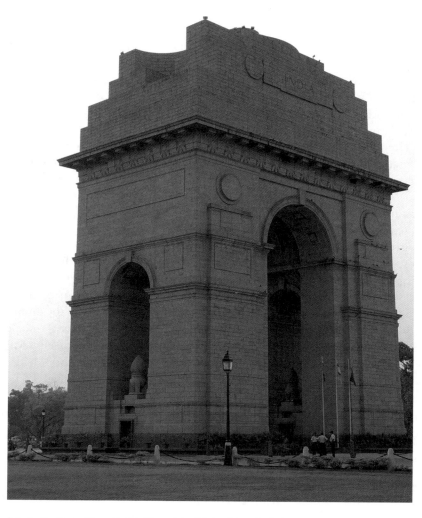

Fig. 1.1. India Gate, New Delhi. Copyright Michael Janich. Released to the public domain.

materially represented. While conventional war memorials are now sometimes accused of playing a part in honorifically freezing the meaning of an event, it remains unsurprising that we nonetheless find popular resistance to experimental approaches in their form, media, and theme. For some, the inclusion of a perspective considered overtly political degrades the purity of the sacrifice made by those who fought – by suggesting that their involvement was not in the enduring interests of what is honorable and was instead only *politically* useful (or even a mistake). This hazard represents an intrinsic difficulty for many memorials: on the one hand, there is the expectation that they should be unique, memorable, and iconic, with some metaphorical visual tie to the event. On the other, they need to accommodate messages that support commemoration amongst the populace at large, which often means upholding conservative values of national tradition and religious salvation.

While the *form* of World War memorials is significant, there is another reason at this early point to linger on them before turning to memorial museums: they have helped to engender and consolidate social *practices* of visitation. While planning committees, architects, designers, and landscapers can construct the intended aesthetic purposes of memorials, it is only through being repeatedly viewed and experienced that they gain cultural significance. Practices surrounding memorials were not just influenced by the extreme political developments during the first half of the last century that informed the message that monuments might bear, such as – in a single breath – nationalist fervor, the triumph of state fascism and communism, unprecedented levels and ever-more efficient modes of killing, the creation of new states born from warfare, and the demise of colonialism in Africa and Asia. Less explosive, but no less important social developments were also essential to the modern experience of memorials. The rapid growth of urban architecture and the city crowd, the growth of mass media (especially visual media such as photography and film), broader access to education, and increased mobility (including the nascent development of mass tourism) also form the historical context for today's mode of visiting.

World war memorials see rituals of visitation that have a precedent in more deeply historical forms of pilgrimage and funerary rites. Longstanding activities include: travel to a particular site (perhaps a cemetery, a place that saw death, or a town square to where the dead were brought home); attending on a particular date (such as an anniversary); a physical approach towards the principal monument from a distance, culminating in intimate contact with earth, metal, water, or stone structures; prayer or silent contemplation; and the offering of a tributary item such as a wreath. Visitors also hold the basic expectation that the site should remain reliably constant, in order that the memory of the event can be consolidated in a physical form, and to allow the visitation ritual to be repeated over generations. As Edward Casey puts it, "honoring in a full-bodied way requires more than passing praise. It seeks to preserve and stabilize the memory of the honoree, and to do so in a time-binding, invariant manner. The explicit aim is to maintain this memory in the face of the corrosive action of time's passing."[9] Others emphasize the importance of the *process* of creating a memorial. The

practical activities required in the planning and funding of any project can themselves be beneficial, since they provide a means through which a damaged community can come together socially and a tangible focus for otherwise difficult conversations and interactions.[10] Beyond this initial groundwork, we can also deduce that the organization of post-inauguration ceremonies and anniversaries can continue to provide a socially supportive context for private grieving, reminding people that their loved ones did not die alone and that neither are they alone in their grieving state.

Attention to visitors' actions is especially important since the memorial itself is not, in a peculiar but important sense, the object of the visit. As James Young has recognized, we do not typically go to a memorial because it is beautiful, novel, or fascinating (unlike an art museum) or because we expect it to teach us a good deal about a subject (unlike a standard history exhibit). Instead, we come in respect, bringing with us a sense of history, often loaded with familial significance. Personal conscience then becomes the reference point for an (often internal) dialogue with what we physically encounter. We expect that as public art, memorials will lead us beyond their own materiality and back in time to the persons and events it commemorates. As Young puts it, "the aim of memorials is not to call attention to their own presence so much as to past events *because* they are no longer present."[11] Memorials support this transference of attention towards the viewing subject's historical imagination by avoiding references to their own life, which might include practicalities such its cost, construction, or political support – the authorship of the inscription it conveys is also normally phrased as an abstracted sense of "the general will." Hence, in summary, World War memorials act more as staging points for mourning and reflection than as destinations that explain the significance of an event.

While the Holocaust is tied to the Second World War, its obvious antinomy to "conventional warfare" has meant that its memorialization has required considerable departures in form and meaning. This alternative sensibility has not meant consensus; there is no internationally uniform or orthodox Holocaust memorial form. The variety partly reflects the expansive Holocaust iconography situated in diverse sites such as former concentration camps, mass graves, transportation routes, ruined synagogues, and in non-site-specific memorials and museums. It is also due to memorials being constructed in various periods and political and cultural frameworks.[12] For instance, at Dachau, Buchenwald, and Bergen-Belsen, prisoners constructed makeshift memorial towers out of dismantled barracks within days of liberation.[13] In postwar Poland and Czechoslovakia the communist regimes produced Holocaust memorials that predictably had strong antifascist interpretations (that is, Nazis as oppressors of the working class).[14] Austrian and German Holocaust memorials formalized by national government boards in the 1950s and 1960s tended to reflect self-critical national concerns that may have had little to do with the subcultural images held by Jews and other persecuted groups. By contrast, the Yad Vashem complex in Jerusalem (1953) has generally reflected (over several alterations and enlargements) a Zionist framework. Using the relics, writings, and artwork of those who suffered (the recording of biographical data of victims and survivors is a partic-

ular priority), it tells the story of the Holocaust by emphasizing Jews as experiencing subjects rather than objects in Nazi hands. From the 1980s Holocaust memorials proliferated worldwide, often far from the actual sites of torment. In Australia, for instance, the phenomenon of Holocaust denial prompted Jewish constituencies to establish memorials to educate the public.[15] Holocaust memorials have rapidly spread in the U.S.A., where there are now as many as 250, according to one tally.[16] These tend to deploy a narrative that, while naturally decrying Jewish treatment, teaches a redemptive lesson that promotes pluralism and tolerance as necessary future outcomes. While these museums are ostensibly humanistic, their emphasis on democracy and tolerance carries an American inflection.[17]

This international variance does not mean, however, that common Holocaust design features do not exist. Widespread elements include, as Caroline Wiedmer summarizes, "an imposing monumental façade adorned with symbolic, often allegorical descriptions of the dead and their fates; some poems or religious sayings; a crypt where the 'representative' dead are buried; urns containing soil or ashes from actual sites; and finally, in genuflection to the spiritual, the eternal flame that watches over the dead."[18] These elements, therefore, share much with Second World War memorials. The Memorial to the Murdered Jews of Europe, for its part, can be seen as the latest in a nascent rise of "counter-monuments." These challenge the ethics and aesthetics of the very notion of building an artifice to represent violent conflict – let alone annihilation. In the eyes of a new generation, the didactic logic of monuments – their rigidity and sense of historical closure – too closely resembles traits associated with fascism itself. Another key counter-monument, situated in a nondescript suburb of Hamburg, is "The Monument Against Fascism," designed by Esther and Jochen Gerz (1986). The monument consisted of a column, twelve meters high and one square meter at the base, sheathed in soft lead and equipped with metal styluses. This enabled visitors to inscribe their personal reflections towards Germany's fascist history. In six stages over six years, the monument was lowered into the ground, so that since 1991 only a small portion has been visible through a window in a pedestrian tunnel. Such monuments reflect the stance of many contemporary German artists who find intolerable the possibility that memory of events so grave might be reduced to exhibitions of public craftsmanship or symbolic pathos.[19] While themes of absence, impermanence, and unsettlement have become critically favored in recent years, they are not necessarily the chief response to negative histories. This point will become more apparent in the next section as I introduce the memorial museums that form the core of my analysis.

THE RETURN OF THE REPRESSED: NEW MEMORIAL MUSEUMS

Given the cluster of terms used so far – memorial, monument, museum, memorial museum, and memorial site – a note about terminology is useful at this point. I use *memorial* as an umbrella term for anything that serves in remembrance of a person or event. As such, it can take a non-material form (such as a holiday or a song). While

some writers distinguish between memorials and monuments based on their political function – memorial often signifies mourning and loss, whereas monument signifies greatness or valor – we often see measures of both in any single structure, making this distinction fuzzy (consider, for instance, the noble/tragic duality of World War memorials mentioned earlier).[20] Daniel J. Sherman has made the case that memorials can communicate their own significance visually, whereas museums construe history as scientific rather than commemorative, and therefore require explanatory textual strategies.[21] Rather than pursue such distinctions, I instead follow James Young by accentuating a formal distinction: monuments are best seen as a subset of memorials, characterized by their physical appearance.[22] That is, a *monument* is a sculpture, structure or physical marker designed to memorialize. A *museum*, as we know, is an institution devoted to the acquisition, conservation, study, exhibition, and educational interpretation of objects with scientific, historical, or artistic value. I use the term *memorial museum* to identify a specific kind of museum dedicated to a historic event commemorating mass suffering of some kind. A final term, the memorial *site*, is used to describe physical locations that serve a commemorative function, but are not necessarily dominated by a built structure.

Any distinctions between monuments, memorials, and museums should not be considered indurate; a key point of my analysis is to show that traditional formal distinctions between these designations are blurred, in intriguing ways, by these cases I examine. Indeed, a vital issue is whether older categories of analysis remain suitable for describing this new commemorative form – "memorial museum" is a compound made necessary by the complication of conventional museological categories. On initial consideration, the memorial museum spells an inherent contradiction. A *memorial* is seen to be, if not apolitical, at least safe in the refuge of history. This is largely because we recognize that honor will accrue to most people – no matter their actual worldly deeds – simply because honest evaluation of the dead is normally seen as disrespectful. A history *museum*, by contrast, is presumed to be concerned with interpretation, contextualization, and critique. The coalescing of the two suggests that there is an increasing desire to add both a moral framework to the narration of terrible historical events and more in-depth contextual explanations to commemorative acts. That so many recent memorial museums – whether in Argentina, New York, or Rwanda – find themselves instantly politicized itself reflects the uneasy conceptual coexistence of reverent remembrance and critical interpretation. Furthermore, I am consciously concerned with how the mission, audience, educational strategies, and generational framing of memory *change* when a memorial has, as its main feature, a museum, or when a museum seeks to function as a memorial.

This book will provide a critical survey of issues in memorial museums. It is deliberately wide-ranging in scope, taking in a large number of institutions. This of course produces certain limitations: no single institution is afforded truly in-depth analysis, and my discussion moves between political and cultural contexts in ways that may be unsatisfying for academic area specialists. I see this as a necessary sacrifice, since I posit that the memorial museum now has a sufficiently coherent form and mission

across contexts that it deserves analysis as a global institutional development. My research methods vary according to the accessibility and importance of various sites. Where possible, I have visited the museums and collected data; in other cases I rely on the observations of other scholars and local reporters. I am more interested in exploring the present and potential themes and connections that memorial museums collectively raise than in producing an authoritative account of the life of each organization. The assortment of physical spaces and edifices I have in mind is best appreciated by introducing my case studies. This listing is not intended to be exhaustive, but instead names and describes the sites that are discussed to differing extents in this book (other less prominent examples also appear at times). While it is patent that there has been an upsurge in memorial museums – one critic is almost certainly right to claim in 2005 that "more memorial museums have been opened in the last 10 years than in the past 100" – I will substantiate this assertion of a recent "boom" by mapping their creation in chronological sequence.[23]

HIROSHIMA PEACE MEMORIAL MUSEUM, HIROSHIMA (1955)

Although this complex was created several decades before the main period of this study, it warrants analysis due to both the unprecedented event it commemorates and its role as a formative memorial museum. Governed by Hiroshima City, the museum currently draws about one million people per year. The "Atomic Bomb Dome," as it is now known (the original building dates from 1915), was almost directly beneath the nuclear hypocenter, and was the closest structure to partially withstand the blast. The building has been preserved in its damaged state and was designated a UNESCO World Heritage Site in 1996. In the museum's east building, Hiroshima's militarist past and the process leading to the dropping of the bomb are documented. The west building displays graphic objects and images recovered from the day of the blast, demonstrating its devastating and otherworldly effects on the city and its inhabitants. Between the museum and the dome stands the Cenotaph for Atomic Bomb Victims, which lists everyone killed, either by the explosion or due to long-term radiation effects. The Peace Park surrounding the museum contains dozens of smaller monuments and sculptures sponsored by national and international organizations, which generally exhort the need for global peace.

MAISON DES ESCLAVES, SENEGAL (1978)

In 1444 Portuguese navigators discovered Gorée Island, on which Maison des Esclaves ("The Slave House") now stands. The island was ideally located along the transatlantic route of the African slave trade, which exploded in the fifteenth century with the development of the coffee, sugar, cotton, and tobacco plantations in the Americas. Gorée's warehouses became crammed with European and African merchandise, and with slaves. During the 300–350 years of the African slave trade, 15–30 million persons were trafficked to plantations in the Americas. Built in 1776, this particular slave house was one of several on Gorée that provided a way to "ware-

house" men, women, and children, typically for three months. Maison des Esclaves, which functioned until 1848, was declared a UNESCO World Heritage Site in 1978. Administered by the Senegalese government, and drawing over 75,000 visitors annually, the memorial museum relies heavily on the remnant architecture (given the absence of preserved material objects) to illustrate the function of such houses in the slave economy. In 2001, in collaboration with the British Embassy, the museum opened a new exhibit of sixteen illustrative panels that add a more personal dimension to the agony of slaves' captivity.

TUOL SLENG MUSEUM OF GENOCIDAL CRIMES, PHNOM PENH; CHOEUNG EK KILLING FIELD, PHNOM PENH (1980)

The years of Democratic Kampuchea (DK) rule in Cambodia saw 1.7 million people killed between 1975 and 1979. During that period, the regime established a secret prison to interrogate and exterminate suspected "enemies" of *Angkar* ("the Party"). Officers at S-21 prison extracted false "confessions" from prisoners using especially brutal torture techniques. Extensive records of prisoners' activities, including thousands of photographs, were stored near the prisoners' cells. After the fall of the DK regime, the Vietnamese reopened Tuol Sleng (as the building, originally a school, was known) as a museum documenting the crimes of the regime. Several rooms of the museum are now lined, floor to ceiling, with photographs of some of the estimated 20,000 prisoners who passed through the prison. Only seven survived. The museum, now managed by the politically independent Documentation Center of Cambodia, is largely preserved as it was found after Khmer Rouge soldiers fled it in 1979. Choeung Ek was a nearby "killing field" where captives from S-21 were taken for execution and burial. The grassy field is now a memorial site containing hollowed mass graves, a memorial stupa filled with skulls, and several information boards. Each site currently receives about 100 to 200 visitors per day.

NANJING MASSACRE MEMORIAL MUSEUM, NANJING (1985)

This memorial museum is dedicated to the Japanese slaughter of 300,000 people – and the rape of another 20,000 to 80,000 women – during their annexation of China in 1937. The museum was built on a former mass grave where the remains of some 8,000 peoples were exhumed. Solemn and imposing, the black and white granite block museum consists of three parts: the outdoor exhibits, the tomb featuring recovered bones of some victims, and the main exhibition hall for historical documents. The outdoor walkways are made up of rough concrete blocks, surrounded by sculptures, relief carvings, and beds of stones that resemble giant tombstones. The underground coffin-shaped gallery features a large glass display case covered in a bed of bones from victims whose bodies were dumped on the ground. The main exhibition hall features written documents, photographs, paintings, sculptures, multimedia screens, and documentary films that collectively attest to the crimes perpetrated on the Chinese. In 2006 it received over 2 million visitors.

THE MUSÉE MÉMORIAL POUR LA PAIX, CAEN (1988)

The Musée Mémorial pour la Paix is Europe's pre-eminent peace museum, and has attracted over four million visitors to date. Originally taking the Second World War and the French Occupation as its primary subjects, it now bills itself as the only museum in the world to give an overall view of conflict from 1918 to the present. Located close to Normandy's D-Day landing beaches, the museum consists of several separate buildings. In the first, visitors walk a downward spiral along the path Europe followed from the end of the First World War to the rise of fascism and the Second World War. After reviewing topics such as the failure of peace after the First World War, the French Occupation, and the Holocaust, visitors are probed to consider their own potential complicity with or resistance to fascism. It has now also added images and exhibits related to the Cold War (such as a section of the Berlin Wall) and to worldwide terrorism, from 9/11 to the "Palestinian question." The concluding building shifts to the current era and features interactive devices (in galleries such as "The New Hope," "Deconstructing the World," and a Nobel Peace Prizewinners Hall) that encourage visitors to hesitantly consider prospects for current world peace. An outdoor "International Park" consists of gardens designed by, and devoted to, the Canadian, English, and American "liberating nations."

NATIONAL CHERNOBYL MUSEUM, KIEV (1992); TOWN OF PRIPYAT, KIEV OBLAST (1970–86)

The National Chernobyl Museum, located in a former fire station, was opened to commemorate the 1986 nuclear accident. Its 7,000 artifacts include declassified records, maps, and photos. Documentary videos show in detail the horrific accident and its consequences on the local population. Beyond the building are several outdoor sculptures dedicated to those killed and deformed by the accident. This museum gains greater consequence when considered along with the entire town of Pripyat. Established in 1970 for plant-workers, Pripyat once housed 47,000 people. The houses, streets, and buildings, left almost untouched since the town's abandonment, are promoted as a "total memorial." Since 2002, the town has become a draw-card not only for scientists and journalists, but also for tourists, who receive guided tours of the area. Immediately after the accident, some 650,000 "liquidators" were recruited (many under duress) to clean up the nuclear spill. Most were not informed about the danger awaiting them. A few kilometers from the plant a sculpture called "Memorial to the Liquidators" bears the inscription "to those who saved the world," and names the twenty-eight firefighters who died in the immediate blaze (it is estimated that somewhere between 25,000 and 100,000 liquidators died more slowly). A sculptural piece features large black metallic loops entangling five falling metallic swans, beneath which relatives pin photographs of victims in the ground.

MUSEUM OF GENOCIDE VICTIMS, VILNIUS (1992)

The museum, founded by Lithuania's Ministry of Culture and Education and the Union of Political Prisoners and Exiles, exhibits documentary material reflecting the repression of Lithuanian inhabitants by Nazi and Soviet occupational regimes between 1940 and 1990. The main exhibition space features a jail, left as it was in August 1991 when KGB activity in Lithuania ceased. On view are nineteen common wards, a room of an officer on duty, a watch room, scales for weighing parcels brought to inmates, the cell where fingerprints and photographs were taken, an interrogation cell, and isolation and punishment cells. On some occasions, former prisoners serve as tour guides. In 1997 the museum was taken over by the Genocide and Resistance Research Center of Lithuania. Its stated purpose is to collect and present historic documents about the forms of repression against Lithuanian people, and the methods and extent of the resistance against the Soviet regime.

MEMORIAL OF THE "DISAPPEARED," CEMENTERIO GENERAL, SANTIAGO (1992), VILLA GRIMALDI PARK OF PEACE, SANTIAGO (1997)

Surrounded by rocks, trees, and shrubs is a huge slab of marble, etched into which are the names of approximately 30,000 Chileans believed to have "disappeared" under Augusto Pinochet's security forces. Pinochet came to power after the violent 1973 coup that deposed Salvadore Allende, and set about persecuting leftist persons. Portrait photographs of victims are affixed to the cemetery memorial. Prior to 1973, Villa Grimaldi was a restaurant bearing statues, fountains, and mosaics on its grounds. In the Allende era, it served as a place where intellectuals and artists held conferences and workshops. Under Pinochet it became the site where DINA, the Chilean secret police, detained and tortured around 5,000 people. The Chilean government owns the museum and park, but much of its work is carried out by NGOs such as Families of Executed Political Prisoners and the Assembly of Human Rights of District 24. Visitors to Villa Grimaldi are shown a tree from which one of the soldiers was hanged as an example to other soldiers for showing sympathy towards prisoners. There is a fountain at the spot where prisoners were beaten, paving stones marking the location of prisoners' cells, and a wooden tower, rebuilt after being burned down by DINA, where prisoners were also beaten and tortured. Finally, there is a wall naming the 226 known to have been executed at the site.

SIMON WIESENTHAL CENTER BEIT HASHOAH-MUSEUM OF TOLERANCE, LOS ANGELES (1993)

The Museum of Tolerance is a technologically sophisticated museum housed in a polished granite and glass building. It features two main historical topics – the dynamics of racism in America and the Holocaust – in service of its larger theme of tolerance and respect for diversity. The "Tolerancenter" challenges visitors to confront their own potential for bigotry and racism, chiefly by exploring civil rights issues, while the Holocaust section exhibits original documents and testimonies with

an eye for the same lessons. The museum employs cutting-edge entertainment technology to dramatize history. For instance, the civil rights section recreates a 1950s diner that "serves" a menu of controversial topics on video jukeboxes, while the Holocaust section displays animated mannequins talking politics at a 1930s Berlin street café, and re-enacts Nazi leaders discussing the "Final Solution" at the Wannsee Conference. The museum, which represents the educational arm of the Simon Wiesenthal Center (an international Jewish human rights organization named after the Austrian Holocaust survivor-turned-Nazi-hunter), draws about 350,000 visitors annually.

DISTRICT SIX MUSEUM, CAPE TOWN (1994)

In 1966 the South African government declared District Six, a multicultural Cape Town neighborhood, a whites-only area. Homes and businesses were bulldozed, and 60,000 residents were displaced to faraway tract houses on barren flats, far from family and friends. In 1988, during the anti-apartheid struggles, former residents created the Hands Off District Six Committee. When the Central Methodist Church (one of the few buildings left after the devastation) offered its premises in 1994, memories of the disappeared streets, homes, and stores reclaimed some location. The museum collection initially consisted of a cache of recovered street signs and a huge floor map where visitors could mark sites important to them. This simple re-creation of place stimulated an outpouring of memories as people "wrote themselves back" into the center of the city. Along with this original map exhibit, around eight further exhibitions have been created, exploring topics such as the final days before eviction, or the historical role of sport in the district.

TSITSERNAKABERD ARMENIAN GENOCIDE MEMORIAL AND MUSEUM, YEREVAN (1967/1995)

Of the world's 125 markers devoted to the 1915 genocide that killed around 1.5 million Armenians, the Yerevan Memorial and Museum is the largest. Inspired by the fiftieth anniversary commemorations, a large sculpture was erected in a park on Tsitsernakaberd hill near Yerevan two years later. The 44-meter-high stele is intended to symbolize the national rebirth of Armenians. Twelve slabs are positioned in a circle, representing the twelve Armenian provinces lost to present day Turkey. In the centre of the circle, sunken 1.5 meters, burns an eternal flame. The park also features a 100-meter wall that names the towns and villages where massacres took place. The site was significantly expanded in 1995 when a museum was opened at the far end of the park. The circular structure displays two main exhibition spaces. The Introductory Hall exhibits photographs and ethnographic tables with information about the Armenian settlements, churches, schools, and population figures in 1914 Ottoman Turkey. The second exhibit hall presents eyewitness reports and documents about the massacres and atrocities. It includes many large photographs (many taken by German soldiers who were Turkish allies during the First World War), archival documents, portraits of prominent Armenians, and documentary films. Near the

museum is a grove of trees, planted by foreign leaders in memory of the genocide. Since 1991, April 24 has become the official Armenian Genocide Commemoration Holiday, which sees hundreds of thousands of people parade to the monument to lay wreaths.

PERM-36 MEMORIAL MUSEUM OF THE HISTORY OF POLITICAL REPRESSION OF TOTALITARIANISM, PERM (1996)

Of the roughly 12,000 forced labor camps that existed in the former Soviet Union, Perm-36 was one of the most notorious, and the only one left intact after the collapse of the Communist Party in 1992. It played a special role: although constructed in 1946, it was one of three camps where the most important dissidents served time in the later phase of political repression during the 1970s and 1980s. Using the original woodshop of the prison, the museum has reconstructed and preserved two separate sections of the site: the harsh maximum-security camp (where "unreformed" dissidents serving repeat sentences were held), and the less severe strict regiment camp. Political prisoners experienced highly barbaric methods of imprisonment. Each prisoner, watched over by three guards, lived in a cell locked almost twenty-four hours a day. Three people could barely walk in the yard, which was only two meters squared. The labor camp's decentralized location and its severe but generic structures (rows of wooden buildings and barbed wire barriers) allow it to serve as more general commemoration of the greater number who suffered and died in gulags. Annually attracting about 8,000 visitors per year (along with another 22,000 through programs and traveling exhibitions), the museum is a joint project of the Memorial Society (founded by Andrei Sakharov, the Russian nuclear physicist and human rights activist) and the Perm City regional administration. It also receives support from several non-profit American foundations dedicated to international democracy.

LIBERATION WAR MUSEUM, DHAKA (1996)

In 1971 the Pakistani military regime refused to accept the popular verdict of a national election and instead set about crushing the nationalist movement in East Pakistan. Between March and December, an estimated 1–3 million Bengalis were killed, between 200,000 and 400,000 women raped, and 10 million people seeking refuge in India displaced. After the genocide, popular armed resistance backed by international support culminated in the emergence of the Bangladesh nation state on December 16, 1971. Housed in the three-storied building in the heart of Dhaka where the Pakistani reign of terror began, the museum, across six galleries, presents items relating to the history of Bengali cultural heritage, the uprising against British rule, and the struggle for secular democracy during Pakistani military rule. Funded by the state and private donations, the collection, currently consisting of over 11,000 items, includes rare photographs, documents, and munitions and materials used by "freedom fighters." Aided by the army, the museum also excavated two killing fields near Dhaka. One of these, a "killing field" called Jallad Khana ("Butcher's den") is

preserved for display. The museum also hosts an annual "Freedom Festival," which draws 15,000 participants, and it manages a mobile museum operated out of a large bus, which has been viewed by almost half a million people.

THE MEMORIAL OF THE VICTIMS OF COMMUNISM AND ANTI-COMMUNIST RESISTANCE, SIGHET (1997)

The Sighet prison was built in 1897 at the time of the Austro-Hungarian monarchy to mark one millennium of Hungarian domination in the region. After serving as a common jail until 1944, it was then used as a deportation center for Jews and antifascists en route to German and Polish concentration camps. From 1948 to 1964 it was one of the most sinister prisons of the totalitarian Soviet system of "political purification," and often held Romanian dignitaries such as politicians, academics, journalists, and bishops. Converted into a museum, the old cells display documents recalling the living conditions of the prisoners, and more generally describe other mechanisms of the communist regime, such as cruel psychiatric asylums or the forced collectivization of rural areas. The museum, a wing of the International Center for the Study of Communism, was originally funded by the Council of Europe, and from private donors (often Romanians in exile) and Western universities. More recently, it has also received some state funding. In 1999 the museum, which receives around 35,000 visitors per year, developed the Cemetery of the Poor outside the city in the area where fifty-two political prisoners had been secretly buried. As the graves could not be identified among thousands of others, a landscape project was developed. On the surface of the cemetery, the outline of the nation was drawn and marked by new saplings. The maturing trees will form a vegetal amphitheatre containing a glade-like representation of the nation.

TAIPEI 2–28 MEMORIAL MUSEUM, TAIPEI (1997)

After the Japanese defeat in the Second World War, by 1947 Taiwan had been in the hands of the Republic of China regime for two years. Tensions between local Taiwanese and Kuomintang mainlanders had intensified during the period, as many of the Kuomintang took the view that the locals, raised and educated under the Japanese system, were culturally and politically suspect. The 2–28 Massacre began in Taiwan on February 28, 1947, after a pistol-whipping incident led to a local Taipei street uprising, which was then brutally suppressed, resulting in the deaths of 30,000 civilians after a few weeks. The building where the memorial museum now stands is the former site of the Taiwan Broadcasting Company. Seized by Taiwanese students, the building played an important role in resistance efforts, since it allowed them to inform the public about the events unfolding. The memorial museum's mission is to use documentary evidence to provide a public historical account of the 2–28 Massacre, in order both to console the families of the victims and to keep the memory of the atrocity alive.

ROBBEN ISLAND MUSEUM, CAPE TOWN (1997)

From seventeenth-century rebels captured in Dutch East India colonies and Xhosa chiefs imprisoned by the British following the Cape Colony frontier wars of the 1830s, to later influxes of lunatics and lepers, Robben Island has been a place of banishment and imprisonment for nearly 400 years. Yet it is undoubtedly its role as a maximum-security prison for political protesters during the apartheid years for which it has become famous (operating from the 1960s until 1991). It is especially famous for the twenty-year stay of Nelson Mandela. The prison was not only a place of repression, but also of activism and political organization; this idea has helped it to become a cultural showcase for new South African "rainbow nation"-style democracy. Some of the tour guides are themselves ex-prisoners, who show visitors through cells featuring photographs and recorded testimony. The museum has quickly become a major tourist attraction, currently receiving around 400,000 visitors per year.

OKLAHOMA CITY NATIONAL MEMORIAL, OKLAHOMA CITY (2000)

On April 19, 1995, Timothy McVeigh and Terry Nicholas bombed the Alfred P. Murrah Federal Building in Oklahoma City, which contained seventeen government agencies and a daycare center. The blast, which killed 168 people and injured over 600 others, was apparently in retaliation for the U.S. government's attack on the Branch Davidians' compound in Waco, Texas two years earlier. Replacing the spontaneous "memory fence" memorial erected immediately after the attack, the grassy outdoor Symbolic Memorial features 168 bronze, stone, and glass chairs, each of which bears the name of a victim. These stand in the "footprint" of the former building, and are arranged in nine rows, according to where the victims were located in the building's nine floors at the time of the explosion. Tomblike "gates of time" mark the formal entrances to the memorial. The East Gate, inscribed with "9:01," represents the last minute of peace, while the West Gate reads "9:03," framing the coordinates of the memorial in the minutes before and after the blast. The site also includes a large museum, opened a year later in 2001. Along with a "Gallery of Honor," which includes a picture and display case for each victim, several galleries exhibit retrieved office and personal objects, and show displays related to topics like the recovery effort. The museum concludes with a thematic exhibition called "Hope."

PARQUE DE LA MEMORIA, BUENOS AIRES (2001) ESMA DETENTION CENTER MEMORIAL, BUENOS AIRES (2006)

Parque de la Memoria (Memory Park) was inaugurated along the riverbank of Rio de la Plata to commemorate those who "disappeared" during Argentina's Dirty War under the military junta between 1976 and 1983. The park's "Monument to the Victims of State Terror" features a sinuous fissure traversing part of the fourteen

hectares, symbolizing the open wound left in Argentinean society. The four zigzagging non-continuous walls bear the names of 30,000 who disappeared, arranged alphabetically and by year. Many plaques remain nameless, signifying the voiding of identity that preceded disappearance. During the Dirty War, ESMA (an acronym for the Navy School of Mechanics) served as a clandestine detention and torture center – at least 5,000 of the "disappeared" were moved through the building (only around 150 survived). Thousands of photographs of disappeared persons have been attached to the palisade of the seventeen-hectare military compound by relatives and human rights groups (in particular, Memoria Abierta – "Open Memory") who have campaigned for the site to be made a museum. In its current state, visitors are limited to traveling down a corridor once cruelly called "Happiness Avenue" to the torture rooms, passing a maternity ward for pregnant prisoners whose babies were abducted by military officers. At the time of writing, the final appearance and function of the site is still being deliberated: some want a small and simple memorial; others a larger complex that would include a documentation center and human rights academy; others still wish to see the compound razed and replaced with a park.

TERRORHÁZA ("HOUSE OF TERROR"), BUDAPEST (2002)

Although originally built in 1880 as a private mansion, in 1940 the Hungarian ultra-right Arrow Cross Party established their headquarters in the house. The party leader Ferenc Szálasi called the building "The House of Loyalty." In the autumn of 1944, when the Hungarian Nazis came to power, the basement was used as a prison. After the occupying Soviets rid Budapest of Nazi rule, the communist-led Political Police then claimed the house in February 1945 and created a prison labyrinth by connecting several basements along the city block. The Museum, sponsored by the Ministry of Cultural Heritage, is a monument to the memory of those held captive, tortured, and killed in the building. At the entrance to the building there are two memorials, one to the victims of the Arrow Cross and Nazi persecution, and the other to victims of communist oppression. The building's awning has the letters TERROR cut out of it, which casts a shadow around the letters onto the ground. The museum, which received one million visitors in its first three years, features reproduced prison cells, an executioner's basement, an exhibit on life in the gulags, a display of social realist art and propaganda, a "Hall of Tears" for victims, and a "Gallery of Victimizers" condemning the culprits.

SREBRENICA MEMORIAL AND CEMETERY, POTOČARI, BOSNIA (2003)

The genocide in Srebrenica is the most notorious of the episodes of the Eastern Bosnian war in 1995 (which was part of the wider conflict in Yugoslavia that began in 1991). More than 8,000 Muslim men and boys were systematically killed when the town of Potočari fell to the Serb army. The exhumed and identified bodies (which so far number around 1,300) are buried at the Potočari Memorial Cemetery, where commemoration ceremonies are held annually on July 11. The Memorial was

established opposite the abandoned, bullet-scarred U.N. base where thousands of Bosnian Muslims sought sanctuary in vain. The memorial site features burial fields plotted out in petal-like array around a central area that features an open-air prayer room and a crypt with a garden. A Memorial Room, consisting of two black towers, was added in July 2007. One presents a continuously running film, while the other contains twenty showcases depicting the lives of twenty of those killed. In these displays, visitors can view cigarette lighters, tobacco tins, keys, photographs, and other personal effects excavated from mass graves over the last ten years. It is also planned that 10,000 white tombstones will eventually stand on the site.

MUSEUM OF OCCUPATIONS, TALLINN (2003)

This large modern museum, largely privately funded by an Estonian-American couple, traces Estonia's political history from the Second World War to the end of the Soviet occupation in 1991. During the 1941–4 Nazi rule, 1,000 Estonian Jews perished and 20,000 Jews were sent from elsewhere in Europe to die in the city. This period was followed by a half-century of harsh Russian occupation. Filmed eyewitness testimonials and hundreds of photographs and artifacts – from tattered prison uniforms to iron prison doors – are featured. One display case shows dissident anti-Soviet literature that had been typed on wispy paper and secretly passed from one reader to another at the risk of death. Replica locomotives, one stamped with a swastika and the other with a red star, loom in the main hall as a reminder of the human cargo shipped to and fro during a series of twentieth-century occupations – first by the Soviets in 1940, then by the Nazis, and then again by the Soviets, who exiled at least 35,000 Estonians in cattle wagons to Siberia. Another transport-based exhibit is a wooden boat used by Estonians to escape the incoming Russians. The outer walls of the main room are lined with battered brown suitcases, symbolizing the hasty departures made by nearly 100,000 Estonians.

MURAMBI GENOCIDE MEMORIAL, GIKONGORO; KIGALI MEMORIAL CENTER, GISOZI, NTARAMA ROMAN CATHOLIC CHURCH MEMORIAL, BUGESERA (2004)

These memorials commemorate the Hutu massacre of some 800,000 Tutsis (and some moderate Hutus) over the course of 100 days in Rwanda. On April 25, 1994, 27,000 people were squeezed onto the school campus at Murambi in Gikongoro, where they were told to go for their own protection. Over two days almost everyone on the campus was murdered. Today they are buried on the site in mass graves or await burial in the classrooms where they were killed. Although only one of perhaps 200 sites of mass killing, Murambi will provide a permanent facility to enhance understanding of the causes and consequences of the genocide. The Kigali Memorial Center is the site selected for the mass burial of the 250,000 victims from the capital. Developed by Aegis Trust (UK) in cooperation with the Kigali City Council, the Memorial Center includes, in addition to mass graves, a memorial museum and garden, a children's memorial and a national documentation center.

The principal memorial in the town of Nyamata, 30 km from Kigali, is at the main Roman Catholic Church. While the interior has been partly cleared, bones remain on the floor and bloodstains spatter the walls. An outdoor chamber displays several thousand amassed skulls of the 5,000 or more killed there as they sought refuge in the church. Further development of the site, supported by contributions from foreign governments, is underway. Other key memorials are being developed in the Nymata, Bisesero, Nyanza, and Nyarabuye districts.

ATOCHA TRAIN STATION MEMORIAL, MADRID (2004)

After the March 11, 2004 terrorist attacks that killed 192 people, a spontaneous memorial was erected at the Atocha Train Station. Candles, flowers, photographs, and written messages filled the public spaces in and around the station. These have been replaced by "video walls" installed at the station, where 65,000 people have paid their respects to the victims by leaving electronic messages instead of notes and bouquets. A competition sponsored by the Spanish government and the City of Madrid to install a permanent design was won by a group of young Spanish architects. In March 2007 the 11-meter-tall transparent glass and brick cupola was unveiled. The inside is inscribed with thousands of the handwritten testimonials that mourners left at the station in the weeks following the attack. These are viewed from a chamber beneath the hollow monument. (At the request of Spain's Association of Victims of Terrorism, the architects revised their initial proposal to engrave the names of the dead.) The commemorative engravings are arranged so as to be illuminated sequentially by the course of the sun through the day and the seasons, and will be lit from within at night.

WORLD TRADE CENTER MEMORIAL, NEW YORK (2009)

While the permanent memorial museum has yet to be built, a variety of memorial projects have commemorated the terrorist attacks on the World Trade Center, which killed 2,823 people. Immediately after the catastrophe, those seeking urgent information about loved ones posted homemade notices around the city's streets, parks, and subway stations. Candles, flowers, photographs, notes, and flags quickly joined the fliers. These were soon removed offsite, and an official exhibition about the World Trade Center was affixed to the site's perimeter fences. Before long there was a proliferation of other commemorative exhibitions. "Here is New York: A Democracy of Photographs" displayed pictures taken by both amateurs and professionals in a SoHo gallery. Another memorial, "Tribute in Light," consisting of forty-four searchlights shining vertical beams into the sky, has periodically illuminated the Manhattan skyline. In April 2003, the Lower Manhattan Development Corporation announced that Michael Arad and Peter Walker had won the competition for the permanent memorial. Their design, "Reflecting Absence," is based on the preservation of the sunken "footprints" of the twin towers in pools of water. The names of those killed will be inscribed on its walls. The memorial will be accompanied by a large underground museum, the contents of

which are currently being determined. In the meantime, in late 2006 the Tribute Center opened adjacent to the site. A project of the September 11th Families' Association, the small museum consists of four galleries that focus on personal stories. After four months it had received its first 100,000 visitors.

This survey section should be concluded with a note. Readers will notice that I have largely excluded Holocaust memorial museums from my discussion. This is for several related reasons. First, they have been widely written about elsewhere in detail, and often with a good deal of sophistication. Second, as Holocaust Studies has become its own academic field of inquiry, contributions to this area have become subject to a field of literature and debates that, while important, would sidetrack my greater international focus. Third, I am most intrigued by cases that have received little serious attention. While numerous Holocaust memorials and museums have opened during my period of inquiry, they generally follow the template already described thus far. Nevertheless, I am far from inattentive to their emergence, and many have informed my thinking about this topic. Major examples include: the Holocaust Memorial, Miami Beach (1990), Los Angeles Holocaust Monument (1992), Sydney Jewish Museum (1992), U.S. Holocaust Memorial Museum, Washington, DC (1993), Holocaust Centre – Beth Shalom, Laxton (1995), the Holocaust Museum, Houston (1996), Topography of Terror, Berlin (1997), The Museum of Jewish Heritage – A Living Memorial to the Holocaust, New York (1997), Cape Town Holocaust Centre (2000), the Jewish Museum, Berlin (2001), the Montreal Holocaust Memorial Centre (reopened in 2003), the Budapest Holocaust Memorial Center (2004), the revamped Paris "Wall of Names" Holocaust Memorial (2005), Berlin's Memorial to the Murdered Jews of Europe (2005), the Museum of Human Dignity Museum of Tolerance, Jerusalem (to be completed in 2009). Alongside the existing rich literature on Holocaust memorialization, it now appears timely to accord greater recognition to these generally lesser-known cases.

BEARING THE PAST

From genocide to terrorism, from state repression to nuclear calamities, the events that my focal sites commemorate are patently diverse. Yet they share certain thematic similarities that have a strong bearing on museum displays: the victims were mostly civilians, meaning that women and children were not spared; they were killed in circumstances that range from the morally problematic to the utterly inhumane; those who died did so "unnaturally," meaning that their deaths cannot easily be inter-preted and represented as heroic, sacrificial, or somehow benefiting the greater good of society or the nation; in each event, the motive of the killers and the mode of killing loom large in the public consciousness; hence, the histories have a dramatic quality that lends itself to evocative reconstruction and storytelling for memorial museums and visitors alike; finally, issues surrounding the identity, culpability, and punishment of perpetrators are often contentious or unresolved.

More significant than the shared negative qualities of these historical crimes against humanity, however, is the idea of devoting sites and structures to them. To be sure, memorial museums overlap with conventional history museums that sometimes depict genocide, atrocity, resistance, and persecution. However, history museums are different; they assemble their exhibitions in more neutral institutional settings, often alongside permanent galleries that showcase less volatile topics. The cases I have introduced involve some stark departures from conventional historical exhibitions. Some of these key aspects include: their site is usually integral to their institutional identity; they often maintain a clientele who have a special relationship to the museum (such as former members of a resistance, or the families of victims of persecution); they regularly hold politically significant special events (such as memorial days); they often function as research centers geared towards identifying victims and providing material to aid the prosecution of perpetrators; they are frequently aligned with truth and reconciliation commissions and human rights organizations; they have an especially strong pedagogic mission that often includes a psychosocial component in their work with survivors; educational work is stimulated by moral considerations and draws ties to issues in contemporary society in a way that is uncommon in standard museum presentations of history.

The identification of such characteristics forms a sufficiently potent basis for the study of memorial museums, and leads to other, larger questions: what do they actually contain? Why have they proliferated worldwide in this particular sociopolitical epoch? What is the basis of their appeal for visitors? What effect might their creation have on other kinds of museums and heritage sites? Will they (if they have not already) become a permanent feature of the urban landscape, and, indeed, of public historical consciousness? I use the following chapter topics to structure my exploration of these questions. Chapters 2 (The Surviving Object: Presence and Absence in Memorial Museums"), 3 ("Photographic Memory: Images from Calamitous Histories") and 4 ("Rocks and Hard Places: Location and Spatiality in Memorial Museums") will go inside various memorial museums to critically focus on what I consider their most fundamental elements: the object, the image, and the space. Decisions concerning which objects and images to use, how to organize them, and how to choose a space in which to display them (for instance, whether a recovered site of atrocity or a custom-designed new building) involve aesthetic and ethical issues typically loaded with significance. In particular, I am interested in the strain between authenticity and evidence, on the one hand, and the desire to create an emotive, dramatic visitor experience, on the other. In these chapters I explore the persistent tension that bears upon the cognitive and emotional construal of the relationship between the curatorial and architectural intentions informing the deployment of objects, images, and spaces, and the historical narrative to which it relates.

Having examined the actual material substance of key memorial museums, subsequent chapters engage with larger critical concepts. Chapter 5 ("A Diplomatic Assignment: The Political Fortunes of Memorial Museums") examines more closely the political lives of various memorial museums: who founded them, how, and why?

From government departments, to survivor groups, to non-governmental organization-backed research institutes, there is marked diversity in this matter. How do the interests that these categories of actors hold impact on the story told? How have the political uses of key memorial museums changed throughout their institutional lives? Chapter 6 ("The Memorial Museum Identity Complex: Victimhood, Culpability, and Responsibility") explores how memorial museums encourage visitors to think about their cultural identities within these publicly visible, ritually employed, and politically loaded spaces. Ideas about victim status, inherited guilt, and moral responsibility are paramount as they are both shaped by, and interpreted within, memorial museums. The concept of visitors "confronting the past" through memorial museums assumes that these sites can provide a lucid conduit to the event in question. Theories of collective memory are integral to this chapter, as they provide a way to conceptualize the often-unsteady relationship between the institutional mediation of the historic event in question and its contemporary public recollection and (re)interpretation. Chapter 7 ("Looming Disaster: Memorial Museums and the Shaping of Historic Consciousness") considers the effect that memorial museums, as increasingly visible arbiters of public history, might have on the broader understanding of the shape of the past. I analyze, for instance, how memorial museums demarcate the temporal, spatial, and social context for the histories they represent. Does the growth of memorial museums worldwide help to establish cross-cultural continuities, producing a sense of the interconnected flow of history? Or, alternately, are some concepts and vocabularies of political violence applicable only to specific events? My concluding chapter ("In Conclusion: Fighting the Forgetful Future") speculates on the future of memorial museums. If they are to become an enduring fixture in the heritage landscape, what might we make of their influence? Do they help foster a culture of self-pity, or help inspire the universal struggle against injustice? This is not just a conundrum for those working in museums, but one that asks all of us whether we should now expect, and desire, the creation of appropriate memory institutions for every kind of disaster. Alternatively, is it possible that the social, cultural, and political conditions that helped to create these institutions might be exposed as sufficiently transient that memorial museums become a passing fad, a brief but vivid moment in the longer chronicle of cultural-historical institutions?

In summary, an underlying aim of this book is to introduce to the emerging but under-explored field of memorial museums the level of criticism that conventional museology enjoys. There are a number of little-criticized precepts about memorial museums (which can be found in scholarly writing, journalism, and public discourse alike) that, to date, have not received vigorous analysis. For instance, the memorial museum is promoted as an effective apparatus for producing a range of desirable social responses – from allowing victims to mourn, to forgiving perpetrators, to keeping criminal acts at the forefront of public consciousness, to aiding the cultural redevelopment of an afflicted people, to imparting to all of us values that might make us better human beings. Unfortunately, there is a lack of critical writing that

establishes how – or even whether – they are effective in this regard, beyond the descriptive biographies of individual institutions that characterize the existing literature in this area. This book, in short, will introduce an overdue benchmark for the critical analysis of such ideas.

2 THE SURVIVING OBJECT: PRESENCE AND ABSENCE IN MEMORIAL MUSEUMS

THE PHYSICAL REMNANTS OF VIOLENCE

On first reflection, we might assume that objects tied to abhorrent events deserve no place in the museum. The association of the museum with all things historically precious and valuable is one that remains largely stable in the public consciousness. In history museums, the prized object has qualities related not primarily to aesthetic excellence, as found in art museums, or the rare and representative specimens that fill natural history museums, but which instead pertain to *authenticity*. Memorial museums, for their part, are acutely aware of the role of primary artifacts, not only because they give displays a powerful appeal, but also because in many cases they exist as tangible proof in the face of debate about, and even denial of, what transpired. Yet compared to conventional history museums (dedicated to the stories of, say, an immigrant group, a form of labor, or a region or nation) there is a basic difficulty with the object base of memorial museums: orchestrated violence aims to destroy, and typically does so efficiently. The injured, dispossessed, and expelled are left object-poor. Moreover, the clandestine nature of much political violence means that perpetrators aim to purposefully destroy evidence of their destruction. Records and bodies are buried. Hence, memorial museums' collections are often restricted in size and scope. When materials are recovered, the process often proceeds in an almost archaeological fashion. Figure 2.1, showing a glass-floor section at Lithuania's Museum at Genocide Victims, which reveals pliers, a belt, flask, knife, keys, and other KBG officer tools, conveys this notion literally.

Such exploration can, ideally, make the formation of a memorial museum collection a revelatory process, where ordinary people are provided a space in which they can come forward to share materials and their experiences. This entrustment of confidences can lend memorial museums' collections hefty moral weight. Yet it also produces an equivalent sense of volatility concerning the way it is utilized. The combination of the calamitous "story" of the event, its political and existential gravity, and the scarcity of material traces left behind makes the objects that *are* shown all the more crucial. Where a large generic history museum can turn its hand to a wide variety of topics, the relationship between the memorial museum and its event is singularly focused. This chapter aims to show that despite memorial museums having an uncommonly circumscribed mission – that is, to illuminate, commemorate, and educate about a particular, bounded, and vivid historic event – this situation does not make the process of exhibiting objects straightforward.

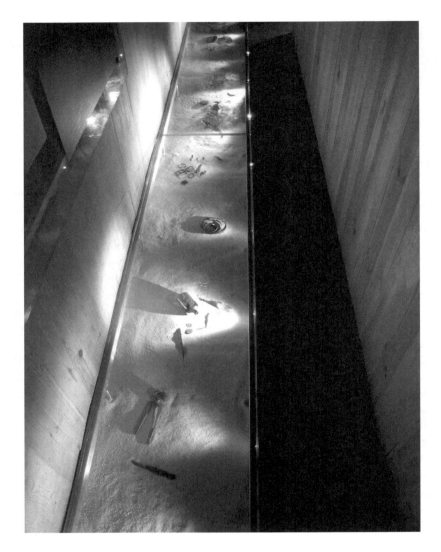

Fig. 2.1. Objects discovered in the "partisan bunker" at the Museum of Genocide Victims, Lithuania. Copyright the Museum of Genocide Victims, Lithuania. Used with permission.

A marked feature of the memorial museum collection is that it is defined by – or even held hostage to – what the perpetrators in each event *produced*. Institutions must hence decide how to incorporate, frame, or repudiate the output that the calamity generated, given that it constitutes the stuff of public recognition. The First World War, for instance, was shocking to the public for its sheer apocalyptic carnage. Yet memorials practiced strategies of avoidance and transferal. Little of that bloodiness was translated into direct words or images; death was treated through allegory, metaphor, and allusion.[1] While the Holocaust is notably associated in object form

with the industrial machines that effected the disappearance of human bodies (such as boxcars, gas chambers, and ovens), it also produced, as terrible "byproducts," clothing, money, jewelry, eyeglasses, watches, and hair. These movable items are emblematic for Holocaust museums worldwide, along with keepsakes and diaries hidden by victims, official Nazi regime equipment and insignia, and civilian artifacts from the period that help to evoke 1930s' and 1940s' *mise en scène*. With Holocaust museums as a dominant frame of reference, the development of memorial museums has proceeded with allied expectations about the kinds of artifacts shown. If this has consolidated a "genrefication" of memorial museum objects, what can we say about the understandings they support or preclude?

Memorial museums considered in this book were inspired by events involving diverse forms of violence. Those in Dhaka, Nanjing, Taipei, Srebrenica, Phnom Penh, and Kigali, for example, share a sense of intense brutality that was intimate and corporal, yet socially dispersed – that is, attacks occurred one-by-one, but were also part of a much larger national pattern. Memorial museums in these countries tend to display objects related to the bare action-and-effect of these encounters – the weapons of the assailants and the remains of their victims. They display what the perpetrators aimed to effect: *lifelessness*. Memorial museums in Perm, Vilnius, Sighet, Budapest, Tallinn, Santiago, and Buenos Aires based in detainment and torture centers also involve a sense of intimate violence; systems of political terror aimed to produce compliance, through either the damaging or the disposal of bodies. Where torture instruments are displayed, they are usually counterbalanced with testimonial from survivors. While the idea of objects "revealing the truth" is an aspect of all memorial museums, it is an especially pertinent oppositional strategy in memorial museums detailing histories of harsh suppression. They aim to foil what the perpetrators sought to effect: *silence*. In contrast to visceral, somatic weaponry, cells, and shackles, Hiroshima and Chernobyl produced (in starkly different contexts) forms of vaporization. What remained were the otherworldly effects of the nuclear fallout on everyday objects and streetscapes. The display of alienated objects produces a distancing effect from human actions, communicating *unearthliness*. Terrorism in Oklahoma City, New York, and Madrid similarly produced objects contextualized by the instant of the attacks. These events are defined more closely by the exact architecture of the violence – a government building, commercial tower, and transport hub, respectively – that housed (and were calculated to contribute to) carnage. Those objects recovered from the sites (and added to through spontaneous memorials) are intended to stand in as luckless *fragments* of lost lives.

From this preliminary synopsis we can anticipate the kinds of objects on display. But memorial museums face a choice in this regard: while many visitors will arrive with some familiarity with the most notorious symbols of an atrocity, is it best that institutions foreground these as access points in the hope that they form a gateway to deeper understanding? Alternatively, should the particulars of any event (and especially those produced by offenders) be presented as merely circumstantial, so that visitors' attention is instead turned to larger principles such as political freedom or

human injustice? While curators will seldom approach this issue through an either/or scheme, it is a useful frame for introducing the potential effects that the illumination of different categories of objects might produce. To explore the quality of visitor understanding that might result from different artifacts, I have organized this chapter into three object categories. These are: first, victims' remnant personal effects and perpetrators' tools of atrocity; second, bones and other human remains; third, public tokens and commemorative offerings. Before turning to these sections, however, it is worth briefly introducing, as an indispensable background to my discussion, some issues that the display of Holocaust objects brings to bear.

COLLECTING THE DISCARDED: THE HOLOCAUST PRECEDENT

> Voshchev picked up the dried leaf and hid it away in a secret compartment of his bag, where he used to keep all kinds of objects of unhappiness and obscurity.

> "You had no meaning in life," Voshchev imagined to himself with meagerness of sympathy. "Lie here, I will learn wherefore you lived and perished. Since no one needs you, and you are straying about in the midst of the whole world, I will preserve and remember you."

> Andrei Platonov, *The Foundation Pit* (1929, published 1969)

> After I left the [U.S. Holocaust Memorial] Museum, I bought a soda and strolled along the Mall. When I finished my drink, I found a trash can and was about to toss in my bottle when I noticed a familiar-looking grey card sitting atop the garbage; Holocaust museum identity card No 1221, Maria Sava Moise, born June 1, 1925, in Iasi, Romania. Maria, a gypsy, had survived the war, only to wind up as part of the litter of a Washington tourist's afternoon.

> Philip Gourevitch, "Nightmare on 15th Street,"
> *The Guardian*, December 4, 1999

Memorial museums can save items from the anonymity and inevitable decay of real life. Objects can be restored as emblems loaded with emotional and historic weight almost certainly greater than that enjoyed in their initial incarnation. The force of the "museum effect" – that is, the enlargement of consequence that comes from being reported, rescued, cleaned, numbered, researched, arranged, lit, and written about – enables objects from the past to be valued in entirely new ways. Indeed, one could argue that this revaluation provides personal objects with false significance, in the sense that memorial museums ask them to represent a narrative that could never have been grasped for all its historic import in the moment. While it is easy to become absorbed with the signifying power of objects, it is important to bear in mind the converse: for all the connotative power assigned to an item, what else is overlooked or unknown? The transferal of ownership of an item from use-value to signifying-value often involves the loss of a good deal of intimate knowledge: was that gun

exhibited in the display case fired in fear or anger? Did that crude metal bowl contain a vital meal for a prisoner or was it a castoff discarded by a guard? Beyond these circumstantial considerations, can we ever gain an affective sense of the gun being clutched by white-hot knuckles, or the desperate scraping that scratched the bowl?

Within the meta-value of authenticity noted earlier, objects in traditional history museums are typically chosen for collection, preservation, and display on the basis of one of three grounds. These initially seem quite distinct: there is, first, those that are particularly rare or revelatory; those, secondly, that have the significance of typicality and are able to a represent a category of experience; thirdly, those that are important by virtue of belonging to a remarkable person or group. However, the kinds of objects displayed at memorial museums (such as victims' clothing, jewelry or bones, offenders' weapons, uniforms or supplies, or equipment such as food bowls, shackles, or written rules and directives) often fall into more than one of these categories. As arguably history's most famous Holocaust artifact, we can see that something like *The Diary of Anne Frank* fulfils all three categories. Moreover, something that was typical (such as the ubiquitous Star of David yellow fabric badge forced on Jews by the Nazi Security Police) can be traced back to being the possession of a single person, and this person may have since become noteworthy for their historic destiny. The peculiar combination of both the aberrant exceptionality *and* the widespread social impact that characterizes the events represented in memorial museums means that objects typically overflow and complicate the categories of being rare, typical, or individually totemic.

The *Anne Frank* and Star of David examples are not inadvertent; the aesthetic constitution of themes of absence and loss in object form is indubitably informed by Holocaust museums. By the 1990s, a canon of Holocaust victims' objects had been established, heavily influenced by the example of Auschwitz II-Birkenau Memorial Museum, known for its display of camp objects and items found at the site after being plundered from the victims of mass extermination on their arrival: suitcases with nametags still attached, shoes, hairbrushes, mirrors, glasses, toothbrushes, jewelry, and zebra-striped uniforms. Other retrieved personal items include identity cards, toys, letters, and photographs. Piles of objects contribute to a homology of absent bodies. This idea is made explicit at the U.S. Holocaust Memorial Museum, where, for example, a wall label gives a pile of shoes a collective human voice:

> We are the shoes, We are the last witnesses
> We are shoes from grandchildren and grandfathers.
> From Prague, Paris, and Amsterdam
> And because we are only made of fabric and leather
> And not of blood and flesh,
> Each one of us avoided the hellfire.[2]

The shoes function simultaneous as primary evidence and as an incisive signifying device. The deprivation represented by bodily objects gains its power from their corporeal nature (while it might be folly to think we can "put ourselves in their shoes," the metaphor is there). What is hard to conceive on viewing the shoes is that

they already meant that the person had been processed and numbered, and in effect, consigned to the past. As James Young has written: "These artifacts ... force us to recall the victims as the Germans have remembered them to us: in the collected debris of a destroyed civilization ... In great loose piles, these remnants remind us not of the lives that once animated them, so much as the brokenness of lives."[3]

Attempts to make use of objects beyond this established, remnant-themed iconography have often been problematic. This became apparent in a fracas over objects acquired by Berlin's Jewish Museum for its 2001 opening exhibitions. A focal point was the modest living room furniture that accompanied the Scheuers, a German-Jewish family expelled in 1938 from Staudernheim to the U.S.A. Museum spokeswoman Eva Söderman stated that the furniture represents "the exile of the little people."[4] Chana C. Schütz, deputy director of Berlin's Centrum Judaicum (housed in Berlin's New Synagogue, rededicated in 1995) challenged the choice of acquisition, asking, "can you tell me one Jewish object that is not a Holocaust object that can be that impressive? They [the Jewish Museum] shouldn't think buying furniture of people who immigrated to the United States makes a good object. It's still old furniture."[5] For the Jewish Museum's curatorial staff, the point was that it *was* typical. As Thomas Friedrich exclaimed, the point is "to show people that these things exactly looked like everything else. They're not *Jewish.*"[6] Yet, for Schütz, justifications on the grounds of typicality mask a fascination with the idea that the objects that were actually there – that they were the property of Jews, and that this gives them gravitas through being tied to the Shoah. For Schütz, this perpetuates a vision of Jewish history that is maudlin rather than strident; the furniture acts as a signifier of evacuation and loss that avoids harder political condemnation. Instead of producing exhibits based around, for instance, personally naming Jewish wartime collaborators (something the Centrum Judaicum has done), "everything at the Jewish Museum will be politically correct because they are very afraid of making any mistakes."[7]

While Schütz's contention is probably as much politically inspired as philosophically inquiring, it nonetheless raises an important question regarding the signifying abilities of objects. Any item exhibited in a museum is never allowed to remain the thing itself, but instead invokes meanings greater than the world of objects from which it has been picked out. How do we perceive the limits or boundaries of an object's meaning? To invoke René Magritte: *ceci n'est pas une pipe* (ou chaise); in such a museum, the chair cannot help but signify. But to counter via Freud: *sometimes, a pipe is just a pipe* (or chair). At heart, this is a philosophical question about any artifact's simultaneous role as a linguistic sign and a plastic element. Trying to judge how objects variously symbolize, represent, connote, denote, constitute, embody, realize, signify, or objectify points towards the difficulty in assessing how they can reliably reflect social relations. Given their amplification in the museum context, artifacts can be considered prime contributors to mythmaking. As Daniel Miller has theorized: "The process of signification is what accomplishes the task of the myth; it subverts simple denotation through its wider connotation, it naturalizes culture as the given order of the day, and it utilizes the ambiguities and tendencies of the process of signification itself in order

to effect its apparent closures."[8] Although the intrinsic solidity of any museum object appears to make it both dumb and still, museums often seek to grant it a dynamic life history, assigning it a dramatic role in the historical story of any event. That is, the idea that an object "witnessed" an atrocity is a rhetorical strategy that aims to humanize something that existed during the period; the object itself gains a "life." Yet the museum's reliance on "witnessing objects" forms its own implicit lament, in that they are as close as we get to a person; belongings and images are often all that remain. Yet by foregrounding *this* effect on *this* item (an entry etched into a diary, a bloodstained shirt), the object has the effect of foreclosing the life to which the museum attaches it by reducing it to its period of greatest suffering.

A SINISTER APPEAL

Whether in Central and Eastern Europe under Nazism and communism, in China at the hands of the Japanese, in Cambodia or Rwanda as self-inflicted annihilation, or in Argentina or Chile as covert civil terrorism, one typically finds in memorial museums a comparable collection of deadly apparatuses. Worn and used, and displayed either *in situ* in rudimentary cells or torture rooms, or presented with contextual explanation in display cases, visitors might see bludgeons, guns, knives, grenades, shackles, torture instruments, uniforms, propaganda posters, and written or coded memoranda between officers. These objects are insidiously arresting, particularly because we assume that they were actually used in terrible acts. Yet, as those familiar with an array of memorial museums can attest, they can also appear somewhat generic and interchangeable, lacking in specific bearing to any particular event. At the Museum of Genocide Victims at Vilnius, for instance, the separation of the histories of Nazi and Soviet repression into two separate, adjacent galleries means that in each visitors are shown objects that, although slightly different in form, produce a similar effect. We see two sets of guns, two uniforms, two versions of secretive notes from members of the resistance, et cetera. This is less a criticism than a point for consideration: what can instruments of violence teach us?

We normally associate the display of armaments with conventional war museums. While lamenting the loss of those who served, these museums typically focus on military experiences that lionize soldiers' sacrifices. The weapons, vehicles, uniforms, rations, medals, maps, and propaganda posters that form their collection base are intellectually captivating and often culturally aggrandizing. While it has become commonplace for traditional war museums to add a memorial component (a good example is the addition of a Holocaust exhibition to London's Imperial War Museum in 2000), they generally remain places of pride more than sorrow. While the differentiation of memorial museums from national war museums is normally reasonably straightforward, some examples are confounding. Consider the Siem Reap War Museum, opened under Cambodia's Ministry of Defense in 2001. A large collection of discarded weaponry from the nation's various post-Second World War conflicts fills the grounds. Visitors can encounter a Soviet helicopter, artillery, antiaircraft

guns, and a motley assortment of tanks and armored vehicles. Nearby sheds house dilapidated automatic weapons, mines, grenades, rocket launchers, uniforms, and Khmer Rouge flags. The only information attached to the items is taxonomic, citing their type and place of production. Visitors are given almost no information identifying the conflict in which the weapons were used, or any wider discussion of those histories – let alone their political, social, and cultural impact. There is no discernable exhibition narrative in the museum; the spectacle of seeing (and being able to climb over, pick up, and pose with) well-used weaponry is supposed to be sufficient reward. Despite the country's tormented modern history, this museum glosses war as simply any situation in which military equipment was used, no matter whether it was to fire on the French, the Americans, Sihanouk's army, the Lon Nol clique, the Vietnamese, or one's own kin at the direction of the Khmer Rouge. When set alongside the Tuol Sleng Museum of Genocidal Crimes, with its careful documentation and victim focus, the nation's "official" war museum is quite bewildering (and demonstrates, if little else, that the Hun Sen government is more interested in capitalizing on the financial benefits from tourism at nearby Angkor Wat than in developing heritage projects in aid of national reconciliation).

The opportunity to interact physically with perpetrators' weapons at the Siem Reap War Museum goes against the general norm of other memorial museums, where the objects of primary focus are those with a warm, human presence (shoes, jewelry, coats) rather than those that feel foreign to our sense of bodily comfort and emotional attachment. If the chilling yet transposable nature of weapons is limited for educational purposes, identity cards form a less alienating category of objects. On the one hand, they represent the property and mechanisms of state bureaucracy. When the regime in question had baleful ends, paper and plastic cards themselves formed a tool of political control. While the infamous "J-stamp" identity cards (which preceded Star of David badges) constitute a well-known Holocaust example, an equally important case involves Rwandan state identity cards that, in a sense, facilitated genocide. Given that cultural or physical differences between Hutu and Tutsi were murky at best (despite popular rhetoric among murderers that such distinctions were obvious) it was through house-to-house and roadblock inspections of identity cards that life and death verdicts were made. Some of these are displayed with human remains at Rwandan memorials, serving to both identify and commemorate. On the other hand, then, intrinsic relation to personhood makes identity cards indispensable objects for memorial museums as their emphasis on "personal stories" grows.

The identity card tactic is most famously deployed at the U.S. Holocaust Memorial Museum. On entering, visitors can pick up a museum-produced identity "passport" of an actual person who died in, or sometimes lived through, the Holocaust. As the visitor moves through the museum, he or she is meant to turn the page of the booklet at the end of each floor, both of which correspond to new developments in Nazi Germany. Although this tactic of personal identification between the visitor and victim has been critiqued for its encouragement of unrealistic empathy, it has nonetheless influenced, for instance, the renovated US$56 million

Yad Vashem, which reopened in spring 2005 at four times its earlier size.[9] Its previous dimly lit displays were heavily based on photographs, the textual records of Nazis and their collaborators, and Judaic symbols and emblems. In an era of dwindling numbers of Holocaust witnesses, the new museum represents the Holocaust through more than ninety well-documented individual stories. One involves fifteen-year-old Dawid Sierakowiak, who died of illness in a Polish ghetto in 1943. Passages from his diary he left behind, such as a detailed description of the occupation of his city of Lodz in 1939, are posted on the wall, and join other journal entries, artwork, personal belongings, and videotaped accounts from survivors. Visitors see a doll taken into a ghetto by a young girl, or a postcard written from Auschwitz in a mother's pleading hand. "We want to bring a very personal encounter between the story and the storytellers," says Avner Shalev, chief curator. "We want to build empathy." The new focus on the personal diaries and visual testimony is to "give back the faces."[10]

Although this chapter began with the suggestion that memorial museum collections are built around objects recovered from destruction and loss, it is critical to note that such artifacts can only touch on an event in a basic way. Acts of physical violence are ephemeral: it is difficult to capture much of what transpired on walls, in display cases, or on plinths. In a sense, it is the *story* that is the object, insofar as it is not the item itself that is distinctive, but the associated history to which it is attached. This point raises the sticky question of authenticity: if the museum conceives of objects as tools or even props supporting a historic story, how necessary is it really that all objects displayed have a provenance definitely known to be of the event, linked to a certain person and place? This idea – that sometimes the objects most closely related to the event are in some way ambiguous or insufficiently charged to communicate its tumult, and that more evocative but less authentic examples might take their place – points to the importance of dramatic effect in making the history contained in any memorial museum sharp and compelling. In this, memorial museums are implicitly subject to the notion that being faithful to documentary evidence and serving the historical imagination may pull in different directions.

Expanding on this theme, we can call those objects that may lack self-evident attachment to the narrative at hand, but possess a high emotional quotient and hence lend themselves more easily to emotive spectacle, "hot." A key example is from the "Women in Prison" gallery at the Memorial of the Victims of Communism and Anti-Communist Resistance in Sighet. It showcases the story of two detained women who were separated from their children. One of the most affecting items is a bar of soap sent from a husband at home that bears the carved words "I love you." Similarly, at the Museum of Genocide Victims in Vilnius, polychromic tests carried out in 1995 and 1996 revealed that cell walls of the old KGB building had received eighteen coats of paint since the 1940s. Each layer was added to cover up the writing and scratchings left by former prisoners. The museum has stripped back individuals layers to reveal some of these desperate, forlorn messages. In both situations, the idea of the prisoner "calling out" to us through clandestine means is stirring (despite that

prisoners never, of course, conceived museum visitors as their intended audience). "Hot" objects, then, can be made to speak emotionally due to their high capacity for personification.

"Cool" objects more easily explain details of what occurred. Their more functional illustrative qualities carry the risk, however, that they may flatten the story into a historical "book on the wall." At Taipei's 2–28 Memorial Museum, a pile of boot-legged cigarette packets forms the pictorial basis for the flashpoint that led to the massacre. These are arranged in front of a large woodcut image depicting a Kuomintang soldier firing on local peddlers (Fig. 2.2). When bureau officials attempted to violently arrest a woman for selling the untaxed cigarettes, locals, among whom discontent was already running high, resisted the officers. As a result, armed reinforcements were sent for from the mainland, and the island-wide suppression begun. In this case, although the cigarette packets are unremarkable themselves (and it is not made clear whether they are original or reproduced), they provide a visual "hook" that might assist visitors in recalling the story. Yet, as museum guides will attest, visitors are seldom hooked in predictable ways. An object that held my attention was a rudimentary wooden pinball machine, which has nails to channel the

Fig. 2.2. Woodcut of 2–28 flashpoint, cigarette packets in background. Image taken by author.

ball and tin bottle tops to indicate the targets (Fig. 2.3). On these tops are Chinese logogram characters bearing short slogans like "We must at all costs reclaim the mainland." The game, custom built for the mess hall of Kuomintang soldiers, now has a somewhat derisory connotation, given that historical hindsight tells us that the massacre's perpetrators failed to become China's victors. Another factor makes it noteworthy. Within the museum's rather matter-of-fact walk-through organization of the story of the 2–28 massacre, this object stands out because it suggests a point of

Fig. 2.3. KMT Pinball machine, 2–28 Museum. Image taken by author.

view often denied by memorial museums: offenders at leisure. The presentation of an object of this kind encourages visitors to consider a response that, while probably not as warm as understanding, acknowledges the perpetrators' perspective nonetheless.

If we have so far examined objects associated with violence at close-quarters, a different consideration involves the physical aftermath of large industrial-military scale disasters. How might personal, domestic relics appear in this context? The distance between the mundane equipage of everyday life and the ruins of grand political events suggests the limits of victims' objects in producing visitor comprehension. A prime example concerns the town of Pripyat, which served workers at the Chernobyl nuclear plant before being abandoned within a day following the disaster. Since 2002, guided tours have been available. They begin with a view of Chernobyl's "sarcophagus," the hastily concrete-clad remains of reactor number four. Visitors are then led through the town of Pripyat, where they pass the once-prized Polissia Hotel, the darkened Energetic Theater, and a silent amusement park that had its grand opening only days before the catastrophe. Visitors can enter former school classrooms where books lie open, and houses where laundry, toys, clothing, and decorative domestic touches remain (Fig. 2.4). As they pass by all of this, tourists have little way

Fig. 2.4. Classroom, village of Shipelichi, the Chernobyl Exclusion Zone, 1995. Copyright David McMillan. Used with permission.

of knowing whether any quickly abandoned residence housed someone who died quickly, who was made terminally ill, or who was safely evacuated by bus. The town is part living memorial, part eerie walk-through theater. Its attraction is, paradoxically, the thing that cannot be seen: radiation does not look, taste, or smell like anything. Nor does the town hold many signs of what occurred. Buildings and machinery are rusted, yet they are perhaps surprisingly filled with thriving flora and fauna. Yet this condition is hardly unique to this particular dilapidated settlement. Hence, what might we imagine visitors learn from the site? Is it a eulogy for the loss of many single lives, for a 50,000-strong community, for a politically unified Soviet Union, for a failed political ideology, or for our universal human folly? Alternatively, perhaps the authenticity associated with actual objects — that *these* limp things were once part of life in *this* house — is primarily enjoyed for the way it heightens voyeuristic scopophilia. As Christian Metz has theorized in relation to the measured distance between the subject and the screen in the cinema, it is this detachment that actually facilitates out ability to gaze at others.[11] The theme of voyeurism appears especially pertinent in the Chernobyl case because, compared to standard museological conventions that advise visitors not to touch, it is the risk of radiation — that unknowable source of fear and fascination — that forces tour guides to ask visitors to keep their hands off objects, and which instead fuels the visual imagination.

A second case involves New York's Ground Zero, a site that, far from being forsaken to nature, is the focus of relentless redevelopment plans. In its current state, the site cannot be explored in any truly physical way and is instead better conceived as a stage. The ticket-system viewing platform constructed in the first half of 2002 overtly situated tourists as spectators (perhaps frustrating those who wanted to escape their mediated experience of the event and encounter the "real thing"). To see objects more evocative than the construction site, visitors have been drawn away from Ground Zero towards objects residing in museums in New York, Washington, DC, and further afield. Various museums began collecting material from the rubble very shortly after the event. These objects arguably allowed viewers to "bear witness" more successfully than the site itself. The emblems displayed "frozen in time" are those mostly with strong associations not with business or the building, but with workers' daily lives. *Recovery: The World Trade Center Recovery Operation at Fresh Kills* on view from November 25, 2003 through March 21, 2004 at the New York Historical Society showed some of the finds of the 1,400 people who toiled at Ground Zero daily, sifting through 1.6 million tons of material. They found 54,000 personal items, ranging from lipstick to paperweights, clothing to molten credit cards, and around 4,000 family photographs.[12] The Smithsonian National Museum of American History's *September 11: Bearing Witness to History* (displayed from September 11, 2002 to July 6, 2003) also focused on everyday objects, mostly sourced after the event rather than being excavated from the site. For instance, a woman who escaped from building one was asked to donate the heels she removed so that she could descend the stairs more swiftly. These became part of the collection, along with her leather briefcase also later found (it was identified because, remarkably, it still contained her

résumé).[13] In these examples, the artifacts fulfill a more conventional museological paradigm of lost objects reinstalled into an exhibition in order to pull together stories that partially reconstitute an event. In these more conventional indoor exhibitions, it is not, unlike the Pripyat tour, the viewer's roaming eye that selects objects from an unpredictable field of features; instead it is the curator who performs the selective work. In this way, the museum's institutional authority normalizes, and therefore diminishes awareness of, the visitor's sense of voyeurism.

A final example on this theme involves objects displayed at the original "ground zero" in Hiroshima. Displayed at the Peace Museum are recovered items demonstrating the unearthly effects of the atomic blast, including tattered school uniforms, lunchboxes, shoes, spectacles, toys, radios, and other ephemera. Notably, the museum uses the fleshy body to illustrate the same point. Visitors see, for instance, the deformed fingernails of survivors, hair that fell out in giant clumps, or shards of glass expelled from victims' bodies years after the bomb. These hylic objects are accompanied by the audio taped testimonies of *hibakusha* (the damaged persons). (This display of biological abnormality is not unique to this museum: the Chernobyl Museum in Kiev also features preserved deformed human and animal fetuses to demonstrate radioactive effects.[14] Likewise, the War Remnants Museum in Ho Chi Minh City displays fetuses malformed by Agent Orange suspended in liquid in glass jars.) While the museum intends its selection of visually shocking objects as a warning about the peril of nuclear war, it is precisely because Hiroshima-Nagasaki has not been repeated that the objects can be interpreted as not just ghoulish but anomalous: into what personal cognitive framework can such objects be incorporated? Such is the apocalyptic vision of nuclear devastation that the objects on display may seem only *normally* dreadful, rather than inconceivable (hardest to conceive are those at the blast's epicenter, who of course left no trace). The body is, amazingly, also present in built form. On display is a section of the walls and steps of the Sumitomo Bank, which features a human shadow burnt onto the stone. A customer was sitting on the bank's steps waiting for it to open as the bomb exploded. The flash cast the shadow and at the same instant the intense heat rays turned the surrounding stone steps whitish, leaving the shadowed area dark. This extreme case raises the question of how we might separate the object from the self: should human remains be considered along a continuum with other things associated with selfhood (like hairbrushes, eyeglasses, or even scorched shadows), or do they represent a fundamental break with the generic category of objects?

IRREDUCIBLE EVIDENCE: HUMAN REMAINS IN MEMORIAL MUSEUMS

Viewing bodies in public buildings is itself not such an unusual practice. "Lying in state" – the traditional process where a dead body is ceremoniously displayed in a government building before being interred – is a feature of the deaths of many modern leaders, including Lenin, Stalin, Mao Zedong, Ho Chi Minh, Churchill, Eisenhower, and Reagan. The modern management of the bodies of soldiers killed in

conventional warfare has normally meant their removal from view through either burial or placement in a memorial crypt. During and after the First World War, European states took control of these bodies, normally making the decision that soldiers who died in battle overseas should be buried there in individual but identical graves. As opposed to earlier wars, where soldiers were buried in mass graves, this new mode of burial implied at once the democratization, individualization, and bureaucratization of death.[15] War cemeteries spoke of both the leveling qualities of death and the specificity of individual sacrifice. A cenotaph often served as the consciously nationalist centerpiece of such graveyards. The alphabetical listing of names without reference to class or rank communicated the egalitarian ideal of mass collective duty, deserving of a permanent place in national memory.

The public remembrance of civilians who died wretchedly is less practiced, as we shall see. The issue of human remains in museums has primarily related to histories of the expropriation of indigenous peoples' bodies by imperial museums over the past 200 years and their repatriation in recent decades. Rare cases have also existed where modern European remains were exhibited, such as at Vienna's Museum of Natural History, where the Nazis organized the exhibition of Jewish skulls, alongside those of non-Jewish Poles for comparison. They remained in its collection until 1991, when they were turned over to the Austrian Jewish community who had them buried. As a general rule, however, museums find the display of human remains from modern atrocities untenable. The position of the U.S. Holocaust Memorial Museum, for instance, is that "it must be assumed that objects such as hair, bones, and ashes will not be considered as potential accessions … They do not belong in an American setting, where no concentration camps stood and which was not the primary arena for the Holocaust."[16] The museum's Director of External Affairs at that time, Alvin Rosenfeld, also added: "At any standard, the display of human hair and/or ashes and bone is offensive to the memory of the dead." Such displays, he believed, would "offend, repel, and sicken many visitors physically, emotionally and spiritually."[17] The issue of the exhumation, placement, ownership, preservation, display, and interpretation of human remains is obviously highly sensitive.

Unlike conventional war memorials, which make abstract the act of dying, in cases of atrocity corpses are often made integral to the understanding of an event. As exhumations have become a familiar part of certain political landscapes, graves have revived difficult questions about the scale of repression, and the awareness and culpability of different government commands. Indeed, a major theme for cultural historians writing about the demise of Eastern European communism has been the symbolic political utility of dead bodies, whether those of the nation's ex-leaders or of anonymous victims.[18] The exhumed bodies of victims have been used to signify the death of the old regime and the creation of a new community united in the memory of its martyred ancestors.[19] The visible presence of human remains seems to offer some conduit not just to *what occurred* but also to how it can be *mentally resolved*. The very irreducibility of human remains makes them amenable to an interpretation that asks us to confront the tragic flaw in our common humanity. Yet there

are important paradoxes related to the ontology of human remains, particularly as it relates to "evidence" of killing. First, while bones are vitally primary and *literally* the person in question, they struggle to communicate much about life. Their likeness and interchangeability makes them only symbolic of a life within a larger tragic historical narrative. Both irreducibly personal and yet unable to convey much beyond the person's demise, human remains possess an unsettling ambiguity. Second, bones fulfill that primary urge amongst visitors to history museums to experience an object that was *actually there*. Yet if we can say that an object "witnessed" an event, it seems perverse to suggest that a body experienced something without an animate mind that can attest to it. A focus on bodies appears to test the idealized memorial-remembrance experience, which is based on an empathetic projection of one's self onto the object of contemplation. While "it could have been me" is a fantastical projection in relation to any historical circumstance (made possible by the safe knowledge that it was not), is it really possible to produce such a split in ego that we imagine ourselves among the dead?

Any discussion of human remains in memorial museums needs to take seriously the concept of sacredness. Rather than attempt to account for the range and complexity of Christian, Buddhist, Hindu, Islamic, Jewish, and Shinto religious interpretations of death that exist in the nations affected by the events I consider, I instead limit myself to notions of the sacred and profane. I begin with Emile Durkheim, who theorized that "the pure and the impure are not two separate genera but two species of the same genus that includes all sacred things. There are two sorts of sacred, lucky and unlucky."[20] For Durkheim, an object is not intrinsically sacred due to its form, but because of the importance of the social rituals surrounding it. By conceiving sacredness as being governed by *rites* involving certain sanctioned behaviors, museum visitation itself has religious overtones. Even without housing the bodies of the deceased, rites such as prayer and the offering of tributary items speak to a belief that memorial museums at least possess their spirits. We might also ask whether this sacredness is decisively compromised by, first, the general absence of explicitly religious textual interpretation in displays, design, and physical iconography, and second, in cases where remains are kept, the somewhat paradoxical fear that bodies are made profane when kept earthbound as material *evidence*. I propose that memorial museums display objects and support social rituals in a fashion somewhat unlike traditional sacred spaces. This form of interpretation might instead be called "secular sacredness." I will now explore several examples to explain why this ambivalent, unresolved concept is a suitable one.

One of Durkheim's key insights is that the sacred qualities of any object are created and passed on through their physical contact with people. This principle is observed in rituals of consecration, when things are made sacred by being touched by persons already considered sacred (which Durkheim illustrates through the Catholic practice of anointing). The "contagiousness" of the sacred is obviously problematic in the museum context, as objects are not handled by visitors – they are normally only seen, not touched. Further, to allow the profane hands of the ordinary visitor to touch

human remains would be to dirty them, spoiling their ability to ascend to the realm of the sacred. It was this dilemma that led to the removal of the 12-square-meter "skull map" at the Tuol Sleng Museum of Genocidal Crimes in Phnom Penh. The 300 skulls attached to a wall in the shape of Cambodia had been on display since 1979. In 2002 the skull map, dirtied by years of exposure, was dismantled and placed in a wooden case. Buddhist monks chanted and prayed for the victims in order to liberate them from the unpropitious association that accompanies a violent death (rather than allowing the deceased to move on to the realm of rebirth, it leaves the spirit of the deceased stranded at the location as a ghost).[21] Yet this problem still plagues the Choeung Ek Genocidal Center, located just beyond the city limits. The "killing field," dotted with trees (having been an orchard before its brief life as a mass grave), is pocked with dozens of hollows, each several meters wide and deep. Fragments of human bone and cloth can still be found around the disinterred pits. From my observations, visitors, like myself, were highly reluctant to make physical contact with objects at the site, and were torn between paying respect to the remains and fearing them. Visitors to such sites may instinctively feel that remains are profane *to begin with*, insofar as we fear that touching them would render us unclean. In the center of Choeung Ek's grassy field is a 30-meter-high memorial shaped like an elongated Buddhist stupa. Erected in 1988, it is stacked with over 8,000 skulls, arranged by sex and age. These are visible through the glass, along with scraps of clothing used as gags and blindfolds. The skulls are often cracked, testament to the fact that most victims were bludgeoned in order to save precious bullets. On the floor of the stupa lie rusted hammers, saws, garden shears, hoes, and leg chains that were used as instruments of torture and death. While the Buddhist stupa implicitly speaks of religious contemplation and forgiveness, it also gainsays that role, since the uncremated, anonymous human victims who suffered a highly inauspicious death deserve, in the minds of many, to be put to rest.[22]

The intersection of sacredness and public display is just as pointed at the main Roman Catholic church in the town of Nyamata, around 30 km from the Rwandan capital of Kigali. While the interior has been partly cleared, some bones remain on the floor and bloodstains spatter the walls.[23] An outdoor chamber displays several thousand amassed skulls of the 10,000 or more killed there, who had hoped the church would provide a refuge (a trend repeated throughout Rwanda). Indeed, more died in churches and parishes than anywhere else.[24] This might appear a natural site for local memorials for multiple reasons – it "witnessed" the killing, it offers a place to mourn that supports themes of redemption and the afterlife, and, politically, it can provide a bridge between Hutus and Tutsis who share a common religion. Yet while the remains of the victims might communicate the same sacred/impure ambivalence of the Cambodian examples, the role of the church in this case complicates matters, given that a significant aspect of its sacredness stems from its historic role as a sanctuary of care. The participation or complicity of many members of the Rwandan Catholic Church in the genocide has now been documented. However, ascribing blame remains difficult. Was it the church's association

with the government it supported that led to its disintegration shortly after the genocide, or did it too suffer – given that churches were deliberately targeted to damage the fabric of local communities, and a third of its clergy were killed?[25] Either way, those wishing to find solace may have difficulty accepting the church as a place of consecration or an agent aiding the spiritual transcendence of victims. While human remains displayed in churches may be naturally perceived as sacred, many of the values associated with the church – security, solace, personal reconciliation – may have been, in the Rwandan case, radically disturbed or denaturalized.

In the case of the Bangladesh Liberation War Museum, human remains are regarded as an important outcome of the museum's work. After having received a number of eyewitness accounts, in November 1999 it collaborated with the Bangladesh Army in excavating an abandoned pump house in Mirpur. They discovered 70 whole skeletons and 5,392 bones. The site ("Jallad Khana" – the "Butcher's Den") has been preserved as evidence of the Pakistani Army's crimes, while some of the remains are on display at the museum. In this case the remains, whilst remaining distressing, can be somewhat redeemed within a narrative of national sacrifice. An association of human remains with the taboo, mortal fear, and the abject means that, in situations that lack any mitigating narrative, they convey little but anguish and danger. Considering that most of those who govern, design, explain, and interpret memorials believe that their principal role is to engage the public in activities of commemoration and future vigilance, might the repellant nature of human remains in fact inhibit commemoration? This emotional dimension is a principal reason why both Cambodian and Rwandan memorial museums have recently chosen to display human remains less plainly. Chea Sopheara, director of Tuol Sleng, said of the skull map: "By removing the skulls, we want to end the fear visitors have while visiting the museum."[26] Ildephonse Karengera, director of Rwanda's Kigali Memorial, also sees the display of remains as unproductive: "We want the memorials to be centers for the exchange of ideas, not collections of bones."[27] Others suggest that the remains should stay in place as evidence of what happened, in order to defy those who would doubt or deny the genocide. But as Rwandans traditionally bury their dead, some argue that it is disrespectful to leave so many remains exposed. A practical compromise has emerged. "For those who say it is undignified to show bones, we're burying them, in a sense, behind dark glass," said Dr. James Smith, who runs the Aegis Trust, a British-based organization that is working with the Rwandan government to refurbish several of its memorials. "For those who say it is necessary to see the death, we're accommodating them, too."[28]

In the U.S.A., the proximity of Christian churches to sites commemorating terrorism has been claimed by many Americans as more than coincidental. Four directly bordered Oklahoma City's Alfred P. Murrah building. On a corner adjacent to the terrorism memorial is an old sculpture titled "And Jesus Wept," erected by St. Joseph's Catholic Church – one of the first brick and mortar churches in the city, and mostly destroyed by the blast. The statue is not part of the memorial, but is nonetheless popular among visitors as an adjunct attraction. If "Jesus wept" in Oklahoma

City, some believed he performed a miracle in New York. St. Paul's Chapel (where George Washington worshipped on his inauguration day) has similarly been interpreted as a sign, given that it emerged near unscathed despite being in extremely close proximity to the World Trade Center. It also served as a base for the eight-month recovery effort. As a result, the chapel has erected a continuing exhibit, *Unwavering Spirit: Hope and Healing at Ground Zero*, which draws attention to its preservation of, for instance, the scuffmarks left on the pews by resting workers' boots and tool belts. While some might balk at the close association forged in these cases between public commemoration and salvation, the popularity of these symbols is perhaps unsurprising: as Benedict Anderson has observed, "nationalism is more properly assimilated to religion than political ideologies because most of the deepest symbols of nations are symbols of death."[29]

Along with the popular avowal of a spiritual presence at "ground zero," significant prevarication towards sacredness is nonetheless observable, centered on the question of human remains. Out of nearly 3,000 victims, fewer than 300 whole bodies were recovered by the time New York's medical examiner's office finished its work in February 2005. Nearly 20,000 pieces of bodies were found in the ruins – more than 6,000 of these were small enough to fit in a five-inch test tube. The most matched to one person exceeded 200, yet more than 800 victims were identified by DNA alone.[30] Since at least 1,100 victims cannot be identified, many families held wakes with coffins holding photographs and personal mementos. The nature of the catastrophe, where the buildings and its contents were near vaporized, has meant that human remains were mostly indistinguishable from other forms of debris and dust. Hence, this dust was awarded sacred properties in commemorative acts in the weeks and months that followed. In October 2001 then-Mayor Giuliani (who refused to clean the shoes he wore on 9/11) established a procedure whereby a handful of dust in an urn was presented to families:

> This dust (which was otherwise being hauled from the site to the Fresh Kills landfill on Staten Island) was gathered into 55-gallon drums, blessed by a chaplain at Ground Zero, and given a police escort to One Police Plaza. There, officials scooped the dust into bags, which they held in gloved hands. Each family was then given a five-inch urn of dust with "9-11-01" engraved on it, wrapped in a blue velvet bag.[31]

While media reports from that period made iconographic the two steel beams in the shape of a cross standing upright in the ruins (a spot where rescue workers prayed and religious services were held, and which has been earmarked as a permanent feature of the memorial museum), any sacredness attributed to the ruins was compromised by other reports showing the debris being carted to Fresh Kills landfill. Given the strong association of the unclean with the dishonorable, the sacredness of the remains was jeopardized. Furthermore, belated reports about the toxicity of the dust that blew over New York made the dust not just profane, but even dangerous. The difficulty in separating the ill health associated with building debris from the mere

psychological damage associated with the chance of breathing human ash meant that, for New Yorkers, the emotional tragedy of the event existed in an ambivalent relationship with its physical remnants.

A final example on this topic shows that the magnitude of human remains need not be great in order to draw controversy. Lea Rosh, who led the seventeen-year campaign to establish what would become Berlin's Memorial to the Murdered Jews of Europe, came under fire during the later stages of the design process because of her plans to place in one of Eisenman's concrete pillars a tooth she had found at a mass grave at Belzec extermination camp. Germany's Jewish population accused her of irreverence and blasphemy, and threatened to boycott the memorial. Albert Meyer, the chairman of Berlin's Jewish Community, angrily raised the issue of protocol: "If this happens, we Jews have to consider whether or not we can set foot on this site." When Rabbi Chaim Rozwaski similarly argued, "if the tooth is buried in a pillar, it is an exhibition piece and therefore it has a use," he reiterated the idea that the sacredness of an object relies on its lack of function: the tooth's reintroduction into the social world would symbolically exhume the person to whom it belonged, denying him or her rest.[32] Lea Rosh, in response, decided she would rebury the molar in Belzec. This episode, which may appear considerable bother over a tooth, makes two points clear. The first is the indubitable sacralization of *all* forms of Holocaust victim objects. The second issue (perhaps connected to the first) is that the Nazi attempt to erase telltale signs of human remains was largely successful. The shocking appearance of the unsecured remains sixty years later testifies to the way that representations of the Holocaust are now controlled and contained in less raw, visceral ways. Indeed, it is difficult to tell how memorial museums might have been influenced had there been anything approaching six million sets of Holocaust remains. Might their display have been more likely? Such conjectures aside, it appears that a key aspect of the sacredness of human remains – whether material or corporeal, whole or in trace form – involves their emplacement.[33] The examples discussed here involve a common strong resistance towards moving remains from their final resting place. As they are quite evidently "out of place" in an overtly constructed museum environment, their displacement and re-placement is highlighted. Since museums are quite obviously regulated and controlled in terms of its orchestration of space, professional activities, and programmatic, day-to-day procedures, the existence of an object that symbolizes a violent, chaotic event – a base object of humanity – may be all the more startling.

Returning to the concept of "secular sacredness," it appears a suitable theme in the display of human remains for several reasons. First, memorial museums are sites that draw diverse visitors whose range of spiritual affiliations cannot be presumed. Second, museums are spaces that have historically existed separate from explicitly religious interpretation. Indeed, when we consider the ways and means that memorial museums came into being (discussed in Chapter 5) one notable aspect is that they have typically been formed as agents of the public sphere dealing with reconciliation and loss working outside organized religion. Third, in several cases the role of organized religion is far from faultless. While this is potent in the Rwandan situation, this

observation also has a broader philosophical connotation. While religion can obviously offer succor, it struggles to account for or explain patently "inhuman" acts; the scale and lack of moral restraint they involve necessarily challenges any faith-based interpretation. Indeed, humanity is wholly embraced in memorial museums: exhibition narratives universally maintain not only that human life has intrinsic value (without regard for the chain of reasoning behind it) but also that universal support for a secularist vision of human rights forms the brightest hope for future avoidance of atrocity.

As a final point for reflection in this section, we might consider why human remains are deemed appropriate for display in some situations and not others? While interdisciplinary writing about death and its public memorialization has grown over the past twenty years, there is a notable lack of cross-cultural analyses, particularly between "first" and "third" world nations. Why is a tooth objectionable in one nation, while whole human remains are shown without the same consternation in Cambodia, Rwanda, and Bangladesh? After recent acts of high-impact terrorism in Madrid, New York, and London, images of bloody death and its commemoration, previously chiefly associated with developing nations, have returned with a force to the West. At this juncture, cross-cultural comparisons offer to make the topic of memorialization a more culturally nuanced affair. After the 9/11 attacks, local authorities sifted through 1.2 million tons of debris to recover every last part of human remains – some 19,000 fragments – and subsequently spent millions of federal dollars to scientifically identify as many as possible. For those 9,000 remains that could not be matched with a person, strict institutional, cultural, and personal ethics makes their public display quite unthinkable. Instead, family members of victims will have access to a private storage chamber inside the World Trade Center Memorial from which to view these remains from behind glass. An adjacent "contemplation room" will allow the general public to pay respects in front of a symbolic urn. This vessel will be empty, as much for practical as cultural reasons: it is not sufficiently large to hold the unidentified remains; it is not possible to keep it climate-controlled; the medical examiner's office requires easier access to the storage chamber.[34] The cloaking of human remains in this instance upholds a clear divide between the pressing familial need to mourn and the general public's less urgent desire to commemorate.

We might assume that in developing countries like Cambodia and Rwanda, it is acceptable to publicly display skeletal remains simply because, to flog a familiar cliché, "life is cheap." Of course any single life is not worth any less for those affected. Instead, two better ideas help to explain the visibility of human remains. The first is practical: the expertise and equipment needed to identify bodies is very costly. In the face of the urgent need in an afflicted society to reconstruct one's daily life, and given a government's priorities in restoring order and providing assistance, the task may not rank highly. In the case where hundreds of thousands or more have been killed, individual identification is impractical. Hence, remains are allowed to become de-individuated, making them unlikely to become the claim of any particular family or

group. Second, human remains may be displayed primarily where there is a felt political need. Human remains are shown in order to convince doubters that the event actually occurred, and, where bones are piled up, that it occurred on a grand scale. Few people in Western nations would doubt the devastation they have recently witnessed from live media feeds of calamitous events. Inside Cambodia, Rwanda, or Bangladesh, however, where there was little media coverage of genocide, eyewitness accounts formed the primary mode of avowal. Human remains may be rare evidence in situations where there was otherwise little media entrusted to account for what was occurring. In these situations, the extremeness of human remains as a visual symbol may be what is required to keep the event at the forefront of media and public consciousness, which in turn may help to sustain support for the work of courts, truth commissions, and similar organizations.

RE-DISPLAYING PUBLIC TRIBUTES

A growing trend in memorial museums is their current propensity to collect and display as artifacts offerings left by visitors. While spontaneous commemoration may be instinctive on an individual level, and has been brought to the fore of public consciousness in recent years by popular responses to terrorist attacks, historical precedents may instead suggest that what is spontaneous may be a practiced behavior repeated for its aptness and resonance. When Edwin Lutyens's Cenotaph in Whitehall, London was erected in July 1919 in time for a military victory parade in celebration of the first anniversary of the armistice, it was a temporary construction in wood and plaster. What was quite unanticipated about the memorial was the number of people from the throng who placed flowers at the foot of the structure, not just on the day of the parade, but for many months afterwards. Recognizing the significance of this response, the cards and ribbons attached to wreaths were sorted, inserted into albums, and preserved as a record by city officials. By March 1921, as these came to number more than 30,000, the project was abandoned.[35] When the cards were proposed as a gift to the newly created Imperial War Museum, an official commented, "I cannot believe that the majority of these cards will be of the slightest interest as a museum exhibit." As a result, the museum does not hold any of the cards today.[36] The force of the practices of public remembrance, however, convinced the War Cabinet to permanently establish the monument in stone.[37]

A more recent instance of this phenomenon involves the Vietnam Veterans' Memorial and the collection held by the Museum and Archaeological Regional Storage Facility (MARS) in Maryland. The archive catalogs and houses tributary artifacts according to their date of collection. While those left in early years were generally small unsigned offerings, they have evolved into personal assemblages of combinations of objects, often framed and laminated. (Some of these objects are shown at the National Museum of American History's ongoing Vietnam War-related exhibition *The Healing of a Nation*, which opened in 1992.) The variety of objects has also greatly increased. The conventions of appropriateness associated with

conventional funerary objects have given way to a more diverse range of remembrance rooted in the idiosyncrasies of pop-Americana. Along with flowers, flags, medals, and notes, workers at the MARS warehouse report handling cans of beer, high-heeled shoes, aftershave, pop tarts, music albums, baseballs, a piggybank, a glass sliding door, and urns containing human ashes.[38] This last example is interesting since the Vietnam Veterans' Memorial is obviously not the site of fighting, nor is it a graveyard. Yet the ashes are those of people who wish to be buried with their military family members (without necessarily having served themselves). The site has been made sacred through the personal emotion and national ritual attached to its visitation. This has made it, for some, a de facto public burial ground. Workers, facing the moral conundrum of storing ashes in a facility for which it was not designed, instead choose to honor the wishes of the family of the deceased by sprinkling them over the memorial site.[39]

Within days of the 1995 Oklahoma City bombing, a two-meter-high steel fence had been built around the rubble. "Memory Fence," as it was dubbed, became used for the placement of candles, flowers, pictures, notes, ribbons, military medals, stuffed animals, and religious mementos. After a year these objects numbered about one million.[40] The Oklahoma City National Memorial has since collected and stored the mementos that were left on and around "Memory Fence." Its similarities to the fence around the World Trade Center (and the range of cultural institutions, from the Library of Congress to the New York Historical Society, collecting, cataloguing and preserving the public offerings) are obvious. Since the event they both commemorated was immediate and obvious, these commemorative objects do not normally directly reference what occurred. Rather, they are the small, portable items that might be left at any private gravesite. These tokens come to exist in an odd temporality, given that the messages often treat time as absent, as if the deceased is still with them, yet they themselves become historicized artifacts. These are objects where, in most cases, only the donors fully know their intended meaning and significance. If they are to be made useful for future generations, it will only be through a display that can explain their context. Yet any such curatorial intervention would also mean that the particularly private, domestic style of the objects that saw them stand in stark contrast to the architecture and facilities of the city – the iron and concrete structures of the park fence or subway station walls – would be lessened. Housed in a museum, they might lose both a sense of their arbitrary, spontaneous posting, and their poignant public placement.

The importance of the ritual associated with the placement of physical tributary objects might cause us to speculate whether there is some dissatisfaction, for instance, with the installation of "video walls" at Madrid's Atocha Train Station in 2005. After station workers and commuters expressed both practical and emotional difficulties with the sheer volume of tributes crowding the station, they were removed in favor of computer kiosks in front of large digital flat-screens. Within months, more than 65,000 visitors had left a computerized handprint and a searchable electronic message. Given that this imprint lacks the same physical mark as a candle, photograph, or

written note, those paying tribute may be frustrated in their desire to leave a marker in a specific geographic spot (personally selected for its physical resonance or feel). There is a nuanced way in which physical objects are chosen with a particular person in mind, and *offered* to them in a real sense. By contrast, a minimally customized message uploaded to the video wall may feel both generic, and primarily to be viewed by other visitors. That there remains something about *objects* that is central to commemoration is also borne out by the hesitant status of websites that have sprung up to remember victims of recent terrorism.[41] These digital formats are quite dissimilar from concrete memorials in several ways: they are globally available yet are not necessarily easy to find; they are viewed in personal spaces, yet may not engender a strong personal response; contributions are generally text-based and posted in private, hence allowing all kinds of expression and ideas that have little to do with social ritual, and involve a different kind of voyeuristic gaze. It seems certain that digital, screen-based, potentially global forms of commemoration are here to stay. What remains to be seen is how their virtual qualities affect the user's perception of how their remembrance is positioned in relation to "real" events.

Further removed from memorial museums' focus on both primary then-and-there artifacts, and secondary spontaneous tributes is their recent willingness to collect documents made some time after the event as a creative response. The collection and display of what we might call tertiary artifacts – those objects self-consciously intended as commentary – represents a new endeavor for museums. When they previously collected letters, diaries, photographs, and similar items that provided some indication of how people felt about the event at the time, it was assumed that these were produced for themselves or those close to them. Yet the Museum of the City of New York, for example, has created what it calls a "Virtual Union Square" based on people's drawings, posters, paintings, shrines, poems, or other such handiwork. Similarly, the New York Historical Society has invited New Yorkers to "share their reminisces of the people and events of September 11," along with a name and contact information for further elaboration. As Josie Appleton has observed, this development suggests two things. One is a lack of courage on behalf of the institutions in deciding what is worth collecting. This fear of missing something can also be seen in historical and cultural context as absurd: can we imagine a time and place richer in commemorative resources? The other involves the way that museums increasingly see their mandate as being supportive of social therapy.[42] While the task of incorporating stories from members of the public is one progressively prescribed by museums themselves as mainstays of policy devoted to "civic dialogue" or "community consultation," a broader cultural influence also comes to bear: the idea of ignoring these offerings would probably feel unacceptable in a time when every act of remembrance or emotional gesture is held, at least in the American context, to be precious – or at the very least non-disposable. In the event, however, that decades down the line these tertiary 9/11 artifacts were forgotten in a manner similar to the cards at the London Cenotaph, would the museum world lose much in terms of the human record, or would it simply find it answerable to those contributors whose therapeutic confidences had been betrayed?

CONCLUSION: ON WHAT REMAINS

For all the museum objects we can count as proof of violent, atrocious events, it is dizzying to imagine all those hidden or lost. In some situations, objects that once stood as markers of memory can be again buried; a new tragedy can destroy the material remainders of older ones. This point has been most recently noted with regard to the destruction on 9/11 of the black granite fountain that commemorated the 1993 World Trade Center bombing. A lesser-known fact concerns the volume of archival and memorial material stored in the lower levels of the Twin Towers that was also destroyed. For instance, 40,000 photographic negatives documenting the Kennedy presidency were obliterated. The archive of New York theater photographs between 1970 and 2000 was lost. The Port Authority of New York and New Jersey collection, which documented the history of the city's physical infrastructure, including the subway system, roads, bridges, and transportation networks was gone. This collection also once included important materials excavated from the eighteenth-century African Burial Ground and some 850,000 nineteenth-century objects excavated in the Five Points area.[43]

This theme of overlaid historical loss is also provocatively illustrated, in a different way, by the case of the celebrated old pine tree that stood near the city of Pripyat in Ukraine. Local ritual had imbued the tree with sacredness, largely because of its unusual configuration; the "W" shape of its branches mimicked the shape of religious candelabra. In the 1940s, the tree took on sinister qualities when Nazis used it to hang Soviet sympathizers. Decades later, the tree was eventually poisoned and killed by radiation following the 1986 Chernobyl accident. If faith, iniquity, and tragedy marked three different stages of its life, it has gained a fourth in the afterlife. A replica of the tree now stands in the Chernobyl Museum in Kiev, alongside photographs depicting it when alive. Embroidered towels are draped across the tree's artificial limbs, copying the ritual clothing of Orthodox icons throughout Russia and Ukraine.[44] In this display, the museum object is not evidence of atrocity – nor could the original tree have easily spoken of these multiple occurrences. Instead, the replica is useful precisely because it represents something impossible in humans: it both "saw" different forms of dying and eventually expired as a result of what it has been forced to live through. In this, even a *replica* can be imbued with spiritual significance, precisely because we understand that stories about the past are what give life to objects, rather than vice versa.

That is, we cannot expect that the physical qualities of objects – their shape and proportion, their timeworn patina, their visual magnetism – can reconstitute a historic event for us. Even in combination with other common documentary forms (photographs and film, written placards and brochures, audio-visual testimony, and guided tours), the question of what an event "looks like" resides in the mind – in those mental pictures gathered from outside the museum and even manufactured by one's imagination. Yet objects may be indispensable in terms of providing some solidity and common reference point for collective memory. While any individual

can play down, alter or refuse a historical narrative, the existence of objects from that time, in a concrete present location, makes the reality of event not easily done away with. As Timothy Brown has noted: "the artefact is an analogue for traumatic repetition, it is symbolic of trauma's *literal* return, which engenders and forestalls the materialization or dissolution of symbolic and political power. It is the symbolic nexus of society's wounds and celebrations."[45] In a historical era of ever-quickening material replacement, when (to invoke Marx and Engels for different ends) "all that is solid melts into air," the salvaging of concrete objects from an episode deserving of historic gravity seeks to hedge against it being forgotten.

In short, there is *something about remnant objects* that remains, especially in the context of loss and destruction, little understood on a psychosocial level: they exist at the intersection of authentic proof, reassurance, and melancholia. Yet reassurance or melancholia are emotions that one does not normally *perceive* in an object. Rather, I would argue that ambiguity and equivocation are more prevalent responses, relating to the temporal qualities invoked by the "return" of the object before the public gaze. That is, the artifact represents two sentiments towards a terrible past. On the one hand, the ability to display the object in a museum reassures us that the event has been determined or resolved to some extent. As witnesses to history after the event, we are confident that we have some control over what the calamity meant, at least some assurance that it is no longer happening. Yet, on the other hand, the artifact also stands as unsolved, as something that, through its concrete unchanging form, makes plain our present inability to ameliorate or change it – to "make history better." As we experience this temporal moment, the mute object offers little way to resolve this unease. It may be due to this conflicted feeling of helpless frustration about the past and relief about not having lived through it that the most useful pledge we are encouraged to make is future-oriented: "never again."

3 PHOTOGRAPHIC MEMORY: IMAGES FROM CALAMITOUS HISTORIES

PICTURES ON PAPER

Images are both representations of the past and vestigial artifacts from it. As we leave behind the previous chapter, we should note that the image is also properly seen as part of the larger category of objects. As Roland Barthes observed: "In photography I can never deny that *the thing has been there.*"[1] Although the camera was undeniably present, it is a notable initial paradox that, in the museum context, photographs are typically viewed as interpretive illustrations rather than objects that existed in the world at that time. There are several reasons for the lesser status that photographs have traditionally held in museum collections. One is historical: from its inception in the mid-nineteenth century, debate has continued over whether photography, which Pierre Bourdieu calls "a middle brow art," deserves a privileged place in art museums.[2] While photographs have been more easily integrated into history museums, even there they have generally been displayed to corroborate object-based exhibition narratives. The ability to make multiple, exact copies is arguably one reason photographs lack the same aura as physical artifacts. Another is that the most vital photographs may not even reside in history museum collections; they will often be obtained from sources like newspapers and magazines, historical libraries and archives, and stock photograph suppliers. Perhaps the greatest factor that distinguishes photographs from physical artifacts is that they are commonly viewed in places outside the museum (such as newspapers, magazines, books, posters, television, and the internet). Indeed, images viewed in museums may well have gained their recognizability and cultural currency from outside contexts. Iconic artifacts, by contrast, are closely wedded to the museum, and typically only gain a life outside it as – circuitously – a picture.

The emergence of the modern concept of atrocity in the mid nineteenth century coincided with rapid technical breakthroughs in the development of photography. This situation encourages speculation about the relation between the photographic visualization of lifelikeness, and our ability to mentally conceive the quality and scale of such violence. A key point in the legal definition of atrocity is the 1864 inaugural Geneva Convention, which codified rules of war. Essentially, the international assembly concluded that war crimes punishable by imprisonment or death included attacking defenseless citizens and towns, plundering civilian property, or taking from civilian populations more than what was necessary to sustain an occupying army. Less than a decade earlier Roger Fenton spent four months in 1855 on the battlefields of

the Crimea, producing about 360 salted paper and albumen prints. Although these depicted the war landscape and posed shots of participants rather than combat scenes or its brutal aftermath, they were nonetheless considered remarkable for their true-to-life quality – and for their potential as political propaganda.[3] A few years later, photographers under Mathew Brady's supervision captured the carnage after bloody American Civil War battles like Gettysburg. These images were politically vital, as they were the first where photography had an influence on public opinion while fighting was still occurring – and the first in which photographs were more significant in shaping mental images of a war than paintings, prints, or drawings. Aftermath images from the 1890 Wounded Knee Massacre by photographers like George Trager are also well known for their tragic (although staged) images of frozen Lakota Sioux corpses. Equally vivid are pictures made by small-town photographers of lynched African Americans that proliferated in the post-Civil War era in the American South.[4] In each of these cases, death was revealed as not as the gallant sacrifice often depicted in painting, but instead as both strangely absorbing in its realism, and yet perhaps somehow hollow in the lack of revelation that this produced.

Following a heavy ban on war photography during the First World War, it was arguably after Robert Capa's famous "shot" during the Spanish Civil War – the grainy image of a Republican soldier in a white shirt collapsing backward on a hill from the blow of a bullet, his right arm flung behind him as he loses his rifle – that the shock of confronting death *as it happened* became available. As Jane Livingstone has summarized:

> A gradual and yet dramatic shift occurred from the carefully framed, and often panoramic or symmetrically composed photographic image, to a kind of image that could be an intimate close-up of a face, or an instantaneous freezing of bodies in violent motion. This profoundly divergent set of new pictorial attitudes inevitably altered our perceptions about what the world was like through the camera lens. In short, style has changed in war photography, both the style of the technique of the image and the style of journalistic presentation. Both have evolved so drastically as to make of still photography not just one artistic medium, but several.[5]

By the Second World War, lightweight portable cameras were carried by photojournalists, soldiers, and civilians alike, resulting in a vast set of images that included a wide range of atrocities (although most were deemed unpublishable in newspapers of the time). Photojournalists' freedom of expression is reckoned to have reached its pinnacle during and soon after this period. Subsequent conflicts in Vietnam and the Falkland Islands, and the 1991 Gulf War can be positioned as progressive stages in the loss of faith in the association between war photography and truth.[6] Along with censorship in publication and a progressive restriction in photojournalists' access to "hot spots," the influence of television by the 1960s (which supplanted movie newsreels) arguably diminished the camera's status as the primary provider of news images. At this juncture, the significance of the internet

as an unregulated host for uncensored digital images of atrocity remains somewhat undetermined.

Notwithstanding these historical developments (of which I can only provide a cursory overview here), photographs arguably possess a power to captivate that remains greater than that of other visual forms. Certainly, they are far more regularly displayed in memorial museums than moving images.[7] This may be partly circumstantial: for most of the twentieth century analog cameras were far more likely to be used to record events than movie or video cameras. Yet I suspect it is also because there is something incomparably powerful about still images in a museum setting. As David L. Jacobs has put it:

> In contrast to the preponderance of death imagery in the mass media, still photographs of death are something of a rarity. On television, death can be highly dramatic, but is always fleeting. Still photographs are much less tractable; their evidence is not as easy to dispense with, particularly since the viewer, as opposed to the film director or editor, controls when to look and when to move on.[8]

Although perhaps endangered, classic silver-halide analog photography has certainly not disappeared. It shares – with the bricks-and-mortar museum – a resilience and vitality that confounds the futurists who predicted the demise of both in the face of digital technologies. While postmodernists have similarly attempted to unhinge the modernist view of analog photographs and museum objects as vital, meaningful traces of a past reality, it appears that the public at large is much less skeptical. Museums are not only receiving visitors in high numbers, but they poll as the most trustworthy of any public institution.[9] Photographs are, for John Tagg, "currency" that gain value as evidence primarily when endorsed by an institution possessing proper moral authority.[10] Hence, the museum is crucial not only in its ability to provide photographs with the expert technical verification that establishes their truth-value, but also with cultural verification, wherein the institution's decision to collect and display the image establishes its cultural worth.

Alongside objects and text, photographs are central to the production of meaning in history museum exhibitions. The ability to "read" photographs using a trained and cultivated gaze is a talent usually associated with art museums. Historical images are typically treated as having a basic, transparent representativeness that negates the need for tutelage in the appreciation of photographic aesthetics. Viewers' questions tend to be direct and information seeking: who are these people? What is their role or status? When and where did it happen? Is this a unique or typical scene? What happened next, and where are they now? If these aspects constitute the primary information to be gleaned, there is another less discussed meta-question concerning historical images: *what does it mean to look?* It is notable that while we can stare openly at the former possessions of others (a winter coat, or a pair of spectacles, for instance), we attribute photographs of people with semi-sentient qualities, making our act of viewing more self-conscious. Photographs somehow elide the difference

between the chemical process that produces a manifestation of the phenomenological world, and the world itself. In looking at photographs, museum visitors engage in a process that is not monocular, but involves multiple looking positions: at once, the viewer can be an incredulous onlooker struggling with the picture; a retrospective witness attesting to its occurrence; a person watching others in the museum, who sees both them in the act of looking and what they see; this gaze is also turned on the viewer, who is also watched while looking at images, and while looking at others.[11] This self-consciousness compounds the ethical questions at the heart of viewing pictures depicting atrocity. After all, why are they shown? Are they an attempt to visually recreate the realities of what occurred some time ago? Are they a tributary vestige of the little that could be recovered from great loss? Does the museum anticipate that visitors will accommodate the images or resist them; will they encourage sympathy or revulsion? Is there something intrinsically wrong in turning an image of human suffering into some appreciable aesthetic form?

In engaging with these questions, it will probably come as little surprise that, again, the Holocaust is the touchstone for both public recognition of atrocity photographs, and for debate about their reception and meaning. Around two million Holocaust-related photographs are estimated to exist in the public archives of more than twenty nations.[12] Yet we are largely familiar with, as Marianne Hirsch has put it, a "radically delimited" range of certain famous scenes, mostly based on the select news photographs taken by the Allies after their liberation of concentration camps in Austria and Germany.[13] The photograph of emaciated Buchenwald survivors lying in bunk beds, taken by Pvt. H. Miller of the U.S. Army's 80th division on April 16, 1945, is among the best known (Fig. 3.1). Familiarity with such an image, reproduced in newspapers, magazines, and museums, has caused some writers to worry that they have become little more than decontextualized memory cues, and following, that they have lost their ability to re-energize shock and concern.[14] Ulrich Baer worries that they falsely "represent the past as fully retrievable (as simply a matter of searching the archive), instead of situating us vis-à-vis the intangible presence of an absence."[15] As Umberto Eco has summarized:

> The vicissitudes of our century have been summed up in a few exemplary photographs that have proven epoch-making: the unruly crowds pouring into the square during the "ten days that shook the world"; Robert Capa's dying miliciano; the marines planting the flag on Iwo Jima; the Vietnamese prisoner of war being executed with a shot in the temple; Che Guevara's tortured body on a plank in a barracks. Each of these images has become a myth and has condensed numerous speeches. It has surpassed the individual circumstance that produced it; it no longer speaks of the single character or of those characters, but expresses concepts. It is unique, but at the same time it refers to other images that preceded it or that, in imitation, have followed it.[16]

If museums play a key role in making images iconic, does this iconicization enable or impede understanding? Might atrocity photographs in memorial

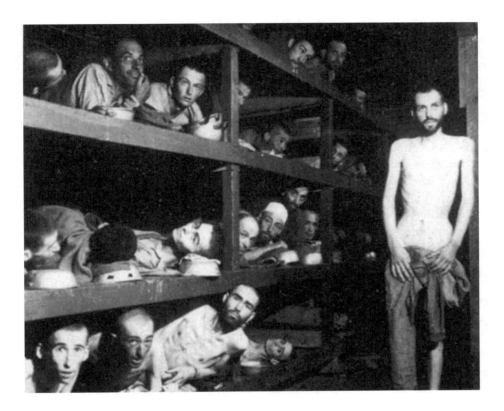

Fig. 3.1. Buchenwald survivors. Copyright public domain, U.S. government.

museums gradually accrete to create expectations about content and style? If so, can obscure or unseen images be found shocking and revelatory in each instance? When we view, for example, Nick Ut's famous 1972 photograph of a naked young Vietnamese girl (Kim Phúc) running with other children along a bridge to escape her napalm-bombed village, do we look each time for meaning, or simply mentally register our recognition of it?

My discussion so far assumes that all incidents possess usable visual images. What happens to events that have struggled to rise to this level of public consciousness, likely because we have been left with little visual documentation? Atrocities in Taipei, Chernobyl, Cambodia, Argentina, and Chile, to select a few from my examples, were only minimally documented in the midst of the calamity. By contrast, the 9/11 attacks have been called "the most photographed disaster in history."[17] Already, the image of fireballs erupting from the buildings has been folded into the visual archive of world history, into a context where it might one day have as much to do with the Apollo 11 moon landing picture as it does with, say, the attack on the *Oslobođenje* building during the Bosnian War's Siege of Sarajevo. What might this radical disparity in visual representation across nations and contexts mean for memorialization?

In order to explore the questions raised in this introduction, I focus my attention on two predominant kinds of atrocity photographs, each of which has a different significance for museum interpretation. The first is the action shot, which depicts people being forcibly detained, relocated, injured, and killed. The second is the identification picture, where we see headshots used to identify killed or disappeared persons both in the immediate wake of violence and cataclysm, and in later commemorative acts. Weaved into this discussion is a consideration of what happens when these photographs are moved between private and public contexts (between, for instance, familial, domestic settings, and spontaneous public memorials and museum institutions). I also look at several examples where images of catastrophe have been exhibited as aesthetic objects in art museums. Combined, these areas of investigation explore a "crisis of reference" related to the way museums make suffering seemingly wholly available to visitors, but offer few cues about both how to assimilate them, and what assimilating them might mean.

"ACTION PHOTOGRAPHS" AND THE ACT OF VIEWING

Forced evictions, cowering captives, wounded victims, executions, bodies, bombings, and burning cities constitute "in the moment" photographic scenes that attest that an event occurred and provide a dramatic (although not necessarily representative) sense of how it looked. Unlike those photographs that migrated from the drawers and attics of private homes to populate the collections of social history museums, photographs of violent scenes are typically not recorded by those who endured the experience. Photography ranks understandably low as a practical priority during times of personal tumult (and further, we are naturally disinclined to record bad experiences). Hence, the task is usually left to photojournalists, who have a privileged, semi-detached relation to the event and its entangled issues of cruelty, blame, compassion, and victimhood. (After all, their professional mandate not to interfere with events justifies their non-complicity in violent acts). With a story to sell, the photojournalist emphasizes emotional impact through techniques such as juxtaposition (guns pointed at children, the starving or naked next to the robust and uniformed), political symbolism (bloodstains, flags, identity cards, or some combination thereof), and magnitude (such as trails of refugees, or heaps of rubble, weapons, or bodies). The aestheticization of turmoil, made plain in "photograph of the year" awards made by news magazines, may be visually gratifying, if somewhat morally troubling.

In many of the cases in this book, dreadful events were carried out in high secrecy. During periods of state repression in Eastern Europe, Russia, and South America, for instance, well-informed, politically neutral reporting was near impossible. The unavailability of photojournalists' images has sometimes meant that memorial museums have had to turn to a more unsettling source – those of the perpetrators. As disturbing as the psychological motivation to record the infliction of pain on another might be, these recovered souvenirs or keepsakes often form a significant section of a memorial museum's collection. Fixed to museum walls, the anxieties they

generate may be both intensified and quelled, depending largely on museum tactics: does the museum make it plain who took the pictures (assuming it knows)? Does it inform visitors how they came into the museum's possession? Is the photographers' political intent and point of view obvious from the content of the image itself? If not, does the museum incorporate its own editorial statement?

Even if perpetrators' intentions were dissolute, might the museum world be better off for having their images? By accepting them into the memorial museum, we stake that a new explanatory context can overcome their original purpose. The issue is that, for victims, the camera was itself an instrument of humiliation and psychological torture. By displaying their pictures, there is a valid fear that museums might perpetuate this original intent, forcing those pictured to remain in submissive subjugation and recreating the disidentification that enabled the photographer's act. As Andrea Liss suggests, photography is not only a way to get close to an event, but also to create distance from the reality of what is occurring:

> Photography's claims to realism also lie in its double-edged capacity for holding forth the promise of honoring while marking and fixing its subject. In the very moment of its giving name and face to a previously undocumented or undisclosed reality, photographic nomenclature also works to stigmatize and hold at bay the subject/object of its view.[18]

A recent example pertinent to this idea involves the Abu Ghraib prison photographs. From September to November 2004, New York's International Center for Photography (ICP) held an exhibition titled *Inconvenient Evidence: Iraqi Prison Photographs from Abu Ghraib*. The torture pictures were first reported on CBS's *60 Minutes II* in April of that year, published a week later in *The New Yorker,* and were absorbed into wider public consciousness as they were featured in numerous newspapers, magazines, and internet sites. Frightened masked prisoners, attack dogs, sexual humiliation, and mockery of the dead were the prime symbols of the cruel wartime pornography that photography has arguably done much to facilitate. As ICP chief curator Brian Wallis averred, "these pictures also raise troubling moral questions about the role of photography in our culture."[19] By demonstrating how uncensored digital images could be near-instantly disseminated to a worldwide audience, the controversy re-energized the longstanding dilemma surrounding the dark side of pictorial objectification.

A different line of inquiry involves the basis on which these images were deemed suitable for exhibition in a fine arts museum. They were obviously not intended as art, nor as breaking photojournalism. Curated from otherwise readily-downloadable images already part of the public domain, their placement in one of the world's preeminent photography museums seemed to be instead based on their cultural significance, and on the institutional gravitas the museum could add to the broader field of political condemnation. What might any on-site visitor gain from viewing such images – already highly familiar by the time of the exhibition – blown up large? A greater understanding of the nature of cruelty? Or only an enlarged view of the

malevolent vision perpetrated by American soldiers? While the ICP undoubtedly intended some form of critical social commentary, the wanting nature of this exhibition helped to bear out the value of specifically dedicated memorial museums. The key difference involves audience: to what constituency was the ICP exhibition directed? An aggrieved Iraqi citizenry, or only an already appalled American public? Given its weeks-long duration and New York location, it was plainly unlikely that it could function as a memorial for the inmates depicted, their families, and other Iraqis. Instead, it could achieve little more than provide the images with a scale that the tormentors never intended, and arguably, that the victims depicted never requested.

Photographs can make horror palpable and convincing, and they are easily reproduced and distributed. These qualities make them indispensable for those seeking to make acts of terror known (not just to friends "back home") but to the world at large. This raises a troubling question: even when viewing images of violence in a commemorative frame of mind, might repeatedly viewing them itself play into the psychic violence the assailants desire? As Barbara Kirshenblatt-Gimblett has asked of the endlessly reproduced World Trade Center images, "were all of us fulfilling a script by doing precisely what was intended by the attackers? Namely, we were spellbound by the catastrophic spectacle, not just at the moment of impact, but, thanks to all the photographs and videotape we made, forever after. Reruns, according to the script, will deepen the psychic damage that terror is about."[20] While the display of provocative images can result in a feeling of shocking disclosure in situations where evidence has been little seen, in incidents that have already produced a media-saturated iconography, what might we gain from re-viewing them? Can repetition ever produce revelation?

The potential power of the "first look" at hitherto unseen images was ably demonstrated by the example of the *Verbrechen-der-Wehrmacht* (Crimes of the German Wehrmacht) exhibition. Organized by the Hamburg Social Research Institute, the exhibition visited museums in thirty-three cities in Germany and Austria between 1995 and 1999, drawing almost 900,000 visitors.[21] It was comprised of mostly unknown graphic photos sourced from private collections of German soldiers involved in war crimes in Eastern Europe. Impassioned arguments broke out at the venues displaying the exhibition. There were large demonstrations in Munich and Dresden, the exhibition was vandalized in several cities, and in Saarbrucken right-wing extremists attempted to firebomb it.[22] These events forced the German Bundestag to respond. Two long televised specials followed, which featured parliamentarians engaged in impassioned debate about feelings of inherited personal and national guilt. While the exhibition organizers could handle demonstrations and vandalism, in October 1999 a different kind of disaster struck. The very images that provoked such self-critical debate came under scrutiny. A historian challenged photographs of Wehrmacht soldiers in Tarnopol, Poland, apparently standing over the bodies of recently slaughtered Jews, arguing that the bodies were in fact those of Ukrainians murdered by Stalin's retreating army before the Wehrmacht arrived. The

ensuing scandal over the authenticity of the pictures (duly seized upon by right-wing groups) forced the organizers to close the exhibition, pending a report by an independent commission. The commission concluded that the original thesis was correct, but that the photographs had been carelessly sourced and sloppily used. The retitled Tarnopol pictures formed the basis for a new component of the *Verbrechen-der-Wehrmacht* exhibition called *Photos as Historical Sources*. The charges of falsity were disturbing not just since they raised questions in viewers about their possible manipulation, but also because they made people question a cognitive facility often taken for granted: recognizing what one sees.

Along with photojournalists' and perpetrators' pictures, another situation involves cases where the photographer is either unknown, or where the museum considers it unimportant to highlight his or her identity. These unattributed photographs are probably the most common kind. They arguably possess unmatched cachet in memorial museums, both because one may imagine them as having been taken by a concerned witness (a viewing position which the museum visitor can comfortably share), and since pictures of restive events seem more authentic when amateurish in composition. Susan Sontag has noted that pictures taken by military-amateur photographers at Bergen-Belsen, Buchenwald, and Dachau concentration camps at the time of their liberation have been widely regarded as more valid than those by professionals like Margaret Bourke-White and Lee Miller.[23] With their lack of technical prowess, anonymous shots may be appreciated precisely because they are not normally designed to arouse compassion.

Yet even when individual photographers are credited, the immersive power of a historical scene can serve to make him or her forgotten. Viewers easily overlook the invisible mediating photographer, instead focusing only on what is visually made available:

> What is seen in the picture was there – not only in the sense coined by Roland Barthes (that is, as testimony that what is seen in the photograph was present facing the camera) but in the sense that the time lapse makes present the gap between a seemingly stabilized object seen in the camera and the photographer's apparently external point of view. Thus, the spectator is liable to plunge into what's seen in the photograph and forget that a photographer had been there when it was taken.[24]

If the act of taking a picture is fleeting, the subject depicted may have been even less aware of the moment. Consider, for example, an anonymous photograph displayed at the Museum of Occupations, Tallinn, captioned "Ingers being repatriated to Finland" (Fig. 3.2). What is happening here? Who are these people? Who took the picture? The primary information in this scene is, for those like myself with only a hazy sense of the Second World War history of the Baltic Sea region, not obvious. We learn from the museum that the Ingrian are rural peasant Finno-Ugric people who lived in the area of the Leningrad oblast. We see, pictured, an example of their forced evacuation during 1942 or 1943 as they are overseen by both a Finnish

and a Nazi officer. Victims of the 1939 Molotov-Ribbentrop Pact, these unnamed people were displaced to Estonia and eventually on to Finland. (Many others were executed, deported to Siberia, or forced to relocate to other parts of the Soviet Union.) In the process, they were deprived to the extent that their language and culture is now considered largely extinct.[25] The Museum of Occupations displays this photograph to illustrate how forced evacuations should be understood as a vital justification for the regained independence of the Estonian state.

The anonymous evacuees depicted could never have known (if they were even aware of the picture being taken) the narrative that their captured actions would be held to represent. As museum visitors, we bring to the exhibition space the hindsight of history's judgment – a perspective that suffering subjects could not know at the time. Hence, at a secondary level of interpretation, I am interested in the level of consciousness captured by such images. Does Figure 3.2 allow us to gauge the degree of trepidation and angst experienced by the Ingers? While the actions of the focal victim-subject seem to hold the key to understanding what we see, the power and foreknowledge of what was to happen next lies in this case solely with the officers. As viewers we understand, in a very different way to everyone in the image, the ramifications of their actions – that is, its historic magnitude and bearing. And yet all of the subjects in this photograph took the particulars of their own experience with them. In searching for historic meaning in photographs, viewers may visually and emotionally overcompensate, imputing more to the split second of facial expressions and body language than either the subject or photographer could have intended. As Ulrich Baer has noted: "Empathetic identification can easily lead us to miss the inscription of trauma because the original subjects themselves did not register the experience in the fullness of its meaning ... The viewer must respond to the

Fig. 3.2. Ingers being repatriated to Finland. Copyright the Museum of Occupations, Tallin. Used with permission.

fact that these experiences passed through their subjects as something real without coalescing into memories to be stored or forgotten."[26]

Similarly, when Eduardo Cadava wrote that "the psyche and the photograph are machines for the production of images," he meant that both are concerned with framing and selection.[27] Yet, as he recognizes, neither the psyche nor the camera are especially effective at recording an experience; both will normally miss most of what occurred, instead fixating on a particular moment. Indeed, photography is not suited to communicating duration. The snapshot is suited to recording assaults, assassinations, or explosions – in Barthes's words, "of everything which denies ripening."[28]

Here it is useful to distinguish the photographic *picture*, as an autonomous representation of reality that ceases to refer to anything outside itself, from the *event*, which makes viewers aware that it is only a fragment of reality, and calls attention to the fact that something has been frozen since we can envisage life continuing beyond the frame.[29] While the *picture* can appear deathly because it denies life around it, the *event* produces a paradoxical effect of capturing life-in-motion but being unable to convey it. As Marianne Hirsch has similarly discussed:

> We contain and circumscribe the enormity of the event, but even as we stare at the small square print, we know that it is only a fragment and that, in itself, brings us back to all that cannot be contained by the frame. Around the edges of the image we catch a glimpse of something huge and incomprehensible except as it is broken into small and painful stories and snapshots. The framing and the flatness of photographs give a sense of the fragmentariness of our knowledge, the inability we feel to take in the magnitude of the event and the losses it engendered.[30]

Since most photographs are taken without regard for what eventually became their historical consequence, and due to their slightly accidental quality, some critics see them as lacking the moral veracity and intent of other artistic and documentary forms:

> Our response to historic photographs of war … is this not one of genuine identification or credulity: rather, we may find ourselves studying the image, reading it rather as we would a painting or drawing, but with even less credulity than a drawing or painting often stimulates. This odd phenomenon, a kind of suspended belief or emotional distancing when we confront the actual moment recorded in the photograph, suggests a moral problem in relation to photographs of palpably amoral, or immoral, acts or scenes.[31]

The suspicion that there is less invested in a photograph is a question of both effort (since, after all, it is produced with a "click") and intentionality. Some viewers might indeed doubt that any particular photographic spatial arrangement is packed with meaning, if it is partly the result of chance. In comparison, Tuol Sleng's display of Vann Nath's grisly paintings depicting Khmer Rouge torture and murder made in the years after his own torment, or Huang Rong-Chan's "Terrifying Inspection" series of

woodblock prints made in the months after the 2–28 Massacre which now hang in the Taipei's 2–28 Museum, for instance, are as primary as "artistic evidence" can be (both were survivors and witnesses of their respective situations). Although their after-the-fact response suggests some temporal distance from the event, and are hence less possessing of documentary exactitude, they are arguably purposeful, morally guided, and labored over in a way that is harder to argue for photographs.

The production of photographs makes us confront the uncanny, disquieting nature of temporal simultaneity. The camera produces an "an instantaneous abduction of the object out of the world into another world, into another kind of time."[32] Photographs may strike us as disturbing precisely because they are incapable of effectively retrieving the past. Rather than capturing or preserving history, they show us the living image of the moment that has been alive. Images of those we know to have died involve a "defeat of time" that alludes to a double absence: the "anterior future" declares, to quote Barthes, "both that this person is going to die and that he is already dead."[33] That is, the people in the pictures are forever looking at death, forever about to be murdered. In considering the picture of a young Lewis Payne waiting to be hanged (for his murder attempt on U.S. Secretary of State William H. Seward in 1865), Barthes observes that the "punctum," the personally affecting detail, is:

> *He is going to die.* I read at the same time: *This will be and this has been*; I observe with horror an anterior future of which death is the stake. By giving me the absolute past of the pose … the photograph tells me death in the future. What *pricks* me is the discovery of this equivalence. In front of the photograph of my mother as a child I tell myself: she is going to die: I shudder … *over a catastrophe which has already occurred.*[34]

Once a person dies, the mimetic function of the photograph is negated, for one can no longer compare the image to its referent. The camera may have frozen a likeness in time, but it no longer refers to an existing life. Indeed, notwithstanding those rare cases when the person pictured was personally known to the viewer, museum visitors seldom have a referent. Yet even though most of us are aware of the capacity for forgery and manipulation in photographs – the dark underbelly to their status as evidence – we never conceive of pictured people as imaginary or fictional; the "reality effect" of the photograph, combined with the moral determination of the museum, ensures that such thoughts are rare.

In the memorial museum, the "pain of looking" involves not only victims' agonizing experiences, but our discomfort at having to see. While the act of looking is typically understood as a necessary burden in order to appreciate what is at stake, the viewer's actual response may be more self-consciously rooted in the shortfall of his or her emotional reaction. John Berger has noted how arresting images of suffering and pain can "bring us up short":

> As we look at them, the moment of the other's suffering engulfs us. We are filled either with despair or indignation. Despair takes on some of the other's suffering

to no purpose. Indignation demands action. We try to emerge from the moment of the photograph back into our lives. As we do so, the contrast is such that the resumption of our lives appears to be a hopelessly inadequate response to what we have just seen.[35]

Since photographs isolate a dramatic, discrete historical moment that is wholly discontinuous with the viewer's present sense of "here-and-now," Berger sees the viewer's own cognitive "cut off" as somewhat unavoidable. For the morally guided memorial museum, such moral impasse in the face of violent photographs will be disconcerting. Ideally then, the museum seeks to produce a context-rich environment where the content of the image is not dismissed for its impossible relation to the viewer's everyday life, but where the viewer can forget his or her museum-going reality to instead become immersed in an alternative historical reality.

Finally, there appears to be a qualitative difference in viewing practices depending on whether the image engenders feelings of *tragedy* or *horror*. It may be that action photographs appeal more to horror, while identification and aftermath photographs contain the pathos required to make them tragic. Horror is based on instantaneous repugnance and agitation, strongly connected to our own natural fear about the body's destruction. After all, it is not just perpetrators who are frightening, but also their victims, who often look more harrowing, less human. Rather than the perpetrators, it is the victims who "constitute such a convincing picture of what *we* neither are nor intend to become – a picture of what we constantly strive to insure our well-being against."[36] Is it possible, after all, to feel real affinity with the picture of someone heinously injured – or even killed? Tragedy is a more of an emotional after-effect based on the power of what we know to have happened. Hence, there is a temporal dimension related to the categories of horror and tragedy. Horror invokes uncertainty and the visual chaos denied by the still image – it is left to our imagination to anticipate and fill in unknown actions before and after what is depicted. Tragedy, however, seems to show the actors frozen, as if the relations depicted in the elements of the picture are allegorically meaningful, stilled as if to speak of history quite clearly. I turn my attention to a particular type of tragic image, the headshot, next.

PICTURING THOSE MISSING: IMAGES OF IDENTIFICATION

In cases where violence has occurred mostly out of view and its victims have vanished, identification photographs are often all that remains as a visual testimony to their former existence. Few images are designed to be more singular and basic than the headshot photograph. The background is a clear space, open to vision and super-vision. Where photographs have an in-built representational paradox – objectivity is in-built, yet it always involves a point of view – the idea of the headshot is that its point of view is decided to the extent that it is not a factor. Given no context, the face is forced to yield to minute scrutiny. Despite this minimalism, the frontal photograph is credited with being able both to describe an individual and to inscribe them

with a certain social identity. "Photography," writes Barthes, "began historically as an art of the Person: of identity, of civil status, of what we might call, in all senses of the term, the body's formality."[37] In this section, I suggest that these headshots possess a distinctly unsettling, uncanny status. The very limited information they divulge poses challenging questions about how they can illustrate grievous acts and the ways in which they are utilized in personal remembrance, and in larger processes of justice and reconciliation. Given that headshot photographs can provide little information about the fate for which the person is to be remembered, the way they are contextualized and narrated is vital. The expressly public, politicized, and unresolved nature of the three events I will pay particular attention to makes these factors especially critical.

The first involves the civilian "disappearances" in Argentina after the March 24, 1976 coup, which saw the military junta seize power and engage in a seven-year reign of terror intended to eradicate alleged left-wing terrorism. Under martial rule, thousands of people – most of them civilians unconnected with violence – were arrested and vanished without trace. After democracy was restored in 1983 a national commission was appointed to investigate the fate of these *desaparecidos*. Its report detailed the systematic abduction of men, women, and children, the existence of secret detention centers, and methodical torture and murder. Human rights groups estimate that as many as 30,000 were killed.[38] Beginning when the junta was in power, the Madres de Plaza de Mayo (Mothers of Plaza de Mayo) have demonstrated continuously in protest. Parading in front of the presidential palace in Buenos Aires' Plaza de Mayo on Thursday afternoons, they wear white handkerchiefs on their heads featuring the names of disappeared family members, and hold aloft signs demanding information about their missing relatives and justice for those responsible. Strikingly, the women also pin to their dresses headshot photographs of their lost family members. Over the past two decades, international media has made icons of these women and the photographs they bear. In the past couple of years they have gained renewed attention as the effort to prosecute key junta authorities has gained ground, and as plans rapidly progress for an official state-supported memorial museum at Buenos Aires' ESMA Navy Mechanical School Detention. The transferal of some pictures to fences around ESMA in recent years suggests a move towards their institutionalization, and with it a possible shift from being emblems of remonstration to those of reconciliation.

A second case concerns S-21, the secret prison in Phnom Penh that formed a key mechanism of the DK regime's system of genocidal terror. There 17,000 suspected "enemies" were photographed and interrogated before being tortured and killed. The camera was one of many Khmer Rouge weapons of psychological terror. Prisoners were transported to Tuol Sleng wearing a blindfold, which was removed only seconds before the photograph was taken. Prisoners look startled, tired, shocked, and disbelieving. Sightless and disoriented, captives' powerlessness in front of the shutter eye meant that the camera became a forcible psychological weapon. S-21's teenage photographer Nhem Ein "shot" the victims with his camera, and in doing so, began

the process of forced confessions that condemned them to death.[39] After their 1979 invasion, the Vietnamese uncovered a vast archive of dossiers including the headshots, which quickly formed the basis for the exhibition that has existed since. Although they represent only a few of those killed, these headshots remain a valuable part of the halting memorialization of Cambodian genocide and act as evidence that may yet be used to prosecute surviving DK regime leaders. In mid-1997 a further episode was added to the life of a selection of about twenty of the photographs when they were exhibited at New York's Museum of Modern Art (MoMA). Their presentation as photographic studies of the crisis of the human condition saw them vividly distanced from their origins as an apparatus of Khmer Rouge terror.

My third case involves those lost after the 2001 terrorist attacks on New York's World Trade Center. Immediately after the event, those seeking urgent information about loved ones posted homemade notices, consistently featuring a headshot picture and a physical description, around the city's streets, parks, and subway stations. An estimated 500–700 families and friends created and posted about 100,000 fliers.[40] While these were initially a plea for information, they soon became memorials for people of whom often no trace was found. They also became more general public property, as people began to add flowers, candles, written messages, and American flags to the posters. In later weeks this process became more formalized, as schools, churches, and community groups across the country sent their own murals and collages, which were displayed alongside notices in churches and subways, and affixed to fencing around Ground Zero. These memorials were themselves soon transformed into aesthetic artifacts through photography, where they were pictured on internet sites and in commemorative books and magazines. The photographs have also been the subject of several prominent art exhibitions, and have traveled to major national and international museums as cultural artifacts. In their different stages of reproduction they have variously represented desperate personal appeals for help, artifacts in spontaneous public memorials, art objects, and objects of cultural diplomacy.

War photographs typically aim to evoke for viewers the dynamic story that produced the moment. In the case of headshots, the action that we imagine beyond the frame is not necessarily the background action excised by the photographer. Only in the Cambodian case is the headshot cruelly representative of the victim's demise; in Argentina and New York, the generally bureaucratic or domestic context of the original picture does not match the highly charged scene that we imagine accompanied their deaths. When we look at a headshot with an explicit awareness of the political events that made an otherwise indistinct person noteworthy, we are tempted to create a dramatic (probably inaccurate) pictorial narrative for their life. Hence, the headshots do not just belong to or reside in history, but help to decide it, according to the stories we attach to them. It is the realm of "imagined memory" that can shatter the obstacles of photography's space-time configuration to piece salvaged fragments together into a new meaningful order. While "imagined memory" is a problematic phrase (to the extent that all memory is creatively reconstructed) the concept allows us to distinguish memories grounded in lived

experience from those produced by media fragments and creatively conjured in different ways by each of us.[41]

In all three cases, along with others as diverse as Budapest's Terrorháza and Taipei's 2–28 Memorial Museum, victims' photographs have been displayed in a grid style. The omission of any person's importance, class, or rank communicates a strongly egalitarian theme (a tradition carried over from undifferentiated lists of names inscribed on war memorials). As Michael Rowlands has observed, the notion that any one of them "could have been me" effectively strengthens the notion of the one being sacrificed for the many.[42] In actual practice, however, the viewer may find it difficult to accommodate a large number of portraits of those killed. Not only is the scale too great to comprehend, but the difficulty with absorbing even some of the hundreds of images of those killed in Cambodia, Argentina, New York, and elsewhere is the numbness of conscience that repetition brings. Aware that every face represents a life, viewers may want to pay tribute to each, yet find it unbearable to consider each one in turn. Instead, certain pictures stick, often for reasons that are, awkwardly, based on visual pleasure. Why do we focus on some images over others? Of the hundreds of headshot images from Tuol Sleng, the one shown in Figure 3.3 is easily the most reproduced. The combination of the woman's youthful beauty, her resigned

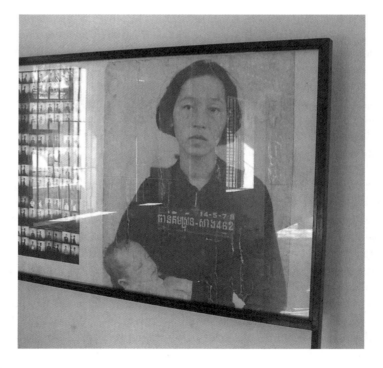

Fig. 3.3. Picture of Mother and Child at Tuol Sleng. Copyright Adam Carr. Released to the public domain.

expression, and the infant in her arms is visually poignant and speaks eloquently of innocence. Beyond its callous overtones, the dilemma that arises from "preferring" some headshots over others is partly due to a modern paradigm that holds that the dual powers of photography – generating documentary records and creating works of art – should be kept separate. The conventional separation of headshots and portraiture in both style and intent is conventionally maintained due to their allied connotations of government identification versus artistic expression, or state subject versus creative personhood. In short, we feel that images associated with suffering should not be openly deemed attractive. While the technical conventions of the portrait and headshot are similar, they are assumed to show only *either* intimate character *or* bureaucratic supervision and reform.

The cases where such categories have been blurred are therefore significant. From May 15 to September 30, 1997, a selection of twenty-two headshots from Tuol Sleng were displayed as *Photographs from S21: 1975–1979*, at MoMA. The exhibition came about after two American photographers, Chris Riley and Doug Niven, visited Tuol Sleng in 1993 and discovered 6,000 original 6 × 6 cm negatives in a cabinet.[43] They copyrighted possession of 100 negatives and decided that the pictures deserved a larger audience (Riley and Niven also made several sets of art-quality prints for sale to collectors). By selecting those images that were most aesthetically satisfying and emotionally powerful, the curators performed their own kind of culling. Todd Gitlin has compared the prospect of selecting which images to print and display to having to decide who was going to live or die – yet it is unclear if Gitlin means that those displayed have been saved.[44] Instead, our looking at them may condemn them to a new death every time, since they are allowed to stand for nothing else.

In New York (a location that could scarcely be further from the site of forced collectivization) the photographs were largely presented as fine art. Next to each image MoMA placed a placard:

> Photographer unknown. Untitled. 1975–79.
> Gelatin-silver print. 14 × 11″.

The lack of artistic intention in these photographs is signaled by these multiple absences. Nevertheless, one reviewer flattered the photographer (who somehow unknown to MoMA was Nhem Ein) with a comparison to Diane Arbus and Richard Avedon, and wrote that, "these starkly powerful photographs are as complex and human as any series of portraits."[45] Recalling my earlier discussion of the Abu Ghraib images, what are the ethical guidelines surrounding instances where victims could never have imagined being studied by Westerners as portraits of events in which they played no part except as casualties? By radically removing the images from the conditions of their creation, and by exhibiting only a digestible number, the images at MoMA were granted autonomy from the location and magnitude of what occurred that is not found at Tuol Sleng. If many of those pictured appear pleading before Nhem Ein, they appear to ask us, the inheritors of history, a different rhetorical question: for what purpose was I killed? A response supported by an art museum (that might reside in the pictorial

qualities of the image) is of course insufficient. The illusion that viewers are offered an unobstructed passage to death is partly due to the photograph's nature as both an *image* and *object*. They are not just secondary representations of history, but primary evidence from it. However, provided with only a cursory historical overview through MoMA's wall text, and situated thousands of miles from the place that one can picture the killing occurring, they lose much of this evidential status.

In the rush to memorialize 9/11, exhibitions based on images from that day were organized very soon after the event. The impulse to document was immediate for many members of the public, prompted by the realization that it was an instantly historic moment. For others, photography may have provided both a means of participation and a kind of safety valve, in that it provided the semi-detached role of documentarian. Exhibitions included *Here is New York: A Democracy of Photographs* (2001), which featured images of the actual impact, the burning aftermath, and the subsequent recovery. Works by well-known photographers were interspersed within hundreds of images from members of the general public (none were labeled or signed). All reprints were on sale for $25, with proceeds going to charity. The show traveled from the small SoHo gallery where it began to eleven American locations and then on to Japan and eight European cities. In *Witness and Response* (2002) the Library of Congress collected and exhibited thousands of recovered objects and photographs. *Faces of Ground Zero* (2002) is a series of oversized framed images made by *Life* photographer Joe McNally using a room-size Polaroid camera. They show rescue workers, survivors, and relatives of the victims of the attack, posed monumentally against a white studio backdrop. The show has toured major U.S. cities and the Royal Exchange in London. *After September 11* (2002–2004) combines images of the ruins of the World Trade Center by Joel Meyerowitz (the only photographer granted unimpeded access) with elegiac quotes from American heads of state. Sponsored by the U.S. Department of State, the exhibition has traveled to nearly 100 towns and cities worldwide. This exhibition in particular represents a major act of cultural diplomacy, aimed at, as Liam Kennedy surmises, "perpetuating a visual assumption that the United States is the epicenter of the culture of humanity." At the least, the exhibition is "an ideological component of the State Department's broader efforts to remobilize the 'soft power' of cultural propaganda in the service of national security."[46]

Two other exhibitions are especially notable given my headshot focus. One is *Missing: Last Seen at the World Trade Center, September 11, 2001* (2002) which was comprised of between 175 and 210 missing persons fliers. Photographer Bronston Jones, who watched the events from California, traveled to New York to take pictures of the fliers, ostensibly to preserve them from the elements. The exhibition then toured Santa Barbara, Illinois, Oklahoma City, Pennsylvania, and Washington, DC. It was criticized for its drive towards aesthetics; only color fliers were selected to be photographed, and these were carefully framed as portrait pieces.[47] Another is *Missing: Streetscape of a City in Mourning* (2002) shown at the New York Historical Society. This museum chose not to display the fliers themselves, but instead showed only wide-lens shots of the posters as they appeared in street shrines. "We're not ready

to show the actual missing posters. They're just too fraught with local emotion and association," said Jan Ramirez, then-director of the museum. "We actually made some initial phone calls to the numbers [on the fliers] and found that a lot of people weren't ready to talk and weren't ready to have their loved ones historicized so quickly."[48] The New York Historical Society exhibited rare restraint amongst the greater willingness to make every image publicly available. Out of some pressing sense that the victims' headshots could not be left inactive or functionless, they gained additional lives through further acts of photography: the headshots were clustered together to form memorials; many others took pictures of those memorials; and others even took pictures of others taking pictures of memorials. The question of whether the missing persons notices were public or private property was largely overlooked. Further, the issue of what it meant to look, in a gallery space, at people normally unknown to the viewer was one ignored in exhibition catalogs and websites. Is it really so simple that "putting a face" to disaster deepens understanding? Or does it simply aid plaintiveness by supplying pictures?

In the wake of 9/11, a few commentators became interested in whether missing persons posters could produce amongst a highly modernized nation's inhabitants some empathetic connection with people in developing regions who have also used headshot photographs to mourn the dead.[49] It is notable, for instance, that in parts of the Arab world, graves are often marked by a photograph of the deceased attached to the top of a thin metal pole, creating a kind of forest of pictures in cemeteries.[50] However this cross-cultural, humanistic notion of picturing victimhood is one that others, most notably Susan Sontag, rail against. In *Regarding the Pain of Others*, she argues for the necessity of specificity, since, she observes, compassion usually becomes floundering and abstract when violent conflict is pictured as a universal problem. For peace activists, war is a generic problem of human dysfunction that strafes across all social and cultural contexts. For those embroiled in a conflict however, what matters is precisely who is killed and by whom – especially where persecution is based on one's perceived identity. Sontag's point is borne out by the cases I consider here. In the regimes of Cambodia's Democratic Kampuchea and the Argentinean junta, one's identity was of deadly importance. Status and ideological positioning were seen to be immediately discernible in one's physical appearance and demeanor. During the Cambodian genocide, those who wore glasses were targeted as intellectuals. Other Western styles in clothing, hairstyles, jewelry, or makeup also marked people as highly suspect, and even as spies. Other religious and ethnic identities visible through appearance (such as Buddhist monks and Muslim Chams) also made the person vulnerable to persecution. Once in power the Argentinean junta installed a strict code of appearance that served to both identify its suspected enemies and to discipline the public (particularly the young). The stipulated dress code was:

> Males: short hair, ears visible, no beard, classic trousers, jacket, shirt and tie.
> Females: hair pulled back, no makeup, white apron covering shirt, blouse or sweater, shirt buttoned at the neck or white undershirt.[51]

Being seen to be physically performing the new national identity was key to survival. For this reason, it was especially significant when the Madres de Plaza de Mayo appeared with photographs of their children in their non-regulated, casual attire. The women and the photographs they bore formed a challenge of appearances to the regime.

The way we view victims' portraits can change along with the political context of their reception. Writing shortly after the beginning of the Madres de Plaza de Mayo's protests, Tona Wilson reported that the photographs of *desaparecidos* have a reflective dimension that challenges onlookers to confront the basis of their own survival:

> There is a silent presence – on the walls of the cathedral, on pillars, on trees, on the pyramid that is the central monument in the plaza – of the faces – photocopies of photographs – of many of the thousands who were kidnapped, tortured, murdered, by the military. Strong, shy, angry, smiling, those eyes watch us, reminding us of a recent past that must not be forgotten, at the risk of being repeated. Most of us return the look, with a sense that " ... it could have been me, but instead it was you."[52]

More than two decades on, this sense of personal transposition may now be a less likely form of interpretation in Argentinean society. The memorialization process is now closely tied to, among other projects, the imminent ESMA Museum of Memory announced on March 25, 2004 by President Kirchner. While at the time of writing the contents and narrative of the museum are vague, some have voiced skepticism about whether this institution will form the breakthrough that can spur further political justice and aid social reconciliation.

> Nothing here is quite what it seems. This is the country of anti-memory, a country that consumes its own archivists. So despite what clearly appears to be the best of intentions, it remains entirely unclear what exactly a museum at ESMA will provide for Argentineans. What will be held there? The still-disappeared documents retained by now aged but still impugn former generals? Implements of torture which, a quarter of a century later, are impossible to find? Or perhaps the transcripts of the magisterial 1985 trials in which these very officers were tried and convicted of torture and murder before being pardoned and set free? [53]

Like the portraits and busts of Pol Pot that were either removed from S-21 or displayed toppled to the ground, the first symbolic action at ESMA was to bring down the portraits of junta generals that previously lined the walls. Over the past few years, hundreds of photographs of *desaparecidos* have adorned the palisade of the seventeen-hectare compound, put up by relatives and the human rights groups who have long campaigned for the site to be made into a museum. It remains to be seen whether these headshots will be displayed inside the complex, and whether the detailed lists and photos, which the junta kept of every single arrest and "transfer" (the euphemism employed for execution) will be exhibited. If so, might the move

from the city fence to the gallery wall make this history a little less raw, and less urgently debated as a result?

The pictorial reappearance of the faces of the vanished in public squares and museums alike has emerged as a powerful form of memorialization. Yet these sites remain politically sensitive and subject to constant monitoring. Those who move through the Tuol Sleng compound, skirt the perimeter of Ground Zero, or stand before the fence at ESMA cannot help but be reminded of a martial presence, as armed police guard each site; during quiet periods especially this surveillance uncannily amounts to, as Diana Taylor puts it, "policing ghosts."[54] This effect is also achieved by the presence of *siluetas* in Buenos Aires and other South American cities – the silhouetted outlines of disappeared persons painted directly onto walls, or traced onto paper and stuck to them. These figures, which imitate the chalk outlines police sometimes trace around the deceased, attempt to reinsert the bodies figuratively into social space. The association of victims' faces with a city location is an effort to provide them with a sense of place, even if is somewhere related to their death rather than life. Clearly, then, the relationship between photography and space in the memorial museum concerns not just the space contained in the flat photographic image, which often forms the focus of interpretation (especially in art museums). The manner in which the photographs become an element in a spatial, three-dimensional installation is, in the cases I have described, vital.

CONCLUSION: COMMEMORATION, IMAGINATION, AND VISIBILITY

The events analyzed here problematize many of the capacities that we typically attribute to the historical photograph, such as to record faithfully, to bear witness, to aid mourning, and to provide a "history lesson." In fact, my discussion suggests that photographs associated with monumental loss often have particularly ambiguous qualities. The details of "action shots" often obscure problematic moral issues involving the identity and motivations of the photographer. Further, the action in a shot may be little experienced by the subject and overdetermined by the viewer, foiling the commonsense view that photographs provide unimpeded access to historical reality. The headshot involves a different kind of conundrum. By starkly displaying the faces of victims, the hope is that a visual reminder of their humanity will encourage viewers to appreciate the gravity of what occurred. Yet these people did not ask to play any part in making history. We might ask what we actually come to understand by focusing on a stranger who is, even when given some biographical description by the museum, ultimately reducible to being "not me." In other words, both the inevitable terror of the action picture and the egalitarianism of the headshot in memorial museums may only communicate the tragically interchangeable nature of those unlucky enough to be alive in the wrong place and time. Is there anything to be *learned* from this circumstance exactly? Nevertheless, despite such misgivings, the planning of memorial museum exhibitions always proceeds with an implicit acknowledgment of the indispensability of primary visual evidence. Pictures certainly

possess *something* vital, perhaps precisely because history is, for all but those who directly experienced an event, *imaginative*. It may be that photographs, above all, are valued as much as cues for mental visualization as for evidence per se.

An artist who understands both the ethical dilemma surrounding photographs of violence and the potential role of the imagination in filling in the "dark spaces" of terrifying histories is Alfredo Jaar. After taking thousands of pictures amidst the Rwandan genocide, his work, against expectation, deals with the rare theme of *refusing* images. His *Real Pictures* series (1995) commissioned by the Museum of Contemporary Photography, Chicago, is based on more than 550 photographs. All of these, however, are sealed in 100 black archival photographic boxes, which were displayed in galleries stacked upon one another to create monuments of various shapes and sizes (Fig. 3.4). Disturbed by the way that those in the West *saw pictures* of the genocide, yet still failed to act, the very dark exhibition spaces in which Jaar installed the exhibition mirrored this sense of blindness. Jaar has noted that the idea for the work came from his own disappointment and psychological withdrawal at the idea of simply showing his images. Disheartened by their representational inadequacy and potential complicity in what he saw as false commemoration, he could not initially even look at 3,000 photographs he took in 1994. Upsetting conventional expectations, the images were pointedly withheld from viewers. In the twilight of the gallery, it was possible to read white texts printed on the lids of the small archival vaults. On each box the text concisely described the event "pictured" inside. One example reads:

Fig. 3.4. "Real Pictures." Copyright Alfredo Jaar. Used with permission.

Ntarama church, Nyamata, Rwanda, Monday, August 29, 1994. This photo-graph shows Benjamin Musisi, 50, crouched low in the doorway of the church amongst scattered bodies spilling out into the daylight. 400 Tutsi men, women, and children who had come here seeking refuge were slaughtered during the Sunday mass. Benjamin looks directly into the camera, as if recording what the camera saw. He asked to be photographed amongst the dead. He wanted to prove to his friends in Kampala, Uganda that the atrocities were real and that he had seen the aftermath.

Real Pictures both theorized and materialized a photographic "crisis of reference" in order to force visitors to picture scenes of atrocity for themselves. Jaar was inter-ested in the way that "the camera never manages to record what your eyes see, or what you feel at the moment. The camera always creates new reality."[55] As he further explained:

> If the media and their images fill us with an illusion of presence, which later leaves us with a sense of absence, why not try the opposite? That is, offer an absence that could perhaps provoke a presence ... People were already shown a great quantity of images, but they did not see anything. No one saw anything because no one did anything. Then I thought, this time I won't show the images so that people can "see" them better. What we have here is an absolutely radical and utopian logic, a study, an experiment in representation.[56]

The idea of a "nonpresentation" is an artistically effective means of refusing what vis-itors normally implicitly assume they have the right to see. *Real Pictures* asked where the political value of photojournalism might lie, if it indeed fails to inspire action.

Although memorial museums typically aim to put a "human face" on tragedy, the end result can be depersonalization, insofar as the person or people depicted are often received as little more than representative sacrificial victims of a historical narrative. Photography can be charged with bringing experience close and making it available as acquired knowledge, but only at the expense of transforming its original object.[57] This is particularly true when we consider the question of privacy. The question is not just who takes the photo, but whether the subjects want to be seen in the state to which they have been subjected, and whether they want to become public prop-erty, able to be endlessly reproduced in the name of historical representation. Taipei's 2–28 Museum has arrived at an effective display tactic that draws attention to how photography can be made to maintain a meaningful moral bearing across genera-tions. One exhibition space shows panels that juxtapose a black and white photo-graph of the victim from around the time of their murder with another more contemporary image that shows a (normally elderly) relative holding the earlier photograph in front of them (Fig. 3.5). A key problem commented on throughout this chapter – that is, the ethical issues surrounding the removal of images of victims from the private to the public realm – is ameliorated through this simple display technique. It is clear that the families participated in the process of this curatorial

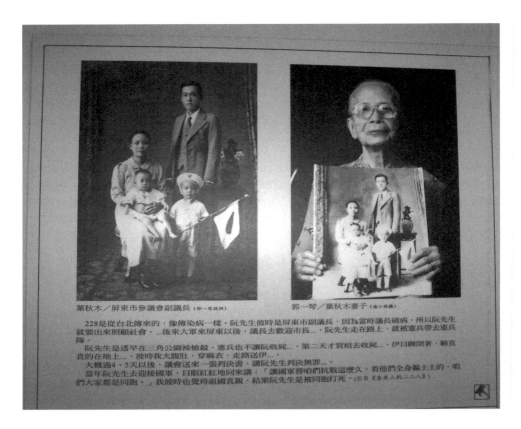

葉秋木／屏東市參議會副議長 (郭一琴提供)　　郭一琴／葉秋木妻子 (潘小俠攝)

228是從台北傳來的，像傳染病一樣。阮先生彼時是屏東市副議長，因為當時議長破病，所以阮先生就要出來照顧社會。...後來大軍來屏東以後，議長去歡迎市長...，阮先生走在路上，就被憲兵帶去憲兵隊。

阮先生是透早在三角公園被槍殺，憲兵也不讓阮收屍...，第二天才實棺去收屍...，伊目睭閉著，躺直直的在地上...，彼時我大腹肚，穿麻衣，走路送伊...。

大概過4、5天以後，議會送來一張判決書，講阮先生判決無罪...。

當年阮先生去迎接國軍，目睭紅紅地回來講：「講國軍替咱們抗戰這麼久，看他們全身軀土土的，咱們大家都是同胞。」我彼時也覺得祖國真親，結果阮先生是被同胞打死。(引自《台灣人的二二八》)

Fig. 3.5. Image of 2–28 victims at 2–28 Memorial Museum. Image taken by author.

project, and, through its use of family archive, this tactic effectively communicates the idea of history as a social effect through time. The 2–28 Museum also employs this strategy to draw attention to the continuity of location. One recent color photograph of an otherwise ordinary-looking empty train station platform is revealed, in an adjacent black-and-white photograph, to be the historically significant site where KMT soldiers turned their fire on gathered Taiwanese commuters who demanded that the officers also buy tickets. Another example uses a recent photograph of a murky river underneath a Taipei traffic bridge. The adjacent image shows a much older picture of the same site, which, we learn, was where the body of a prominent Taiwanese judge was dumped when a KMT truck used for his abduction broke down. By showing that concrete referents have existed through time (whether family members or city locations), the museum aims to show that photographs can have more staying power than any momentary click would suggest.

In sum, the *crisis of reference* that may be endemic to all historical photographs is especially accentuated in photographs of violence and atrocity, which carry a heavy emotional charge and grave political consequences, and moreover, are closely related

to the psychological state of trauma. A key symptom of trauma involves the way one's mind is unable to edit and place an event within a coherent mental, textual, or historical context.[58] There is a close connection between the theory of trauma and the visual aesthetic of shock. When the human psyche tries to process a traumatic event, it will endlessly replay it, struggling to find meaning, or resolution through the replay. Hence, traumatic memory, like the camera, has been described as consisting of an arrested moment that is disconnected from the forward motion of linear time, and lacks the ability to take part in some story that can offer resolution or sense to terrible events.[59] While we can gain *information* by establishing the context of any image, we do not necessarily *understand* the subject's traumatic experience, since not only is it not the sum of what an outsider can adduce from the contextual signs in an image, but moreover, it denotes something that may not even have been fully experienced, in a contextual-historical sense, by the traumatized subject. As Cathy Caruth explains: "The history that the flashback tells – as psychiatry, psychoanalysis, and neurobiology equally suggest – is, therefore a history that literally has no place, neither in the past, in which it was not fully experienced, nor in the present, in which its precise enactment are not fully understood."[60] The memorial museum acts as a site of recovery in which photographs can gain a new value. Very few pictures were taken with the expectation that they would one day be shown in a museum; very few subjects depicted could have imagined that their lives would be held as representative of much beyond their own existence. While museums may strike us as a natural home for these kinds of images, they rely on a radical decontextualization, not only from the private to the public, but also from the moment that may have been little experienced, to a history that may remain permanently evident.

4 ROCKS AND HARD PLACES: LOCATION AND SPATIALITY IN MEMORIAL MUSEUMS

ON BEING THERE

The importance of space and spatial effects in the museum experience is a topic routinely neglected within museum studies. Perhaps because the field is partially descended from art history, it has inherited a strain of decontextualized analysis more interested in the field of meaning generated by artifacts than that of the larger institution. Where space is analyzed, it is chiefly in terms of architecture and the aesthetic relation between gallery space and artworks.[1] Where non-art museums are considered, their analysis is generally limited to issues surrounding the relative disposition of exhibition space granted to topics. The single critic's object-focused walk-through exhibition analysis has remained, in the past couple of decades, the mainstay of museum criticism. However, such accounts are at odds with visitors' experiences, where the encounter with the physical dimensions of any site, and with other people, is not just physically unavoidable but wholly integral. As Sharon Macdonald avers, we still "need to move towards further elaboration of ways in which museums are unlike texts."[2] In line with this thinking, this chapter explores the social, cultural, and psychological dimensions of memorial museums' spatial effects.

Academic neglect of this theme is surprising, given that museums are partly distinguished from other forms of historical representation by their "sited-ness"; by the nonverbal nature of their messages that resides not just in material culture, but also in the museum's particularly visible sense of spatial orchestration. As visitors move through museums, they gain meaning as much from the size and character of spaces, the relation between them and the activities they support, as the objects and texts they contain. The museum is a cultural project in which, as John Urry puts it, "spaces, histories and social activities are being materially and symbolically remade."[3] Centrality and marginalization are related through the relative attribution of space. Accordingly, visitors create "imaginary geographies" in which social divisions and cultural classifications are expressed using spatial metaphors or descriptive spatial divisions.[4] Those at the forefront of the concept design of new memorials and museums are consciously aware of the way museums operate in two spatial registers: foremost, they are concrete objects in space intended to serve practical purposes; on a secondary level, physical design elements are used to shape the construction of visitors' mental images of the topic to which they are dedicated.

Over the past twenty years, "museumification" has become a prevalent strategy for transforming urban (and occasionally rural) space. The age of the memorial museum

has coincided with the tactic among urban planners of establishing museological "event spaces" in which historical narratives are given an aesthetic architectural form. These projects share much with Henri Lefebvre's idea of "representational space." Unlike "representations of space" (such as those intellectually conceived by urban planners and technocrats) or the spatial practices of everyday life (the relation between daily routine and the paths and routes that link and separate work, leisure, and private life), "representational spaces" are "heavily loaded, deeply symbolic and embedded culturally, not necessarily entailing conscious awareness. [They] call on shared experiences and interpretations at a profound level … representational spaces are the loci of meaning in a culture."[5] Representational spaces are often based on images and symbols that overlay physical space, making symbolic use of its objects.[6] Town center war memorials built around a bridge, clock, gate, bell tower, walkway, or park are archetypal example of such a space. Increasingly, however, we also see destructive histories forming the basis for the reinvention of space, from "Parque de la Memoria" on the coastal fringe of the Rio de la Plata near Buenos Aires, to the "Memorial to the Murdered Jews of Europe" in Berlin, to "Statue Park" in Budapest, to the "Park of Arts Museon" in Moscow, to New York's forthcoming World Trade Center Memorial, among others. Each space is designed to accommodate public congregation, providing a tangible, physical hub for social reconciliation. These spaces bring historical commemoration into regularly used outdoor social spaces to make them an accessible part of everyday life. For, as Vito Acconci has succinctly put it, "A museum is a public place, but only for those who choose to be a museum public."[7] In most cases, the size and centrality of these squares and parks makes them, compared to cloistered indoor spaces, difficult to overlook.

While observable in many places, it is Berlin that serves as a prime example of a city "reorganizing itself as a permanent exhibition of its own ambitions."[8] Public squares and monuments from the Kaiserreich, the Third Reich, the German Democratic Republic, and the reunification era fill the city. While much writing about the spatial location of monuments, memorials, and history museums describes them as places where collective memory is locally rooted, at the same time, concrete representations of historical calamities are increasingly being promoted as a key draw-card for tourists. It might appear that the two goals – to serve both local commemoration and tourist novelty – can only mean tension. More obscure manifestations of local histories may not provide the spectacle required of a tourist attraction. Consider, for example, how local memory is manifest in Gunter Demnig's *Stolpersteine* (stumbling stones). Since 1997 he has embedded in the pavement 30,000 small brass plaques bearing the names of Jews outside houses in German cities where they lived before the Holocaust. This project includes involving local people in researching and carrying out the installation, street by street, and sometimes amid neighborhood hostility; they have been banned by the Munich City Council on the grounds that the project will become a focus for neo-Nazis.[9] (The *Stolpersteine* are reminiscent of "Sarajevo roses" – the form of memorialization practiced in Sarajevo where residents have painted the pockmarks made by mortar splashes on the streets

with blood red resin, marking the places underfoot where someone was killed). By contrast, spectacular monuments designed to attract the tourist gaze risk forgoing relevance in everyday city life. There is already discussion, for instance, that the visually stunning Memorial to the Murdered Jews of Europe may soon become an empty maze, used mainly as a children's playground.[10] Similarly, reflecting on the glut of First World War monuments in 1930s' Europe, novelist Robert Musil wrote:

> The most striking feature of monuments is that you do not notice them. There is nothing in the world as invisible as a monument. Doubtless they have been erected to be seen – even to attract attention; yet at the same time something has impregnated them against attention. Like a drop of water on an oilskin, attention runs down them without stopping for a moment.[11]

We might speculate whether the contemporary boom in memorial sculptures and museums may one day inspire a similar lament. For now, we should observe how pressing appeals to remember are closely tied to ambitious built structures with a physical presence in the world. As Deyan Sudjic has written, "architecture matters because it lasts, of course. It matters because it is big, and it shapes the landscape of our everyday lives. But beyond that, it also matters because, more than any other cultural form, it is a means of setting the historical record straight."[12] It appears that faith in urban architecture as a redemptive social and historical force has emerged as a key defining belief of our zeitgeist.

Given the site-specific nature of most memorial museums, an appreciation of their larger geographic location is vital (I consider this another aspect of my analysis that productively deviates from standard museological critique). Factors such as the physical size and grandeur of the institution, the prominence and accessibility of its location, and the proximity of other city features (either related or dissimilar) determines the "geographic reach" of the historic event, which in turn influences the degree to which it infiltrates public consciousness. The visibility of memorial museums (alongside other reminders like statues, plaques, street signs, and honored buildings or parks) critically affects the "scaling of public memory" – that is, the way an incident's recollection is prompted as people physically move through cities, regions, and nations.[13] We might expect it to follow, then, that events represented by memorial museums situated in rural or remote locations or hidden in obscure urban nooks are more likely to be overlooked. Alternatively, however (as the tradition of the pilgrimage suggests) it may be that the commitment involved in traveling to and finding more obscure sites heightens the significance of the visit. It can also contribute to the institution's own sense of interpretive drama, in that its clandestine or remote location can help express the nature of the misdeed. Hence, the visibility and geographical proximity of memorial museums has implications for who goes, the expectations with which they arrive, and the museum's own dramatization. I will next move through a series of themes – authenticity, absence, hybridity, and minimalism – to explore the physical qualities of actual cases. The latter part of this chapter will then go inside the walls of the memorial museum to consider internal spatial dynamics.

THE AUTHENTICITY DILEMMA

As different communities and nations attempt to cope with the continued unease and loss associated with mass violence, the damaged landscapes associated with it are increasingly being claimed as hallowed ground. Yet the relationship between the event-location of the catastrophe and the site of a memorial or museum can be unreliable or insecure. To be sure, in many cases, the site may be obvious and uncontested, as locals easily recognize and vouch for its historical accuracy: *this* building was used for *this* purpose; *these* people were killed *here*. Historic locations may have existed without much attention for years before political and economic conditions – and the will of an individual, group, or government – made it possible to be framed as "unearthed" or "exposed." Where the site is newly claimed by a certain group or government to have been "discovered," it has more often become the subject of contest. While sites are not often entirely forgotten by those in the locality of a heinous act, the decision to exhume it by certain people at a particular time denotes a political intervention as much as an archaeological unveiling.

Geographical authenticity becomes particularly problematic in relation to events situated in more remote or "deeper" history. At Senegal's Gorée Island Memorial Museum, visitors pass through the old building's dungeons to peer out its famous red-washed "door of no return," the final threshold to the Atlantic Ocean. Museum guides and common wisdom equally hold that the building and its aperture to the ocean served as the main departure point for 15 to 20 million Africans sold into slavery between the fifteenth and nineteenth centuries. Yet Gorée Island's historical role has recently been critically questioned. Historians have challenged that departing slaves likely never walked through the door at all, since Gorée was one of hundreds of slave posts dotting Africa's west coast, from modern-day Senegal south to Angola. They claim that those slaves who did pass through the island (at least 26,000 were recorded) were actually loaded onto boats at a beach about 300 meters away,[14] and that most sold into slavery in the Senegal region would have departed from thriving slave depots at the mouths of the Senegal River to the north and the Gambia River to the south.[15] Further, Philip D. Curtin has challenged the idea that the dungeons of the elegant mansion ever housed anyone except perhaps the resident merchant's own slaves.[16] Despite these contentions, others counter that the door dramatically communicates the idea of stepping into the abyss and helps to create an emotional shrine to the slave trade. "For me, it's a false debate," says Hamady Bocoum, an anthropologist at Université Cheikh Anta Diop in Dakar. "Every African village has the right to develop a memory of slavery." Gorée Island head curator Joseph N'Diaye concurs that "even if only ten slaves left through Gorée, they would deserve to be remembered."[17] Exactly, say critics: so why exaggerate? This disagreement shows how interpretive effect remains tethered to historical accuracy. For most visitors, a historic site must possess more than a poetic or allegorical effect if it is to win their emotional and psychological investment. Indeed, it seems unlikely that if it was well known that "only ten" slaves had passed through Gorée, the island would have the kind of

symbolic importance that has made it a significant tourist site, and a mandatory stopping point recently for figureheads such as Bill Clinton, George W. Bush, Pope John Paul II, and Nelson Mandela.

Clinton's 1998 tour and speech at Gorée Island was not the only time that year he became unwittingly connected to a controversy over memorial museum authenticity. His trip only days before to Rwanda coincided with an early attempt to construct a genocide memorial in Kigali. Clinton was asked by the Rwandan government to lay a wreath at a memorial erected at the city airport in anticipation of his visit. A white concrete structure had been purpose built within the airport compound to enable a secure and convenient ceremony. It was planned that some victims' human remains along with machetes, knives, picks, axes, and clubs would be displayed. Then-President Pasteur Bizimungu and Vice President Paul Kagame were to greet him, with Rwandan children lining the runway. When an American government official refused the request, stating that agreed-on plans did not include a memorial, the Rwandan government and groups representing survivors were reportedly bewildered and disappointed. An obvious concern that prevented the event was security (it was at Kigali airport that on April 6, 1994 Rwandan President Juvenal Habyarimana was due to land after returning from peace talks with Uganda-based Tutsi rebels. His plane was shot down minutes before landing, and the mass killing began within hours). However, there was also a question of commemorative ethics: the Rwanda News Agency reported that Clinton's aides had told Kigali officials that he believed its hasty construction and its location trivialized the genocide.[18] Indeed, in a country filled with genuine sites marking massacres, the airport was a rare exception. In this case, the memorial's authenticity was interpreted, from the American diplomatic perspective, as being based in its physical appearance and location, rather than the desires of the constituency attached to it.

The perceived authenticity of a historic site is greatly enhanced when it contains tangible proof of the event *in place*. Given their sacred qualities and the sense of finality they provide an event, graves form a forceful basis for a memorial museum's location. The Nanjing Massacre Memorial Museum, for instance, was built in the west of the city over a shallow pond that once formed a mass grave for hundreds of bodies. Photographs of this grave appear in the museum (the many others like it throughout China are known as *wan ren keng* – "pit of ten thousand corpses"), and some of the skeletal remains are displayed within a glass chamber. In places like Argentina, Chile, Cambodia, and the Balkans where death was hidden, graves stand as visual evidence of the scale of killing. As Allen Feldman has observed, "undiscovered graves – literally the emblems of surplus sacrificial history – actually constitute the moral geography of many postviolence nation-states."[19] Since their discovery across scattered sites provides no obvious central location, the question of where to rebury is loaded with import. The mutilated and tortured remains of those executed by Chile's military government after the 1973 coup were taken to Chile's National Cemetery "Patio 29" and buried in graves marked with small metal crosses with "NN" (*no nombre*) painted on them. In 1982, in an attempt to cover up some of their

most egregious violent excesses, the military government disinterred hundreds of bodies and disposed of them in unknown locales, and reportedly ground the bones into chicken feed. After the return of the civilian government a decade later, the remains of those that had not disappeared were found in this plot, and were identified and returned to their families with the help of forensic specialists. The bodies were then usually relocated to the crypts in the memorial wall at the opposite end of the cemetery.[20] Although they moved a short distance, the act of exercising control over their physical location was vital for families. An analogous example involves the way families of 9/11 victims have sought that the retrieval of human remains discovered at Fresh Kills Landfill be re-interred in a private viewing chamber at the forthcoming World Trade Center Memorial. Such cases suggest that memorial complexes can provide the valuable function of providing a burial site in situations where few suitable options otherwise exist. Their reburial in a public memorial space reflects a desire that the unnatural and historically significant nature of their deaths is socially recognized.

ABSENCE AND INVISIBILITY

Few events have engendered such fascination with themes of architectural absence and replacement as 9/11. Given few other tangible focal points, the former World Trade Center site has become a screen against which Americans' hopes and anxieties have been reflected. The coming to terms with human loss was reflected in the emotional ways people spoke about the buildings: there was a "hole in the skyline"; the weight that "anchored downtown" was "missing." Architects (normally behind-the-scenes figures) competing to design its replacement were suddenly awarded the mantle of public leaders. "Build them in their exact image" said many. "Even taller!" cheered others. In *Sixteen Acres*, Philip Nobel posits that this collective craving for a new architectural symbol reflects a pre-9/11 need for media-friendly images rather than any genuine engagement with the complexities of a post-9/11 world: "In tapping the sensibilities of the day before to make sense of the aftermath, it became clear what every effort shared: a culture of surfaces had left its artists poorly equipped for depth."[21] In this line of reasoning, it is unsurprising then, that the most popular response to the event to date has been the "Tribute in Light" memorial that, for 9/11 anniversaries, has used eighty-eight searchlights to recreate the shape of the two vertical columns (Fig. 4.1). The project was initially called "Towers of Light"; it was renamed to shift the focus away from the memory of the buildings.[22] The renaming mattered little. New Yorkers largely made sense of this human event through the lens of the city skyline; through the physical space defined by destruction and replacement. The beams of light have acted as a placeholder for a city awaiting a concrete replacement.

A vivid contrast to this hyper-real, technology-dependent, media-saturated form of commemoration can be found in Russia's Perm-36 Memorial Museum. Its location at the western edge of the Urals requires a four-hour drive along a bad road from the austere city of Perm. The journey ably demonstrates the severance of the gulag system

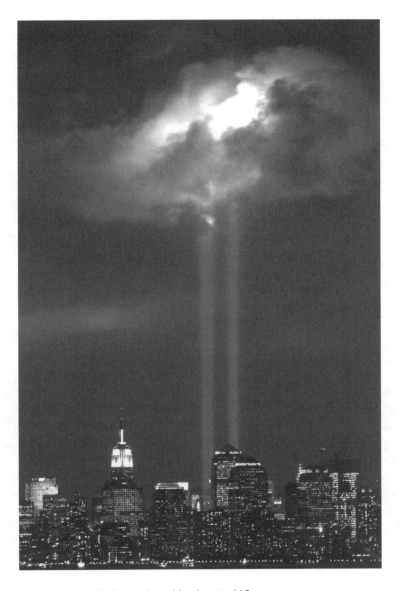

Fig. 4.1. "Tribute in Light." Copyright public domain, U.S. government.

from everyday Russian city life. Watchtowers, barbed wire, and electric fencing surround the low, often snowed-in dull wooden buildings (Fig. 4.2). The idea of prisoners laboring in such isolation (in this case, felling trees initially to build their own barracks, and then floating the timber down the Chusovaya and Kama rivers to the Volga) accentuates both the soul-destroying nature of the work and its enormous waste of money and talent.[23] It is poignant then that when a group of acquaintances

(including camp survivors and their children) began Perm-36's restoration project during the late 1980s' glasnost period, their first task was to work on those same wood-cutting machines to produce replacement boards for the derelict buildings. It is notable that neither Perm-36 nor the Solovetskii Concentration Camp Memorial near the White Sea (another notable gulag memorial) was an initiative of the state. Both suffer not just from insufficient funding, but also from cultural and political marginality. While on a working visit to Norilsk, one of the most harsh and punishing points of the gulag system, President Vladimir Putin recently laid flowers in honor of Stalin's victims in front of a plaque and cross installed in 1990. While this may have ordinarily been a more widely noted gesture, on Nanci Adler's reckoning it is the physical inaccessibility of gulag memorials that allows current state officials to contain the social reverberation that official recognition of the era might bring. (City-based Communist Party memorial tours are available, but are well beyond the means of most Russians: for US$700 one can tour Stalin's Second World War bunker, while Moscow's KGB Museum at the infamous Lubyanka Prison is open only for prearranged tours at US$60 per person.)[24] As long as efforts toward promoting official memory remain limited to isolated events and places (or affluent budgets) they will presumably remain outside mainstream Russian cultural life.[25]

By making mapping its central interpretive strategy, District Six Museum in Cape Town produces a spatial sense of memory. Its activities suggest geography in its most

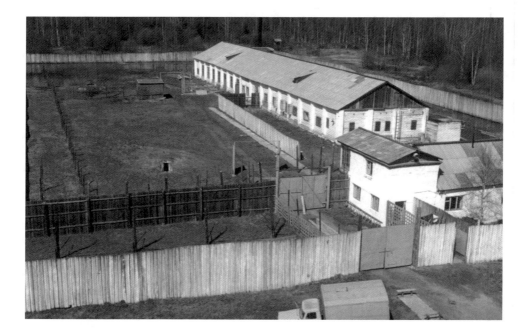

Fig. 4.2. Aerial view of Perm-36 Gulag Museum. Copyright Perm-36 Gulag Museum. Used with permission.

literal form ("geo-graphy" as "earth-writing"). Mapping, which orders and controls terrain, has an obvious relation to the spatial practices of apartheid. Housed in a church (one of the few structures remaining from the former district) the museum exists in a recursive relationship with the locality where it stands (Fig. 4.3). A panoramic photograph of the old skyline extends along one wall, allowing people to visualize the way the church once existed within it, while the floor features a large laminated street-map that recreates the former layout of District Six. Former residents use marker pens to draw houses and buildings, and write names, comments, and descriptions around the streets. The museum acts as a physical synecdoche where ex-locals and expatriates can once again "walk the neighborhood." An aspect rarely noted by those describing this institution is the experience of moving through the neighborhood to arrive at the museum. It may be that visitors deliberately overlook the existing vicinity in order to conjure the lost neighborhood more effectively. Since the museum produces a mnemonic model of a space outside that no longer exists, it can hardly avoid the trap of nostalgia (even – or especially – for tourists who never knew the original neighborhood). This effect recalls Jean Baudrillard's concept of *simulacra*; "copies of things that no longer have an original, or never had one to begin with."[26] While the sense that earlier generations experienced a richer, more vivacious sense of community is a key tenet of nostalgia generally, this effect might be amplified in this situation where the neighborhood is remembered as one that existed in

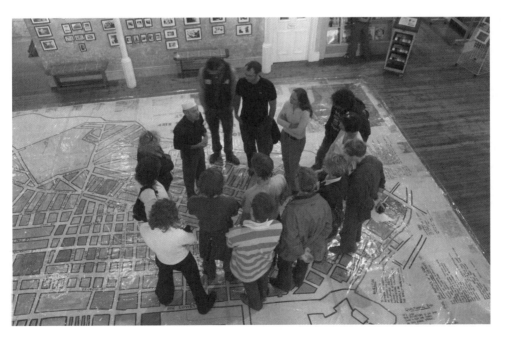

Fig. 4.3. District Six Apartheid Museum. Copyright District Six Apartheid Museum. Used with permission.

multicultural harmony, as the contrariety of apartheid.[27] The museum, like any dedicated to a past community, risks transforming the district into myth, thereby removing from memory the violence, overcrowding, and poverty that it was also marked by. Indeed, some critics have noted ambivalence about the map motif that covers the floor, arguing that it reifies the memory of the space, setting District Six in stone.[28] It may be that the museum represents less some longstanding comradely *organic* community, and instead has created a new *moral* community mobilized by the condemnation of apartheid.[29]

While the theme of physically overlaid histories is given a figurative form at District Six, it is one applicable to cities generally. We glimpse in the palimpsest of urban architecture the idea of the city as text, as it has been written and overwritten by successive waves of capital speculation, political ideology, and violent conflict.[30] As M. Christine Boyer has written, "to read across and through different layers and strata of the city requires [that] spectators establish a constant play between surface and deep structured forms, between purely visible and intuitive or evocative illusions."[31] That is, history is not simply "readable" in the city's built form, but instead exists in the interplay between concrete representations and pasts that reside in the imagination. For every notorious place brought to light as the location for a memorial museum, there are obviously a great many more that have slipped into the recesses of little recounted history. Thousands of years of European conflicts, for instance, have been inevitably disproportionately overlaid with the newly scarred landscapes and memorials of those of the last one hundred. The Armenian Genocide Memorial and Museum at "Swallow Castle" in Tsitsernakaberd, for instance, sits on the site of an Iron Age fortress, the above-ground traces of which have now all but vanished. It is intriguing to consider those little-documented and near-invisible structures that have been abandoned and almost forgotten, or have reverted back to having an everyday use. At present, a car park, a Chinese restaurant, and a mini mall cover arguably the world's most famous non-site: Berlin's Führerbunker. This location is interesting precisely because it is so conspicuously anonymous; government and city authorities have ensured that the ground above it remains pointedly generic in its use in order to disallow it becoming a neo-Nazi shrine. The unearthing of the Nazi Party organization has instead come about through an underground archaeology project, the nearby "Topography of Terror." The open-air site, which has almost no artifacts or historical recreations, instead consists simply of excavated cells, affixed to which are photographs and documents related to Nazi leadership activities. Initially created as a temporary exhibition in 1987, the site is a product of years of citizen activism, with support from some left-leaning politicians, historians, and city elites.[32] As the headquarters and prisons of the former Gestapo, SS, and Reich Security Service, the site is less tied to Hitler's cult. Although it added a documentation center in 1997, the site remains quite ambiguous, neither a ruin, nor a memorial park, nor a fully functioning museum. It is simply a place of perpetrators, and remains an "open wound" that allows visitors to ideologically and emotionally make of it what they will.[33]

The excavation of the remnants of cells led to a rather less productive outcome in the early 1990s in Nagasaki. Builders at the Peace Park commemorating the city's atomic bomb destruction discovered the foundations of a prison where Korean and Chinese slave-laborers had died during the Second World War. A group of Nagasaki citizens argued that the site should be preserved to demonstrate a contrasting view of Japanese conduct during the War than the martyrs-for-peace theme portrayed in the Peace Park. However, conservative groups (with the support of city counselors and the Nagasaki mayor) were able to bury the idea (in this case literally, as the excavated site was covered over and turned into a car park).[34] Political interests defeated what could have been an unusually effective manifestation of a complex topic: the moral gray area that clouds any straightforward assignation of offender or victim status in the heat of wartime. The cells might have formed a physical and conceptual layer of interpretation that, like the Topography of Terror, could have been left open as a kind of contemplative space.

A final example on this theme of absence concerns the ten-storey headquarters of Sarajevo's largest newspaper, Oslobođenje (Liberation), which was destroyed in the siege of the city in April 1992. Bosnian Serbs, angry with the paper's reporting and with its ethnically mixed staff, shelled the building relentlessly.[35] It remains as it fell: two connected elevator shafts form a kind of turret, while concrete rubble is piled beneath. It has no sign, plaque, or means for physical entry, but instead can only be observed from the street as a monument to destruction. Its status as a memorial has emerged over time. Like Berlin's Kaiser-Wilhelm-Gedächtniskirche, which bears the scars of Allied bombing in 1943, there was, at first, neither the will nor the resources to repair or remove it. It became part of the cityscape, gradually accepted as a symbol of what occurred. The ruins also point to the role city institutions are forced to play in violence. Rather than conceive of cities as backdrops for war, terror, and displacement, urban spatiality is essential to organized political violence, both as organizational apparatuses and as enemy targets. Stephen Graham has observed that since the end of the Cold War, "the informal, 'asymmetric' or 'new' wars which tend to center on localized struggles over strategic urban sites have become the norm."[36] Structures like the Oslobođenje building demonstrate how "contemporary warfare and terror now largely boil down to contests over the spaces, symbols, meanings, support systems or power structures of cities and urban regions."[37] In this instance, the violent silencing of unwanted news reports could scarcely be more symbolically enacted or starkly physically represented.

Despite the symbolic power that sites marked by violence and the resultant destruction can wield, we should be aware of the limitations in relaying histories through single concrete locations. When a historic site is made to stand for some form of historic atrocity, a focus on physical location might mean that we miss much else of what was lost. That is, primary, authentic sites can struggle to communicate the status of nations – such as Cambodia or Rwanda – where the educational system, religious and cultural traditions, economy, social formations, and family structures were also leveled. To some degree (although this may not be always visible) the

stunted economic development, continued sporadic violence, preponderance of war-wounded, and everyday psychic malaise form visible symbols of the impact of war and genocide. These transient, occasional reminders are, in a sense, antithetical to the logic of the museum, which inhabits a zone of seclusion, typically standing outside the flow of daily city life. As enduring witnesses to history they symbolize timelessness; as sacred spaces they take people out of their normal surroundings in order to concentrate their thoughts on more elevated, cerebral ideas. By contrast, the day-to-day living out of traumatic events by unremarkable persons may represent the ultimate kind of invisibility.

HYBRID SITES, IRREGULAR USES

Of the institutional spaces converted into memorial museums, the most common is the former prison. These exist alongside their more frivolous relations – the dozens of entertainment-oriented prison museums, which include Clink Prison in London, Alcatraz in San Francisco, the Bridge of Sighs in Venice, and the Old Melbourne Gaol, to name but a few. Museums that commemorate political prisoners share with these attractions a focus on claustrophobia and harsh conditions, but generally refuse the drama of re-enactment that characterizes such places, instead focusing on contextual information. Tours of the Robben Island Museum, for instance, highlight the "elite" Section B (which contains Nelson Mandela's cell), and the museum decorates those of others differently to display the contrast in living conditions over the years – from the spartan, single blanket quarters all political prisoners endured until the 1970s, to the addition of beds and newspapers, and even a radio supplied after 1980. The size and physical condition of the cells provides a material and spatial dimension to visitors' indignation at apartheid injustice. Prison space is made appreciable at the Memorial of the Victims of Communism and Anti-Communist Resistance in Sighet in a different form. Beneath the original watchtower, the prison courtyard features a dozen or more naked sculpted bronze "prisoners" in various kinetic poses (Fig. 4.4). The visually arresting sculpture provides an embodied sense of scale to an otherwise barren, cold prison courtyard. The figures highlight the everyday anxious, wary movements of prisoners. By occupying a courtyard with non-disposable figures, the museum reinforces the permanence of the site's current interpretation. Its aesthetic historicization aims to nullify the possibility of its re-emergence as an active, violent site.

Knowing life as a political prisoner is obviously a difficult projection for those who never suffered. Once a prohibitive space is made accommodating as a tourist facility, other forms of identification (personal objects, photographs, and recorded testimony) are added to make the suffering of prisoners more readily available, giving the prison greater historical context and emotional texture. In one sense, then, the exhibition space can give voice to the – normally silent – "body in pain" that is central to all forms of violence and trauma. Yet there is something about the aestheticization of the prison-museum space that, in an uncanny way, relates to the psychic disturbance

Fig. 4.4. "Parade of the Sacrificed," by Aurel Vlad. Copyright the Memorial of the Victims of Communism and Anti-Communist Resistance, Sighet. Used with permission.

associated with incarceration itself.[38] As Annie Coombes has observed: "In many ways the structure of the exhibition space itself could be understood as a metonymic representation of traumatic memory. In other words our experience of the space and the display is primarily physical and profoundly disruptive. The threatening implausibility of the relative spatial registers of both cells and objects shakes our confidence in our own judgment."[39]

That is, the effect of constructing the imprisonment experience by forcing together alienating and empathetic objects and interpretive devices (that would never have coexisted while it was being used for punishment) may strike us as unnatural in a basic sense. In other words, can we, as visitors, reconcile the private, confined, and unimaginable pain associated with imprisonment and torture with the public historical "lesson" facilitated by curatorial "show-and-tell" techniques?

The prison-museum hybrid reawakens a connection that cultural historians have forged between the two historic entities.[40] The late eighteenth century saw the development of both the corrective surveillance developed within Jeremy Bentham's panopticon prison, and the disciplinary self-conduct encouraged by the newly public museum. In *Discipline and Punish*, Michael Foucault describes how the state used prisons to control persons by withdrawing them from the public gaze and by making them aware of their own constant surveillance. Prison architecture, he wrote, is "no

longer built simply to be seen … but to render visible those who are inside it; in more general terms, an architecture that would operate to transform individuals: to carry the effects of power right to them, to make it possible to know them, to alter them."[41] Developing this insight, Tony Bennett is interested in an associated display of power in those institutions he groups as forming the "exhibitionary complex." These include museums, expositions, fairs, arcades, and department stores, which relocate objects and bodies from enclosed, private spaces into open, public realms. Throngs of visitors in these spaces came to monitor their behavior in response to the glances, gazes, and stares of others out of a wish to view themselves in an ideal image of orderliness and refinement. As the didacticism of perfect, idealized objects was ideally matched by the exemplary behavior of persons in public museums, it was hoped that inferior classes (once allowed in the museum's front doors) might learn, through imitation, proper forms of appearance and comportment.[42] Prison inmates, of course, provided an allied lesson, through opposite means. Deprived of any objects of value and reduced to "bare life," prisoners were denied a civic identity. They instead provided a warning – generally envisaged by others rather than directly seen – about the perils of vice and immorality. Prisons remind "all who would enter, or even pass by, of the power of confinement to alter the spirit through material representation."[43] Museums, by contrast, offered all who entered the opportunity to raise their moral fiber through a rarified form of amusement.

In the contemporary prison-based memorial museum much of this logic is upturned. Visitors do not passively accede to the authority of the state by conceiving inmates as malevolent, as per the normal societal conception, but instead, in cases of political persecution, view them as the blameless victims of a malevolent state. Former inmates are narrated not as cautionary examples but instead as heroic martyrs. At both Robben Island and the Museum of Genocide Victims, Vilnius, where ex-inmates often serve as tour guides, this dynamic is further turned on its head. Unlike the valuable objects spotlighted in conventional museums, artifacts in the prison museum – generally desultory implements marked by want or violence – hardly inspire a sense of personal moral uplift. Instead, museum visitors will typically regulate their bodily comportment through feelings of spatial trepidation and deference to the memory of those who spent time there. In all of these ways, then, the commemorative prison museum speaks to the way that new cultural forces – specifically, the upsurge in the drive to commemorate and interest in sinister tourist attractions – remind us that the origins of prisons and museums were not formed as historical opposites per se, but as negative and positive instruments of governmental power.

Public parks share with museums and prisons a historical function as spaces of nineteenth-century social reform. Parks aimed to achieve "improvement" by immersing citizens in bucolic surrounds – and by bringing recreational behavior into view. They were developed as an antidote to street culture, and nature was seen, in the Romantic tradition, as an expression of divinity. If parks were designed as a refuge from the perils of base humanity – its conflict, squalor, and politics – it is a curious

historical reversal that sees two Eastern European cities creating parks as political graveyards. Budapest's Szoborpark ("Statue Park") opened in 1993 in a field near a highway in the southern part of the city. In 1991 the Cultural Committee of the Budapest Assembly had invited a tender around the question of "what is to be done with the statues?" The winner, architect Ákos Eleőd devised a scheme to be experienced as follows:

> The park is arranged in the form of a straight path, from which "figure-of-eight" walkways lead off (so that the wandering visitor will always return to the true path!), around which statues and monuments are displayed. In the centre of the park is a flowerbed in the form of a Soviet Star. Eventually, the path ends abruptly in a brick wall, representing the "dead end" which state socialism represented for Hungary: visitors have no choice but to walk back the way they have previously come.[44]

At Statue Park the sculptures are clustered close together to achieve a superfluity of ideological symbolism (Fig. 4.5). Vilnius's "Grutas Parkas" (also known as "Stalin World") is a similar sculpture garden that opened in 2001 in a wooded park. The tender put forth by the Lithuanian Ministry of Culture in 1998, for the establishment of an exposition of dismantled Soviet sculpture, was won by a local millionaire. Viliumas Malinauskas (who made his fortune canning mushrooms) designed and financed the park. A cattle-car marks the gateway to the numerous statues of Lenin and Stalin, which are surrounded by barbed wired and interspersed with guard towers. The relocation of city sculptures to a Budapest suburban field or a Lithuanian forest park has several effects. It banishes them from their "natural" habitat where they exerted significant ideological power. In doing so, it denies obvious rallying points for leftist political groups. At its time of opening – on April Fool's Day – Grutas Parkas spurred a fierce debate between its supporters and those who saw it as sacrilegious.[45] The almost comical repetition and proximity of figures within a landscape where they have little function (and risk being grown over) is an uncommonly effective distancing mechanism. Nonetheless, in the future it could also be perceived as a blatant form of reverse-propaganda. For these nations seeking to rebuild affiliations with Central and Western Europe, the parks serve as an expression of a very different brand of civility than that imagined by Victorian social reformers: as political artifacts are insolently intermingled with nature, visitors' sense of sophistication involves appreciating the irony associated with putting the past "out to pasture." Purpose-built political parks have, in these novel examples, become the way that inner cities can again be politically redeemed.

Along with prisons and parks, schools are another category of governmental site that have on occasion been transformed through atrocity. There is obviously a great degree of dissonance where places of killing are those closely associated with learning and virtue. Cambodia's Tuol Sleng was a well-regarded school before becoming a torture and killing center. A technical school campus in Murambi in southern Rwanda has emerged as a key locus for that nation's genocide memorialization. On

Fig. 4.5. Statue Park. Copyright Réthly Ákos, Statue Park, Budapest. Used with permission.

April 25, 1994, some 50,000 Tutsis were squeezed onto the campus where they had been advised to seek refuge. In just over a day virtually everyone gathered there was murdered.[46] Today the corpses are buried around the grounds in mass graves or lie in the classrooms covered in lime, awaiting burial. As a semi-sanctified space, strongly associated with innocence, the school is pointedly infused with symbolic meaning. We understand schools as semi-autonomous spaces, like museums, where we learn about history – not where it is itself violent enacted.

While we can describe the hybrid nature of museums in prisons, parks and schools within a common historical Victorian social reformist framework, other sites confound any such thematic continuities. Consider, for instance, the "Old Bridge" in Mostar, a historic town in Bosnia and Herzegovina. The twenty-meter-high, thirty-meter-long single-span bridge was built in 1566 by Ottoman architect Mimar Hajrudin, and is included on the UNESCO World Heritage List. After having linked the banks of Mostar for centuries, the Old Bridge was blown up by Croat forces in November 1993. As writer Predrag Matvejevic lamented:

> When a bridge is broken, there often remains, on one side or the other, a sort of stump. At first, it seemed to us that it had crumbled entirely with nothing left behind, taking with it a piece of the mountain, the stone towers on either side, lumps of Herzegovina's soil. We saw later, on both sides, real scars, alive and bleeding.[47]

The celebrated locus for the town's reconciliation has been the brick-by-brick restoration of the bridge, carried out between 1999 and 2004. Its restoration was lauded by the media for its practical and symbolic value, uniting the Catholic Croats on the west side of town, and Muslim Bosniaks on the east. The labor that went into unifying the ethnically divided city has itself been regarded as a productive force in the reconciliation process. In September 2005 the city decided to add another monument near the bridge. This would be a new symbol of unity, an icon that could be admired by Muslims, Croats, and Bosniaks alike. The eventual choice was quite remarkable: a statue of kung fu legend Bruce Lee! Supported by a grant from a German organization, the statue, cast in bronze and showing the martial arts master in a defensive fighting pose, has been modeled by a local sculptor and erected in the town square. Critically, Bruce Lee will be facing north, so as not to appear to be defending either side of town. A group of enthusiasts came up with the idea of honoring Bruce Lee in 2003, on the thirtieth anniversary of his death. Veselin Gatalo, leader of the Urban Movement Mostar organization, told Reuters that, "this will be a monument to universal justice that Mostar needs more than any other city I know."[48] As Gatalo explains, the late Chinese-American actor represents the virtues of justice, mastery, and honesty – and, critically, he is useful because he is decidedly not Muslim, Catholic, Jewish, or even European.[49] The basis for this peculiarly postmodern act of commemoration may be the problem of commemorating recent political disaster (where propitiation is key) through a bodily figure. The lack of contextual significance that a Bruce Lee monument possesses may form its own lament, in the way it suggests that few alternatives existed that would not sow renewed resentments in this fragile town.

While in the cases above the idea of taking responsibility for the memory of a contentious event is achieved by concretely locating memory "at home," this is often near-impossible for refugees, displaced peoples, and members of emigrant diasporas. A key example of such geographically detached commemoration is Hong Kong's "Pillar of Shame." As a counterpoint to the "Goddess of Democracy" statue (modeled on New York's Statue of Liberty) that became a well-known symbol of hope during the 1989 Tiananmen protest, the pillar commemorates the aftermath: the 500 to 1,000 (or more) pro-democracy protesters killed. The three-storey high conical bronze monument, designed by Danish sculptor Jens Galschiot, is covered with molded contorted faces and copper plates, on which are engraved slogans from the Tiananmen protest, images of protestors, and facts about contemporary human rights abuses in China. "The old cannot kill the young forever" reads its chief inscription. The pillar was erected in Victoria Park on June 4, 1997, but only after causing grave confrontation in the Hong Kong parliament, when around 40 percent of parliamentarians walked out after the majority voted to refuse to allow the pillar to be displayed publicly. The sculpture was later the centerpiece for a 50,000-person candlelight vigil, but after scuffles between students and police it was moved to Hong Kong University. The pillar remains perhaps the best-known symbol of protest against the suppression of freedom of expression in China. Its form has since been

duplicated by sculptors in Rome and Berlin, and has been transported through parts of Mexico and Brazil, making it a movable, reproducible, transnational rallying point for various human rights struggles.

MINIMALIST AESTHETICS

In one way, the grassroots, dissenting values attached to the "Pillar of Shame" arguably makes it an edifice of its age. Its form, however, shares more with tributary statuary. In the past two decades or so, there has emerged a distrust of majestic state monuments. In reaction to both right- and left-wing monumental statist aesthetics, a more skeptical visual language of size, scale, line, color, and weight has come to dominate new artist-competition style memorial projects. Memorial architecture has followed the path blazed by modern art: from works that spoke of human affairs, to those that presented us with scenes and shapes we had never encountered in order to have us contemplate the invented qualities of these new works. Modern artists and monument designers alike wanted works "that would not be *about* things in the world but would themselves *be* things in the world."[50] The current ideal is that subjects will physically engage with the form in order to arouse some sensory mode, rather than standing back to contemplate a semi-realistic representation.

The seminal example of this minimalist genre is probably Maya Lin's Vietnam Veterans Memorial. The design is based around two long reflective black granite walls sunk into the ground, the tops of which are flush with the earth behind them. The names of the 58,249 American casualties are inscribed in chronological order according to the year of their death. While it was derided by some as being explicitly ideological, by associating the efforts of servicemen with a "black ditch" or "gash of shame," most would agree that its success lies in the way it does not move the visitor in any particular direction – whether comfort, anger, or sadness. Given the distressing events they aim to evoke, the "slash" and "void" have perhaps unsurprisingly emerged as key symbolic forms in minimalist design. Daniel Libeskind is the architect most closely associated with this brand of minimalism. "Voids" and "shards" feature most notably in the Jewish Museum, Berlin (2001), the Imperial War Museum North, Manchester (2002), and in plans for New York's forthcoming Freedom Tower (2009). In this latter case, Libeskind proposes sections of the building that would leave parts of the pit exposed, to complement Michael Arad and Peter Walker's "Reflecting Absence" memorial. This memorial, based around two nine-meter-deep pools where the towers once stood, into which water would cascade from the edges, received a behind-the-scenes push from Maya Lin herself.[51] Her design also appears to have been influential in the design of Buenos Aires' *Parque de la Memoria* (2001). Its main feature, the forthcoming "Monument to the Victims of State Terror," is a sinuous fissure cut into and crisscrossing the fourteen-acre park that aims to express the "open wound" permeating Argentinean society.

Some standardization in the symbolization of atrocity has emerged. Those memorials geared towards "softer" themes of healing and forgiveness tend to use emblems

associated with the elements, suggesting a source of redemption greater than the mortals who perpetuated or suffered the act. Pools of water, beams or shafts of light, stone plinths, and an eternal flame are common, and share stylistic elements with memorials to the "conventional" world wars. Newer spaces are typically designed in ways that encourage more idiosyncratic metaphorical readings. The Oklahoma City Memorial, designed by Butzer Design Partnership, features an empty chair for each person killed. Evenly spaced, they each face a reflecting pool.[52] This design borrows from the convention of leaving seats empty at social gatherings to honor those absent, and from riderless horses at state funeral parades. More generally, it expresses themes of unfulfilled lives, people denied their place in the world, and, given that victims included children at a daycare center in the building, childhood innocence. A similar memorial at the 9/11 Pentagon Memorial Park will open in 2008. Its 184 cantilevered outdoor benches, each one inscribed with the name of a victim, will be lit from underneath to create a field of glowing light pools.

Although minimalism is traditionally associated with the avant-garde, it can also be seen, at least in the memorial field, as signaling a refuge from overtly political ideas about responsibility and blame. We can observe this in plans for the imminent $30 million Flight 93 Memorial to be constructed at the 9/11 crash site 130 kilometers from Pittsburgh. The winner of the design competition, Paul Murdoch, has divided the 890-hectare site, to be run by the National Park Service, into three sections. The "Tower of Voices," twenty-eight meters high (or ninety-three feet, chosen to match the flight number), will aid the visibility of the site from the road, and is to be filled with wind chimes. A semicircular arrangement of maple trees ("Crescent of Embrace") will blaze red each fall. (Some commentators expressed uproar at this design due to the symbolism of the Red Crescent – used on the national flags of Muslim nations like Turkey, Algeria, Pakistan, and Uzbekistan – forcing Murdoch to offer to make alterations. It is likely that critics sought a more triumphant memorial, given that Flight 93 was the only instance resembling "victory" on that morning.)[53] On the south end of that arc, a series of low black slate walls will shield the crash site ("Sacred Ground") from the public. The total design represents, according to Christopher Hawthorne, "Hallmark-card minimalism" for the way it attaches reassuring interpretation (such as the "Voices/Embrace/Sacred" themes) to a design that carries few concrete referents.[54] Predictably perhaps, the tenor of the names of the three sections of the memorial strongly suggest the site will delimit the possible interpretations of the event, instead upholding a message that is affirming and nationalist in orientation.

Other sites use representative spatial analogies to represent the social and cultural ruin wrought. The theme of loss – spanning possessions, culture, and people – is found in Berlin's cobblestone stretch called the Bebelplatz, where Nazi book burning took place in May 1933. On that site in 1995 Micha Ullman, an Israeli-born artist, created a small ground level window that looks into a subterranean white room lined with empty bookshelves. The 2,711 charcoal stone steles that form Berlin's Monument to the Murdered Jews of Europe aim to express, in a more abstract

manner, similar themes. Yet in this case it is not clear at whom a feeling of being trapped or uncomfortable, brought about by oppressive surfaces and unevenness in scale, is directed. Does it matter that the physical encounter produces a somewhat common experience among all who visit, despite critical differences in visitors' subject relation to the event? Stephen Greenblatt wrote about the entries for the competition for the memorial in the following way:

> It has become increasingly apparent that no design for a Berlin memorial to remember the millions of Jews killed by Nazis in the Holocaust will ever prove adequate to the immense symbolic weight it must carry, as numerous designs have been considered and discarded. Perhaps the best course at this point would be to leave the site of the proposed memorial at the heart of Berlin and of Germany empty, to abandon it to weeds and, in Hamlet's words, to let things rank and gross in nature possess it merely.[55]

Wariness about the way that memorial projects might reify or enshrine the memory of an event has turned some artists and critics in another direction: towards deliberately *not* building, or even destroying. At least one commentator expressed the view that leaving the World Trade Center's seven-storey pit of debris would best memorialize 9/11.[56] A submission for the memorial competition by artist Horst Hoheisel proposed blowing up the Brandenburg Gate, grinding its stone into dust, sprinkling the remains over the proposed site, and then covering the entire area with granite plates.[57] Hoheisel has a clear mistrust of the way that commemorative forms promise an assured, knowable position towards historical calamity. If, for Hoheisel, the event seizes him as dreadful, then his creative response will also reflect some similar negativity. While his proposal is unlikely to be taken seriously by those seeking some broadly accepted symbol of reconciliation, it is worth noting for the way it brings attention to the potential folly of assuming that a properly designed memorial can help us unlock and understand the past.

INTERIOR DIMENSIONS: INSIDE THE MEMORIAL MUSEUM

I will now move from reflections on the scale and texture of outdoor memorials to consider the ways that internal museum spaces shape interpretation. In an important article, Valerie Casey positions the "performing museum" as the successor to two preceding models: the "legislating museum" of the nineteenth century, which displayed paragons of aesthetic and intellectual excellence, and the twentieth-century "interpreting museum," where a range of techniques – from label text to docent tours – have aimed to explain and contextualize objects.[58] The emergence of the performing museum has come about from the confluence of two phenomena: a surge in memorialization (with its attendant focus on the expressive lives of ordinary people), and the spread and acceptance of more theatrical display techniques. Precisely because the high stakes associated with the topic and content of memorial museums can produce drama more effectively than other types of museums, they are

now at the forefront of this "performing museum" paradigm. Layered on top of traditional interpretive museum practices are theatrical tropes largely based on "reality effects." These include architectural styles that pointedly show the authenticity of the space through, for instance, exposed walls or glass floors that display archaeological finds, stage-set-like scenes and rooms (such as reconstructed officers' quarters or torture cells), and the use of personal testimony (where, using an audio device or video screens, a survivor virtually "accompanies" visitors as he or she moves through galleries).

In the performing museum, the total physical environment itself becomes the attraction. In a process analogous to the planning of a theater production – where play texts are selected, casts auditioned, sets designed, and lengthy rehearsals take place – museum objects are spatially arranged and decorated, placed in showcases and lit, and given explanatory panels and audio-visual augmentation before the show opens. Yuichiro Takahashi has explored this parallel by drawing attention to Richard Schechner's concept of "environmental theater" as a model for the visitor's exploration through museum exhibition space. Schechner's experiments in the late 1960s and 1970s were based around upsetting the unidirectional gaze which had the audience solely focused on the stage. Instead, he brought the set and actors in, around and behind the audience. Further, Schechner held performances on the streets and in nature. Properly three-dimensional staging and polyphonic articulations were intended to make audiences aware of their own bodies in space.[59]

Rather than viewing designed, curated museum space in a solely cognitive sense, as theatrical environments museums are as equally concerned with, as Barbara Kirshenblatt-Gimblett describes, the visceral, kinesthetic, haptic, and intimate qualities of bodily experience.[60] A richer appreciation of this physical dimension can help us to question the common insistence that memorial space is fundamentally about the representation and symbolization of events. This can be appreciated by returning to the case of Daniel Libeskind's use of architectural "voids" in the Jewish Museum, Berlin. For one critic, the voids represent "the tragic failure of the Enlightenment project, simultaneously with the memory of its human victims."[61] For another, the museum aims to "evoke and particularize an absence more than a presence: the unnamable of the voice of God, but also absence as an accusing form of presence of an incinerated culture and community, in whose cremation modernism was burned as well."[62] While not discrediting creative interpretive readings of space, it is important to note that this museum's affective power lies not just in ideas, but also in the experience of its awkward, foreign, claustrophobic spaces. The building's design is barely evident from the street, and its zigzag motif is difficult to grasp as a whole – even when one is in its midst. When the door is locked by a docent behind visitors in the thirty-meter-high "Holocaust void," the immediate impression is only of darkness and disorientation. As one's eyes adjust, the imprisoning effect of the concrete space becomes evident, and abjectly alienating. Outside the tall, empty, unheated space, lit only by a single high slit that gives no view of the sky, one can just hear the muffled sounds of the city outside, yet never well enough to feel reassured. All of this is felt in the body.

A useful analogy that illuminates the importance of sensory experience in the memorial museum is that of churchgoing. We can speculate that people attend not so much to learn information (such as details of scriptures), but because they wish to be in a total environment that rehearses and affirms a sense of being in place. Both memorial museums and churches make concrete the notion of sacred ground and bring people together (as a *congregation* perhaps) under a single topic of communion. (There are other related parallels: both teach in a moral tone, emphasizing our common propensity for grave sins and hideous acts toward others and advocate the need for ongoing self-examination). While the Durkheimian concept of "civil religion" is not new to the theorization of the museum visitor experience, it has largely been conceived in ways that relate to the broad social effect produced by mass communion. What now deserves attention is the slippery topic of an individual's quality of feeling that stems from being in a certain place, around others interested in exercising the same moral concern. An accent on the physical is in line with the idea, central to the study of trauma, that we remember not so much in a cognitive, declarative fashion, but in one that is bodily and sensory. This is especially pertinent when the themes related to us by memorial museums are those of physical discomfort, pain, and alienation.[63]

Psychoanalytic theories of trauma posit that those most affected by a catastrophe crave some experiential return to the event. This principle has also suggested to museum educators that in order for visitors to grapple with what others endured, the idea of an event must be "burned in." This phrase is Friedrich Nietzsche's: "'If something is to stay in memory it must be burned in: only that which never ceases to *hurt* stays in the memory' — this is a main clause of the oldest (unhappily also the most enduring) psychology on earth."[64] His observation is closely allied with the Freudian notion of "repetition-compulsion"; those working in memorial museums who follow it would suggest that an effective display would release in survivors a subconscious desire to return to the time in which the trauma occurred in order to mentally re-enact it. As Jenny Edkins has written:

> It is not just because the traumatic experience is so powerful that it is re-lived time and time again by survivors. It is because of the failure to allocate meaning to what happened. Trauma is not experienced as such — as an experience — when it occurs. Instead, in the words of war correspondent Michael Herr, it just stays "stored in the eyes."[65]

This observation might partly explain why 9/11 families reportedly crave in the forthcoming memorial museum a first-hand reconstruction of that day's events.[66] Following the demise of the contextual historicism of the International Freedom Center (discussed in the next chapter), consultants' new proposals were explicitly there-and-then:

> The notion is keep this as an immersive experience. You're in the moment experiencing it, in the way the 102 minutes unfolds as a book. You're in the Twin

Towers, you're in the White House. We're taking you to a number of rounds, and the air traffic control towers. We are very caught up in the chaos of it. It's not a chronology of 10:52 this, 10:58 that happened. It's much more episodic in the way that it unfolded as a chaotic jumble. And we want to tie all of these things directly back to these artifacts so that the voice, the anecdote, the oral history is tied directly to the object and directly to the experience.[67]

While it is possible that this re-enactment might eventually allow those most affected to assert mastery over what occurred, for others an immersive exhibition risks producing a cinematic attraction. As a theme discussed in museology more widely, the issue of the privileging of spectacle is one that holds special gravitas in memorial museums – although the trend is often referred to as the "Disneyfication" of museums, the pageantry found in memorial museums surely suggests the antithesis of "the happiest place on earth."

While the auratic artifact in the museum has always been capable of invoking a physical response in the visitor, what has changed is in the way we have seen "a de-materializing of the museum object as it perpetuates a selective semi-fictionalized account of the past that reflects cultural memory."[68] In other words, there is an increasing sense that the object is not so much the truth from an earlier time, as a prop in the larger dramatization of the story. Information and objects are valuable primarily in the staging of experience. This shift should not be underestimated: in this scheme, the object's importance diminishes – it is the interpreting visitor who becomes the museum's focus. The experience of how it feels and what it means to "be-in-place" is the museum's outcome rather than its by-product. Anyone who stands alone in a cell in Cambodia's Tuol Sleng is immediately aware of the creeping uneasiness of occupying the space (let alone touching anything); anyone who makes the trip to Russia's Perm-36 cannot help but feel the isolation and loneliness of the location. The preserved aftermath of these sites, where some original artifacts are maintained *in situ*, is itself a tactical effect that requires a willful dedication to keeping otherwise changeable sites static.

Of a museum's internal spatial tactics, perhaps the most conventional is the "walk-through" the chronological history from beginning to end. Beyond this, the possibilities are more interesting. The U.S. Holocaust Memorial Museum reworks this linear sequence by producing a sense of *in medias res*. A large disturbing photograph of around fifty corpses at Ohrdruf concentration camp is the first image visitors to the museum see. It aims to slightly mirror the shock experienced by American soldiers who initially encountered the camps. A different method of creating a dramatic spatial atmosphere is found at Budapest's Terrorháza, where one descends from the light of the street into dark basement cells, and from objective history into subjective terror:

> One enters the museum through a doorway embroidered with the similar insignia of both totalitarianisms … to the sound of solemn music interrupted occasionally by the clang of a prison door or the ranting of some demagogue,

one walks from the top of the building, through the last 60 years of Hungarian history, each floor illustrating some aspect of oppression – the fascist murder of Jews, the communist show trial of Cardinal Mindzenty, the starvation of the peasantry, the sudden liberating eruption of the 1956 Hungarian revolution, its suppression, the systematic round-up and punishment of the revolutionaries (including the execution of children), and the long banality of "goulash communism" under Janos Kadar's cynical dictatorship – until one reaches the lowest level of all. This is the cellar torture chambers, narrow cells with bare boards for beds, where the regime's victims were beaten, scalded, electrocuted, suffocated, drowned, and shot in their innocent thousands.[69]

The path begins with the mere suspicion of wrongdoing, triggered by the recorded "clang of the prison door." However, as visitors step into a slow-moving elevator and descend deep into the building, a three-minute video shows a guard explaining execution methods. Visitors then exit at the basement torture chambers, and their fears of what was overheard earlier are confirmed. The physical and emotional movement, in other words, is also from the head to the stomach.

Newly designed and appointed museums located in non-site-specific places are those that typically contrive a high degree of theatricality. Both Los Angeles' Museum of Tolerance and The Musée Mémorial pour la Paix in Caen rely heavily on creative *mise en scène* to enliven the imagination. The construction of an outdoor café representing 1930s' Berlin at the Museum of Tolerance has life-size mannequins seated against a gray backdrop (Fig. 4.6). Visitors hear the mannequins at the tables talking to one another, some expressing concern at the developing political situation, while others are nonchalant. At the Musée Mémorial pour la Paix, visitors to the Occupation-themed exhibition are greeted with a large board bearing the question: *40 million de collaborateurs ... 40 million de résistants?* In a fashion similar to the red-prejudiced/green-non-prejudiced doorways at the Museum of Tolerance (discussed further in Chapter 6), the museum neatly divides the gallery space into two corresponding parts of the divide, one dealing with collaboration, the other resistance. Visitors must choose one of the long gloomy hallways without knowing which is which. According to Yves Devraine, self-described "scenographer" of the Caen museum, "the impression is oppression."[70] He aims to produce a sensory experience that triggers memories, which, he believes, reside in the human subconscious, irrespective of one's proximity to the event – or even whether they one was alive at the time:

> I have always been tempted to call myself more a time-space producer than an "arranger-director," since I try, most of all, to relate the dynamics of the time to my own reflections. For example, maps are fixed, standard, static documents but I try to "stroll" within them, within a drawing to relive the times, moving along from one place to another, sometimes feeling the need to sit in a corner and "breathe" the smells of a given period – the beginnings of remembrance.[71]

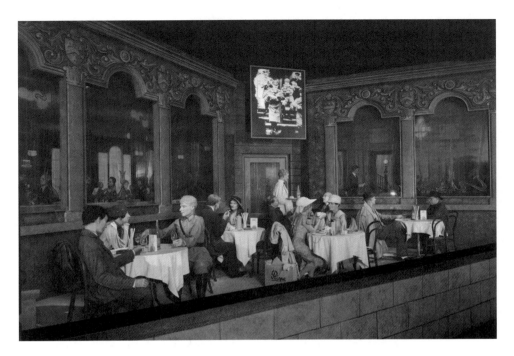

Fig. 4.6. Café Kranzler display at the Los Angeles Museum of Tolerance. Copyright Simon Wiesenthal Center. Used with permission.

The danger is that the insertion of objects into an obviously fabricated visual environment risks compromising their interpretation as *evidence* of atrocity, precisely because we associate drama with manipulation. The tactic whereby a sense of the political and social zeitgeist is produced through popular media – posters, films, songs, et cetera – from the period is enticing, given its immersive qualities. Yet they can also be misleading, warns Pierre Sorlin:

> General grief, grief about one's country, about a lost generation or a group of the dead is an abstract feeling, a representation in which things that people have seen or gone through can be subsumed. Reconstructing this grief is haphazard but it is documented by what people wanted to read, by the songs they wanted to sing and the films they wanted to watch. These sources have their limitation. They are imaginary products which reduce to a few images long hours of misery or struggle and offer a synthesis of tragic events all the more unreal in that it has been performed by professionals used to mimicking all sorts of emotions.[72]

Building on Sorlin, it appears that there are at least two key potential difficulties with this increasingly popular tactic. One is that an immersive *mise en scène* may be suitable chiefly when invoking situations where survivors no longer exist. The notion of creating a setting that relives a time seems unsuitable for those affected people who,

rather than seeking a secondhand experience, instead desire a place for personal recollection. Second, we wonder whether the production of performative spaces might produce a leveling of experience, where every experience becomes part of a predictable aesthetic scene of "negative histories." Might a growing willingness to make atrocities the subject of evocative visitor experiences see the memorial museum move in the direction of a morbid theme park?

CONCLUSION: UNCERTAIN TOPOGRAPHIES

Memorial museums operate against the conventional premise that we preserve markers of that which is glorious and destroy evidence of what is reviled. There is now a widespread sensibility that if events are to be remembered, they require a concrete locus for public attention. "Memory attaches itself to sites, whereas history attaches itself to events" wrote Pierre Nora.[73] We exist in a time when there is great confidence in the idea of physical locations as appropriate repositories for genuine local memory and as loci that will help others gain a tangible sense of an event. For those with first-hand knowledge of what transpired, this remembrance works on a sensory level: the reinstatement of a location can trigger memories not likely to emerge elsewhere. As Maurice Halbwachs wrote:

> ... every collective memory unfolds within a spatial framework. Now space is a reality that endures: Since our impressions rush by ... we can understand how we recapture the past only by understanding how it is, in effect, preserved by our physical surroundings. It is to space – the space we occupy, traverse, have continual access to, or can at any time reconstruct in thought and imagination – that we must turn our attention.[74]

Location affords not only the ability to picture the traumatic episode, but also to reawaken the feeling of an event triggered by ambient textures of sound, light, and smell. The notion of the memorial museum as a live sensory experience goes some way towards ameliorating the "crisis of reference" that nags suspiciously at the role of the object and the image discussed in the previous two chapters. It is, arguably, a sense of place – rather than objects or images – that gives form to our memories, and provides the coordinates for the imaginative reconstruction of the "memories" of those who visit memorial sites but never knew the event first-hand.

As various examples from this chapter demonstrate, urban sites are overlaid with histories piled upon histories and will inevitably change further. Museums, for their part, have typically supported temporal fixity. That is, the permanence associated with their vow to exist in perpetuity for future generations is one typically reserved not only for their collections: we generally assume that, once established, museums are a rare city institution that will stay in place. Yet we also know that museums themselves form valuable targets in acts of violence. Beginning in April 1992, Serbian attacks on Bosnian cities and towns deliberately and successfully targeted

national museums, libraries, and archives, in the process wiping out the larger part of the written history of Bosnia. In April 2003, a significant (but still unknown) portion of the National Museum of Iraq's 170,000 ancient artifacts was looted. Hence, along with more mundane occurrences such as deficiencies in funding, patron support, and building evictions, museums do disappear, as much as they momentously arrive, or linger little-noticed in the background. Along with certain monuments, historic houses, squares, parks, bridges, cemeteries, and street names, museums are markers that remind us of a range of questions about our personal relationship with the past: do we seek them out to aid remembering, or bypass them to enable forgetting? Do we embrace them as cornerstones of community, or isolate them as sections of tourist routes? Such questions suggest that the significance of memorial museums cannot be established *a priori*, but is decided through social attitudes towards them and the quality of the practices with which they are popularly associated.

This kind of phenomenological account of space can usefully draw on Michel de Certeau's distinction between *place* and *space* to consider the benefits and drawbacks of fixing memory at a particular site. In his reasoning, a place comprises an organization of things that is referential, static, and permanent. A space, by contrast, is identified when vectors of direction, cadence, and time are appreciated. In this distinction, the "place" of the city, for instance, is composed of buildings, streets, and parks, while the "space" of the city incorporates the movement of people, including the (difficult to quantify) summation of users' feelings and impressions. As Certeau puts it:

> Places are fragmentary and inward-turning histories, pasts that others are not allowed to read, accumulated times that can be unfolded but like stories held in reserve, remaining in an enigmatic state, symbolizations encysted in the pain or pleasure of the body. "I feel good here": the wellbeing under-expressed in the language it appears in like a fleeting glimmer is a spatial practice.[75]

Where place is defined in formal, stable terms, obeying "the law of property" that ascribes one function to any single location, space carries a variety of meanings awarded by multiple users.[76] His distinction between *maps,* as scientific representations of place that erase the itinerary that produced it, and *tours,* as an everyday narration of movement, also clarifies this distinction. Hence, we can see how memorial museums straddle two functions: on the one hand, they are unusually visible, vibrant, and unregulated locations in which visitors can "practice space" in their own idiosyncratic manner in casual outings with no fixed, determined structure. On the other hand, there remains a strong ritual component to visitation. Grave and often official impositions of meaning also firmly situate memorial museums as perpetual, reliable city spaces, perhaps as functional as any other. Hence, memorial museums are especially interesting in the way they seek to support a wide, open-ended variety of practices in visitors, yet also aim to make some authoritative statement about where and

how to remember the past. They will continue to remain interesting and controversial spaces precisely because they uncommonly represent structures associated with serious historical narratives and institutional permanence, yet also offer a personal freedom of response, interpretation, and use.

5 A DIPLOMATIC ASSIGNMENT: THE POLITICAL FORTUNES OF MEMORIAL MUSEUMS

THE FREEDOM CENTER AND ITS ENEMIES

In August 2005, while one day poring over details of the dispersed global field of memorial museums at the core of this book, I unexpectedly found many of them referenced by front-page headlines at New York's newsstands. "Making a Mockery of Ground Zero" decried one.[1] "Another Insult to America's Heritage at Freedom Center," another chimed in.[2] The story concerned the political deliberations surrounding the International Freedom Center (IFC), which was to be the museum component of the World Trade Center Memorial. Over 28,000 square meters the IFC planned to "focus on the historic stories of freedom that help to give context and definition to the attacks. Stories of New York City, America, and the world, will, in different ways, explore the architecture of a free and open society – probing the question, what makes for a free country and why does it matter?"[3] While details are scarce, proposed exhibits included a large mural of Iraqi voters (scrapped in favor of less provocative photographs of Martin Luther King Jr. and Lyndon Johnson). Documentary films would tell the stories of, "a recent immigrant kitchen worker that tells of the lure of economic freedom in the U.S.," "a successful African-American bond trader whose background is linked to the Civil Rights movement of the 1960s," and "a Russian immigrant whose family fled Stalin."[4] The scheme was that "the memorial to the victims will be the heart of the site, the IFC will be the brain." Planners envisaged the IFC as the "magnet" for the world's "great leaders, thinkers, and activists" to participate in lectures and symposiums that examine "the foundation of free and open societies."[5]

The hot topic for the media was the advice the IFC sought from an organization called the International Coalition of Historic Site Museums of Conscience. Founded in 1999, some of its members include District Six Museum, South Africa; Memoria Abierta, Argentina; Gulag Museum at Perm-36, Russia; the Terezin Memorial, Czech Republic; the Liberation War Museum, Bangladesh; and the Maison des Esclaves, Senegal.[6] Supported by several non-profit groups including the Ford Foundation, the Rockefeller Foundation, the Open Society Institute, and The Trust for Mutual Understanding, the Coalition aims to aid activists and museum professionals in using historic sites to highlight human rights issues. In July 2003, representatives from the Coalition began meeting with the IFC, the Lower Manhattan Development Corporation, and Studio Daniel Libeskind. The choice quotes at the center of the newspaper stories were taken from the proceedings of the Coalition's 2004

conference at Terezin Memorial, where members drafted the following response to IFC plans:

> The Freedom Center is a caricature of the typical American response to everything (telling every story from an American viewpoint). The World Trade Center was attacked because it was a symbol of power and influence. In building the Freedom Tower, the U.S. reasserts its power in an arrogant way: Does this mean the U.S. will not only build the biggest building, but also define freedom for the world? The concept of freedom has some limits… . it seems that whatever Americans want, Americans get! Is the definition of the "struggle for freedom" simply defined by the victors, or also by those engaged in ongoing struggles? Will Americans *really* create a balanced vision of freedom?[7]

The most publicized of the Coalition's advice for the IFC was the simple statement: "Don't put America first." Also widely derided was a quote from Sarwar Ali, Coalition chair and trustee of the Liberation War Museum, that due to charges of racial profiling following the 9/11 attacks, "the average Bangladeshi feels that his/her human rights have been violated by the U.S." Writing in *The Wall Street Journal*, Debra Burlingame, a board member of the World Trade Center Memorial Foundation (and the sister of a 9/11 pilot) met the Coalition head on:

> The so-called lessons of September 11 should not be force-fed by ideologues hoping to use the memorial site as nothing more than a powerful visual aid to promote their agenda. Instead of exhibits and symposiums about Internationalism and Global Policy we should hear the story of the courageous young firefighter whose body, cut in half, was found with his legs entwined around the body of a woman. Recovery personnel concluded that because of their positions, the young firefighter was carrying her.[8]

Following an intense period of objection from a range of critics, in August 2005 the 22,000 member-strong Firefighters Union announced its withdrawal from the Memorial Foundation due to objections over the "politicization" of the IFC. Following criticism from former Mayor Giuliani, Governor Pataki stated his own objections: "We will not tolerate anything on that site that denigrates America, denigrates New York or freedom or denigrates the sacrifice and courage that the heroes showed on September 11."[9] Senator Clinton soon added her own opposition.[10] After months of steady and rising criticism, Pataki announced the eviction of the proposed IFC from the site.[11] With that, the museum declared itself out of business. The World Trade Center Memorial Foundation has since been left in limbo, struggling with both the form and content of the replacement museum, and with raising the anticipated US$510 million dollars needed for the memorial and museum (which would make it the most expensive memorial project ever).[12]

Two primary questions are raised by this commotion: in commemorating distressing events, what is the primary story to be told? Who should be authorized to tell it? Should the story be one of personal loss that binds groups like "9/11 Families

for a Safe and Strong America" and the Firefighter and Police Unions who, out of sad circumstance, have an unparalleled political purchase? Or should the storytellers be those who dedicate their professional lives to the story of human rights struggles against all forms of tyranny? Although these two "sides" are largely talking past one another – the IFC and its Coalition advisors were responding to a mandate to build a museum around the theme of freedom; the families of those who died sought assurance that their relatives would be commemorated in a permanent public home – it seems that the inevitable overflow of passions in this situation forgoes a middle ground that could adhere the public and private. I begin with this case because, amongst ongoing deliberations over the site, it is useful to consider all existing memorial museums not as predestined and stable, but as the result of particular power struggles. Furthermore, political and economic factors are not resolved by an institution's creation, but instead continue to pose considerable challenges. Such dynamics are the subject of this chapter. Given the impossibility of detailing the ambitions, confrontations, concessions, and defeats that background every case in this book, I will instead highlight a handful of examples that illustrate political predicaments especially pertinent to memorial museums.

MUSEUMS IN A POLITICAL MINEFIELD

Few commemorative projects remain as politically thorny as those related to the Argentinean Dirty War. During the process of exhumation, which began in 1982 when forensic experts uncovered about 400 unidentified bodies, the public became, according to Antonius Robben, "mesmerized" by almost daily discoveries. The revelation that those who had disappeared were actually dead was devastating.

> The meaning of the exhumations underwent a considerable development after October 1982, and the social memory construction of the dirty war changed along with it. The repeated shocks of disclosure at the turn of 1983, the 1984 proof of births in captivity, the 1985 establishment of guilt, and finally the positive identification of the victims of repression, saturated the exhumations with meanings that had diverse political consequences and contested the validity of several competing discourses about the past.[13]

While human rights organizations and many Argentineans saw the forensic identification of those killed as a positive development, the Madres de Plaza de Mayo felt ambivalent about the exhumations on the grounds that it might "settle" the memory of the Dirty War. As former leader Hebe de Bonafini declared,

> Many want the wound to dry so that we will forget. We want it to continue bleeding, because this is the only way that one continues to have strength to fight ... But, above all, it is necessary that this wound bleeds so that the assassins will be condemned, as they deserve, and that what has happened will not happen again.[14]

The group suspected that the exhumations were part of a government scheme to set in motion a mourning process that would eventually achieve the demobilization and depoliticization of relatives and other protesters.[15] Nevertheless, in January 2006, after about 25 years and 1,500 Thursdays, the Madres decided to march for the last time, after the group reached a consensus that the government was finally ready to properly seek justice. The initiative to create a "Museum of Memory" at Buenos Aires' ESMA Navy Mechanical School has recently received government backing. At a ceremony on March 23, 2006, President Néstor Kirchner unveiled a plaque that promised *"Never again coups and state terrorism."* "Sectors of society, the press, the church, the political class, also had their role," as did "powerful economic interests," Kirchner declared, speaking just outside ESMA. "Not all of them have acknowledged their responsibility for those facts."[16] Kirchner also asked for a pardon for the state for "the shame of having hidden so many atrocities during 20 years of democracy." He was followed on the platform by Juan Cabandié, who revealed that he was one of those born in the ESMA cells, seized by the military, and given to new parents. He affirmed that, "in recent years our society has reached a turning point. A new framework has opened up within which it is possible to revise history. People are beginning to come together, to think as a collective."[17]

Critically, Kirchner made his speech surrounded not just by human rights leaders, but also the military high command. That very month the press revealed that the naval intelligence agency has continued to spy on public officials, journalists, and political leaders, including Defense Minister Nilda Garré, who had days before ordered that all military archives from the Dirty War period be opened, and Kirchner himself. Two admirals, one of whom was director of naval intelligence, were fired and all its activities were suspended pending a complete investigation. Meanwhile, as "never again" posters were pasted around the city to mark the Dirty War's thirtieth anniversary, Argentina's Congress passed a bill that makes March 24 (the date of the coup that ushered in the dictatorship) a holiday called the National Day of Memory for Truth and Justice. June 2006 also saw the beginning of the first trial in twenty years of a former member of the junta's security forces, after the Supreme Court struck down amnesty laws in 2005. These acts have ignited the passions of Kirchner's supporters and opponents alike. Many Argentineans marched or held commemorative vigils during that month, while a few congregated outside the homes of former military officials, at which they heaved eggs, rocks, sticks, and containers of paint. Additionally, a small bomb exploded at a Ford car dealership. This act was politically loaded, since Ford supplied the Falcon, a car that became the feared symbol of state security forces. The Ford Corporation is also being sued by a group of former employees who were labor leaders, who accuse the company of cooperating with state security in having them kidnapped from the plant floor and illegally detained. At the other end of the political spectrum, the city of Córdoba (a stronghold of death squads during the dictatorship) saw masked men break into the home of a leader of the Abuelas (grandmothers) de Plaza de Mayo. After beating her the intruders made clicking sounds, as if holding a gun to her head and pulling the trigger.[18] In this

troubled context, the opening of the ESMA Museum of Memory and other allied commemorative practices is a form of historical intervention, staged within the lifetime of those responsible. It forces citizens, politicians, and military leaders alike to take a stance on the degree of openness they can bear in "digging up the past," and, as such, provides a test of the state of Argentina's democracy.

Although current international law holds the state responsible for enforcing human rights standards, a good deal of human rights literature makes a case for the vital role of civil society, and NGOs in particular, in promoting awareness of human rights. The detachment of NGOs from the state and from justice mechanisms like truth commissions is particularly important in societies that are in transition, having recently emerged from conflict. NGOs are invaluable in cases where the state fails to establish and promote sites of social rehabilitation, due perhaps to political pressures or the felt need to promote stability over justice and reconciliation. This is evident, for example, in the situation surrounding the commemoration of Chilean disappearances under the Pinochet regime. Upon the release of the report of the Chilean Truth and Reconciliation Commission (which detailed the fates of 2,920 victims) President Aylwin, who succeeded Pinochet in 1989, stated that "for the good of Chile, we should look toward the future that unites us more than to the past which separates us." He added that to work toward consolidating a future democracy was better than "to waste our energy in scrutinizing wounds that are irremediable."[19] This official caginess may partly account for the low visibility of Chile's memorials. Teresa Meade has observed that although Villa Grimaldi Park of Peace and the Memorial for the Disappeared at Santiago General Cemetery are open to the public, neither tourists nor most residents would learn much from either visit without a knowledgeable guide. Meade views this situation as a careful balancing act; the current government has fulfilled a basic responsibility to remember the memory of victims without going further to open up the brutal details of the regime. The memorial markers at Villa Grimaldi are informative, but relatively discreet. Among the flowers and sculptures are brick plaques that name the various points of torture, such as prison cubicles, electric torture rooms, and bathrooms. The next step – increasing the visibility of the sites through more visceral objects or explanatory textual or audio-visual material – would move toward assigning blame to the Pinochet government, which is still a tentative prospect in Chile.[20]

Pedro Matta, who was himself tortured at Villa Grimaldi, has been particularly instrumental in locating former prisoners and DINA (secret police) collaborators since the early 1990s. With the assistance of groups like the Agrupación de Familiares de Ejecutados Políticos (Association of Relatives of the Executed Political Prisoners) and Agrupación de Familiares de Detenidos Desaparecidos (Association of Relatives of the Detained-Disappeared), he has reconstructed the day-to-day functioning of Villa Grimaldi during its period as a torture center. In the debates over the site's future, he was the chief proponent for its preservation as it was found after the dictatorship (other favored having it rebuilt to its time of functioning as a torture center, or having it leveled altogether to be replaced by a bucolic park).[21] In 1998, when

several human rights groups added to the site a "Wall of Names" of 226 Chileans killed there, no government representatives attended its dedication. Matta, in response, stated that any officials would be unwelcome at the event, since it would be "unacceptable, incongruent, and inconsequential" for them to attend while at the same time refusing to allow Pinochet to be tried in Spain for crimes against humanity.[22]

The Bangladesh Liberation War Museum, created by eight key scholars, and now sustained by volunteer community workers, is also testament to the value of NGOs. The museum has a strong collection of about 14,500 war-related objects and draws significant visitor numbers. It remains somewhat insecure in terms of its political backing; the museum receives a token government grant, but otherwise relies on sponsorship from international, extra-governmental organizations.[23] Without the resources to undertake and publish original research on the war and its consequences, the museum seeks to bolster its authority from other institutional quarters. It recently called for the publication of academic studies by international scholars "to help build a national consensus on the ideals of the Liberation War," and to "throw light on genocide in Bangladesh and also on how a predominantly Muslim country fought to uphold their national cultural identity and establish secularism as a state principle."[24] Working within a political environment where the government has been accused of failing to confront the nation's recent tide of Islamic extremism, the museum has assumed a pedagogic role. Rather than simply celebrating Islam as a unifying force, as it could in earlier times, the museum increasingly positions itself as an educational bulwark against the growing threat of Islamic terrorism that targets religious minorities and secular intellectuals and politicians and threatens to upset the nation's fragile political situation. By focusing attention on the sacrifice of those who died in 1971 and the common language and culture that formed the basis of the new nation, the museum aims to prevent a new wave of sectarian violence.

Due perhaps to the power of their provocative exhibition content, an often-overlooked aspect of memorial museums is their work as centers for research, fact-finding, and legal justice. Each summer for the past decade, gulag survivors and public historians have met at Sighet where they have added to the history of communist repression in Romania. They have so far published at least forty-five monographs and memoirs and 3,000 oral history tapes of interviews with former victims.[25] Similar activities are being pursued by The Aegis Trust, an NGO operated out of the Holocaust Centre in the UK, which has become a key body in the documentation and memorialization of Rwandan genocide. The Aegis Trust aims to create links between local politicians, aid workers dealing with the social and psychological consequences of genocide, academics that document and analyze it, and members of the public who seek answers. In January 2004 the Aegis Trust's data acquisition team went door to door. They interviewed 2,573 people, identified 4,522 families in which members were victims, the names of 17,970 victims, the location of 466 mass graves (each typically containing between 20 and 30 bodies), the sites of 887 roadblocks within Kigali, and they scanned 1,261 photographs lent by the families of victims.[26]

This work is being conducted against a background of uneven judicial process. While advances are being made in prosecuting genocidal leaders through the Rwandan National Court system, and (since 2001) through the informal Gacaca village justice program (where an interactive court is presided over by judges who are untrained citizens, resulting in swifter, less costly justice), the work of the U.N. International Criminal Tribunal for Rwanda has been dogged by a lack of cooperation from the incumbent President Kagame government. This is unsurprising, given chief U.N. tribunal prosecutor Carla Del Ponte's determination to try current officers in Kagame's Rwandan Patriotic Army for reprisal killings committed during the 1994 civil war. Within such an environment, NGO documentation is valuable because it can be held and published independently of government. The Aegis Trust's efforts exist in a precious space free from the Rwandan Patriotic Front government's increasing crackdown on dissent, which has included "outlawing ethnicity": six-week re-education camp programs aimed at purging Hutus of any ethnic ideologies harbored from 1994 have been established; reference to ethnicity has been removed from schoolbooks, government identity cards, and all official documentation; the country's newspapers and radio stations, tightly controlled by the government, also eschew the labels.[27] A new crime of "divisionism," which includes provocative speech about ethnicity, means that most Rwandans will shy away from engaging in truthful public discussion about the genocide. An NGO like the Aegis Trust provides a forum for dialogue freed from direct government prohibition.

The Documentation Center of Cambodia (DC-Cam) is another politically independent body working closely with memorial sites. In November 2005 DC-Cam brought twenty-five Khmer Rouge operatives and twenty-five who suffered through the genocide to Tuol Sleng and Choeung Ek. They initially traveled in two separate buses, stayed at separate hotels, and visited the sites separately. Gradually brought together, by the end of the three-day journey some of the participants had shared their experiences, exchanged apologies and absolution, and prayed for the dead. Others found the intense and unknown psychological terrain of this exchange more difficult. It remains to be seen what effect this kind of exercise has for the individuals involved, and for wider society if other projects like it follow.[28] Memorial museums can only support reconciliation if they operate under political conditions that lead to understanding rather than ongoing recrimination and conflict. One procedure that may help Cambodia (where 99 percent of the survivors of the DK years reported almost starving to death, 96 percent said they had been forced into slave labor, 90 percent said that a family member or friend had been killed, and 54 percent said they had been tortured) is the political trial of former leaders.[29] After a decade of little cooperation from Prime Minister Hun Sen, who back-pedaled on financial commitments to the tribunal and disparaged human rights groups that challenged Phnom Penh's choice of judges for the war-crimes trial, in July 2007 the Cambodian–U.N. genocide tribunal finally began its work. Khang Khek Ieu (Duch), who was in charge of Tuol Sleng prison, was the first to face charges. It remains to be seen whether the level of justice sought (Hun Sen only wants the top surviving leaders to face trial) will

fulfill the desire for justice, and whether, given the opportunity, many Cambodians will themselves provide testimonies in the trial.

At present, Tuol Sleng and Choeung Ek are arguably more closely tied to Cambodia's nascent tourist industry than to its hesitant reconciliation. On my visit several years ago, it was difficult to predict whether it was the US$2 entry fee, the (work) time needed to travel to the site, or its felt lack of relevance that meant that few locals visited. If talk of genocide as a tourist spectacle has so far been muted, this may change with the recent sale of Choeung Ek. In May 2005 a deal was announced that would privatize the "killing field," handing it over to a joint Cambodian-Japanese venture for development (after having previously been owned by the Phnom Penh Municipality). JC Royal, which has been given a thirty-year management lease starting at US$15,000 a year, has pledged to beautify the site, conduct tours, pave the entry road, build a visitors' center, museum, and documentary film studio – and to raise admission by 600 percent. The company stands eventually to earn about US$18,000 a month in entrance fees.[30] While the 51 percent Cambodian-owned company has announced that it will turn over all profits to charity, the sole charity nominated is the Sun Fund. One man, Chea Vandeth, is chief secretary of Hun Sen's cabinet, the chairman of JC Royal, *and* the secretary-general of the obscure Sun Fund, which is not registered and has no office. In a show of unity, all of Cambodia's newspapers have condemned the deal, and several senior government officials have asked Hun Sen to intervene.[31] Nevertheless, the deal has gone ahead. "This is the memory of the nation. It doesn't belong to city hall. It belongs to the survivors," said Youk Chhang, director of DC-Cam. Similarly, the site's former manager has accused the government of "using the bones of the dead to make business."[32] Both resist the potential reinterpretation of these histories by those with little concern for mourning and healing.

Coming from a different angle, it may not be self-evident that the construction of a memorial museum is the most effective allocation of resources for the purpose of reconciliation. A forthcoming memorial museum located in an industrial site that saw a momentous disaster provides a key case for considering this point. In 1984, the Union Carbide pesticide factory in Bhopal, India, saw forty tonnes of methyl isocyanate burst from a holding tank. The gases injured somewhere between 200,000 and 500,000 and eventually killed more than 22,000 people, making it the worst industrial disaster ever. In 2005 the Madhya Pradesh provincial government's Environmental Planning and Coordination Organisation prepared a competition for a memorial museum. This was won by a team of five Delhi-based architects, whose design shares much with the counter-monumental style described in the previous chapter (indeed, the architects pointedly contrast it with India Gate – the archetypal First World War memorial pictured in Figure 1.1).[33] The design plans to encase the machine sections of the Union Carbide plant in a two-storey glass "transparent envelope" that will allow viewers to peer in on life-size figurines (created by local artists) working at the factory controls. Visitors will pass this in situ scene as they move through an underground tunnel featuring interpretive displays about the tragedy,

culminating with a space the architects call "ground zero" (a point below the methyl isocyanate plant of the factory). Moving outside, visitors can then explore an ecological park spread over several hectares, which features a network of themed pathways and cycling routes. The landscaping of the area will be symbolically inhabited with plant species used in "phytoremediation" (a mechanism where living plants alter the chemical composition of the soil in which they are growing).[34]

The Madhya Pradesh government's pledge to spend close to Rs 100 crore (about US$22 million) to construct this complex has upset those who see a memorial as a secondary priority. The Bhopal Group for Information and Action (an NGO working with victims of the disaster) has angrily questioned why a museum is necessary when the government still fails to meet the medical and economic needs of the gas victims. The group is appalled that the government has moved forward with these plans without first cleaning up 200 metric tonnes of toxic waste still remaining at the site. Other activists, while not disputing the need for a memorial, feel it should be on a more modest scale, and that the committee of gas victims created to advise on the memorial museum should actually be consulted.[35] (This situation is mirrored, albeit in a slighter way, by the dissonance felt by many over news reports since 9/11 that simultaneously update New Yorkers on the World Trade Center Memorial and disclose illnesses caused by downtown air toxicity.) Given the unfeasibility of hard evidence that memorial museums represent an optimal use of resources, might their current proliferation one day look like misallocated folly? Can there be any equation – social, financial, or philosophical – that can solve the tension between the pressing needs of the comparative few directly injured and those of the large but much less affected tourist audience? Further, if the memorial museum takes aim at the perpetrators (in this case the American Union Carbide Corporation and its chairman, who has been charged by Indian courts with culpable homicide and declared an "absconding offender") is the slim sense of symbolic justice that a memorial museum might produce any substitute for legal accountability? If a display of recrimination resulted in fewer tourists visiting the site (some Americans, for instance), would the memorial museum remain economically viable and locally supported? These questions are in one way endemic to the precarious situation that ensues when developing nations create "attractions" with international tourist dollars in mind; in situations where those local conditions carry the persistent weight of collective anger and hurt, the stakes are that much higher.

As the above cases suggest, "reconciliation," while sometimes deployed as an uncritical catchall, can have distinct public and private meanings in the "exit" from a disastrous event or regime. It refers equally to the governmental, public tasks of social cohesion and nation rebuilding, and to the private need to mourn the dead, and to reflect on questions that are bitter, difficult, and divisive. As we might expect, these processes are seldom seamless or harmonious. The kind of critical remembrance that memorial museums offer may be incompatible with the realpolitik associated with a government's desire for citizens to move beyond an event. The memorial museum's concrete location and its advertised roster of temporary exhibitions,

anniversary events, and public programs may periodically refocus public attention on the disaster, and perhaps on old resentments. Alternatively, the incorporation of an event that otherwise threatens to rear its head with inopportunity into a single institution may have the effect of sectioning it off into a public quarter that supports predictable, institutionalized social remembrance. Many museums receive the "arm's length" style of state support, wherein some funding is provided, but the institution is not an official government cultural project, and has no state representation on its board. This arrangement is especially useful for politicians looking to win political currency by making a publicized visit; he or she is seen to be paying respect, while leaving any controversies or mistakes with the institution.

THE POLITICAL REORGANIZATION OF MEMORY IN EASTERN EUROPE

The late 1980s' "Autumn of Nations" in Central and Eastern Europe marked a turning point in recent world history that remains undecided in scale and significance. The fall of communism has raised important questions about to whom that now largely disowned history belongs, and how it may be reincorporated or rejected by former Eastern bloc nations. As they have endeavored to deal with a history of "dual repression," first at the hands of the Nazis and then under various communist regimes, uncertainty towards sites that honor "communist martyrdom" has been common. While starkly ideological monuments might be destroyed, what about those dedicated to Second World War soldiers, who, by exhibiting some aspect of partisan or anti-Nazi activity, are remembered as communist heroes?[36] How can a city or national government treat these objects and places in ways that provide a desired distance from the past without effacing it altogether? While certain sites, such as plazas containing statues and monuments, or buildings such as party headquarters or prisons, can form suitable staging points for commemoration, the actual process by which they are reinscribed is seldom straightforward or obvious. Key cases in point are the German Democratic Republic (GDR) era monuments that remember casualties of the Nazi regime (and credit communism with its downfall). Almost every East German town had an Opfer des Faschismus (Victims of Fascism) square or street. After the demise of the GDR, these lost their ideological footing and social relevance; in a reunified Germany, there was understandable anxiety about being able to distinguish authentic sites of Nazi crime from the ideological staging of commemoration.[37]

A new museum that offers a different, frivolous, postmodern form of remembrance is the GDR Museum Berlin opened in July 2006. Aiming to capture the feel of everyday life during the communist era, it chiefly exhibits popular culture productions, newspaper reports, and everyday locally manufactured consumer items from the period, from snacks to condoms. The museum is set to capitalize on the growing nostalgia for GDR life amongst young East Germans who associate it with bygone childhood. Books, films, specialty shops, design styles, and retro parties also contribute to this trend for which there is a neologism: "ostalgie" (from nostalgia and

"ost" – east). One gallery details with wry affection the Trabant, the small car that sums up the pleasures of East German consumerism. Another re-creates a typical standard-issue East German apartment living room that showcases a slightly spare mimicry of Western pleasures. Hidden in the mock-up of the apartment are several microphones. In this facsimile of private space, visitors' comments are broadcast, unknown, to an opposite corner of the museum where others can listen in using headphones underneath a photograph of Erich Honecker, former GDR leader.

A more solemn memorial museum devoted to the theme of surveillance is housed nearby in a huge cinder block building, once the Stasi headquarters. A few rooms in the Stasi Museum (opened in 1999) have been preserved in their drab bureaucratic 1960s' styling. Exhibitions detail how the paranoid Politburo employed some 190,000 intelligence officers who, remarkably, oversaw 1.5 million informers (meaning that every seventh adult was filing reports on friends and colleagues). Many of the spy tactics displayed are bizarre: visitors can see carefully labeled jars apparently containing the sweat scent of suspects; officers would wipe the underarms or groins of suspects with cloth to be stored in the jars, ready to be later dangled before a tracking dog. Also on display are special phones that tapped every long distance call and could automatically record conversations when special keywords were mentioned. If such displays support the dark humor sometimes attached to the GDR era, the nearby Hohenschönhausen Memorial (1994) eschews any such levity. Housed in the main remand prison for people detained by the Stasi, visitors are able to tour the museum's interrogation center. Accompanied by guides who were all once political prisoners there, visitors are shown torture instruments, tiny cells that barely allowed prisoners to stand, and the rows of subterranean water-torture cells dubbed "the U-boat."

Various observers have described how, against analyses that take for granted the utility and benefits of using memorials to "work through" difficult pasts, local people are often more interested in practical current political and economic progress. In Romania in the early post-communist period, for instance, there was a concerted effort to erase the physical traces of communism; little effort was made to salvage material artifacts. Statues of Ceausescu were toppled, factory banners praising him were removed, and the names of both individual streets and whole settlements were changed.[38] The irony, however, is that disastrous events and political failure have emerged as a key to economic revitalization through tourism. Since the early 1990s Western European and American tourists who have flocked in large numbers to former communist nations, particularly seek out examples of unfamiliar communist political arrangements and living conditions. Duncan Light notes that "as Romanian political life is increasingly dominated by the discourse of greater integration with Western Europe, 'communist heritage' tourism has the converse effect of emphasising how Romania's recent history has been different from that of Western Europe."[39] In those Romanian efforts to reopen the history of the period, a thick network of contemporary political motives has come to bear. Sighet's Memorial of the Victims of Communism and of the Resistance was created by private individuals: Ana

Blandiana and her husband Romulus Rusan. During the Iliescu era, neither financial nor political support was forthcoming from the crypto-communist government. Instead, Blandiana and Rusan turned to the Council of Europe for partial funding, along with Romanians in exile and Western universities. This arrangement saw the government charge the couple with "selling to the foreigners the pain of the Romanians," in an attempt to turn public opinion against the project.[40] Others have pointed to the idea that the museum's strident anti-communist focus deliberately deflects attention from the progress made in bringing to light Romania's participation in the Holocaust.[41] The museum has been criticized on the grounds that it has favorably revised the role of Iron Guard militants and other Romanian fascists and anti-Semites by suggesting that, following the war, they were themselves early *victims* of the new communist state.[42] Against the political bent of the museum, recently departed leftist Prime Minister Adrian Nastase recommended avoiding opening the postwar period to the historical scrutiny sought by the museum. "Anti-communism is obsolete," he said, adding that, "graves should be left in peace."[43] Clearly the museum exists in an environment where its fortunes are linked to swings of political power. While the new Liberal Party leadership is more amenable to the museum's message, it may be that it will take many years, until those once attached to the Communist Party have passed, for the museum to be able to exercise the investigative freedom it desires.

A comparable set of political machinations can be seen in the case of Budapest's Terrorháza (Fig. 5.1). Although the museum drew queues several hours long its 2002 opening year, some harbored reservations about its success: there was a concern particularly among Hungary's Jewish population that many were coming for the wrong reasons. A charged right-wing atmosphere had spread through Hungary under Viktor Orbán's rise to power in 1998. Some worried that the museum provided young fascists the chance to admire, under dramatic lighting, the uniforms, accoutrements, and ideologies of the pro-Nazi Arrow Cross Party. As part of his strident anti-communist campaign, Orbán took every chance to remind the public of the opposition socialist party's affinity with communism. At the museum's opening, Orbán stated that Hungary had "slammed the door on the sick twentieth century."[44] As evidence of the political motives associated with the museum, detractors point to its accelerated development, which, at Orbán's behest, was created in just eighteen months and opened in an incomplete state six weeks ahead of the 2002 elections. Once inside the museum, some felt that the more distant crimes of the Arrow Cross Party had not been subjected to the same glare as those that occurred under communism. This was partly a matter of spatial proportion: communist-era material outstrips that of the fascist period by a ratio of roughly five to one. Further, of the nearly two-dozen rooms devoted to Nazism and communism, only one explicitly concerns the Holocaust.

The dueling histories of repression of the fascist and communist eras are closely tied to contemporary political battles. Right-wing groups make a connection between the prominent role of Jews in the "wilderness years" of postwar communist

Figure 5.1 Exterior of Terrorháza, Budapest. Copyright Jan Ainali. Released to the public domain.

Hungary, and the current Socialist Party. Jews are concerned at the idea that Hungary is being re-imagined as a Nazi victim rather than accomplice, which they feel continues a trend by right-wing historians to whitewash the Arrow Cross Party's role in the death of some 550,000 Hungarian Jews. The right-wing media has intensified this point by pressing the issue of compensation: why should one group deserve recompense for the Nazi Holocaust when other Hungarians would not receive the same under the "communist Holocaust?" Terrorháza's "Wall of Victimizers" display, comprised of a grid of photographs of former leaders, is particularly thorny in the way it singles out perpetrators, some of whom are still alive. After Orbán's narrow election defeat in 2002, the Socialist government was inevitably uncomfortable with this display, since many of those depicted were once members of (or connected to) the Hungarian Communist Party. Mária Schmidt, the museum's director (and a close advisor to Orbán) has remained steadfast over the display, albeit in a diplomatic way: "We considered this issue very carefully. We are prepared for any litigation concerning privacy rights. The perpetrators will have to prepare to answer for their deeds. But if the courts say take the pictures down, we will."[45] At other times, she has been more strident. Faced with the new government's threat to cut the museum's funding, Schmidt threatened to suspend from the building's awning giant inflated

figures of the communist parents of current government ministers. The government quickly backed down, since the threat may have reminded the public that earlier that year Prime Minister Peter Medgyessy had resigned after admitting that he once served as a counterespionage spy for the Communist Party secret service.[46] Since 2004, his Socialist Party successor, Ferenc Gyurcsány, has made a conspicuous effort to counter-claim Terrorháza as a symbolic meeting point for anti-fascist demonstrations. In October 2004 25,000 people, including most members of the government, marched to Terrorháza to mark the sixtieth anniversary of the coming to power of the Arrow Cross regime, and to counter a planned march by the neo-Nazi Hungarian Future Group. (In response, Orbán lamented that the government had turned "the sad anniversary of the Szálasi [Arrow Cross] coup into a propaganda tool".)[47] Right-wing groups, meanwhile, claimed their own historical counter-symbol by marching to the monumental statue in Budapest's District V for Soviet soldiers killed while liberating the city.

This statue is one that escaped being hauled from the city to the suburban *Szoborpark* ("Statue Park"). Created in 1993 to house over forty communist-era icons, the attraction draws around 30,000 visitors per year.[48] The heaping of these together in one place is a rare third way for dealing with unwanted historical symbols that cannot be mobilized in a positive didactic direction (in contrast to various Eastern European memorial museums housed in former prisons, for instance), and those (such as the Führerbunker in Berlin, or the Branch Davidian compound in Waco, Texas) that have been largely erased, since they "cannot be culturally rehabilitated, and thus resist incorporation into the national imaginary."[49] The effect of gathering the statues in a deliberately peripheral, artificial space denies them their former sense of command and risibly devalues them – a tactic that acknowledges that outright obliteration conveys a fear that what is violently repressed can return. Statue Park designer Ákos Eleőd stated: "I had to realize that if I used more direct, more drastic, more timely devices for constructing the park – as many people expected – that is, if I had built a counter-propaganda park out of these propaganda statues, then I would be following the prescribed ways of thinking we inherited from the dictatorship."[50] Eleőd raises a critical point: in nations that have come to associate memorials and museums with outright propaganda, new explicit counter-propaganda structures or spaces may be cynically perceived as only the latest chapter in the seemingly endless drama of historical rewriting.

A different kind of forest of ruins can be found at Führerhauptquartier Wolfsschanze ("Wolf's Lair") in northern Poland. The vast complex that formed Hitler's major eastern front military headquarters was severely damaged by the demolitions carried out during the German retreat (it was considered too valuable to leave for the Russians). Moss-covered and grown over by trees, its immense thirty-foot-thick concrete blocks lie in the forest in a fashion that recalls Percy Shelley's *Ozymandias*: "'Look on my Works ye Mighty, and despair!' / Nothing beside remains. Round the decay / Of that colossal Wreck, boundless and bare." While earlier recognized as a significant site, it was only in the early 1990s that it was preserved and

developed. Each year around 250,000 sightseers come to explore the ruins (although it was feared that it might become a lure for neo-Nazis, very few come, according to site guides).[51] As a tourist facility, Wolf's Lair has been co-developed by an Austrian and a Polish company, who appear more concerned with profit than measured historical interpretation. Visitors can stay in a hotel in former officers' quarters, lease part of the site for weddings, purchase from a gift shop and, on occasion, dance until 2 a.m. at a nightclub named "Hitler's Bunker."[52] More solemnly, a small monument was added in 1992 to commemorate the assassination attempt made on July 20, 1944 by twenty army officers, led by Claus von Stauffenberg, using an explosive-filled briefcase placed under a wooden table in a Wolf's Lair meeting room. Also evocative, then, are the ruins of Wolf's Lair's cinema, where Hitler watched the filmed trial and execution of these men. When in 1992 the developers also removed from the site two murals erected by a former Polish communist government that graphically depicted Germans killing Poles, members of the Polish press were outraged, charging that the site was being sanitized for German tourists.[53]

As Germany has increasingly come to confront its own historical guilt, it has also implicitly come to assert a proprietary right over this responsibility. In July 2004, Germans commemorating the sixtieth anniversary of Hitler's assassination attempt added their own additional monument to Wolf's Lair (then-Chancellor Gerhard Schröder also laid a wreath at the spot in Berlin where the conspirators were executed). At the dedication of the assassination attempt monument, the German embassy's social attaché expressed concern about the larger attraction: "The monument is not the problem. But the ambassador has heard about other plans. The worst plans were for a restaurant with waitresses wearing uniforms of the SS. He expressed doubts about this, and hopes it won't go in that direction."[54] Clearly, the Germans and Poles have different notions of what proper commemoration on the site might look like. The German approach appears more consistent with conventional heritage ideals of education and sustainability. Yet, with their horrific Second World War depredations in mind, who would deny the Polish the prerogative to develop the attraction as they wish? Who wouldn't take some pleasure from the image of Polish club-goers dancing on the ruins of the Nazi Party leadership?

Hitler's legacy has spawned a small cultural industry, consisting of countless best-selling books, historical documentaries, tourist sites, and high-profile media stories. In the UK, 2005 alone saw a number of spectacles: Prince Harry wore a Nazi uniform to a party; Mayor Ken Livingstone was suspended for comparing a Jewish reporter to a concentration camp guard; author David Irving was brought before Austrian courts for Holocaust denial. That each of these made newspaper headlines suggests that the signifying details of Nazism and the Holocaust are by now entrenched in public consciousness. During the development of Berlin's Memorial to the Murdered Jews of Europe, scandal broke when a detail of the Holocaust resurfaced in an unforeseen, unfortunate manner. In October 2003 construction was halted after the story broke that the parent company of Degussa AG, the company supplying anti-graffiti protection for the memorial's pillars, had provided the Zyklon

B hydrogen cyanide pellets used in Nazi extermination camps. For many board members, the association made Degussa's participation untenable (even though the company was open about its past, having paid into a Holocaust reparations fund). Degussa was ruled to have made restitution for its past actions, and the coating was eventually used.[55] The matter was especially provocative for several reasons, not least of which is the memorial's location, situated just off-center of the site of the former Führerbunker. Zyklon B gas is also a visceral reminder of exactly how Jews were killed (amid a memorial that, some claim, distracts attention from the specifics of German actions). The controversy was also timely since it occurred at a time when Germans are looking further than the senior Nazi leadership for culpability. Support provided by industry is an increasingly prominent topic for historians. Indeed, in summer 2005 Berlin's Jewish Museum hosted a special exhibition on Topf & Sons – the builders of the ovens for Auschwitz, Dachau, Mauthausen-Gusen, and Buchenwald. That the manufacturers of both the ovens and of Zyklon-B are now associated with commemoration both indirectly (in the case of those who lay tributes at the concentration camp ovens) and directly (in the case of Degussa's involvement in Berlin's Memorial) shows how, in many cases, remembrance relies on, as much as it repudiates, the apparatuses of perpetrators.

My final European case explores how the creation of a new memorial museum complex can reignite attention to an area otherwise assumed as having been left for dead. In July 2005 the town of Srebrenica, still marked by ruined buildings ridden with bullet holes, high unemployment, and very little economic activity, was the meeting point for tens of thousands who wished to commemorate the tenth anniversary of the Srebrenica massacre, which saw the death of some 8,100 Bosniak men and boys. They planned to bury the 610 bodies found in hillside mass graves at the new Potočari Memorial Center, which serves primarily as a cemetery, but also has a small museum attached. The ceremony was a major nationally televised event. As the bodies were transported in refrigerated trucks from a morgue in Visoko towards Srebrenica, they passed through Sarajevo where 60,000 people had gathered on the streets to watch. While a new memorial site promises eventual reconciliation, it can also form a likely target for those who want to resist any such appeasement. Six days before the ceremonies, Bosnian Serb police found two large bombs containing 35 kg of explosives at the Memorial Center.[56]

The creation of the Potočari Memorial Center has aided the process of human repopulation of the region as survivors have moved back to rebury their kin.[57] About 35,000 people fled the town in 1995, leaving only 20,000 residents, most of them internally displaced persons. While Serbs are drifting back, only a handful of Bosniak families have been able to return to their homes in Serb-dominated Srebrenica. In the past five years more than 4,000 Bosniaks have applied unsuccessfully to Republika Srpska housing authorities, which cited security as grounds for denial. Serb authorities have added to existing tensions by announcing that it intended to create a separate memorial cemetery specifically for Serb victims of the war in the village of Kravica, ten miles from Srebrenica. Republika Srpska authorities deny that this

initiative is a premeditated provocation, but instead only wish to emphasize that Serbs were also war casualties. The village of Kravica, however, is another site where around 1,000 Bosniaks were reportedly killed.[58] Hence, these cemetery memorials are symbolic sites around which particularly severe processes of human geography – of annihilation, escape, displacement, and alienation – revolve. The hamlet of Potočari, the utterly disastrous base for the U.N. "safe zone," may promise reconciliation and commemoration yet it has already witnessed the threat of terrorism and an official disinclination towards Bosniak resettlement. It remains to be seen whether the region can support commemorative practices that defy the ongoing atmosphere of fear and intimidation. If it succeeds, it might provide Bosniaks with a concrete symbol of their moral basis for resettlement.

MEMORIALIZATION AND STATESMANSHIP

While the cases noted in the previous section describe some of the domestic conflict that can emerge from the reanimation of troublesome histories in memorial museums, this section will explore some conflicts they re-energize between nations. The contentiousness of the memorial museum is typically shaped by the prevailing attitudes towards the event in question in their home nation. Has the nation made a decisive break from the conditions of the event depicted by the museum, or do they linger? At one end of the spectrum there are pasts widely considered as settled. In this context where a historic break is made, the memorial museum can represent triumph over adversity; the struggle is vindicated by the eventual beneficial outcome. Such museums – I have in mind the District Six Museum or the Hiroshima Peace Memorial Museum – can be characterized as *offering lessons*. At the other end of the spectrum there are nations where elements of the violence being represented by memorial museums are felt to continue to threaten (such as the various 9/11 memorials or the Potočari Memorial Center). In these situations, where the museum exists in the midst of the event's ongoing repercussions, they can be characterized as staging an intervention. In an area in between, there exist a variety of "unmastered pasts" in nations like China, Cambodia, Rwanda, Armenia, Argentina, and Chile. Working with the premise that a painful history cannot remain safely buried for fear it might re-emerge in politically catastrophic ways, museums in these nations aim to establish the visibility and veracity of the event, and might be characterized as bringing to light.[59] It is this last category on which I will focus in this section.

The Nanjing Massacre is a prime symbol of an "unmastered past." The official apology and reparations sought by China and the continuing Japanese denial of the massacre continue to impact on Sino-Japanese diplomatic relations very strongly. Nearly 84 percent of some 100,000 Chinese surveyed in 1996 chose this event when asked what they associate most with Japan.[60] Beyond its obvious documentation and censure at the Nanjing Massacre Memorial Museum, other aspects of this disaccord in the museum sphere can be found. For instance, in March 1996 Nagasaki's mayor ordered its Atomic Bomb Museum to remove text and graphic photographs that

made reference, although minimally, to the massacre. The demands came at first from conservative city councilors, but soon gained greater political influence, until the prime minister himself instructed the foreign and education ministries to investigate whether all photographs depicting Japanese military aggression in the nation's museums were real or fabricated.[61] This act is consistent with the way that the Hiroshima and Nagasaki Peace Memorial Museums have largely detached the atomic bomb from any discussion of Japanese aggression in Asia and the Pacific. As Giamo Benedict wrote: "in forgetting the causes and conditions of total war, a new kind of Japanese exceptionalism – atomic victimization – is split off from its inherent connection to Japanese wartime aggression. In tandem, the vivid recollections and glaring omissions display a disturbing form of dissociation that defines the myth of the vanquished."[62]

This stance is made explicit in a very different form of war memorial – the Yasukuni Shrine. Founded in 1869 by order of the Maiji Emperor, over a ten-hectare complex the shrine is dedicated to the worship of the "divine spirits" of those who died for the Japanese empire. After Japan's surrender, the U.S. Occupation Authorities ordered Yasukuni to become either a secular government institution or a religious institution autonomous of the Japanese government. Yasukuni chose the latter, and has remained privately funded since. Included in the shrine's "Book of Souls" are the names, dates, sites of death, and native birthplaces of nearly 2.5 million Japanese and former colonial soldiers killed in war between 1853 and 1945. Controversially, 1,068 convicted war criminals are included. More shocking was the shrine's decision in 1978 belatedly to add to the book the names of executed wartime Prime Minister Hideki Tojo and thirteen other Class A war criminals.

The shrine's message becomes starker when we consider that it contains the largest museum of Japanese history, the Yūshūkan. Shut down after 1945, it was reopened in 1986, and has since been noted for its blatant historical revisionism. A documentary-style video shown to visitors narrates Japan's conquest of East Asia in the Second World War as an effort to save the region from the coming Western advance. Displays deny events such as the Nanjing Massacre and systematically portray Japan as a potential victim of Western imperialist plans. In the question-and-answer section of its website (also reproduced on a pamphlet available at the shrine) visitors read that, "War is truly sorrowful. Yet to maintain the independence and peace of the nation and for the prosperity of all of Asia, Japan was forced into conflict." Gifts from Burma's Ne Win and Indonesia's Sukarno are displayed in the museum to reinforce this idea of Asian unity. Further down the webpage the museum states: "There were also 1,068 'Martyrs of Showa' who were cruelly and unjustly tried as war criminals by a sham-like tribunal of the Allied forces (United States, England, the Netherlands, China, and others). These martyrs are also the Kami [deities] of Yasukuni Jinja."[63]

While two of his predecessors made one-off visits to the shrine after 1978, it is recent Prime Minister Junichiro Koizumi who made a point of visiting annually. Some attribute his visits to personal sentimentality, while others identify a wider resurgence of jingoistic nationalism and militarism.[64] In China, North and South

Korea, Taiwan, and other nations that were the victims of Japanese militarism, the shrine is seen as the symbolic center of Japanese right-wing nationalism. China and South Korea have demanded that, at the least, Class A criminals should be removed and enshrined in a separate place. Yet since church and state are constitutionally separated, the Japanese government cannot require the shrine to do so. Moreover, Yasukuni officials are adamant that once a kami has been merged into the shrine, it cannot be alienated. The tension between politicized historical interpretation and respect for local Shinto rites is encapsulated by the opinion of a young priest at the site. In conversation with Ian Buruma he stated:

> The thing is, as soon as you bring historians in, you run into problems, you get distortions. As a shrine, we must think of the feelings of the spirits and their families. We must keep them happy. That is why historians would cause problems. Take the so-called war of invasion, which was actually a war of survival. We wouldn't want families to feel we are worshipping the spirits of men who fought a war of invasion.[65]

The challenge to conventional academic values, wherein the appeal to popular sentiment is privileged over historical accuracy and political blame, is, in a sense, a traditional feature of conventional world war-style memorials. While the incorporation of a history museum within the compound of a religious site encourages a view of history as the aggregated losses of men's spirits, the growing trend elsewhere wherein museums act as loci for national self-criticism throws the stubbornness of this example into vivid relief.

In the face of this obduracy, foreign museums can form external critiques. A little-known but critical example is the Unit 731 Memorial Museum (2001). Located in the city of Harbin in northeast China, once part of the former puppet state of Manchukuo, the museum commemorates the more than 10,000 Chinese prisoners directly killed by Japanese wartime medical experiments, and another 300,000 who died from the biological weapons produced. This was one of a number of units used by the Imperial Japanese Army for the development of biological weapons. At the time it was the world's largest germ warfare complex, boasting over 150 buildings and a staff of 10,000.[66] It now consists of the remains of structures such as rat breeding facilities and laboratories for the production of anthrax, cholera, and bubonic plague. Although the Japanese destroyed much material evidence from the site, around 1,200 items were dug up prior to opening. Displayed in the Exhibition Hall are surgical knives and saws, pieces of incinerators and incubators, and germ-loaded shells. In rooms off long gray narrow corridors with high ceilings, life-size plaster cast models are shown writhing in pain on tables after being injected or cut open without anesthetics by military doctors. Photographs and newspaper stories also provide evidence, while a short film features interviews with Japanese soldiers confessing to what they remember. A souvenir shop sells postcards and roughly translated English copies of textbooks that detail the macabre history. That the museum has a limited collection of the doctors' medical records is itself a potential political flashpoint: the doctors

responsible remained unpunished after the war (many going on to take respectable positions) after the U.S.A. cut the Japanese officers a deal: immunity from prosecution for war crimes in exchange for the experimental data.[67] The Japanese government denied the existence of Unit 731 until 1998, and still maintains that it has no evidence of specific wrongdoings. In 2002 three judges of the Tokyo District Court rejected a claim for an apology and compensation brought by 180 Chinese survivors and casualties' family members.[68] In situations where justice is not forthcoming, memorial museums appear an extra-legal way to gain international attention. China is currently seeking UNESCO World Heritage protection for the Unit 731 site.[69] By mid-2007 its management plans to triple the size of the museum and to add a peace park at a cost of around US$6 million.

The attainment of UNESCO protection would help to spotlight the case and add weight to the push for further trials and compensation. Since 1978, over 800 sites have been added to UNESCO's World Heritage List. Since World Heritage Convention guidelines were amended in 1992 to include culturally important landscapes, thirty-six have been listed on these grounds. Those memorial museums in this book to gain protection include the Island of Gorée (added in 1978), Elmina Slave Castle, Ghana (1979), Auschwitz Concentration Camp (1979), the Hiroshima Peace Memorial (1996), and Robben Island (1999). The benefits of being listed lie not so much in day-to-day conservation (the World Heritage List's annual operating budget of US$4 million means virtually nothing is apportioned to the sites themselves). However, being listed raises a site's media profile, which in turn enables it to bolster its tourist profile.[70] It is this effect that then raises the likelihood of conservation support from other sources. (This somewhat incongruous dynamic is aptly captured by the two signs that greet tourists to Auschwitz: one declares it a World Heritage Site; the other advises to beware of pickpockets.) Yet an elevated international profile can also cause constraints. As Harriet Deacon notes:

> Proclaiming sites of "intangible" heritage by defining their symbolic meaning is a kind of branding. To create a symbolic brand for a heritage site, one has to come up with a simple statement that encapsulates as well as simplifies what is often a complex set of meanings associated with a site. This branding process then influences how we interpret the site and how we manage it. Branding is a feature of all heritage work, to some extent, because the heritage industry is selling something for a particular purpose and from a particular perspective.[71]

Of course, the influx of money into a local area does not itself guarantee either the sound conservation of a site (where increased private investment and admission fees might provide funds for research and preservation), or its careless ruin (as is often feared when non-site-specific infrastructure such as airports and hotels are added). While the idea of supporting culturally significant historic sites has, in recent years, gained favor, there exists within UNESCO wariness about the way it might require the body to self-consciously enter the political realm, particularly as it could create conflict between UNESCO member and non-member nations. At the World

Heritage Council meeting of 1999 it was even proposed that restrictions on dedicating culturally symbolic sites on their own merits be dropped, and that a separate Convention be formed.[72] However, in 2004 the International Council on Monuments and Sites (ICOMOS), which offers advice to UNESCO, reiterated the importance of cultural landscapes through the Natchitoches Declaration.[73] Yet both ICOMOS and UNESCO prefer to frame the cultural or historical aspect in terms of its transformative effect on natural landscapes (hence the primary inclusion of sites of slavery and the atomic bomb). There is less certainty about whether landscapes or sites should be added simply because of the weight of human actions they witnessed.

In 2004 the European Union urged Turkey to consider registering Akhtamar Island for nomination for UNESCO's World Heritage List. The Turkish government has recently promised US$1.5 million to fund the restoration of the tenth-century Holy Cross Armenian Church, which dominates Akhtamar Island off the southern shore of Lake Van. Its bullet-scarred sandstone façade, featuring vivid reliefs of birds, animals, saints, and warriors, will be restored to its original state. The church fell into ruin after the 1915 genocide and stood for decades as a potent symbol of that annihilation, and the abysmal relations between Armenians and the Turkish Republic, which has wholesale rejected the Armenian genocide claim. Turkey has maintained that the number of victims claimed by Armenians is greatly inflated, and that those killed were regular casualties of the First World War. Yet the Holy Cross Church project has been interpreted as a glimpse of a new openness to the topic in Turkey. At the same time, the fact remains that the church, once the spiritual focus for a huge number of Armenian Christians, now has virtually none left to worship in it. Compared to most post-genocide groups who have been able to commemorate their histories on the land where it occurred, Armenians stand out. The restoration may be simply instrumental: the island is Turkish territory, and its redevelopment will serve that nation's tourist economy. Further, the Holy Cross Armenian Church restoration can be viewed as a diplomatic display by those who seek the nation's inclusion in the European Union.[74] France, Russia, Poland, and Germany are among fifteen nations that recognize that Armenian genocide did occur, and pressure Turkey to follow suit. The U.S.A. is not one of these countries. In 2000, President Clinton shook some members of Congress by asking the Speaker of the House to withdraw a bill that would have officially recognized the Armenian slaughter as "genocide." The reason, it seems, lies with American strategic interests in the Middle East, where Turkey forms a key ally.[75] In the face of such political reticence, a more successful attempt to assert the Armenian agenda in Washington, DC, may come in the form of the Armenian Genocide Museum and Memorial, which recently secured a site two blocks east of the White House. It is to be housed in a 1925 building, remodeled at a cost (to be obtained through donations) of around US$100 million.[76] The museum, which will be the largest outside Armenia devoted to the genocide, may represent a diplomatic solution for the American government: it remains a private endeavor, yet gains a veneer of official support due to its Mall location.

If these commemorative projects represent interventions in the ongoing diplomatic "cold war" between the Turks and Armenians, a "hotter" form of museum politics relates to the ongoing Palestine-Israel conflict. In September 2005 various newspapers reported Hamas plans to convert a synagogue in Netzarim in the Gaza Strip, firebombed and partially destroyed, into a temporary weapons museum. A statement issued by Hamas said, "Qassam rockets and other locally made arms will be exposed, since it is the legal weapon that evicted the occupation forces."[77] On display were stones, rockets, instruments used in suicide bombings, and tools for excavating tunnels through which weapons were secreted. The museum was an attempt by Hamas to take sole credit for the Israeli withdrawal from Gaza, and in doing so, to raise its profile before the January 2006 Palestinian election. The responsibilities of government that came with Hamas's stunning electoral victory may temper such an overt ideological statement and cause the Netzarim weapons museum to be dismantled. Equally likely perhaps is that the museum might become a permanent victory monument for as long as the new Hamas government rules.

If this stridently antagonistic tactic only confirmed the callousness of Palestinian extremists, it was striking, then, that Israel suffered its own museum public relations disaster at the same time. In early 2006 news emerged that the site for the planned Simon Wiesenthal Center Museum of Human Dignity in Jerusalem was to be built on an ancient Muslim graveyard. The Maamam Allah cemetery had been in use for at least 1,000 years until the creation of Israel in 1948. The site then served as a parking lot for Independence Park until ground was broken and Governor Arnold Schwarzenegger laid the cornerstone for the Frank Gehry-designed US$150 million museum. A diplomatic war ensued: the removal of 250 skeletons to storage boxes (and the alleged smashing of a skull) drew protest from Palestinians. Charles Levine, spokesman for the new museum, accused Palestinian and Muslim groups of exploiting the issue for political gain. The Simon Wiesenthal Center claimed that permission for its work was granted by an 1894 ruling by the Sharia Court that allowed for the sanctity of the cemetery to be lifted.[78] Adnan Husseini, Director of the Islamic Waqf, avowed that if it were a Jewish rather than a Muslim cemetery, the project would have been canceled immediately.[79] A Muslim cleric brought the issue before the Israeli Supreme Court, which has ordered a temporary halt to work. On initial consideration, the chosen site might be interpreted as an attempt to suppress other histories in order to further consolidate Zionist geography (in line with observations that the location of Jerusalem's military cemetery and Yad Vashem on Mount Herzl serve to mythologize the creation of modern Israel). Yet a Museum of Human Dignity, if it will share much with the Los Angeles Museum of Tolerance, would place the Holocaust among other examples of historical persecution, perhaps dampening its exclusivity (and it might even make reference to the "Palestinian question"). Reports so far suggest that it may not exist harmoniously alongside Yad Vashem. Representatives have stated that another Holocaust museum is unnecessary in Jerusalem, especially one founded by a group with its headquarters in the U.S.A.[80] The idea of an

American-based institution repackaging the Holocaust and presenting it alongside Yad Vashem is undoubtedly galling to many.

My final example concerning the political uses of the museum is overtly internationalist in scope. Washington, DC's forthcoming International Victims of Communism Memorial and Museum showcases how politicized commemoration can be problematic when the institution is not based on the needs of a local constituency. Late 2006 will see the completion of a memorial statue on Capitol Hill on land managed by the National Park Service (the museum is to follow in the next few years). The Mall has emerged as the location par excellence for the honoring through symbols the birth and death of grand political moments. At this juncture, the main rationale driving the museum appears to be the correction of historical imbalance. The major clause in the 1993 legislation behind its creation cites the gross number of casualties attributed to communism – at least 100 million, alongside a belief that "communism may be forgotten as international communism and its imperial bases continue to collapse and crumble."[81] As Richard Pipes, who serves on the Foundation's advisory board, put it:

> People are quite aware of what the Nazis did, but they are not aware of what the Communists did. There is a general sort of presumption, particularly among intellectuals, that, "Oh, Communism was a good idea that didn't work out so well." But in terms of human casualties, what went on in Russia and China is outrageous. It's appalling. And I think this kind of memorial will make people aware of it.[82]

Beyond this theme of historical inequity, the political inferences of this memorial and museum are less clear. The Victims of Communism Foundation's monument – a replica of the "Goddess of Democracy" statue raised and crushed in the Tiananmen massacre (which formed the basis for Hong Kong's "Pillar of Shame") – may simply come across as another monument to American democracy on the Mall. Other figures on the Foundation's drawing board for sculptural representation included barbed wire and watchtowers to symbolize the gulags, boats to represent Vietnamese "boat people," a replica of a section of the Berlin Wall, and a field of skulls to represent Cambodian genocide. While it may have been felt that none of these were sufficiently international in their connotation, any one of these at least conjures a site-specific disaster. The current design communicates an uncertain message; it only minimally mourns those killed, and instead appears to wallow in American triumph and moral righteousness.

At which audience is the proposed museum directed? Might it serve as a commemorative space for immigrants (and tourists) from communist and former communist nations? Alternatively, might its location on Capitol Hill – the nerve center for the Cold War campaign – see it stand as a tribute to American governmental gamesmanship? At this juncture in world affairs, might it have the ideological intent of discrediting remaining communist and leftist states? Or, given its position on the Mall, might it serve to bring dishonor to anti-capitalist or anarchic rallies? Will it aim

to remind youthful and future generations of the dangers of dabbling in leftist politics? Lee Edwards, chair of the Foundation has stated that "we want to keep this in the public mind, and borrowing from our Jewish friends, say: 'Never again.'"[83] Will communism replace Nazism as the cautionary "greatest evil," providing a refreshed perspective through which Americans can cherish national values? What is unclear at this point is whether the museum will have greater use-value beyond the principle that its topic "deserves" historical representation. Aside from the museum's intentions, another point of inquiry is whether communism is a suitable umbrella under which to group a strikingly wide variety of experiences across nations and cultures. Was life under Stalin similar to that under Cambodia's DK regime? If no epoch, region, place, language, religion, ethnicity, or set of local circumstances binds these disparate experiences, does state ideology remain a productive super-category? This is not to deny the conclusion drawn from looking back at the largely disastrous outcomes of twentieth-century communism. Rather, I am asking if this museum might flatten these experiences better represented in local contexts? The key issue lies with the way that the idiom of commemoration ("victims of ...") is used to frame what may well turn out to be a largely conventional, nation-affirming (cold) war museum.

CONCLUSION: THE POLITICS OF HISTORICAL SYMBOLIZATION

In his influential *Sites of Memory, Sites of Mourning*, Jay Winter writes that memorials "were built as places where people could mourn. And be seen to mourn. Their ritual significance has often been obscured by their political symbolism which, now that the moment of mourning has long passed, is all that we can see."[84] Winter suggests that while memorials serve early memory work that is socially necessary and worthwhile, a site will eventually lose this use function and degrade into a bare ideological statement. Compared to Winter's First World War focus, however, the highly variable circumstances of memorial museums discussed in this chapter reveal that the relation between personal bereavement and political function can be more complicated. Returning to the World Trade Center Memorial example that opened this chapter, we can surmise that while it will surely provide an emotional salve for many, it has been conceived with the kind of ideological force that will certainly make it politically stark from day one. Another impending site, Washington, DC's Armenian Genocide Memorial and Museum, forms a converse case. While the museum will undoubtedly politically condemn the Ottoman Turks, it will almost certainly serve as a site of primary and pressing public mourning for those hitherto not afforded the opportunity. Hence, some emotionally fresh events may quickly degrade to ideology, while old events can be made the subject of fresh mourning.

Memorials and museums are now being built with greater haste than in the past. Our current proclivity for building these markers without knowledge of their eventual significance almost certainly contributes to their divisiveness. For instance, on August 27, 2005, in London's aged, carefully manicured Victoria Embankment

Gardens, the first permanent memorial for the London terrorist bombings was unveiled, only seven weeks after the event. Although common sentiment holds that we build memorials in order to remember, there appeared little chance of Londoners forgetting so soon. The plaque in the soil bears the primary inscription: "Under this tree people of all faiths and nationalities, united in grief, laid wreaths in memory of those killed on 7th July 2005, following the attacks on London's public transport system." It contains two supplementary quotes. Mayor Ken Livingstone's says: "The city will endure – it is the future of our world." The other, from Simon Milton, Westminster Council leader, reads: "For all Londoners in our great city." Urban unity and optimism in the city as a force for tolerance are the key themes. However, the memorial's dedication occurs within a period of continuing anxiety, amidst a public debate that cuts open such calls to unity. In September 2005, Muslim committees appointed by the Prime Minister to tackle the problem of extremism advised Blair that that he should end, or amend, Britain's official observance of January 27 as Holocaust Memorial Day (marked since 2001 after a long Jewish campaign).[85] Sensing exclusion from Judeo-Christian national life and a more general sense that Muslim lives are less valued, the advisory committee pointed out that Muslim "genocide" had also occurred in Palestine, Chechnya, and Bosnia. The claim has predictably provoked a strong retort from Jewish groups and others who say the advisers are trying to trivialize and devalue the Holocaust. Other media commentators question whether, with such current turmoil, marking this day is worth the political angst?[86] The politics surrounding the memorialization of terror in the UK shows again that public forms of recognizing history – holidays, parades, plaques, memorials, museums – are increasingly being identified by combative groups and nations as terrain worth fighting over.

The key question – who has the clearest claim to "own" the memory and interpretation of tragedy? – is being fought along lines that acknowledge that museum effects, such as architectural spatial relations, design aesthetics, the display of often confrontational objects, and patronage (or lack thereof) from governments, community leaders, or NGOs, have significant political utility. Hence, rather than memorial museums representing a byproduct, or better, a subsidiary educational arm of concrete political actions, we see them being pushed onto center stage in actually initiating public awareness about past events that are (felt to be) newly required or overdue. As Andreas Huyssen has put it: "discussions about how to remember the past have morphed into an international debate about human rights, restitution, and justice, replete with NGOs (nongovernmental organizations), extradition requests, and prosecution across borders. This debate depends on the recognition of specific pasts as much as it is really concerned with the future."[87] As Huyssen recognizes, atrocities now occur within a "memory culture" in which "national patrimony and heritage industries thrive, nostalgias of all kinds abound, and mythic pasts are being resurrected or created."[88] Memorial museums are especially politically useful in the way they concretize and distill an event. By providing a tangible sense of a topic that would otherwise only exist in the life of the mind and in disparate books, films,

websites, and so on, political activism is projected onto and interpreted through the shape of the memorial museum. Hence, museums serve as surrogate homes for debates that would otherwise be placeless. While courts and truth commissions are other spaces that support historical re-examination, they are chiefly involved in direct, high-level legal questions concerning prosecution, amnesty, compensation, and suchlike. Somewhat fuzzier and perhaps under-recognized aspects of the event, such as the experiences of everyday people, or the quality of emotional hurt, often now find themselves translated into deliberations about the building and refurbishment of memorials and museums, and the medium and message of their displays. In this, they potentially serve a valuable social role as spaces that can provide a public forum for discussion. It is their very ability to stand for unpopular ideas, to be battered by and absorb criticism, and to weather the storm of political sea-changes that makes them suitable vessels for histories that, due to their severity, will remain essentially contested.

6 THE MEMORIAL MUSEUM IDENTITY COMPLEX: VICTIMHOOD, CULPABILITY, AND RESPONSIBILITY

A MORAL MISSION

The strategic use of objects, images, and spatial effects examined in chapters 2, 3, and 4 only goes so far in accounting for the museum's effect on visitors. A larger overarching line of inquiry concerns their pedagogic aspirations. More than almost any other institution, memorial museums purport to be morally guided. They invariably cherish public education as it is geared towards the future avoidance of comparable tragedies. A sample of excerpts from institutions' mission statements bears this out: "that no one else should ever suffer as we did" (Hiroshima Peace Memorial Museum); "to research, document, educate, and ensure remembrance of this Holocaust" (Terrorháza, Budapest); "to remember those who were killed, those who survived and those changed forever. May all who leave here know the impact of violence" (Oklahoma City National Memorial); "to preserve the memory of what occurred during the period of state terrorism and its effects throughout Argentine society, in order to enrich democratic culture" (Memoria Abierta); "to promote democratic values and civil consciousness in contemporary Russian society through the preservation of the last Soviet political camp as a vivid reminder of repression, and an important historical and cultural monument" (Perm-36 Gulag Museum); "to link this history of popular struggle and sacrifices for democracy and national rights to contemporary events of human right abuses and fundamentalist tendencies" (Bangladesh Liberation War Museum); "to remind the world of the fragility of liberties and the need to preserve them, in order to move together towards a universally egalitarian civilization" (Maison des Esclaves, Senegal).

This chapter bypasses a study of the everyday tactics and operations of memorial museums' education departments in favor of a more theoretical issue: how might visitors, possessing a diversity of culturally informed and historically situated identities, respond to this "moral education" – the cluster of ideas concerning personal culpability, victimhood, and responsibility as it relates to past remembrance and future vigilance? That is, how do memorial museums ask and respond to questions such as: which groups suffered? Who was to blame? Are we/they still suffering? Are we/they still to blame? What needs to be done to right historic wrongs? For their part, visitors may ask: how does the memorial museum narrate group experience within its interpretation? How does this accord with my own privately formed sense of the event? If I have little investment in or knowledge of this catastrophe, am I simply a voyeur? In the social space of the exhibition, such dilemmas can be both quelled and

magnified. That is, memorial museums ideally possess conditions and tactics that allow visitors to reflect on these issues in a supportive environment. Yet by making this act of reflection public, nagging anxiety about the visitor's perceived social identity might remain: how am I being judged? Am I viewed by others within one of the museum's victim or perpetrator categories? Should I even be here?

It is no coincidence that memorial museums have flourished during the current age, which sees the entrenchment and naturalization of the phenomenon known as "identity politics." By this I refer to the group feeling associated with social movements, the members of which unite around common cultural practices and experiences of actual or perceived injustice. Identity lies at the heart of memorial museums, since the topics with which they deal (genocide, terrorism, political persecution, displacement, and suchlike) tell stories of certain people being singled out based on their presumed group affiliation. The idea that identity can often be – no matter how accurately – established through physical appearance, language, and custom makes the visitation of memorial museums especially charged, given that people will arrive with a keen sense of their own identity-appearance. Memorial museums inescapably set themselves up to receive visitors whose identities span a range of affiliations – including survivors, their families and friends, perpetrators and their families and friends, those from the affected region or social group, those from regions, social groups or nations that inflicted the harm, the larger national demographic, concerned international visitors, and the more general realm of sightseeing tourists. While remaining wary of the notion that a structural view of one's subject position easily determines interpretation – human variety defies that – it is nonetheless useful to bear in mind this range of personal relationships to an event. Notions of "involved" and "impartial" or "local" and "outsider" are not just relative and relational, but also exist as affective as well as historical-geographic categories – for instance, a foreigner who has experienced an analogous event in their own society may well feel more attached to an event than a local who feels that they were not personally affected.

Unlike Holocaust memorials, which now exist in the nations of perpetrators, victims, and bystanders alike, the memorial museums on which I focus are normally located only in the place of suffering. We might assume that this simplifies an event's interpretation. Yet we should distinguish between calamities internal to that society where people from within it caused or executed the crime (examples include Rwandan and Cambodian genocide, Argentinean and Chilean disappearances, Soviet gulags, the Chernobyl disaster, or Oklahoma City terrorism), from those cases where the perpetrators were foreign (such as the Nanjing Massacre, the 2–28 Massacre, Hiroshima, 9/11 and Madrid terrorism, and the Bangladesh Liberation War). This latter category is arguably more easily conceived through cognitive frameworks of in-group belonging and out-group threats (even if statistics prove that "democide" – murder by one's own government – has killed many more than state-versus-state warfare).[1] Memorial museums based on national "us" and foreign "them" incidents share an affinity with conventional war memorials. Whereas war is institutionally

legitimized in acts of official remembrance, and can often be justified as a regrettable but coherent state response, the foremost reaction to internal violence is typically shock at the irrationality that such self-inflicted violence involved. That is, atrocities perpetuated by a foreign army or militia might be more easily understood as a gross extension "beyond the rules" of conventional fighting. Since it can be framed as (excessive) war, the event can still act as a rallying point for national unity. By contrast, violence and terror that originates at a local level is more insidious in the way it tears at the fabric of social unity. Far from being usable as a tragic but fortifying rallying point, this kind of event will produce ongoing mistrust and resentment, given that both survivors and perpetrators often disappear back into everyday society, carrying with them with a range of unresolved emotions – from fear to vengeance, from guilt to sorrow.

This chapter explores how personal and group identities are recorded, described, and judged by memorial museums. While the message relayed by the institution and received by the visitor may be consistent and agreeable, dissonance may also occur for various reasons. The degree of hurt, guilt, or indifference felt in relation to an event is obviously affected by other larger factors than those the museum can control. These are myriad and complex, and include, for instance: its recentness; whether surviving perpetrators exist; whether it has been broached or reconciled by courts or tribunals; whether it continues to have present-day repercussions between social groups or implications for relations of political power; whether attitudes towards the various group identities have changed as a result of such factors. Moreover, memorial museums are communications mediums that exist alongside other modes of historical narration, such as feature films and documentaries, television specials, fiction and non-fiction books, drama and dance, public art, and school curricula. Prior to a museum visit, any of these might have played a key part in shaping ideas about who constitute the victims, perpetrators, and bystanders.

OBSERVING SUBJECT POSITIONS: ON THE VICTIM, PERPETRATOR, AND BYSTANDER

The body counts tallied in the aftermath of conflict and avouched in the media, history books, and memorial museums gives pause to any belief that the world is moving in a progressive direction. Pessimism towards Hegelian or Marxist interpretations of history-as-progress has been accompanied by the emergence of politico-legal ways of weighing destructive aspects of the past. Concrete political attempts to establish – and partially recover – what history has damaged have been guided by the Holocaust, which acts as the "standard and model" for reparative justice.[2] Actions might be focused on the economic, in the form of financial payments to individuals and groups. They can also be material, such as those involving the settlement of land claims or cultural property for indigenous peoples. Legal attempts to correct aspects of the past include the establishment of special courts and national and international truth and reconciliation commissions. Importantly for my discussion, reparations can also be symbolic. Along with, for instance, the issuance of diplomatic apologies

from current or former leaders, or the provision of a proper burial ground for exhumed corpses, support for the creation of memorials and museums forms a significant symbolic act. In these situations, detrimentally affected communities increasingly come to assert public representation of their suffering as a key moral and political expectation. As different examples from the previous chapter suggest, the "right" to have historical injustice represented is not one that proceeds from any philosophical, extra-political basis, but is decided in the less principled sphere of political and economic influence.

A modern, secular, legally and politically informed notion of the "victim" increasingly overshadows the archaic religious-sacrificial meaning of the word (in which an act of brutality has its origin in a divine belief in the necessity of sacrifice). What remains common to both is the sense that the victimized individual had neither real choice nor agency, and is thus blameless, allowing him or her to retain moral rectitude. As open state-versus-state warfare has partly given way in the past few decades to other forms of ethnic and sectarian conflict, different ways of picturing and understanding victimhood have evolved. The notion of sacrifice intrinsic to the memorialization of soldiers in the service of nation-building has diminished. The idea of victimhood has arguably taken up the slack. Joseph V. Montville characterizes victimhood as: "A state of individual and collective ethnic mind that occurs when the traditional structures that provide an individual sense of security and self-worth through membership in a group are shattered by aggressive, violent political outsiders. Victimhood can be characterized by either an extreme or persistent sense of mortal vulnerability."[3] Montville is right to inflect victimhood with qualities of perceived vulnerability rather than fixed weakness. The enumerative nature of group victimhood means that suffering in a historic event is calibrated not through some objective standard, but through its visibility and recognition in public consciousness. This makes it intrinsically contentious, dependent on ongoing political and social developments that can shift the ability to argue both the existence of an ongoing historical reference group, and the acceptance of the persistent effects of persecution or inequality. Within the categories of race, gender, class, and sexuality that have become institutionalized in the academic humanities in recent decades as normative ways of conceiving discrimination, it is arguably the dimension of race (and ethnicity) that has come to dominate public awareness of claims to historic victimhood: it is in race that historical experience is most widely accepted as being "passed down" between generations, and it is in race that *culture* – the key link between historical experience and contemporary identity – is seen to belong most intimately.

While memorial museums might temper accusations of the culpability of specific people or groups by emphasizing structural elements (where events rather than single individuals account for the course of action) and situational conditions (where the behavioral, conformist aspects of human behavior are emphasized), others more plainly stress intentionalism. Human instinct arguably follows this line of reasoning: it is easier to assign blame to individuals than chains of events, social conditions, or cultures of militancy.[4] A gallery at Tuol Sleng Museum of Genocidal Crimes, for

instance, features a board with photographs of Duch (Kang Khek Ieu), the former director of the torture prison, and the signed memos he wrote to the DK regime leadership reporting on progress against "enemies." Similarly, Budapest's Terrorháza hosts a "Wall of Victimizers" featuring names, positions, dates, and photographs of criminals that have escaped justice. Descriptions of social, cultural, economic, and political elements that form the mainstay of structural and situational narratives are not necessarily less politicized, but tend to attach blame to larger groups or nations. At the Nanjing Massacre Memorial Museum, attention to individuals is, interestingly, not only on culprits but also witnesses. In December 2002 the museum added its "Copperplate Passage of Footprints." Forty meters long and 1.6 meters wide, the path has the imprints of 222 eyewitnesses of the Nanjing Massacre. These people, now elderly, were either civilian survivors of the massacre or delegates to the 1946–48 Far East International Military Tribunal for the trial of Japanese war criminals. Given the politicized denial that surrounds this particular event, those who vouched for the massacre gain a heralded status in commemoration. The museum suggests that, as actors, witnesses are as important to remembrance as the otherwise normally dominant categories of victims and perpetrators.

Other memorial museums avoid direct censure, preferring to present violence and persecution as general human failure. Such accounts are not necessarily tied to an absence of fact or indecision in scholarship. More often, it is due to the desire to foster unity and work towards social reconciliation. Posted at the entrance to the National Genocide Memorial in Kigali is a wooden board bearing the quote:

> Many families had been totally wiped out, with no one to remember or document their deaths. The streets were littered with corpses. Dogs were eating the rotting flesh of their owners. The genocidiaires had been more successful in their evil aims than anyone would have dared to believe. Rwanda was dead.

The culprits here are genocidiaires – not the Interahamwe and Impuzamugambi Hutu militias. The victim is the nation – not Tutsis (and moderate Hutus). Although the context is obviously very different, an avoidance of blame can also be seen at the Oklahoma City National Memorial. Speaking at its dedication, President Clinton stated, "there are places in our national landscape so scarred by freedom's sacrifice that they shape forever the soul of America – Valley Forge, Gettysburg, Selma. This place is such sacred ground."[5] By associating the loss of life through an act of mass murder with that of soldiers falling on national battlegrounds, the Oklahoma City bombing is narrated as a noble sacrifice. It is, perhaps surprisingly, difficult to find reference inside the museum to Timothy McVeigh or Terry Nichol. McVeigh is pictured only once, in the familiar photograph of him in an orange jumpsuit being marched handcuffed by FBI officers. Of the museum's ten thematic "chapters," the first begins with "chaos" (the moment of the blast) and the last is "hope" (the city's current rehabilitation). In between there is little attention to motives for the bombing, to who was responsible, nor to any history of homegrown terrorism. The museum's child-focused public outreach programs also abstract the nature of the violence. "The Hope Trunk"

lent out to schools for a two-week period holds artifacts and classroom exercises that "use the story of the bombing to educate students about the senselessness of violence and the need to find more peaceful means to solve our differences."[6] The setting aside of questions of who and why makes the institution a memorial in its pure, depoliticized sense. Perhaps out of a sense that to name terrorists is to give them a semblance of selfhood, perspective, or reason, victims are the sole frame of reference.

If the blast at 9.02 a.m. represents the decontextualized, under-explained moment of instigation that is nonetheless the tragic *raison d'être* for the Oklahoma City National Memorial, the colossal explosion at 8.15 a.m. fulfils an analogous function at the Hiroshima Peace Memorial Museum. Specific attention to the motives and machinations of the American government and military leadership are similarly obscure. (We might speculate whether 8.46 a.m. and 9.03 a.m. will fulfill a similar "out of the blue" narrative function at the World Trade Center Memorial, effacing the involved causes of the act.) The absence of discussion about *why* the bombs came may reflect the institutional origins of the Hiroshima Peace Memorial Park. The 1948 Peace City Construction Law approved by local referendum expressed the spirit of Hiroshima's postwar reconstruction as the "Peace Memorial City." As Lisa Yoneyama argues, the real impetus came from American-led Allied Powers force, which "welcomed the proposal to convert the field of atomic ashes into a peace park, while simultaneously enforcing censorship on Japanese publications concerning the bomb's devastating effects on human lives and communities."[7] Japanese leaders have adapted annual April 6 Peace Park commemorations for their own ends, utilizing symbols of peace to emphasize the postwar economic affluence that it has produced. In this, atom bomb victims have been positioned as martyrs who sacrificed their lives for the prosperity of the postwar nation.

The museum has been roundly criticized for the way, in positioning itself as a "peace city," questions of historical responsibility for the Pacific War are severed from the "last act" itself. The Nanjing Massacre is the only atrocity (very briefly) cited. There is no other mention of, for instance, the 1941–42 Rural Pacification Campaign in China, which reduced the population in communist areas by 19 million via death and expulsion, the execution of 5,000 Chinese in Singapore in 1942, or the death of some 11,000 prisoners of war during the Bataan Death March in that same year.[8] Instead of references to Japanese militarism and imperialism against Asian nations, discussion of wartime is largely limited to the hardship of domestic conditions.[9] The end product is a curiously ahistorical memorial, best captured by the engraving on the Park's central cenotaph, which reads (translated): "Please rest in peace; for we shall not repeat the mistake." The elegy is ambiguous in two regards: who are "we," and what was the "mistake?" The favored interpretation is the universalist "we" and the global "mistake" of our human willingness for atomic annihilation. A more deliberate interpretation, of course, would make either the Japanese or the Americans the "we," and either side's military activities as the "mistake."

Those who visit out of quiet atonement for their (real or imagined) complicity with the event are a seldom-considered category of memorial museum visitor.

Although those deliberately and unapologetically responsible for others' harm are unlikely to appear, there are others who, for various reasons, may feel less than comfortable about their actions or those of their progenitors. Cultural histories of the Holocaust are highly skeptical about whether those who lived though it can inhabit a passive or neutral relation to the event.[10] Beyond the fact of German culpability, Holocaust literature and scholarship has also explored guilt in relation to two themes: guilt about surviving (and guilt about the gratitude that one was never present), and guilt about inaction or not having done enough.[11] It is a psychoanalytic axiom that lack of opportunity to grieve adds to the persistence of survivors' guilt. For those living with such feelings of deficiency or helplessness, museum visitation might allow a better appreciation of the suffering of others when it could not be fully comprehended at the time. The ritual of memorial museum visitation may appear to be a way to assuage guilt publicly, whilst being afforded a coat of anonymity and the opportunity to reflect quietly. For those who feel true *shame* however, this act may be impossible. Here I draw on Sharon Todd's useful distinction between guilt, which "connects the self to the social world [and is] concerned with how the self is perceived," and shame, which "remains confined within the self's parameters of self-idealization," and "involves something that one cannot bring oneself to articulate to another."[12]

The issue of national guilt has become topical in recent decades. The composite German word *Vergangenheitsbewältigung* expresses the struggle to come to terms with the Nazi past – something that began in earnest from the 1960s when the postwar work of *Wiederaufbau* (reconstruction) became less pressing. Most prominent are the legal investigations undertaken by the Jewish Claims Conference that have resulted in the compensation of Holocaust survivors, and, more recently, of wartime slave laborers of various ethnicities who were forced to perform unpaid labor in German factories. *Vergangenheitsbewältigung* singly references efforts carried out by organizations such as the Lutheran and Catholic churches, government school curricula, and museums and memorials, as well as the ongoing personal and psychological soul-searching undertaken by ordinary Germans. Guilt is a concept that museums inevitably treat sensitively. For instance, Ken Gorbey, the project director of Berlin's Jewish Museum, stated that the museum is less focused on German crimes than on Jewish responses: "We don't want to ignore the concept of perpetration, but to visit a guilt trip upon the German people is not the primary objective of this museum."[13] Director W. Michael Blumenthal similarly affirmed: "The Jewish Museum does not pay testimony to guilt, as one can only make later generations guilty for the mistakes of their predecessors if one believes in a form of liability of all members of a group for the misdeeds of one."[14] It may be that, in a sense, the Jewish Museum is as much a legacy of *Vergangenheitsbewältigung* as it is of the Holocaust itself, in that its self-conscious embracement of architectural and curatorial themes of absence and loss suggests a willingness to address previously closeted ideas of national anxiety and ignominy.

In July 2007 it was announced that the German government would turn Ordensburg Vogelsang, a mock medieval castle built in the 1930s that served as an

educational center for future Nazi leaders, into a museum. Filled with Nazi insignia, murals, and statues, it represents the largest architectural relic of the regime. The castle's transformation into a museum is largely being justified on the grounds that it now represents a rare opportunity to showcase the Nazi apparatus. A historian involved with the project stated that "in places like this we can analyze and explain the Nazi dictatorship more rationally than in, say, concentration camps where respect for the dead requires one to focus on the suffering of the victims. We do not ignore the victims here. We are saying that what was taught here led to the ramp at Auschwitz." The museum's designer has similarly said that "many people are afraid to visit concentration camps but are less afraid to go to a place like Obersalzberg [Hitler's mountain retreat], and are prepared to be informed when they're there. You need a mix of victims' and perpetrators' sites to be able to build a historically accurate culture of remembrance."[15] The Ordensburg Vogelsang development appears to signal an emergent sense – which would have been highly improbable in commemorative projects in previous decades – that understanding perpetrators is intimately connected to remembering victims. This reflects the recent growth of a tolerance-based pedagogy that probes each of us to ask how we could equally be turned into agents of intolerance. The danger with such a scheme is that deep-rooted anti-Semitism becomes less a historical fact in its own right, and more a circumstantial lesson associated with the perils of indoctrination and fanaticism.

The line separating perpetrators from victims is often blurry. Both groups and individuals can be cast as belonging to both categories (such as Jews who suffered during the Holocaust, but who some consider the agents of Palestinian suffering, or African communities that fell victim to, and facilitated, the slave trade). A pressing current example that highlights this conundrum is the proposal for a "National Memorial Center Against Expulsions" to be situated in Wrocław, Poland. At the end of the Second World War, some twelve million Germans living in ex-German Eastern Territories and Eastern Europe were forced to abandon their homes and move to Allied-occupied Germany, despite sometimes having family histories in those places going back centuries. Civilian casualties during the exodus were high, with estimates that range from one to two million. Without having the space to investigate the causes here, it is noteworthy that interest and debate around the expellee experience has recently grown, even though the matter was originally considered largely resolved in the 1960s.[16] While the major German political parties have agreed on the proposal for a museum, continually troubled German-Polish relations have stalled plans.[17] The fear that such a museum could relativize the legacy of German guilt is clearly a major point of difficulty for Poles, Jews, and others. A 2003 petition signed by dozens of European historians declared that "A Centre Against Expulsions would not contribute to a critical examination of the past. Rather, it would tend to pit one people against another, exacerbate national antagonisms and therefore retard the process of European integration."[18] A differing view might instead suggest that the proliferation of museums with incompatible or conflicting views of the past might help to produce a more nuanced understanding of common suffering and moral ambiguity.

The issue of who should be remembered in any memorial can be as vexed as that of who to blame. This question was hotly debated in the lead up to the unveiling of Madrid's Atocha Train Station memorial. The 3/11 bombings by an Al-Qaeda-inspired group that killed 192 people were certainly not Spain's first experience with deadly terrorism. Attacks by ETA, the Basque separatist group, have claimed more than 800 lives over the past 30 years, and yet there exists no national memorial to commemorate those losses. José Alcaráz, president of Madrid's Association for the Victims of Terrorism (AVT), sought to address this discrepancy, stating that "there are more than 460 families in Madrid alone who have been affected by ETA's terrorism. We believe that [the planned memorial] should include them as well."[19] Others resisted linking the attacks, on the ground that they were instigated by distinct groups with very different political aims. Is the basic fact of tragic, unwarranted death at the hands of terrorists enough to unite those killed (and, as importantly, their families) in shared experience? If not, does distinguishing victims according to the circumstances of their deaths serve to define them chiefly through the machinations of killers? A related issue concerns the organization of the names of the dead to be inscribed around the walls of the World Trade Center's "Reflecting Absence" memorial. Should they be ordered alphabetically, making them easily located – so as not to force families to perform another search of sorts? Should they be listed randomly, in order to reflect the arbitrariness of those killed? Or should they be sorted by profession, to demonstrate the primary sacrifice of those in uniform, and also the affiliations of others according to their place of employment? It is this last proposal that has proven especially contentious. Families of victims who worked in the buildings largely oppose an affiliation-based scheme favored by police and fire department officials, arguing that special designations would create a hierarchy of victimhood.[20] In cases like Madrid and New York where violent death occurred in public at the hands of a political faction, it is not surprising that their commemoration is brought out of the private mourning associated with cemeteries to become a public matter. In such instances the topic of "proper" remembrance also becomes, for better or worse, public property, as victims become part of a debate about representation that easily sees their individuality eclipsed. For the majority of onlookers with no personal relation to anyone killed, the "story" of the violence is the focus; individuals become tragic but required minor characters.

A final case in this section further upsets outwardly black and white, victim and perpetrator historical roles. In the memorialization of slavery, the racial designations at its heart make for a strong sense of historical inheritance. Eloi Coli, the director of Maison des Esclaves in Senegal, has confirmed that "white people arrive feeling a sense of responsibility or guilt, while black people arrive feeling victimized."[21] It is the museum's aim, on the one hand, to unburden visitors of these feelings to enable a constructive view of this history. At the same time, Maison des Esclaves acknowledges that for many Africans and people of African extraction, the search for identity and self-reconciliation – which may include feelings of hurt and anger – is real and meaningful. As Sandra L. Richards has described:

Even those who cast themselves as serious-minded pilgrims, rather than fun-seeking tourists, are likely to produce concomitant narratives of resilience, justice, or transcendent purpose, thereby reassuring themselves that their ancestors' lives and their own have some meaning other than degradation. Indeed, these are the memories that African Americans produce in travel accounts, poems, or videos. Further, the memory of oppression raises issues of the responsibility, complicity, and guilt of the original perpetrators, accomplices, and possibly of their descendants – questions that do not offer an escape from reality, but confront visitors with ethnic or racial tensions analogous to what they may experience at home.[22]

Yet visitors may find themselves being identified in ways that are disconcerting and even antithetical to the purpose for which they sought the experience. For instance, among the visitors to the dungeons that are a chief attraction at Ghana's 500-year-old Elmina Slave Castle Museum, a small but significant numbers are African-Americans who describe themselves as making a trip home to their cultural roots. However, as Edward Bruner has described, Ghanaians call these African-Americans *obruni*, which literally means "white man," but, given the way it extends to all tourists, more generally refers to "foreigners." This attribution must rest awkwardly for those African-Americans whose pilgrimage is based on the general sense of "returning home."[23] In this instance, the comparative wealth of American tourists (of any color) overrides any anticipated affinity based on the principle of historical ancestry. Hence, the sociopolitical resources associated with the ability to tour the site may suggests its own powerful–powerless relation more pressing than that residing in the intangible domain of historical inheritance.

TOURISM: WISH YOU WERE HERE

Sent home on a postcard, "wish you were here" is a cliché that normally trades on depictions of the envied life of leisure. For visitors at memorial museums, the phrase not only seems out of place in such disquieting "attractions," but takes on a different, darker meaning: "wish you were (still) here" might instead form an entreaty to the killed and missing. These tourists may come not in search of escape but its opposite: a painstaking concentration on what cannot be made to return. The journey to the most authentic available sites of catastrophe signals a search for the essence of the person or group at its center (Fig. 6.1). Memorial museums are particularly evocative because they usually exist in settings where we can imagine lives otherwise being lived out, rather than those, like cemeteries, that are explicitly marked off as inert and chiefly associated with the afterlife. Unlike traditional acts of pilgrimage however, we do not necessarily expect that the act of traveling to a memorial museum to recognize the suffering of others will result in our own spiritual reward.[24] What, then, is it that authentic sites of suffering might be trusted to truly and enduringly transfer to those who visit them? In other words, where in memorial museum visitation does pleasure or satisfaction lie?

Fig. 6.1. Visitors at Perm-36 Gulag Museum. Copyright Perm-36 Gulag Museum. Used with permission.

Tourists are indeed arriving at sites of suffering in ever-greater numbers. What makes them come? Research addressing what motivates tourists to visit sites of atrocity is of varying usefulness. A. V. Seaton has described what he calls "thana-tourism" as being "travel to a location wholly, or partially, motivated by the desire for actual or symbolic encounters with death, particularly, but not exclusively, violent death, which may, to a varying degree be activated by the person-specific features of those whose deaths are its focal objects."[25] Seaton reaches back to the concept of thanatopsis (the Aristotelian contemplation of death), which was used to relieve the fear of death in early Christian societies. Seaton writes that, "by experiencing the pity and terror of representations of death, a person could be inoculated against, or purged of its terrors in real life."[26] In their related concept of "dark tourism," Lennon and Foley are less interested in the phenomenon's roots in pilgrimage, and more on the influence of modern media. They write that, "global communication technologies are inherent in both the events which are associated with a dark tourism product and are present in the representation of the events for visitors at the site itself."[27] The development of mass media "has changed the relationship between the public and world events. Thus, an event represented as 'dark tourism' is likely to have taken place in the last hundred years and been brought to the public via modern mass media. The scale and scope of the tourism product are likely to be driven by the media."[28] In their study of what they call "heritage dissonance," Tunbridge and Ashworth explore the tension at sites where visitors want to view authentic markers of atrocity, but locals would prefer to move beyond the event to focus on repairing their standard of

living. The paradox of course is that economic revitalization in many cases depends on tourism.[29] It is a maxim in the tourist industry that acts of violence (and accompanying media-informed perceptions of danger) have a crippling effect on tourist numbers, and hence, local and national economies. Less studied is how these affected cities and nations can, in the aftermath of conflict, either shrink attention from those events, or, as is my focus, advertise them as a draw-card.

Locals directly affected by an event generally visit memorial museums in the period soon after their opening. While the Tuol Sleng Museum of Genocidal Crimes now receives a greater proportion of international tourists with each passing year, when it opened in 1980 early visitors were returning expatriates seeking information about disappeared relatives. In its first decade, foreign visitors were usually from socialist countries such as Vietnam, Laos, the Soviet Union, Hungary, and Poland. After the 1993 election and the establishment of the new Kingdom of Cambodia, more visitors to Tuol Sleng have been from Taiwan, Japan, France, Germany, South Korea, the U.S.A., and other wealthy non-communist countries.[30] It appears that after the initial wave of local visitors interested in their own experiences has passed, memorial museums increasingly turn to the domestic and international tourist market. In this shift, not only does the relation of the memorial museum to tourism infrastructure like transport and accommodation become more important, but the style and level of interpretation may change based on the institution's perceived expectations of its new audience. Foreign tourists appear especially fascinated by events where the state has inflicted harm on its own citizens. This perhaps reflects that tourism is partly motivated by a desire to gain an understanding of local culture; while probably inaccurate, the apparent perversity that allowed a nation to harm its own may seem like a shortcut to an appreciation of the cultural psyche. Precisely because of their lack of ties and everyday immersion in the foreign society, tourists are free to speculate, *in situ* and without normal social restraints, about imagined dramas of hurt, accountability, and retribution.

To generalize, a common motivation for most visitors appears to be illumination, whether this means a quest for personal understanding or a more general desire for historical information. To be sure, some tourists may go to a site largely because its assignation of sacred and moral qualities deems visitation the honorable, respectful thing to do. Alternatively, there may be those less interested in education and remembrance who instead seek to fulfill a morbid curiosity at seeing ominous and dreadful objects intimately associated with others' suffering. While this kind of macabre voyeurism is more easily attained at something like a medieval torture museum, or from a film or website, it may be that the reality effect – that this *really happened* – heightens the sense of taboo. Yet anecdotal evidence from those working within memorial museums (and my own observations) suggests that nearly all visitors arrive willing to take their messages seriously. I posit that a key aspect of their appeal is in the way they offer a concrete instance for thinking about extreme conditions and moral choices that both defined the political twentieth century, and also speak to our human fascination with danger, mortality, and loss. That is, in the everyday lives of visitors who will probably never be asked to confront such life and death situations,

historical atrocities allow us to experiment mentally with the furthest boundaries of what life can involve.

A range of possible motivations for visiting may be observed not just across a given museum audience but even within any person. Given this variance, how effectively might institutions be able to marshal attitudes towards the common mission of human forbearance and future avoidance? Can visitor motivations as disparate as duty, curiosity, voyeurism, information, and remembrance be equally channeled into an ideal outcome? Indeed, memorial museums share with other cultural institutions a basic challenge: how can success in this area of "civic uplift" be measured? A focus on conscience and responsibility distinguish the memorial museum from the larger category of museum experience, where knowledge, appreciation, taste, and pleasure predominate. Yet could the work of memorial museums and progressive social outcomes among visitors ever be concretely linked? The idea of inculcating politically useful social improvement is not new to critical histories of the museum. In *Culture: A Reformer's Science,* Tony Bennett examines the role of Victorian cultural institutions in the organization and regulation of forms of visitor conduct.[31] Bennett is keenly attuned to the way that both the cognitive reception of material and the ascribed social performance and modes of conduct among visitors can serve ideological masters. He is interested in how the physical space of the "exhibitionary complex" – where the "show and tell" of artifacts is made public – encouraged self-regulating behavior among those who wished to align their conduct and habits in accordance with this elevated mode of display. Given that first-hand accounts of the actual experience and interpretation of ordinary people in nineteenth-century museums are rare, it is difficult to know whether the experience of self-regulation was restrictive and stifling, or whether it provided its own satisfaction or reward.

In our age of casual comportment many years later, where wine sipping, pop music, and dancing are increasingly encouraged at museum events, memorial museums may be an uncommon instance where ideas about appropriate conduct remain. Solemn respect is generally the order of behavior. Accounts of actions such as the legions posing for photographs beneath the infamous main gate at Auschwitz, carefree teenagers sitting on Dachau bunk beds, or visitors to Tuol Sleng Museum of Genocidal Crimes touching the skulls on the (now removed) "skull map" are common. A similar more recent example involves Berlin's Memorial to the Murdered Jews of Europe. Immediately after the opening on May 12, 2005, discussion over proper behavior began. "Stop Disgracing Ourselves," the *Berliner Kurier* said in one headline. The *Tagesspiegel* complained about some of the visitors' "strange customs" like kissing and sunbathing around the pillars. Some younger people used it as an amusement park, jumping from the top of one slab to another. Other problems were more sinister: on its opening day a swastika was etched into a stone slab.[32] Understandably, memorial representatives are reluctant to reinforce the two existing guards, to erect a fence, or to add security cameras. The association of the Holocaust with forms of policing and bodily control makes such symbolically loaded actions thorny; director of the memorial foundation, Hans-Erhard Haverkampf, reaffirmed that "the basic concept is tolerance."[33] Similarly, it was not uncommon in the

months after 9/11 to hear complaints from New Yorkers and tourists alike about others' manners at Ground Zero. As one onlooker commented: "I could hardly believe it. I was there at Ground Zero to pay my respects. But while I stood in tears reading 'rest in peace' messages scrawled on the walls encasing the platform, a pack of tourists clambered around me to get the best view of the mass grave. What had gotten into these people?"[34] In these situations, as in many war memorial and pilgrimage sites, tourism and commemoration exist in tension. This is, of course, partly because they are based around incompatible behaviors – bodily pleasure versus punctiliousness, or mental escapism versus application. Yet, as the opening of a new memorial site increasingly self-consciously emerges as a highly publicized media event, it may be supercilious to criticize the tourist who displays behavior associated with more spectacular forms of entertainment.

The idea of bodily awareness has been little investigated in museum studies and deserves further attention. The gravity of what occurred at memorial museums located on sites of atrocity tends to produce a high degree of self-consciousness about one's movements and actions. How swiftly should I move between galleries? Can I take photographs? Ask questions? Was I polite to the staff member who greeted me? Could he or she be a survivor? How long should I stay? This brand of anxiety is quite different in character to that otherwise discussed in museology, which concerns people with limited stores of "cultural capital" encountering the esoteric world of "high" art and culture; by contrast, memorial museums offer a vivid experience in apprehension and diffidence for all kinds of visitors. The physical sensation is well described by Henri Lefebvre:

> Prohibition – the negative basis, so to speak, of the social order – is what dominates here. The symbol of this constitutive repression is an object offered up to the gaze yet barred from any possible use, whether this occurs in a museum or in a shop window. It is impossible to say how often one pauses uncomfortably for a moment on some threshold – the entrance of a church, office, or "public" building, or the point of access to a foreign place – while passively, and usually "unconsciously" accepting a prohibition of some kind.[35]

The sense of prohibition in memorial museums involves whether one feels they have the "right" to come so close to the suffering of others. In a previous article I described my experience at first entering the "killing field" at Choeung Ek Genocidal Center (Fig. 6.2):

> Fragments of human bone and cloth are scattered around the disinterred pits. The embankments separating the exhumed pits serve as haphazard paths. After only a few minutes of walking, taking care not to let my footing slip, it became apparent that the identical hollows would yield few revelations. I noticed a cluster of children standing under a tree with a sign that reads: "Chankiri tree against which executioners beat children." "Picture, sir?" pleaded the children, as they gathered around, their heads lining up against the small red target that has been attached four feet up its trunk.[36]

Fig. 6.2. Tree with sign at Choeung Ek. Image taken by author.

Uneasiness typically begins not with entry to the site, but with the decision to go: What will it be like? What other kinds of people will be there? Will I stand out? In comparing the viewing of museum displays depicting atrocity to his observations of the British tendency to avoid staring at street accidents, John Taylor is interested in the awkwardness associated with *being seen* to be inspecting the anguish of others: "Apart from sexual or morbid perversity, another reason why staring and gawping are abhorred, and why there are many attempts to regulate, or at least guide the act of looking, is that meeting eyes opens the possibility of obligation. The 'I-it' relation becomes 'I-thou,' and identification may lead to complications."[37]

Relations between viewer and subject can be especially uncomfortable when they involve a profound disparity in experience. A traveler to a genocide memorial at Nitarma Church in Rwanda described his uneasy exchange with a local person as follows:

> As I waited for a lift, a well-dressed Rwandan lady greeted me. We conversed and she told me she had come out to visit Nitarma Church for the day. She then said that this was her home village and that her mother and children were killed in the church during the genocide. I told her I was sorry and looked away, staring at the banana trees across the road. I said I was sorry again and then we were silent for a while.[38]

Brooding about the purpose of any memorial museum visit tends to generate conflicted feelings. Reflecting on his trips to Auschwitz and Yad Vashem, author Moris Farhi found himself confronting discordant emotions that seemed "wrong":

> In none of my visits did my courage to face what had happened to members of my family give me the strength to brave the world. Instead, I was gripped by despair. I felt the loss of my resolve to do everything within my abilities to prevent such atrocities happening again. In fact, I felt murderous – and right-eous for feeling murderous. Incapable of understanding humanity's banal

servitude to evil and convinced that the next global bloodletting would be the end of homo sapiens, I felt the need to unleash yet another holocaust, one which would be directed against the perpetrators of holocausts and one in which I myself – a demented self – would take part as a purveyor of justice.[39]

Involuntary, solipsistic feelings of personal inadequacy, guilt, anger, or dismay may not lead themselves so easily towards remembering and resolving "never again." While surveys of visitor responses to museum services are widely conducted, much less common are those that seek qualitative information about visitors' emotions. One rare instance asked Israelis exiting Yad Vashem to summarize their responses by choosing one or more concepts from a list. The results were dominated by sadness (56 percent), thoughtfulness (50 percent), and anger (43 percent), and to a lesser extent, by melancholy (13 percent) and revenge (8 percent).[40] Whether these feelings were already formed or changed as a result of the museum visit is unknown. Moreover, it is very difficult to determine whether such sentiments stayed with the person and came to bear on any of his or her later ideas and actions. What then should we make of the link between visitor response and social action that forms the often-stated *raison d'être* for memorial museums?

EMPATHY AND POLITICAL ACTION

The kind of museum most closely associated with future action (and ongoing faith in humanity's rehabilitative abilities) is the peace museum. Unlike memorial museums, these are typically attached neither to a significant historic site, nor to one single event. Prominent examples include the International Red Cross and Red Crescent Museum, Geneva, the Simon Wiesenthal Beit Hashoah-Museum of Tolerance in Los Angeles, New York, and Jerusalem, and The Musée Mémorial pour la Paix in Caen. A lesser-known example is the International Museum of Peace and Solidarity in Samarkand, Uzbekistan. It contains, for instance, a piece of the Berlin Wall, fragments of Soviet and U.S. nuclear missiles, a charred roof tile from Nagasaki, and soil from Auschwitz. Established in 1986 by the Esperanto International Friendship Club and situated at a town located at the crossroads of the historic Great Silk Road, the museum takes as its motto words by poet Alisher Navoi: "Mind, ye people of the Earth, Enmity is an evil state. Live in friendship, one and all – Man can have no kinder fate." Peace museums represent a rare attempt to make such pedagogic utopianism intelligible at a hands-on level. Indeed, this outlook has made them a key site for civic training. In addition to the thousands of school groups it receives annually, the Los Angeles Museum of Tolerance (in partnership with the State of California) has now seen tens of thousands of law enforcement officers pass through as part of its "Tools of Tolerance for Law Enforcement" program, as well as firefighters, social workers, health care professionals, attorneys, and probation officers. What kinds of strategies do peace museums deploy, and why is it felt that they can be socially effective?

On entry to the Los Angeles Museum's "Tolerancenter," a multi-subject, techno-logically rich performative space that precedes its Holocaust exhibition, visitors are

confronted by a speaking character in a ten-foot-high video display called the "Host Provocateur." After spouting an assortment of biases, he asks whether visitors sympathize with anything he has said. Denied any real opportunity to respond, he directs visitors to "enter the door marked Prejudiced, because you are." Visitors see two closed doors, one bright red, marked "prejudiced" the other "unprejudiced" in a more soothing green (Fig. 6.3). Those who persist and try the green door find it is locked. Similar experiences follow, as Oren Baruch Stier describes:

> Wandering among a total of thirty-five "hands-on" exhibits with titles such as "Images that Stay With Us," "It's So Easy to Misjudge," "Me … A Bigot?" and "What We Say, What We Think," we explore, at our own pace, the relationship between words, images, and intolerance, responding interactively to a series of colorful and even entertaining displays. Such relationships are also addressed in the "Whisper Gallery," a dark, winding corridor where racial epithets and hateful slurs ("camel jockey," "jungle bunny," greasy dago," "bulldyke bitch," "loudmouth kike," and the like), assault us.[41]

Although the Host Provocateur returns occasionally to goad visitors, the final screens in the gallery ask: "Who is responsible?" The multilingual answer is "You are." The idea, encapsulated by the often-cited (anonymous) quote – "the man with a clear conscience probably has a poor memory" – is that discrimination is universal, and that those who fail to acknowledge theirs are simply not trying hard enough. The question of the scale of behavior – from an offensive ethnic joke to mass murder – is one that is little acknowledged. Or rather, the sliding scale is exactly the museum's point – Nazis and other demagogues are there to show that if we do not check

Fig. 6.3. Green/red doors at the Los Angeles Museum of Tolerance. Copyright Simon Wiesenthal Center. Used with permission.

ourselves for private thoughts, then terrible actions can easily follow. In this, specific histories are not themselves the focus of concentration and remembrance, but instead are tools in the museum's pedagogical toolbox.

The identity card tactic (borrowed from the U.S. Holocaust Memorial Museum, where visitors receive on entry an identity card describing the life history of someone who suffered through or died in the Holocaust), and the resister/collaborator corridor choice featured at Caen's Musée Mémorial pour la Paix, have been combined at Johannesburg's Apartheid Museum (2001). Upon entrance, visitors are asked to choose from two sets of identity cards according to their racial identity. They are then directed to one of two revolving doors – one for blacks, one for whites. Here the separation experience begins. In the passage for blacks the walls are covered with faded photos from old passbooks they were forced to carry in the days of white rule. Waiting at the end of the hallway are four white men, frozen in life-size photographs. They represent members of the racial-classification board that assigned identities by studying the kink of hair, the width of noses, the fullness of lips, and gradations of skin color. White visitors pass through a hallway covered with their own identity cards. While they can glimpse the black visitors through a metal grid, the two groups remain separated until the passages rejoin, and all visitors meet at the foyer of the main exhibits.[42] The tactics at these museums aim to have the visitor *feel*, as an antidote to the cold intellect associated with Nazism and apartheid that produced decisions about the course of others' lives without regard for emotion. If political histories can be understood though a sensual process, visitors might remember (or conjure) the *experience* of prejudice, these museums wager.

Peace museums are premised on seemingly contradictory ideas: the first is that future peace might be achieved through personal improvement (specifically, values of tolerance and understanding) by using examples of past histories that point to the continual return of undesirable yet undeniable aspects of human behavior. These museums produce an understanding less focused on the recurring conditions of the past century that played a part in producing conflict, and more on violence and bigotry as *aberrations* of human history. Hoping to adapt the most base forms of human behavior, the museums posit education as the agent of change: culture can trump nature, but only as long as a new, enlightened, post-racist culture can shed in- and out-group mentalities – in other words, "cultural identity" as we normally understand it. This, then, is another quandary in the philosophy of peace museums: that we should respect others' cultural differences in the name of tolerance, while at the same time remaining suspicious of "culture" as an agent of prejudice.

Other museums focus less on self-scrutiny than on outward forms that action might take. The U.S. Holocaust Memorial Museum has devoted space to contemporaneous genocides since its opening. In 1994 it created *Faces of Sorrow: Agony in the Former Yugoslavia,* an image-heavy exhibition of pictures of ethnic cleansing. On display at the time of writing is *Genocide Emergency, Darfur, Sudan: Who Will Survive Today?* This exhibition chiefly comprises photographs of ruined towns and local police records of the murdered, framed within an institutional call to action.

Although the question of the permanent representation in the museum of "other genocides" has been raised – a "Hall of Genocide" was proposed during the development period – it has remained on the drawing board, perhaps because such a space might exist in an awkward historic and cultural relation to the larger museum).[43] Nevertheless, the museum's Committee on Conscience has seriously considered the issue of individual activism. Its "What You Can Do" sheet (available at the museum and online) focused on Darfur states:

> 1. Keep Informed. Find out more about what is going on from various news sources and organizations …

> 2. Contact the Media. Write a letter to the editor of your local newspaper or to other news outlets to comment on their coverage of Darfur or to express your views about the importance of public attention to the story.

> 3. Communicate with the Government. Contact your government representatives to let them know your views and concerns about events in Darfur.

> 4. Support Relief Efforts. Find out more about relief organizations mounting efforts to help civilians affected by the crisis. They may have ideas of ways you can help …

> 5. Get Engaged in Your Community. Talk about Darfur to your friends, family, members of organizations you belong to, and coworkers – help spread the word …

> 6. Support the Museum. Help sustain the ongoing efforts of the United States Holocaust Memorial Museum to draw attention to what is happening in Darfur. Send a donation … [44]

The force of displays at memorial museums aims to produce a "negative revelation" that can spur positive action. As Edward Linenthal puts it, the U.S. Holocaust Memorial Museum "offers the civic equivalent of being "born again" – the movement from passive unaware inhabitant of the nation state to active vigilant citizen empowered with the agency of a coherent moral public narrative."[45]

A key organization to directly engage with the relation between sites of remembrance and current vigilance is the International Coalition of Historic Site Museums of Conscience (discussed in the previous chapter). Its stated goal is:

> … to transform historic site museums from places of passive learning to places of active citizen engagement. We seek to use the history of what happened at our sites – whether it was a genocide, a violation of civil rights, or a triumph of democracy – as the foundation for dialogue about how and where these issues are alive today, and what can be done to address them.[46] We believe it is the obligation of historic sites to assist the public in drawing connections between the history of a site and its contemporary implications, and to inspire citizens to be more aware and involved in the most pressing issues affecting them.[47]

The Coalition partners see the museum's ideal role as a public forum for debate and deliberation over pressing social and political issues, and as an organizational structure that supports the public's lobbying and petitioning of governments, businesses, and media. Rather than simply promising "never again" as a general philosophical principle, the Coalition seeks to make it the basis of its member museums' public programs. However, referring to its goals stated above, what might "citizen engagement" look like in practice? Is conventional learning in museums necessarily "passive"? Can the Coalition's institutions be certain that a managed form of participatory democracy is necessarily what people desire of the museum experience? The idea that we should not just learn "passively" is to apply emphasis to ideas of emotion and personal transference (the "it could have been me" effect) rather than simply coming to understand historic catastrophes in their particular sociotemporal context. A main feature of the Coalition's website is the "what if we forget?" tab, which shows contemporary instances of the issues conveyed by the member sites. Clicking on Argentina's Memoria Abierta page, for example, brings up another that describes organizations currently fighting state terrorism in Africa, Asia, and Central and South America.[48] The key promise is that vigilance can prohibit recurrence; the impasse is that it is tricky to represent – or arguably conceive – positive examples where this has occurred.

One of the Coalition's tenets is that the ability to rouse the conscience of visitors is not tied to the level of suffering that the site saw. While the Terezin Holocaust Memorial and the Bangladesh Liberation War Museum are members, so is the Eleanor Roosevelt National Historic Site, a stone cottage by the Hudson River that saw no violence, but provided a meeting place where issues of social justice were discussed. By bringing together diverse subjects with differing levels of gravity, the Coalition positions itself as being more interested in future positive action than in weighing degrees of historic affliction. An example can instructively illustrate this point. After traveling to the Perm-36 Gulag Museum to advise on its development, representatives of the U.S. National Park Service arranged a reciprocal arrangement where objects and images from Perm-36 would be exhibited at New York's Ellis Island (which it manages, along with three member sites of the Coalition). *Gulag: Soviet Forced Labor Camps and the Struggle for Freedom* opened in May 2006.[49] The exhibition displayed a range of primary artifacts (such as axes, saws, and thin coats), photographs of cruel working conditions and emaciated prisoners, and secondary responses from survivors (such as a drawing by a former female prisoner of her and others stripped naked in the snow before being led into roofless enclosures). The last part of the exhibition asks visitors to consider larger concepts. A text panel reads:

> Brutal systems have played a prominent role in many countries, including the United States. Although slavery ended after the American Civil War, its consequences persist. The repercussions of the Holocaust in Europe and apartheid in South Africa reverberate even today. Similarly, Russians face the legacy of the gulag. How can citizens in these countries face up to the horrors of the past?

The visitor's attention is turned in multiple directions. The *Gulag* exhibition is contained within Ellis Island's larger, mostly affirming narrative of late nineteenth- and early twentieth-century immigration. While a small number of intending immigrants were refused entry, as an instance of state maltreatment it sits uneasily alongside slavery, the Holocaust, apartheid, or the gulag system. Are all forms of discrimination (if that is a word that can span these examples) comparable? As a *New York Times* reviewer noted:

> No doubt noble sentiments are at work in this [the Coalition's] roster, but as a result, all specificity and judgment disappears; conscience consumes everything and contains nothing. To make a grand rhetorical gesture, encompassing all human injustice when one particular example seems inconveniently egregious, has become a museum ritual, a political tic.[50]

Against the Coalition's founding philosophy, the nagging question remains: do worker's rights and women's rights produce the notion of "conscience" in the same way as a genocide or "ethnic cleansing?" The Coalition is interested in making conspicuous the idea of something akin to a "world conscience," wherein we might increasingly come to understand the interconnectedness of our local choices, actions, and inaction. As a moral faculty or principle that intervenes in one's decisions, "conscience" is inflected in different ways, however: it is intrinsically subjective (the word's etymological root is self-knowledge, and is often conceived as a "voice within"); it holds a particular significance in the religious realm as both a guiding notion and as something that faith can shape; it is also invoked in a different way in the secular-humanistic work of human rights and humanitarian organizations. In other words, conscience does not have a standard, universalistic value, but is the name we give to our individually defined moral compass.

A key impediment to empathy and action – one that may be considered offensive yet can hardly be ignored – is the perceived distance between the geopolitical status and identity of the observer and that of the casualties being observed. Can hundreds of thousands killed in Darfur, Sudan ever mean as much to New Yorkers as the 2,602 killed at the World Trade Center? The six murdered in its 1993 bombing? Clearly, this is not a question that is resolved objectively; the impact of any event is formed subjectively, and is heavily influenced by its media prominence, itself governed by factors such as its size and scope, its ease of understanding, clearly defined roles of good and bad, the involvement of women and children as victims, and any lateral, circumstantial connections to the observing society. Despite the contemporary emphasis on the role of media (particularly television) in the sparking and dampening of sympathy, musing on the issue of compassion towards distant people is not new. In the eighteenth century, thinkers such as Balzac, Diderot, and Rousseau presumed that geographic, ethnic, and socio-economic likeness to oneself largely determined the degree of human compassion.[51] Ever since that period, when sympathy was first posited as an essential component of the Enlightened Self, there has been an accompanying debate about whether images or other representations of

suffering stimulate our sensitivity to it, or instead produce indifference, numbness, or (to use a contemporary phrase) "compassion fatigue."

Each of us probably remembers (if not first-hand then as media events) a variety of postwar political calamities in our adult lifetimes. We may also have a recollection (perhaps somewhat vague in slowly unfolding foreign political disasters, or more pinpointed in the case of the something like 9/11) of "where we were" as we encountered these events. Yet episodes that cause others' extreme harm and privation may exist outside any useful sense of synchronicity with our own lives. George Steiner has discussed the Holocaust in terms of the impossibility of its contemporaneous time relation:

> One of the things I cannot grasp, though I have often written about them, trying to get them into some kind of bearable perspective, is the time relation … Precisely at the same hour in which Mehring or Langer [two victims at Treblinka] were being done to death, the overwhelming plurality of human beings, two miles away on Polish farms, five thousand miles away in New York, were sleeping or eating or going to a film or making love or worrying about the dentist. This is where my imagination balks.[52]

When we reflect on lives parallel to our own in other places, we can barely imagine those who have suffered such an incommensurable order of human values and experience. In thinking about an event in terms of where *we* were at that time we may be allowing ourselves to defer the question of the *victims'* experiences in favor of our own. The question for memorial museums is whether it is necessary to consider limitations on strategies of identification so as not to encourage bogus similarities between spectators and victims. In the act of making suffering meaningful most of all to visitors, museums may allow us to enjoy an unconscious sense of entitlement to the centrality of our experience. In stressing that victims are "just like us," an emphasis on likeness disguises real differences, and privileges the visitor by making him or her the implicit standard against which "likeness" is measured.

The inversion of this formulation – that all visitors are able and willing to see themselves as potential victims – shares much with the so-called "culture of victimization." As an almost axiomatic pronouncement in the current period, the charge is, as Peter Novick states in *The Holocaust in American Life*, that "nowadays the status of the victim has come to be prized."[53] It has arguably also been extended to broader categories of people. Consider the inscription on the granite memorial fountain dedicated to the 1993 World Trade Center bombing, erected in 1995 and destroyed on 9/11: "On February 26, 1993, a bomb set by terrorists exploded below this site. This horrible act of violence killed innocent people, injured thousands, and made victims of us all." Carolyn J. Dean has skillfully elucidated how the "victim as me" and "me as victim" difference inevitably collapses into a form of solipsism:

> In this discourse, the sacrosanct status of the Holocaust in American life turns out to be a pretext for the assumption of victim status under cover of righteous

indignation. Here the source of empathy's degradation – for giving the Holocaust quasi-sacred status means that we cannot really feel anyone else's pain but our own – is not Enlightenment universalism but its perceived collapse; critics conceive the "culture of victimology" as a symptom of the disintegration of normative frameworks of likeness that permit the proper and properly outraged assessment of injustice.[54]

It is difficult to assess whether an ability to feel empathy across borders is enabled by a "cosmopolitan memory" forged through global media and international travel (in which memorial museum play a small but significant role as attractions), or whether it is in fact because the disastrousness of certain events often reduces victims to a desperate, base humanity that is universally appreciable, precisely because they appear denuded of culture and nation.[55] As Michael Humphrey describes, "in the politics of atrocity, 'homo sacer' is the victim abandoned by the nation-state – i.e., the individual emptied of their citizenship and reduced to their mere humanity or having only human rights (bare life)."[56] Media images of "homo sacer" individuals may invite compassion, but they also have the capacity to provoke fear and repulsion.

A final potential barrier to engendering empathy in the memorial museum involves numbers. A common feature of many memorial museums concerned with violent death is the identification of a number, precise or estimated, of those killed. A large "300,000" stenciled onto the front wall of the Nanjing Memorial Museum is intended to carry great weight. Ostensibly it does, but what does it actually mean? Numbers beyond those we can picture in our minds – perhaps in the area of dozens – default to some enormity where scale is lost and victims become a sheer mass of humanity. As Jim Holt has written: "Where mass scale is concerned, the moral significance of scale seems to be one of those things that our brains aren't equipped to handle. A single life may have infinite value, but the difference between a million deaths and a million and one strikes us as negligible."[57] While quantification implies objectivity, it is not necessarily a guide to our own subjective response to an event. A figure like 300,000 does, in a very real sense, provide the rationale for the institution's existence, yet it requires the elaboration of a narrative to give an event meaning. Hence, the ability to spur conscience is not just a quantitative question reliant on sufficient numbers, but also one that highlights the role of a dramatic "story" – and visual images in particular – in bringing the issue to the world. As a communications medium, museums speak more to the *quality* of experience than to issues of quantity, or to gloss it another way, to memory more easily to history. It is this subject to which I turn in the next chapter.

CONCLUSION: CURATING THE CURATIVE MUSEUM

The remedial turn suggested by the memorial museum promises a fundamentally different form of civic uplift to that historically promised by the general, universalist public museum. That museum model has, as its origins, nineteenth-century ideals

of social reform that sought to draw people away from the turbulence and vices associated with urban life. Public museums were envisaged as places that would encourage contemplation and appreciation rather than base emotion. Through the provision of material examples of a Matthew-Arnold-style vision of the "best that has been thought and said in the world," moral uplift might be achieved. Clearly, memorial museums invert this premise. People are taken away from the comparative safety and pleasures of daily life and immersed in the "worst that has been envisaged and executed." This tactic is significant for several reasons. First, it works with the notion that people can learn as effectively from cautionary tales as from inspirational examples; that the fear and dismay caused by evidence of abhorrence can inspire as much as feats of accomplishment. Yet, secondly, it is not obvious, given their strong emphasis on emotion that "learning" is the best word to describe what occurs in the memorial museum experience. Given the uncertain terrain that abridges curiosity, the personal sense of responsibility that it often felt to "require" a visit, and the gloomy indulgence associated with experiencing the outer limits of human behavior, the less pedagogic category of "experience" might serve us better. Despite the likelihood of memorial museums becoming more socially entrenched and further studied in the near future, an understanding of just *why* people go may continue to evade regular museum visitor studies. The range of motivations – from the merely curious to the deeply committed – that encourage visitors to come are often difficult to articulate. The ambit of feelings with which we depart may be no more communicable.

The overarching dilemma that casts its shadow over this chapter, and this subject more generally, remains: what exactly can we learn from the worst of human experiences? In his review of the U.S. Holocaust Memorial Museum, Philip Gourevitch wrote:

> It was not exactly depression or fear or revulsion that overcame me as I stood before this exhibit. Nor was it that I had seen it all before. The problem was simply that I could not make out the value in going through this. The Holocaust happened – it should be remembered and it should be found repellent. But I felt the way I did when I was a child waking from my nightmare. I know that this is hell and I know that it is true, but the ethical dilemmas and the political choices that I face in my life are not those of the Holocaust. If that should change, and I should find myself in the shoes of any of these brutalized people whose stories surrounded me, nothing I could learn from having studied their plight would help me. I would try not to wind up at the edge of a pit looking down at the corpses whose number I was about to join, but I might wind up there. Along the way, I hope I would try to help others, but I might not have the wherewithal and I might not succeed … The absolute, however, is a treacherous place to seek lessons. By definition, it does not yield. Like the God of Exodus, it is what it is and it shall be what it shall be. For that reason, the absolute is useless as a metaphor. It is incomparable.[58]

To my mind, Gourevitch rightly distinguishes between learning about an event and attempting to internalize that learning to make it a form of memory, on the one hand, and trying to empathize with what victims underwent, on the other. The variety of political, social, and cultural contexts in which atrocious events have occurred might have us ask just what, as a general human populace, we should "never again" do. Should we never again be victims, or never again act as perpetrators? Should we never again succumb to an invading army? Never again support an undemocratic government? Never again allow ourselves to be unarmed and defenseless? Never again watch tragedy unfold from afar? Never again allow ourselves to act on negative human emotions? A general refocusing on tolerant values is perhaps the most often-cited *raison d'être* for memorial museums. Yet, as the now-routinely articulated counter-cliché to "never again" charges: all manner of post-Holocaust events cited in this book were not prevented by the formative memory practices associated with that event. What is it that now encourages us to surmise that a slew of new institutions might overturn this inauspicious legacy of repeating the past?

7 LOOMING DISASTER: MEMORIAL MUSEUMS AND THE SHAPING OF HISTORIC CONSCIOUSNESS

EXPLAINING THE INEXPLICABLE

Any public history project that tries to interpret or explain mass death and injury must contend with a central philosophical problem: the enormity and severity involved in the purposeful destruction of so many lives threatens to defy comprehension. Museums can of course teach us certain facts, such as the identity of the perpetrators, what motivated them, how they carried out their agenda, and to what effect. However, by drawing on standard historiographical categories of inquiry, the event in question is placed within the path of conventional history, which risks normalizing what occurred. How, to put it plainly, could any causes make such extreme outcomes rational or explicable? It has been noted that literature, photography, and art have their own genre limitations, and struggle to do more than signify or gesture toward atrocity.[1] When the 1957 International Committee of Auschwitz assembled a panel to choose a monument for the site, its chair, Henry Moore, found himself lost: "Is it in fact possible to create a work of art that can express the emotions engendered by Auschwitz?"[2] Genocide is often described as "inhuman." This label may be a reflex in the face of unspeakable acts, but it also is a kind of linguistic surrender. After all, and conversely, all atrocious events are an undeniable part of human history – murderous decisions were made in every case not in a vacuum but within a comprehensible social climate. Hence, as a basis for analysis, we should recognize both the possibilities and the representational limits of memorial museums, which can do nothing so complete as recapture the past. Instead they might be considered as an *aide memoire* for events that somehow both challenge our notion of human behavior *and* constitute some of its fundamental historical and cultural signposts.

The rapid escalation in the development of memorial museums over the past twenty years inevitably sees them play an increasingly important role in the shaping of public historical consciousness. As an ephemeral, unscientific phenomenon, "historical consciousness" is maddeningly indefinite in its identification and quantification (much like its cousin "collective memory," which we shall come to later). Theoretical discussions of their meaning are matters of academic reckoning that, although captivating, cannot be awarded their due space here. Rather than exploring the arguments over just what "historical consciousness" entails, I will concentrate on both how it functions as a form of thought influencing interpretation at memorial museums, and, in turn, how memorial museums play a small but significant role in

its formation. Previous chapters provided a description of the concrete reasons spurring certain individuals, groups, and governments to create memorials for certain events. This one instead seeks to investigate the effect on historical understanding of the heavy memorialization of some events, and the comparative disregard of others.

Historical consciousness is strongly influenced by cultural projects and products that serve to remember for us. Museums, memorials, and archives (along with TV and film, journalism and literature, art and theater, and diaries, albums, and websites) each possess their own genre-specific design elements and narrative conventions. They are also all equally organized around a broader human need to make sense of events through structure and arrangement. Hannah Arendt made the case that these narrative conventions (which she calls "stories") are organized to retrospectively define the contours of what occurred: "The story reveals the meaning of what otherwise would remain an unbearable sequence of sheer happenings ... storytelling reveals meaning without committing the error of defining it and brings about ... reconciliation with things as they really are. Stories tell again and again how at the end we shall be privileged to judge."[3] Event narratives are possible if the historical sequence exist above a "threshold of fragmentation, below which an event dissolves," as she put it.[4] These narratives are formed not so much in scholarly writing, but in myriad media and popular culture events, in accounts established through religious credenda, and through the subcultural stories of ethno-cultural groups. The recounting of historical events does not realistically recoup the past, the bulk of which was never precisely appreciated beyond its moment – let alone recorded – but instead produces, in different ways and in different registers, "the fiction of its facticity."[5] As sites that incorporate elements from and provide an interface for all of these fields – the scholarly, popular, spiritual, and ethno-cultural – memorial museums must aim to make sense of the "unbearable sequence of sheer happenings" for a broad audience.

When visiting a memorial museum, the theme of historical distance is crucial, and one not simply reducible to the duration between the time of the event and the present. We construct relations of intimacy and detachment to an event based on the affinity we feel it holds for personal and group identities. It is the museum's task to decide how – or whether – to make past moments close and pressing to the observing visitor in order to intensify its emotional impact.[6] In history books a key tactic might involve the use of close description as a way of engaging readers' sympathies. Museums have a more varied and conspicuous range of tactics – including their site, original artifacts, photographs, audio-visual testimony, and recreated *mise en scène*. While relatively few people outside the university are aware of recent shifts in the style and content of academic history, more could probably describe the changing face of displays in history museums. Indeed, while their relation can be complementary, there are important differences between academic scholarship and content in memorial museums. Most obviously, the level of complexity in academic texts is not amenable to museums, which typically avoid a "book on the wall" approach and aim to produce a less complicated historical story, using available artifacts and images for

illustration. Museums normally struggle to show, through their relatively static displays, historical ambiguity or debates over facts. The need for narrative unity also makes the traversing of geographical space and the back-and-forth between periods (possible in texts) very difficult in history museums. Yet unlike historical texts, museums are (admittedly, to different degrees) self-consciously involved in recording, analyzing, and responding to visitor responses. They are sensitive to the way the story is told and can amend it where needed: to what subjects or displays are visitors drawn? Which are skipped past? What topic should we cover next, and which artifacts and explanatory devices will best aid our desired interpretation? While a case-by-case study of these tactics is beyond the scope of this book, memorial museums add something important to the philosophical consideration of historical understanding: concrete sites that can (albeit unscientifically) gauge the shifting interest in any topic. Before proceeding to investigate this issue, I want briefly to describe some background scholarship on the relation between history and collective consciousness in order to provide contours for this nebulous subject area.

ON THE FORMATION OF HISTORICAL CONSCIOUSNESS

The formation of historical consciousness can itself be understood as a historical phenomenon. John Lukacs, for instance, has influentially posited that the awareness that every human activity could be studied historically (including the study of history) dates from the early nineteenth century, where the idea of history as science gradually replaced the idea of history as a predominantly philosophical or literary concern.[7] This time period, not coincidentally I would hazard, was also the age of the birth of the modern public museum. The nineteenth century saw a particular passion for various forms of commemoration, whether to be found on portable items like coins, postage stamps, medals, statuary, and souvenirs, or in the creation and rapid proliferation of public museums, libraries, and archives. Although these institutions were primarily concerned with art and natural history (social history would came later), the typological and taxonomic arrangement of things, many of which could no longer be found in the world, meant that objects were displayed "with a view towards rendering present and visible that which is absent and invisible: the past history of a particular people, nation, region or social group."[8] By showing how ruins and relics could be organized into a scientifically ordered way of explaining (and lamenting) how things had existed in the past, museum displays must have represented a minor watershed in the formation of popular historical consciousness. As John Czaplicka has put it:

> The historicist impulse was evident in the nineteenth-century obsession with musealization, monumentalization, with the "invention of tradition," and with the quest for the sources of an active principle in the history of states. Cultural history, as Lamprecht defined it in 1896, was *histoire total*: the epochal and morphologically constitutive elements of a nation's collective biography.[9]

In the more contemporary post-Second World War period, we are confronted by events that represent the rupturing of unified nationalist cultural histories. Where the horror of combat in the First World War was certainly shocking, the Second World War dissolved much of the bloody hard-fought optimism that remained. As Jay Winter has asserted, "before 1939, before the Death Camps, and the thermonuclear clouds, most men and women were still able to reach back to their 'traditional' cultural heritage to express amazement and anger, bewilderment and compassion, in the face of war and the losses it brought in its wake."[10] The unprecedented nature and scale of the atomic bomb, the Holocaust, the Nanjing Massacre, and suchlike thoroughly defeated previous associations of death with patriotic glory. If national museums created in the nineteenth century were concerned with building nationhood by displaying objects that communicated an immemorial past, the emergence of memorial museums in the last decades of the twentieth century may have hastened an awareness of the cracks and falsehoods of cultural and national unity. This is not to say that memorial museums are post-nationalist in orientation; a striking message found in many is not just their appeal to ethnic "memory groups," but their dedication to national reconciliation.

Morality is a topic that not only hangs over all memorial museums, whether representing disasters associated with fascism, communism, imperialism, or industrialism, but has also emerged as a way of understanding the entire twentieth century. As Jonathan Glover wrote:

> Immanuel Kant had written of the two things which fill the mind with admiration and awe, "the starry heavens above me and the moral law within me." In Cambridge in 1895, a century after Kant, Lord Acton still had no doubts: "Opinions alter, manners change, creeds rise and fall, but the moral law is written on the tablets of eternity." At the start of the twentieth century, reflective Europeans were also able to believe in moral progress, and to see human viciousness and barbarism as in retreat. At the end of the century, it is hard to be confident either about the moral law or about moral progress.[11]

Many share Isaiah Berlin's declaration of the century as "the worst we have ever had …" or Kerwin Klein's related view that "our epoch has been uniquely structured by trauma."[12] A number of seminal thinkers have contributed to an understanding of the role that modern historical "progress" (particularly in the physical and social sciences) has played in producing moral crisis by facilitating and even driving dehumanization and mass murder. I have in mind Max Horkheimer and Theodor Adorno's argument that technological rationality helped to produce the menace of fascism, and that the banality of the media and culture industries allowed citizens to slip into the barbarism anticipated in Nietzschean nightmares. Consider also Zygmunt Bauman's similar sense that it was the mindset and conditions of modernity (such as urban decentralization, social privatization, and social alienation) that allowed ordinarily non-cruel people to do unconscionable things amid the Holocaust. We might also bear in mind Michel Foucault's account of the way that a

modern technological rationality has allowed and encouraged new forms of state control through surveillance and repressive incarceration.[13]

A less historically situated, more philosophical account of the construction of historical consciousness is found in Reinhart Koselleck's seminal study *Futures Past: On the Semantics of Historical Time*. Rather than seeing events as simply occurring along an empty historical plane, he is interested in the impact that understandings of time had on influencing and even *producing* events. For Koselleck, the French Revolution and the European industrial revolution disrupted the logic of pre-modern memory, where, as he generalizes, "nothing particularly new could happen."[14] Where previously the present and past were seen as being enveloped in a common historical plane where lives were played out in a cycle very similar to those that preceded them, beginning in the late eighteenth century these radical developments opened up a gap between what Koselleck calls the "space of experience" and the "horizon of expectation." By retrospectively imposing periodicity on linear time and conceiving the present as a point of transition moving towards an uncertain future, the notion of historical time began to be standardized. As Koselleck describes, "contemporaries increasingly shared an awareness of the eruption of new time and therefore could retrospectively endow events such as the French Revolution with universal significance. It was in the very casualness of references to recognizable markers such as '1789' or even ''89' that the new temporal order revealed itself."[15] Upheavals and atrocities have come to form potent markers in thinking about linear history ever since (and indeed, 200 years after 1789, another '89 has again produced a marker of "before and after" historicity).

Pierre Nora is interested in how historical events have been produced in concrete form. In his seven-volume *Les Lieux de Memoire,* Nora works from the premise that these representations are a pale substitute for both authentic experience and living traditions. He distinguishes between the social milieu of memory and the *lieux de memoire* – the physical sites established to preserve the memory of events. In his view, these exist because the social environment where the event would otherwise be part of everyday memory has disappeared. For Nora, the acceleration of history means that "things tumble with increasing rapidity into an irretrievable past," and that "the warmth of tradition," "the silence of custom," and "the repetition of the ancestral" have disappeared as a result. He suggests that interest in the past emerges, paradoxically, at exactly the moment when tradition falls apart. "Memory is constantly on our lips," Nora writes, "because it no longer exists."[16]

> The "acceleration of history," then, confronts us with the brutal realization of the difference between real memory – social and unviolated, exemplified in but also retained as the secret of so-called primitive or archaic societies – and history, which is how our hopelessly forgetful modern societies, propelled by change, organize the past. On the one hand, we find an integrated, dictatorial memory – unself-conscious, commanding, all-powerful, spontaneously actualizing, a memory without a past that ceaselessly reinvents tradition, linking the history of

its ancestors to the undifferentiated time of heroes, origins and myths – and on the other hand, our memory, nothing more in fact than sifted and sorted historical traces. The gulf between the two has deepened in modern times with the growing belief in a right, a capacity, and even a duty to change.[17]

The sharp distinction that Nora draws between societies that once lived contentedly and unconsciously with a traditional past, and those that feel the need to expend effort in artificially constructing heritage, has been criticized from a number of directions.[18] While Nora's analysis reflects a melancholic sensibility based on the conjectural notion that we live in a time of historical amnesia, his historicization does usefully posit that the passing of a tight-knit, organic community supportive of "natural" memory may be a root cause of the need to reassert the existence of historically-informed cultural identities in current times.

Rather than linger on Nora's nostalgia-laden account of modern realms of memory, my interest lies with the contemporary transnational cross-referencing of historical atrocities. By this I mean not only that events are made sense of in relation to one another, but further, that they are *self-consciously* pulled from their periodicity and, as a moral-historical lesson, made to dwell in the present. (This outcome is reflected in the conflation of the twin mantras of memorial museums – "never again" and "never forget".) Tony Myers has nimbly explained the way that modern historical time produces in any subject a strong sense of living in the present, yet at the same time being aware of one's self-conscious role in witnessing histories to be recounted in the future:

> Paradoxically, then, at the point of time's historicization time ceases to be historical. For, in becoming less the medium of history and more a historical medium, time is subject to the split of self-reflexivity. Thus, in rounding upon itself, as it were, time privileges synchrony over diachrony, the loop of history over its linear counterpart. This substantial mutation in one of the paradigmatic coordinates of existence finds its registration in the very term "modernity," for what is articulated in that term is precisely a temporal self-reflexivity.[19]

Koselleck is similarly quite aware of the temporal synchronicity of modern times. One of his key ideas is that any particular present is simultaneously a "former future" that was once envisioned through particular themes and ideas. This puts an interesting spin on what it is that memorial museums try to do: rather than simply "representing history," many memorial museums are entangled in the historicist enterprise of *debunking a future that was to be.* That is, they seek to defeat not only the legitimacy of what a leader, regime, or group did, but also, implicitly, the society they had planned. In cases where there is a relatively clear sense of a future that was never played out as perpetrators had plotted, the memorial museum can more easily stand as the defeat of that future's past. (This is perhaps another way of saying that the schemes of incumbent victors are seldom subjected to the historical scrutiny practiced by memorial museums.) Yet, as readers of the recently popular "virtual" or

"counterfactual" histories might appreciate, the fact that something was enacted (even if we now say it "failed") has its historical flow-on effects that cannot be divorced from how we have arrived in the present. Indeed, in trying to decide whether memorial museums are better seen as a counter-force to the future that was planned, or in fact an outcome of that planned future, it is best to conclude that they unavoidably represent both.

While we understand that several generations ago, visitors did not arrive at museums with the kind of politicized subject position that we now understand as being part of "identity politics," they clearly had other socially informed frameworks for understanding the past. We might muse: without instant, global media, was it only an absence of awareness of terrible events that enabled people to live without projects like memorial museums? Consider an example: as debate about the World Trade Center Memorial continues to flare, it has not gone without remark that the nine-meter granite fountain memorial for the six killed in the 1993 bombing, which was also destroyed on 9/11, potentially represents a symbolic effacing of memory. Much less mentioned, however, is another terrorist attack that occurred a few blocks away. On September 16, 1920, a horse-drawn wagon filled with around 100 kilograms of broken-up window sash weights was abandoned on Wall Street in the middle of the day, then detonated. The blast killed 39 and wounded 300. No person or group claimed responsibility, and no one was ever charged with the crime. While pockmarks from the shrapnel are still easily visible on nearby buildings, no memorial or plaque has ever been erected. Today this same act of American terrorism would, with little doubt or equivocation, be made the subject of a memorial. Was there some understood collective lack of psychological need in that earlier period? Or was there a practical sense among citizens and city officials that any act of commemoration would not achieve much, and would be a waste of resources? To turn the question around then: what is it, philosophically speaking, that makes us today want to create, support, and live with permanent, concrete markers of violence?

ON THE CONTEMPORARY NEED TO REMEMBER

Once the preserve of psychology, the study of memory now extends to fields like anthropology, sociology, cultural studies, geography, literary studies, and history. This expanded academic interest over the past couple of decades has created what scholars call the "memory boom."[20] In broader society, memory discourses have also become a marked feature of narratives enjoyed in cultural institutions and popular entertainment alike. There is, however, little consensus about exactly why this surge in interest in public remembering has come about. Kenneth Foote has identified that the earliest public memorial for non-war-related killing in the U.S.A. is as recent as 1990 (commemorating the victims of a 1984 shooting that killed twenty-one people in a McDonald's restaurant in San Ysidro, California).[21] In that same year, the 1970 Kent State University shootings were memorialized in the form of a progression of four polished black granite disks embedded in the earth on a plaza leading up to four

free-standing pylons aligned on a hill. Foote fails to suggest any grounds for this sea change. While such shifts are admittedly difficult to pin down, it is worth proposing a few ideas (which pertain predominantly to the American context, with which I am most familiar).

One relates to the size and visibility of atrocities. The Oklahoma City and 9/11 attacks are significant on any scale, and loom especially large in the public consciousness. They have become often-cited, now-enduring reference points in the news media for all manner of events and would-be dangers. At the same time, such events have occurred against a backdrop of *decreasing* international conflict. *Peace and Conflict 2005*, the biennial survey published by the University of Maryland, reported that the number and intensity of armed conflict has again fallen, continuing a fifteen-year decline that has seen the amount of violence around the world halved.[22] This same period has seen the sharp upsurge in the number of memorial museums. This combination of phenomena suggests something akin to Gregg Easterbrook's concept of the "progress paradox": the better life gets, the worse people feel.[23] Could it be that increasing peacefulness allows us to fixate on violence (and related security threats)? Is it coincidental that, in the U.S.A., the decade before 2001 that saw the boom in memorial museums was also unusually peaceful?

A number of memorial museums have been created since the 1989 "Autumn of Nations" revolutions. With the end of the Cold War, the floodgates opened for the broad reassessment of histories in a number of nations. Most obviously, former Eastern bloc territories like Lithuania, Romania, Hungary, Poland, and Estonia have recently developed important memorial museums that aim to uncover both Nazi and Communist Party state repression. The reunification of Germany has similarly permitted the growth of museums and historical sites dedicated to "mastering the Nazi past." It has "opened up spaces in which it is possible for Germans – and others who study Germany – to describe a past in which Germans committed unspeakable acts of barbarism *and* suffered enormous losses without creating false equations."[24] The expansion of U.S. interests in Latin America during the "late Cold War" aided regimes that sought and carried out the political "disappearances" of those believed to be leftist dissidents. It was, similarly, only after the transition to democracy in the mid-1980s in Argentina, and about a decade later in Chile, that people of those nations have gained the opportunity to confront "Dirty War" crimes. The end of apartheid and the Chernobyl disaster are also events contemporaneous with the end of the Cold War that have produced museums in South Africa and the Ukraine.

Less directly, the American willingness to produce memorial museums that depict its harming (particularly from within, such as the Oklahoma City bombing) might also be considered an outcome of the post-Cold War period, given that it may suggest a lesser need to display images of national strength. Recent years have seen a gradual shift in mainstream heritage-based tourist visitation away from celebrated civic sites like Mount Vernon, Independence Hall, and Boston's Freedom Trail, to those both more frivolous (such as Elvis Presley's Graceland) and less glorious (such as the Vietnam Veterans' Memorial, or the Japanese-American Internment Memorial at

Manzanar, California).[25] Many public events that have caused grief in the post-Cold War period, including mass murder, terrorism from within and without, natural disasters, and wars of uncertain consequence, cannot be comfortably incorporated within nationalist history. Erika Doss has similarly identified a decline in support for nationalistic historical rituals like Memorial Day in favor of more emotive recent events that allow more personalized responses. Disturbing events recognized in civic spaces may be valued by many for their ability to support catharsis, reflection, and redemption:

> An American public that is often hesitant and fearful about death and dying has equated the visual and material culture of grief with the transformative milieu of the sacred, that which Georges Bataille defined as "perhaps the most ungraspable thing that has been produced between men," as a "privileged moment of cultural unity, a moment of convulsive communication of what is ordinarily stifled."[26]

The growing willingness among public figures to speak emotionally about loss may have also influenced American public culture. Although now a cliché, Bill Clinton's "I feel your pain" catchphrase, which entered public consciousness during his 1992 presidential campaign, emphasized the performance of sympathy over more substantial, decision-oriented responses. Such a discourse may have encouraged the extension of ideas about "working through" and "healing" to include those who never actually directly experienced an event (we can see this in the notion of "America" being traumatized by 9/11). The expansion of those who consider themselves affected possibly adds to the viability of memorial museums worldwide, as they come to serve a global, cosmopolitan culture sympathetic to loss.

Nevertheless, it has been little determined what part memorial museums actually play in this process (as a prospective "rehabilitative step"). We tend to accept faithfully the premise that tragedies are better remembered than forgotten, and that remembering as a community activity is a rich and meaningful act. Observing the aftermath of the Oklahoma City bombing, Edward Linenthal wrote:

> Once again, tremendous solace was taken in being a member of an imagined bereaved community, as people were "enfranchised" to enter into this shattering event by the pseudo-intimacy of media connection. Bereavement perhaps, is one of the only ways that Americans can imagine themselves as "one," a condition that seemingly trumps divisions of race, class, gender, and ideology.[27]

Civic renewal – the coming together, rebuilding, and refocusing on positive values – has emerged as a favored response among Americans in the wake of a terrible event. Transferred to a society-wide level, the unremitting rise and acceptance of a culture of therapy (and its attendant discourses of "working through" loss and "achieving closure") allows many to feel that memorial sites and museums are a socially appropriate place to explore personal feelings of sadness and bereavement. Erika Doss has argued that, "Oklahoma City and Colorado's [Columbine High School massacre]

memorials elided the historical realities that produced them, largely because of contemporary assumptions that grieving, in and of itself, is a prescriptive political practice."[28] Although some may view this development as symptomatic of a culture of emotional indulgence, the growing appeal of memorial museums might instead be due to the coming together of two trends over the past couple of decades – a new passion for memory, and a new wave of spirituality, which has produced what Barbara Misztal calls the "sacralization of memory."[29] Misztal is interested in how "the decline in the role of national and religious memories as stable sources of identity reopens the space for search for both authentic identities and useable pasts."[30] Misztal's description of the search for memory involves a new understanding of the sacred that reflects the shift from "an imagery of dwelling," most suited to settled times of social security, to an imagery of journeying, "which is conducive to our present unsettled times."[31] "Journeying" is less physical than metaphorical; the search for a sense of self, suggests Misztal, is increasingly conducted through a notion of personal spirituality, yet also seeks grounding in the history of some group identity.

The danger, of course, is that the attribution of sacredness to memory can see the past harden into myth, particularly when that memory is narrated and understood *en masse* by a cultural or national collectivity. As Duncan Bell has written:

> All the different modes of theorizing [memory] rely on the centrality of nationalist story-telling, on the evocative narration of the links between past, present and future. It is in this space that many theorists of nationalism fall back on discussions of "memory"; and it is also here that the centrality of myth-making in the explanatory schemas of the otherwise poly-vocal theories of nationalism is demonstrated clearly.[32]

In retrospectively re-narrating the details of an event, individuals and museums alike tend to restate the significance of what was endured – and often narrow and simplify its interpretation. This can be illustrated by an example from recent memory. Although now largely eclipsed, in New York shortly after 9/11, diverse, uncertain, conflicting interpretations of the event were explored in everyday civic dialogue. Much of this sense of equivocation and insecurity has subsided as a result of both the passing of time and the reiteration of official historical narratives. Indeed, an enormous amount of official "memory work" has been devoted to the negotiation of those meanings and to the construction of what is now treated as the "unified" reaction of New Yorkers, and Americans and the world. The rhetoric used to characterize 9/11 in the mainstream trades on sacred archetypes: Ground Zero is "sacred ground"; the evocation of New York's "finest" and "bravest" has reasserted images of masculine heroes (*heros* from the Greek "God-person") protecting against "evil"; "innocent" children (sometimes "angels") are lamented as "victims" simply for having had to learn of the event; all of these are enveloped within an ever-threatening "war on terror." As Michael Hyde has written: "Heroes and conscience go hand in hand. Heroes provide the material that directs a society's moral compass, offers instructions for understanding what human greatness is, and thereby informs the members of the

society about what it takes for a finite being to live on after death in the hearts and minds of others."[33] The language and themes used to construct what is a now sacred national memory has placed the event almost beyond dispute, allowing it to harden into myth.

This theme of cultural "mythscapes" is central to another explanation for the "memory boom." The ability to understand personal identity within an ethnic-cultural category significantly relies on the recitation of root "memories" that are said to lie at the heart of group experiences. As Benedict Anderson explains, identity is a way of categorizing experience that is itself necessitated because we cannot ever fully live or know a cultural passing of time: "As with modern persons, so it is with nations. Awareness of being embedded in secular, serial time, with all its implications of continuity, yet of 'forgetting' the experience of this continuity … engenders the need for a narrative of identity."[34] Stuart Hall similarly states that, "identities are the names we give to the different ways we are positioned by, and position ourselves in, the narratives of the past."[35] The will to remember an event appears to be closely associated with whether there exists an ethnic or cultural group that views it as a constitutive aspect of its identity. It is not imperative that most members of the group were directly involved in the event; it is the adoption of that past that is important. This "sociobiographical memory," as Jeffrey Olick and Joyce Robbins call it, is the "mechanism through which we feel pride, pain, or shame with regard to events that happened to our groups before we joined them."[36] Many who never experienced an event first-hand may visit museums to fulfill a need to adopt and develop what Marianne Hirsch has called "postmemory":

> The term "postmemory" is meant to convey its temporal and qualitative difference from survivor memory, its secondary, or second-generation memory quality, its basis in displacement, its vicariousness and belatedness. Postmemory is a powerful form of memory precisely because its connection to its object or source is mediated not through recollection but through representation, projection, and creation – often based on silence rather than speech, on the invisible rather than the visible. That is not, of course, to say that survivor memory itself is unmediated, but that it is more directly – chronologically – connected to the past.[37]

A current example of the exertion of postmemory involves the 1915 Armenian genocide, which has vividly re-emerged in public consciousness over the past decade. April 24, 2005, the ninetieth anniversary of the day when the government of Ottoman Turkey initiated the violence by assembling, deporting or executing about 250 leaders of the empire's Armenian community, saw an extraordinary hundreds of thousands of Armenians trek to the hilltop to the Yerevan Tsitsernakaberd Memorial. On that day I witnessed some 8,000 to 10,000 people pack New York's Times Square. Anecdotal accounts suggest that perhaps 6,000 were non-Armenians, and that these numbers represent a significant increase over earlier anniversary protests.[38] Similarly, memorial museum plans for the Ukrainian Holodomor (the 1932–3 famine that

killed between five and ten million, and is generally considered to have been a deliberate Stalinist genocidal program) have recently gained traction. The government competition for a Holodomor complex to be situated in a botanical garden on the banks of the Dnipro River in Kiev produced significant national debate about suitable design. Such was the level of deliberation about the proposed location (which some claimed would remain dominated by the existing Second World War obelisk on top of the hill), the preponderance of two key images (crucifixes and bushels of grain) and the display of forms of "vulgar nationalism" in several submissions, that of the thirteen projects presented, controversially, no winner was awarded. The competition has now been reopened, and has received a new flood of submissions.[39] It appears that, fifteen years after its split from the USSR, Ukrainian national "postmemory" is, like that of the Armenians, ripe for being re-narrated as a modern foundation for collective memory.

The phenomenon wherein members of ethnic groups increasingly claim the memory of suffering as a sacred asset is one that upsets those who see the value of history as being in its values of causality and accuracy, and its basic capacity for disputation. For instance, Charles Maier has written:

> The surfeit of memory is a sign not of historical confidence but of a retreat from transformative politics. It testifies to the loss of a future orientation, of progress towards civic enfranchisement and growing equality ... The program for this new ethnicity is as symbolic as it is substantive. It aspires preeminently to the recognition by other groups of its own suffering and victimhood. Finally, it cathects to landscape and territory because territoriality has been abandoned as a physical arena for civic action and is nurtured instead as an enclave of historicism.[40]

Meier and others are concerned at how existence is understood as a function of possession: we are a nation or ethnic group because we have a culture (and historical examples of this culture can be displayed in institutions like museums). The idea of cultural identity as an inalienable possession (expressed by the notion of "cultural property") works with the premise that objects are not just experienced subjectively as external to the self but are defining constituents of it.[41] In situations where this principle hardens into ideas about who has the "right" to establish the meaning of any event, or, by proxy, to build a museum, some fear we approach a state of affairs akin to the "ghettoization of history."

The circumscription of certain events as "belonging" to an identity group takes place in a competitive political field – a factor that undoubtedly contributes to the self-perpetuating growth of memorial museums. In much the same way as major American cities felt the pressing need to open a major art museum in the latter half of the nineteenth century in order to compete with those already established, the creation of a key institution like the U.S. Holocaust Memorial Museum in Washington, DC has spurred other cities to create their own. Further, following the marking of the Holocaust, other historically aggrieved groups have aspired to similar

recognition (the Armenian American community has recently secured a space near the Mall to commemorate its own genocide, for instance). Memorial museums have a seemingly natural fit with ethno-cultural identity groups, since they are focused on experiences of historical persecution, and can advertise to the rest of the world that such maltreatment has taken place. Public and political recognition by others is, after all, a factor basic to the validity of group identities.[42]

A final factor accounting for the memorial museum boom may be the spread of "musealization." This phrase was first posited by Hermann Lübbe in the early 1980s to describe the aura that any object gains once it has been turned into something worthy of consideration as a singular, aesthetic, historically loaded artifact.[43] Practices of collection, preservation, and display have been expanded to include topics and geographies otherwise perceived to be extra-museological, Lübbe posited that this fetishization of more and more aspects of the past aims to compensate for "the atrophy of valid traditions, the loss of rationality, and the entropy of stable and lasting life experiences" that had accompanied the collapse of the Enlightenment project after Auschwitz.[44] Crucially, Lübbe published his ideas during the period characterized by the growth in memory discourses in the U.S.A. This saw a broadened public debate about Holocaust perpetrators, victims and bystanders, spurred by the attention media paid to the fortieth and fiftieth anniversaries of events in the history of the Third Reich, along with the film *Shoah,* the network television series *Holocaust*, and the advancement of the survivor testimony/oral history movement, to name the best-known influences.[45] That Lübbe saw the Holocaust as both the emblematic cause of modern alienation, and yet also the key source of new memory projects, suggests to us that the combination of historic atrocity and personal memory bond as an uncommonly striking new basis for commemoration.

MEMORY SKEPTICS

While we can account for this "memory boom" through a cluster of causes – the Cold War, therapy culture, ethnic identity discourses, institutional perpetuation – we should take seriously the idea that it does not necessarily exist in a perfect fit with the memorial museum. Some critics are understandably wary of a view that holds memorial and museum structures (and the cultural-historical objects they contain) to be a straightforward and direct manifestation or expression of memory. Looking at Edwin Lutyens's grand First World War Thiepval Memorial on the Somme, Samuel Hynes reflected that "no pile of brick and stones can cause us to remember what we have not seen."[46] Kerwin Klein has also asked whether it is precisely the public and symbolic presence of objects in museums (and perhaps especially those related to personhood, such as a diary, or a style of clothing, perhaps) that make possible the "analogous leap" from memory in its individual form, to "Memory" as a public outcome.[47] The conflation of the personal and social might remind us of the increasing tendency, in both academic discourse and popular culture, to transfer the Freudian language of personal trauma (such as "working through") to a society-wide

level. Beyond rhetoric, we have only a fuzzy awareness of how collective responses to social trauma actually work, whether there is sufficient unity in peoples' responses to make the notion worthwhile, and, critically, whether concrete spaces like memorials and museums are effective social spaces for aiding reconciliation. Would those most damaged be willing or able to visit a site that not only recounts the details of the event (in ways that may conflict with a personal sense of what occurred), but also places them within a highly visible space where they may feel especially conspicuous?

A nagging conjecture surrounding memorial museums is that (as much writing on trauma suggests) memories may be no more likely to be stirred or recalled by a constructed display than by other miscellaneous sites of everyday life (and their feel, smell, and sound). As Pierre Sorlin has put it:

> Trying to "explore" personal memories is almost hopeless, even when people have written their memoirs, for all remembrances are shaped by a complex of data and ideas which includes rumour, lessons learned at school, monuments, and media. What is more, all kinds of remembrance are neither monolithically installed nor everywhere believed. They are in a constant state of rearrangement under the pressure of competing sources of information often in conflict with each other: produced in the course of these struggles, remembrance can always be questioned.[48]

Bearing this out, we might consider the memoirs of Austrian philosopher Paul Feyerabend who, in a matter-of-fact style, wrote: "During the Nazi period I paid little attention to the general talk about Jews, communism, the Bolshevik threat; I did not accept it, I did not oppose it; the words came and went, apparently without effect."[49] It was only later, and on reflection, that these things came to assume gravitas and certainty for Feyerabend.

In their collective focus and objective style of narration, history museums have a tendency to encourage the view that no matter its impact on any single life, everyone who lived through an event was largely defined by it. In the recorded testimony often presented in audio-visual programs, individual memory is obviously strategically useful for its ability to express first-hand witnessing. Yet any individual's words and ideas may be shaped by, edited within, and made secondary to the event structure imposed by the museum. Remembering, either as a personal or institutional act, can of course never absolutely recall all known aspects of the past. Elements are bypassed as a narrative of "how it happened" is solidified; hence, remembering is also about the rejection of aspects of a narrative that could not be made to fit. Adam Phillips has written deftly about the internal negotiations and contradictions that should give pause to any reflexive platitudes imploring "the need to remember:"

> Our (modern) fear is that we won't get our forgetting right, or that forgetting is not possible; it may, of course, be a wish that atrocities cannot be forgotten; that we cannot bear ourselves as creatures who could actually forget such things. We tend to forget experiences that are too much for us, that are, in the reductive

language of psychology either too pleasurable or too painful. We equate the forgettable with the trivial or the unbearable; and in this picture we have a place to put the unbearable; but by the same token we believe that it (the memory, the experience, the desire) is still there, somewhere, and capable of returning. And we have a place for the trivial where it is effectively disposed of ("remembering everything is a form of madness," one of the characters in Brian Friel's *Translations* says). There is haunting and there is discarding; and it is not always within our gift to decide which is which. And it is this, perhaps above all, that makes forcing people to remember – rather like forcing them to eat – at once so implausible, and so morally problematic.[50]

The issue of how to make people remember is one at the heart of the memorial museum (aspects I cover through earlier chapters on the object, image, and location). As well we being a question of interpretive tactics, it is also one, as Phillips suggests, of degree.

The current period sees widespread skepticism, cynicism and even conspiracy theories gather round national, foundational, "official" histories. An accent on memory instead appears to offer something more grassroots, organic, and communal. Kerwin Klein has made a similar observation:

> It is no accident that our sudden fascination with memory goes hand in hand with postmodern reckonings of history as the marching black boot and of historical consciousness as an oppressive fiction. Memory can come to the fore in an age of historiographical crisis precisely because it figures as a therapeutic alternative to historical discourse.[51]

The "marching black boot" is indeed an apt symbolic description of political persecution and atrocity. It is not surprising then that an alternative, more intimate memory discourse that wrests power from a powerful or violent regime (and those who would write its grand histories or produce displays for them in war museums) is highly appealing. But where is the memorial museum positioned in relation to this "black boot?" Can memorial museums totally dissociate themselves from the connotative allegiances that political museums hold as Gramscian agents of hegemony? That is, while most would imagine themselves sharing a kindred allegiance with the community center, they remain politically motivated institutions, and many are overseen by state departments. As various examples in Chapter 5 illustrated, memorial museums cannot always be viewed as supporting critical, oppositional memory; as a political tool, commemoration can as easily designed to attract support for conservative or reactionary movements.

Furthermore, memorial museums have emerged on the cultural landscape at a time when some express doubt about the role that brick and mortar institutions can play in making history transformative. M. Christine Boyer, for instance, believes that, "By now, traditions have become so thoroughly 'invented' or homogenized, and 'history' so absolutely marketed or commodified misrepresented, or rendered

invisible, that any oppositional potential rooted in collective memory has been eclipsed completely."[52] Tiffany Jenkins, by contrast, sees memorial museums not as politically impotent, but as a symptom of cultural dysfunction: "this mania for memorial museums is a sign of a society with an unhealthy obsession. These new museums indicate a desire to elevate the worst aspects of mankind's history as a way to understand humanity today. Our pessimism-tinted spectacles distort how we interpret the past." These "cabinets of misery," she continues, reflect a "bleak outlook that sees humanity as constantly at the mercy of arbitrary violence." Finally, she suggests that we might "forget the sort of remembering that replaces tradition, Kings and Queens with a theatre of trauma."[53] In their more balanced account, Lennon and Foley also see the memorial museum as a pessimistic reflection of post-modern society. They posit that representations of disastrous events produce anxiety about "the key tenets of ... modernity such as progress, rationality, science, technology, industralization and liberal democracy."[54] Lennon and Foley characterize memorial sites largely in terms of the unease they arouse in tourists. "Darkness" is the point; they identify little else that is socially beneficial. In their account of tourists visiting a former Barbadian slave plantation, Dann and Potter also embrace this theme of anomie. Tourists, they assert, are "yearning for a past they can no longer find in their own social settings. Unable to tolerate their present alienated condition, and ever fearful of the future, they seek solace in days gone-by world where it was once possible to distinguish right from wrong ... pleasure from pain."[55] Andreas Huyssen has interpreted the current fascination with the memory of tragic events in more nuanced ways. He believes that a focus on such extreme histories may be precisely due to a modern fear of forgetting:

> Our secular culture today, obsessed with memory as it is, is also somehow in the grips of a fear, even a terror, of forgetting. This fear of forgetting articulates itself paradigmatically around issues of the Holocaust in Europe and the United States or of the desaparecidos in Latin America ... the more we are asked to remember in the wake of the information explosion and the marketing of memory, the more we seem to be in danger of forgetting and the stronger the need to forget. At issue is the distinction between usable pasts and disposable data. My hypothesis here is that we try to counteract this fear and danger of forgetting with survival strategies of public and private memorialization.[56]

Huyssen sees Holocaust museums as providing a permanent and fixed reference point in a late capitalist era in which time and space, and fact and fiction, are collapsed and being continually reconfigured. In response to what he views as a media-induced simulacrum of Holocaust memory, he has cautiously endorsed the materiality of the museum as a counter to the evacuation of concrete reality in new technologies: "the permanence of the monument and of the museum object, formerly criticized as deadening reification, takes on a different role in a culture dominated by the fleeting images of the screen and the immateriality of communications."[57] Aware that a backward look reveals monuments and memorials that today linger in relative obscurity,

Huyssen is, at the same time, aware that those we are currently building may one day find themselves in the same state.

In contrast, Marita Sturken challenges such pessimism towards contemporary memory discourses. She argues that "it is precisely the instability of memory that allows for renewal and redemption without letting the tension of the past in the present fade away." Rather than labor the fear that authentic memory may someday be lost, she sees its very contestation and variability (and the concomitant idea that some events can become diminished, others enlarged) as "crucial to its cultural function."[58] For Sturken, creative processes of re-enactment (such as making films and theater), and of the use of spaces like memorials and museums (which can involve debate and protest as much as dutiful visitation) are crucial. Although these forms of commemoration might alter the meaning of events, they allow a way for people to "try out" new interpretations, which, Sturken continues, can only be positive in the way it keeps an event alive. Between her optimism and the cynicism of others, we arrive at a central tension in the memorial museum brand of historic commemoration: between "history" that can be accused of being unresponsive to personal recollection but relays "facts" vital to the museum experience, and memory, which adds empathetic and personal effect, yet is also more susceptible to myth-making and even cultural falsehoods.

THE ACCRETION OF ATROCITY NARRATIVES

The meaning of any event is typically partly forged around socially constructed, media-orchestrated themes that refer to other incidents. If, as Koselleck describes, the late eighteenth century represented a shift in consciousness in conceiving historical time, and the nineteenth century saw the height of what Bazin called "the museum age," the twentieth century has seen another revolution in memory, brought about by electronic forms of recording and transmitting information.[59] As I raised in Chapter 3, there is a case to be made that massive political atrocities only gained a readily recognizable shape from the mid to late nineteenth century onwards, since they rely partly on the availability of documentary visual evidence (especially in the form of photography and film). Although these media forms certainly bear the marks of age (black and white stock, graininess and glitches, absent or unreliable sound in film, faded diaries, broken and incomplete objects) they nonetheless bring an event into the present in a way that makes interpretation not just available to audiences but seemingly transparent – what happened is what we are seeing. It is certain that acts of atrocity in the developed world will never again lack for recorded evidence.

The rendering of historical atrocities as textual and audio-visual information has undoubtedly contributed to the emergence of hybridized signifiers. These have been difficult to miss: in the year or so after 9/11 there was much talk of it being "our Pearl Harbor" (despite misgivings from several quarters: Noam Chomsky points out that Hawaii is better viewed as having been a colony at the time; Geoffrey M. White makes the case that the comparison is not grounded in historical accuracy, but works

chiefly in terms of visual images of stark destruction, and a narrative of surprise attack and a collective national response).[60] Madrid's Atocha train station bombing was named "3/11," the London bombing quickly became "7/7," while the Bali bombings are sometimes called "Australia's 9/11." Similarly, the world's most recent genocide in Darfur, Sudan, is reflexively related to those in Rwanda, former Yugoslavia, Cambodia, Armenia, and the Holocaust. Argentina's "dirty war" disappearances are compared to those in Chile under Pinochet, and to a lesser degree, those in Bolivia, Uruguay, and Peru. State repression in the former Soviet Union and China are also less often-cited reference points. The Caen Peace Memorial makes this cross-referencing of epochal events explicit, adding a 9/11 display to existing exhibits depicting the D-Day beach landings, the fall of the Berlin Wall, and more (Fig. 7.1). However different the context-specific events in question may be, they are understood as sharing certain contours: against the bare fact of obliterated or concealed bodies, there are questions of political implication, of conspiracy and subterfuge, of heroism and tragedy, of perpetrators, victims and bystanders.

We tend to assume that the person who "learns from history" is the principled, civic-minded observer; it seldom occurs to us that history also formed the motivation or alibi for history's villains. Hitler, as is well known, saw history as proof. Two events

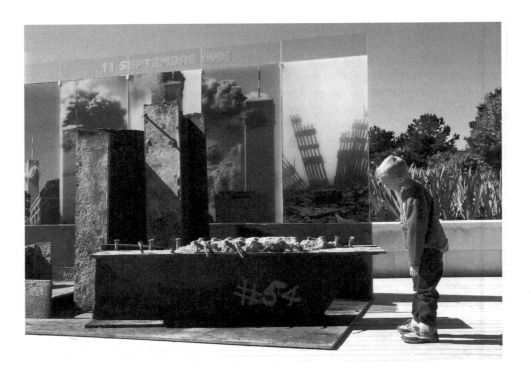

Fig. 7.1. World Trade Center display at Caen Peace Memorial. Copyright Caen Peace Memorial. Used with permission.

– defeat in the First World War (at the hands of the "traitors of November 1918") and the Russian Revolution – were pivotal in his thinking about the maneuverings of power and social conditions that contribute to upheaval.[61] Also important is Hitler's alleged, often-cited assurance to his advisors, when discussing the "Final Solution": "After all, who remembers the annihilation of the Armenians?" Cambodian genocide was also spurred by a number of historic events, including not just modern occurrences like Mao Zedong's Cultural Revolution and the torment of foreign imperialism, but also in the Pol Pot clique's dream to restore Cambodia to the glories of the twelfth-century Angkor civilization (an image of the Angkor Wat ruins featured on the DK regime flag).[62] More generally, the sense of historic mission, of self-consciously "making history," that drove all kinds of persecution was often framed as an act of conscience – of making right the historical injustice that had befallen a group.

In some cases, memorial museums were themselves created with explicit reference to earlier examples. Mai Lam, who was appointed with turning S-21 torture prison into Tuol Sleng Museum of Genocidal Crimes, had earlier organized The War Crimes Exhibition in Ho Chi Minh City, and before that traveled to Poland to study the Auschwitz-Birkenau State Museum. Collaborating with East German memorial specialists, he introduced some Holocaust imagery into Tuol Sleng to link the DK and Nazi regimes. The tattered clothing heaped in one of the cells, for instance, is highly reminiscent of concentration camp display tactics. The addition of photographs of Pol Pot meeting with Mao Zedong is intended to make clear the complicity of the Chinese in the genocide. A concrete bust of Pol Pot made by Vann Nath, one of the few S-21 survivors, has been left toppled on the floor, evoking similar relics associated with Stalin and Mao. Unsurprisingly, Vietnam's initial support of the DK regime goes unmentioned. Mai Lam sought to distinguish between "legitimate communism" practiced by the Vietnamese and perverted, even "fascist" DK regime communism. It was important that the Vietnamese could both justify their 1979 invasion and argue that what had happened in Cambodia, and particularly at S-21, was genocide that resembled the Holocaust, rather than the murder of political enemies that has blotted the histories of the Soviet Union, China, and Vietnam alike.[63]

The theme of historical cross-referencing was borne out, in a very different institutional context, with the February 2006 announcement that the director of the World Trade Center Memorial Museum was to be Alice Greenwald, the associate director for programs at the U.S. Holocaust Memorial Museum. Greenwald herself drew parallels, stating, "I don't think I would have considered leaving had I not had the fundamental belief that this [World Trade Center] museum has the potential to have the same level of moral significance." A representative of a victims' families group ("September's Mission") concurred, stating, "she has told a very painful story and memorialized those millions who were killed in a horrific way. We hope that she tells the difficult story of September 11 just as well." When asked about the now-abandoned International Freedom Center, Greenwald called it "an incredibly creative

idea that was woefully premature." By contrast, "this is a museum of memory. And when you're talking about memory, it is never too soon."[64] Implicit in Greenwald's statement is the distinction between history, which deals with "big ideas" and is hence combative, and memory, which acts as salve. She may have also been wary of the problematic conflation of quite disparate historic experiences at a Freedom Center. Questions of scale, context, and meaning were to be potentially collapsed under the airy, variable heading of "freedom" which, before 9/11, would not necessarily have had "terror" as its opposite. Writing before that event, Saul Friedlander identified Nazism as the primary reference point for a free-flowing concept of America's opposite:

> Nazism and evil have become so naturally intertwined that this identification triggers an ongoing and expanding process of representation but also of recall by association: "Schindler's List," "Life is Beautiful," *The Reader*; Kosovo, Le Pen, Heider; gay bashing, mercy killing, abortion or anti-abortion, and so on. But doesn't that ever-spreading reference mean an ever growing dilution and ever growing simplification, and ever growing vulgarization? Moreover, is the process self-triggered, or does it fulfill a function in our society?[65]

With little effort, we could update this stream of references in the half-decade since 9/11. As Friedlander would also likely anticipate: will the further musealization of negative events of all kinds (which could conceivably include fatalities from natural disasters, diseases, or urban violence) aid in the separation and clarification of events, or will they become seen as different examples of a single genre of tragedy, perhaps clouding important differences?

In an interesting study of visitors' remarks left in the comments books at the U.S. Holocaust Memorial Museum directly after 9/11, Michael Bernard-Donals describes how many entries associated Americans with Holocaust-era European Jews on the basis that both were killed because of "who we [they] are." As visual images, there was a felt resonance between the recent memory of 9/11 headshot photographs in New York, and those of Holocaust victims. In comments, visitors extended Hitler's personal qualities as the embodiment of "pure evil" to Osama Bin Laden (and, to a lesser extent, Yasser Arafat).[66] Connections between the Holocaust and contemporary events only very tangentially related to it reveal how it has come to form an essential yet potentially dehistoricized frame of reference upon which to project all manner of atrocities. Bernard-Donals's study also reflects how, at that point, 9/11 lacked its own internal and agreed-upon historical coordinates and moral references.

The proposition that our consciousness of history, and the representations of it we create, is neither objectively weighted nor rationally informed is hardly novel. Since the 1920s, when Maurice Halbwachs and Marc Bloch began to expand on Durkheim's work in theorizing "collective memory," issues of simplification, distortion, and the effects of a "presentist" perspective have remained central critical concerns. Halbwachs was one of the first to note that every individual memory existed not as an autonomous act, but instead often expresses a collective viewpoint

indicative of collective memory.[67] He was interested in the fact that "one does not remember alone but also uses the memories of others, and that one grows up surrounded by phenomena and gestures, sentences and images, architecture and landscapes that are full of strange pasts that preceded the subject."[68] These reminders of the past generally strike us, however, not as abnormal or anomalous, but as part of the historical course that we believe we have inevitably followed. It is this normalization of the *path* of the past, present, and anticipated future that allows us to feel that collective memory has been passed to us, and that we can pass it on without significant breaches or distortions.

Traditionally, those working in the field of collective memory have cited society – its institutions and the messages they convey, its public rituals such as anniversaries, holidays, and parades, its everyday street exchanges – as the vital crucible of meaning. In contemporary times, our collective processes of memory selection have become more colored by the media, and often now in a self-conscious fashion. Events that are highly spectacular, and yet are able to be cognitively and culturally assimilated, gain prominence. Wars and violent events obviously loom large: they contain the weighty dramatic attributes that make them prime in the narration of "current events" and the retelling of history. Within any conflict, there are incidents that come to bear an especially large imprint. For instance, in *The War Complex: World War II in Our Time,* Marianna Torgovnick shows how four events – D-Day, the Eichmann trial, the Holocaust, and the atomic bombings – now possess grand significance and effectively define what the Second World War meant.[69] As some events are amplified and their details become increasing mythologized, context and internal contradiction tends to recede. As Tony Judt observed of the Holocaust:

> If many Europeans had managed to ignore for decades the fate of their Jewish neighbors, this was not because they were consumed with guilt and repressing unbearable memories, it was because – except in the minds of a handful of senior Nazis – World War II was not about the Jews … In retrospect, "Auschwitz" is the most important thing to know about World War II. But that is not how things seemed at the time.[70]

Memorials and museums play a key part in circumscribing the contours of a historic event. They affirm what should be regarded as crucial to it, and what is to be understood as extraneous or "outside." Consider, for instance, Washington, DC's Vietnam Veterans' Memorial, which omits the names of those who died outside the theater of engagement in South-East Asia. Veterans who later succumbed to the effects of Agent Orange or committed suicide are not awarded the same recognition as combat victims.[71] Beyond the privileging of death over physical and mental suffering, "Vietnam" is related in both a temporal and spatial dimension – death had to occur in combat between 1959 and 1975, and "over there." Sturken uses the concept of a "screen memory" to conceptualize how societies use mnemonic aids – photographs, television, film, memorials, and museums

– to block out other memories, ideas, and images that are too difficult to represent. The theory of "screen memories" derives from Freud, who used the term to describe certain recollections that function to hide, or screen out, those the subject wants to keep at bay. For Sturken, the Vietnam Veterans' Memorial "both shields and is projected upon."[72] This is evident in the way it focuses public memory on the American-ness of the tragedy – the naming of 58,196 deaths and MIAs allows less easily assimilated truths (such as the two million Vietnamese killed, the depredations suffered by Vietnamese civilians, or the treatment of American veterans) to remain unmarked. Over time, the mnemonic device can come to dominate the shape of the memory, as the distinction between the screen and one's original recollection becomes indiscernible. Sturken's theory seems best suited to those catastrophic events where public awareness needs to be "managed" or deflected in some way – the ongoing arguments over the size, form, and contents of the World Trade Center Memorial can itself be seen as fulfilling a similar "screen" function in the context of ongoing war.

In situations where the event has been officially repressed, the memorial museum can serve a liberating function by drawing out memories rather than deflecting them. We should be cautious of the view that memorial museums will only exist if the events they depict are somehow aligned with prevailing social and political mores. In the 1997 edition of *Shadowed Ground: America's Landscapes of Violence and Tragedy*, Kenneth Foote proposed that in American places of mass murder caused by human failing or misfortune that reflect badly on a community, the shame and grief will typically be too difficult to bear, and that as a result, no permanent site of public remembrance will result.[73] Notably, in 2003 Foote revised the edition, adding sections that dealt with the Oklahoma City bombing, the Columbine High School massacre, and the 9/11 terrorist attacks – those that might have hypothetically been considered "shameful" in his earlier edition. A more suitable theory explaining why these events can now be commemorated involves their characteristics: in all three there were discrete, spectacular events with clear roles of "evil" and innocence; all took place within a short, contained time frame; in each there was a sense that it represented an underserved, unforeseeable, one-off aberration. James E. Young has mused that "only rarely does a nation call upon itself to remember the victims of crimes it has perpetuated. Where are the national monuments to the genocide of American Indians, to the millions of Africans enslaved and murdered …? They barely exist."[74] While appreciating his sentiment, Young seems to overlook how certain kinds of events possess qualities that make them amenable to commemoration. While histories of violence and oppression towards Native Americans and Africans in the Americas are of course extremely important, they are historically extensive and socially complicated; they suffuse so much that they lack easy representation. This does not mean they do not deserve better commemoration; rather, it is simply more difficult to imagine single institutions straightforwardly relating centuries-long histories.

CONCLUSION: LOOKING BACK AND FORTH

To move towards a conclusion, I want to turn to two pronouncements, one from the heights of American political power, another less so, that reflect on some of the issues raised in this chapter. It is not normally President George W. Bush to whom we turn in seeking elucidation about the relation between time and memory. Yet it is worth considering a passage from his commemorative address made three months after 9/11:

> In time, perhaps, we will mark the memory of September 11 in stone and metal, something we can show children as yet unborn to help them understand what happened on the minute and on this day. But for those of us who lived through these events, the only marker we'll ever need is the tick of a clock at the 46th minute of the eighth hour of the 11th day. We will remember where we were and how we felt.[75]

The spectacular brevity and materiality of the events of that morning has indeed made the clock (and skyscraper) essential interpretive elements. Perhaps unwittingly, Bush (or his speechwriters) touches on one of the central tenets of memorialization: that while memory is a temporal phenomenon wherein the past constantly impinges self-consciously on the present. Hence one can never freeze the past or make it still. The observance of a minute's silence on the anniversary of a symbolic event represents the attempt to perform this premise – we mentally summon the past and ask it to inhabit the present that is produced with each passing second. Those who will come to live with the historic "postmemory" of 9/11 will have it made available through built space (markers "in stone and metal"), which exist to make static an aspect of the past in the face of speed – that is, the endlessly replacing surroundings of the present. Yet, despite the appeal of a living-memory versus future-history scheme, the tick of a clock and stone markers are complementary – not opposing – ideas. It is not future generations who are asking for a concrete memorial. Rather, the memorial is a product of our desire *that they should know what we felt to be important.* This is quite different to the traditional American "delayed memory syndrome" that has seen "a period of roughly fifteen years of relative neglect or repression following some major historical traumas."[76] The theme of commemoration was based on a time lag; the idea being that memorials and museums represent ideas that, only on reflection, are eventually established as deserving commemoration. Our willingness to disregard this lag may acknowledge not the magnitude of recent events, but our fast-emerging belief in the political and cultural benefits of swift memorialization.

My second episode also occurred in 2001, when representatives from the U.S. National Park Service traveled to Russia's Gulag Museum at Perm-36. They came as consultants aiming to help the memorial museum develop expand its programs around the theme of "civic engagement." Heartened by their experience, their written report concluded with an analogy: "Imagine if a group of dedicated Americans had established a historic site museum at a slave auction site or plantation

at the end of the Reconstruction period in the 1870s. Imagine the power that experience would have had for visitors who had recently been enslaved or owned slaves. Imagine the kinds of dialogue it could have created."[77] The analogy is interesting precisely because it is almost impossible to imagine this kind of memory work taking place at that earlier time. The formation of a historical consciousness that could conceive utilitarian, slavery-based objects in a museum as a device for remembrance and debate (when these themes would have themselves been thought to represent discordant objectives) has only really arisen in the past two decades. What is it that an exhibition 140 years ago could have be hypothetically imagined to effect: A meaningful conversation between hostile strangers? An alteration of the course of American history? A nonplussed confusion at the purpose of the display? Indeed, what might we alternatively expect our contemporary sites of memory to produce for those 140 years hence?

I will conclude with a quote from Sandy Isenstadt, who has observed that it is our ability to retain some events as meaningful, and to forget others, that allows the built form to emerge as a meaningful statement about the past.

> Oblivion is the usual fate of those occurrences which cannot fit the departments of mental perpetuity; needless to say, there are no examples to give … What's great about this is that poor memory spurs invention. We strive continually to fix events before they dissipate, to make lives and experiences impervious to the solvent of time … Memory does indeed possess an affinity for inhabited space. As ordered space or material presence or both, architecture provides us with ways to remember. By acknowledging weaknesses and at the same time allowing us to overcome them, the creation of architecture is among the most human of activities.[78]

That is, Isenstadt avers, if total and reliable representation were possible, it might even be debilitating, "since simultaneous moments that were spatially distributed would, in a single mind, necessarily succeed one another."[79] What we are left with in the form of memorial museums is an account not of calamitous history per se, but of those parts of it that can be made to fit within a nationally and culturally interested institutional program. While much is left out, the content that *is* included currently receives attention, for better or worse, like never before.

8 IN CONCLUSION: FIGHTING THE FORGETFUL FUTURE

EXPANDING THE MUSEUM CONCEPT

Plaques, memorials, historic sites, and museums have a peculiar relationship to time. Most obviously, they retrieve the past with a view towards warning the present and future about the dire results of an event's recurrence. The felt need for their current existence at the same time makes plain the notion that other periods were, for a variety of reasons, careless or unmindful about marking their present with the same historic sensibility. Have we endured a difficult twentieth century that earlier commemorative sites, had they existed, might have prevented, or at least explicitly warned us about? Contemporary memorial museums, in one view, thereby have a role in rectifying this legacy of neglect. Their establishment represents a brave stand against "history as usual," or indeed, "tyranny as usual." A contrary strain of argument holds that the ritualization and fixing of historic events in a concrete structure will inevitably make them, over time, over-familiar and even pedestrian. This position maintains that rather than enlivening the moral consciousness, the expanding presence of memorial museums may, over time, deaden their topic as they become established as another set of historical markers blending blandly amongst heritage districts, conventional war memorials, statues of long-gone leaders, and little-noticed bridges, fountains, and plaques. Between these poles – one leaning towards idealism, the other cynicism – we might begin to map the likely outlook for the reach and effect of the new memorial museum movement. Rather than recapitulate the explorations and findings from my earlier chapters, each of which I hope forms a reasonably self-contained study, this conclusion aims to consider some themes that are largely hypothetical and future-oriented. For those familiar with the threads of my discussion this far, this last chapter will provide further lead-off points for ongoing scholarship and debate on this fast-emerging subject.

Readers will have noticed that many cases mentioned in this book do not squarely fit the "museum" or "memorial" designation (definitions of which are discussed in Chapter 1). The Mostar Bridge in Bosnia, the deserted city of Pripyat, the Srebrenica Cemetery Memorial, Hong Kong's "Pillar of Shame," Poland's "Wolfsschanze," Akhtamar Island's Holy Cross Armenian Church, Budapest's "Statue Park," and Vilnius's "Grutas Parkas," for instance, are neither stable museum institutions, nor the staid mourning places we often associate with the memorial. Yet, I would argue, they properly highlight salient museum issues. Indeed, a goal of this book has been to allow the variety and complexity of my examples to enlarge standard concepts of the museological. Each of my cases shares a sense of sitedness

that creates the opportunity for people to gather in public with the intention of reflecting on the past. This loose description falls short of more restrictive ideas proposed in organizational policy. Consider, for instance, the most recent definition expressed by the International Council of Museums (ICOM): "A museum is a permanent institution in the service of society and of its development, open to the public, which acquires, conserves, researches, communicates and exhibits, for purposes of study, education and enjoyment, the material evidence of people and their environment."[1] We inevitably see great disparities in the material resources of regions and nations in their ability to produce memorial sites. While the World Trade Center Memorial is currently mired in large-scale, billion dollar deliberations concerning signature architecture, insurance, downtown economic revitalization, private support, and high-level politics, towns in Rwanda have erected simple plaques and one-room museums (normally in already-existing structures) that rely on part-time volunteer staffing. In the terms prescribed by ICOM above, their permanence is not financially or politically assured; they struggle with conservation; their collections extend to little more than weapons and bones; their research is fledgling at best. Yet, I would argue, they are museums as vital as any other. In short, their intended effect – historical remembrance in public space – should trump considerations of *how* this is achieved.

The measure of the effectiveness of memorial spaces – as grand as a complex of museum buildings or as humble as a walkway bearing a plaque – lies with the *quality* of visitors' often-inexpressible experiences. Compared to a regular museum visit, travel to a memorial site nearly always encourages some reflection on why the effort has been made: what have I come to understand? This act is physical as well as cognitive, and is significantly made sense of through the power of place. It is location, after all, that allows memorial sites to tackle the problem of the unsuitability of the "history as usual" museum model that would otherwise draw primary attention to a visual narrative within an ordered, interior display. Visitors might gain more from exhibitionary spaces that defy the highly choreographed, user-tested, education department approved model that characterizes highly professionalized museum work. In outdoor sites, or buildings that were once prisons, government offices, or secret medical facilities, their appeal may have much to do with the unanticipated *feel* of the place – the accidental observations, the physical contact, the self-aware footing and awkward stumbling. For instance, in my view, Gunter Demnig's *Stolpersteine* inconspicuously dotted along Berlin's streets (Fig. 8.1) are as powerful a statement of a lost Jewish presence as the city's new architecturally impressive, display-rich Jewish Museum. Given that the kind of upheavals described in this book were mostly metropolitan – their scale was the homes, streets, and cities where lives took their course and where the perpetrators' goal was the destruction of the same – it appears that their commemoration also best fits that same field of unstable, unpredictable streetscapes. As institutions that enclose artifacts indoors, museums sometimes struggle to show how these objects once existed out in the world. While the immovable, three-dimensional nature of outdoor objects and environments may not have

the same capacity for explanation and interpretation as a museum exhibit, they do carry the power of being in the midst of ongoing living history.

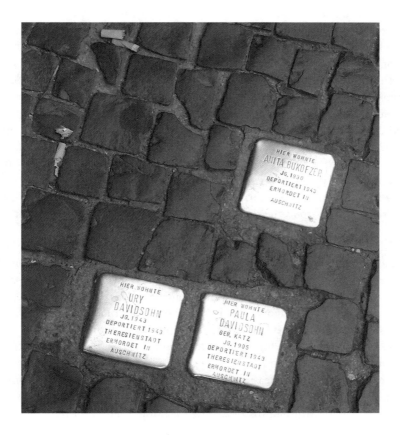

Fig. 8.1. *Stolpersteine* in Berlin. Image taken by author.

THE "OTHER SIDE" OF PROGRESS

In the broad historical context of the past 200 years, public museums are, by now, not such novel attractions. Like fairgrounds, zoos, worldwide expositions, international sporting contests, and other historically related spectacles, museums now provide a familiar, even habitual experience, despite the effects of new technological and architectural trends in recent decades. Generally speaking, museums have shown us the best and brightest; those things held by famous hands, whether paintbrushes or swords. Perhaps, then, a key reason for the surge in popularity of memorial museums involves the way they turn the very idea of the museum on its head by offering the public what it least expects: the worst and most bleak. They not only bring hesitation to any breezy claims of civilization and progress, but also question

the philosophy that lies behind our traditional devotion to preserving artifacts that offer an assenting view of the past. The objects memorial museums contain embody a kind of historical "return of the repressed." "There is no document of civilization that is not at the same time a document of barbarism," noted Walter Benjamin. "They are called cultural treasures," he wrote, but they had origins he could not "contemplate without horror."[2] This often-cited quote is used as shorthand for the duality of museum objects gained acquired through warfare, imperialism, and other violent plunder. In this sense, memorial museums offer a mirror to the collections of great museums. This mirroring relation is not as neat as we might be tempted to think, since the bulk of large, famous national museums' collections were purchased, acquired, or looted in periods well before that of twentieth-century atrocities. Memorial museums help us instead to see, as Hannah Arendt cautioned, that "we can no longer afford to take that which was good in the past and simply call it our heritage, to discard the bad and simply think of it as a dead load which by itself time will bury in oblivion. The subterranean stream of Western history has finally come to the surface and usurped the dignity of our tradition."[3] Memorial museums bring to light the "subterranean" possessions, often literally buried, of those historical casualties with typically very little left that could inhabit a conventional museum. Memorial museums have emerged as a comparatively object-poor institutional opposite to the wealth contained in museums of affirmative history. Or rather, the source of their wealth is contained in the stories entrusted to them and the confidence imparted to them by survivors, family members, and their descendants, who use them as both spaces of private mourning and public ceremony.

Memorial museums also function as an opposite in a quite different sense. In drawing attention to the most terrible aspects of what a society has endured, they can function as a yardstick for measuring current progress (in terms of showing how a society has progressed, and what it is no longer). In this way, memorial museums never simply display "finished history." The meaning of an event remains unfinished inasmuch as considerations of its "lesson" are gauged against the prevailing conditions of the society in which it resides. Saul Friedlander has observed that "in order to identify its own ideals and the nature of its institutions, any society needs to define the quintessential opposite of its own image."[4] He believes that Nazism now achieves this function in present-day Germany, as more and more museums and memorials are constructed that both aid in, and demonstrate, *Vergangenheitsbewältigung* (coming to terms with the past). Nazism is also currently the villain *par excellence* in the U.S.A., aptly demonstrated by the location of the U.S. Holocaust Memorial Museum, where visitors exit the dread of the museum to find reassurance in the various monuments to democracy on the Mall. (It will be interesting to observe whether the proposed Museum for the Victims of Communism will supplant the Holocaust museum in this role.) Friedlander's notion provides a useful frame for thinking about when and where memorial museums are likely to find support. They can serve to clarify political values in two chief situations. One is when the conditions and events depicted are largely finished and absent, and are therefore able to be

represented as largely "mastered" (consider, for instance, South Africa's anti-racist post-apartheid sites, or Hiroshima's anti-nuclear memorial museum). The other involves conditions where the depicted event is one against which the society remains vigilantly opposed. In this context, the memorial museum marks continuing political commitment (see, for example, the World Trade Center Memorial, or Hong Kong's "Pillar of Shame"). This premise gains credibility when we alternatively consider cases where less assuredness about the status of the event exists. Although the Vietnamese-created Tuol Sleng Museum of Genocidal Crimes ostensibly marked the demise of the DK regime, the partial resurgence of the Khmer Rouge in the 1980s may have lent the museum an aura of fear as much as of relief. Similarly, the Potočari Cemetery Memorial currently appears as much a magnet for threats and social instability as it is a place of mourning.

In the aftermath of violence and dispossession, decisions about how to treat authentic sites are often fraught. Compared to other social history topics that can be exhibited in fairly standard and interchangeable institutions, the future existence of a memorial museum may depend on the fate of meaningful locations. Locations of violence and loss tend to provoke extreme reactions that can result in an all-or-nothing outcome. Should we obliterate or sanctify this place? This either/or quandary was raised recently in an article by Christopher Hitchens about Iraq's Abu Ghraib prison:

> Layers of excrement and filth were being shoveled out; cells obviously designed for the vilest treatment of human beings made one recoil. In the huge, dank, cement gallery where the executions took place, a series of hooks and rings hung over a gruesome pit. Efforts were being made to repaint and disinfect the joint, and many of the new inmates were being held in encampments in the yard while this was being done, but I distinctly remember thinking that there was really no salvaging such a place and that *it should either be torn down and ploughed over or turned into a museum.*[5]

Against our probable likely assumption, ploughing over and preservation are better seen not as opposites, but as parts in the same line of thought. That is, the will to extinguish and forget and the will to preserve and remember share the basis that the event was sufficiently important that something else must happen: the site should not "carry on as usual." If a location is allowed to continue as it had before, so too could the activities that occurred within it: obliteration and preservation are negative and positive impulses aimed at denying that kind of future for the site.

The preservation/destruction dichotomy becomes even more vivid when we consider that the devastation of heritage has been a key psychological weapon of armed conflict. War in former Yugoslavia was particularly notable for the way built heritage was targeted. A 1995 report documented that damage to Croatian property alone amounted to 90 archives and libraries destroyed; 37 museums damaged and four destroyed; 500 monuments damaged and 107 destroyed; 223 historic sites damaged and 60 destroyed.[6] In direct contravention of The Hague Convention for

the Protection of Cultural Property in the Event of Armed Conflict (1954), such sites are targeted because they hurt the most. Museums are a valuable target because they possess great riches; these possessions are treasured precisely because they often risked scarcity and extinction to begin with. Thomas Keenan's meditations on the relationship between museum preservation and the threat of loss are insightful:

> Museums are built on loss and its recollection: there is no museum without the threat of erasure or incompletion, no museum not shadowed by the imagination of the impending destruction of what it therefore seeks to stabilize and maintain. We can say that the museum finds in loss its most powerful alibi ... The museum wants to be a salvational and sheltering institution, a machine for preservation and transmission, an archive of what is lost or at risk of disappearing and a mechanism for re-animating it, a platform that allows it once again to communicate with the present. Loss and the fear of destruction, especially after the exposure of the fragility of a collective identity, is a terrible stimulus to preservation and to a hygienic ordering of the patrimony and its legatees – nothing teaches us this as well as the violence that constantly accompanies responses to this fear, today in Bosnia, Rwanda, or the corridors of Western state power.[7]

Hence, as museums build collections in certain societies with an ever-present threat of their ruin, memorial museums stand as confirmation that, in many cases, such fears are justified. That is, memorial museums add to the greater field of museums a self-conscious cautionary example about the political uses and abuses of cultural patrimony. Heritage can be deployed to inspire, uphold, and magnify religious, ethnic, or national pride. In the way it can provide a spur for feelings of cultural superiority, it can equally form a valued psychological target for others.

HALTING MEMORY

At this juncture, which might represent the height of the memorial museum boom, a few voices have emerged that make a case for a halt, or at least some stocktaking, of the now near-automatic rush to build memorial museums in times of public catastrophe. Visiting the Hiroshima Peace Park and Memorial, Ian Buruma disparaged what he saw as an uncritical overflow of exhortations for world peace (Fig. 8.2). He wrote that the message is "hammered home so relentlessly, through memorials, monuments, pagodas, fountains, school-children, missionaries, parks, symbolic tombs, special exhibits, sacred flames, merciful deities, peace bells, peace rocks, peace cairns, statues, and signs, that in the words of Italian journalist Tiziano Terzani, 'even the doves are bored with peace.'"[8] Hiroshima is, of course, an extreme case, given its symbolic status as a "peace city." Yet the issue of cities "living in remembrance," even to a lesser degree risks foreclosing the continual re-examination of an event. The broadly assenting, humanistic spiritual remembrance of the kind promoted by Hiroshima discourages artistic acts, academic inquiries, and social behaviors that are

less than honorific. If the wrongs of history can be symbolically corrected through virtuous representation, can such projects tip too far? When is enough remembrance enough? This question has also been tentatively raised in the wider debate over Berlin's Memorial for the Murdered Jews of Europe: is another Holocaust memorial really necessary?[9] The prospect of the world's cities (particularly those of Europe) becoming increasingly crowded with memorial museums and other supportive commemorative forms raises questions about both the effect of saturation on empathy and political action, and also on the effects on urban life of the increasing apportionment of city space to ceremony and reverence.

In response to what he saw as a surfeit of commemorative moments after London's 2005 public transport bombings, Mick Hume questioned the influx of state-sponsored memorials, vigils, floral shrines, religious services, books of condolence, and benefit pop concerts. Noting that the customary one-minute silence had, the day before, been inflated to two minutes, Hume called for a "12-month silence" on the "morbid theatrics of public mourning rituals."[10] His view is that these events are both culturally indulgent and self-perpetuating: as one group or cause participates, others would be seen to be callous not to follow suit. To ask what purpose such events serve, or, going further, to conjecture that they are little more than well-meaning exercises in collective wallowing, is to run up against not only those who would find such charges disrespectful, but others who might ask: what is the harm? Author Moris Farhi has, uncommonly, made the philosophical case that there is greater moral and political worth in the notion of (what he has coined) "forgetness" than in the much-touted ideal of remembrance:

> On the laudable pretext that we must never allow such atrocities to happen again, we had elevated them to an immaculate form of suffering. We had, in

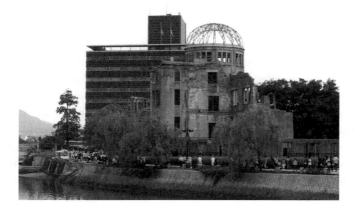

Figure 8.2 Hiroshima Atomic bomb dome. Copyright Dan Smith. Released to the public domain.

effect, sanctified them. We had rendered them into modern versions of the Suffering Servant's torments or of Jesus' Passion on the Cross. Thus we have created an eleventh commandment: thou shalt remember your tortures and your torturers forever! And, for good measure, we have asserted that the observance of this commandment, the remembrance of a tragic past as a prescribed devotion, is an extraordinary act, an act of courage, no less ... Then an antithetical idea invaded my mind. If, as the Holocaust Museum curators believe, voluntary acts of anamnesis require courage, then, surely, voluntary acts of forgetness would require even greater courage.[11]

Rather than accepting the inference that "forgetting puts the seal on death," Farhi cites the creation of the European Union with Germany, once the myrmidons of Hitler, as a principal member, and the work of the Truth and Reconciliation Commission in South Africa, as prime examples of the benefits of "forgetness." While he warns of the impossibility of any future utopia (which he reminds us, were goals of fascism and communism and required conformity through violence), Farhi believes that "never again" cannot be achieved by focusing on the past, since it reinforces a view of the world where bitter social divisions reign. He writes:

With memory used as a weapon, we are burdened with an even viler trauma: the worship of brutal death. Seen from this point of view, the veneration of the victims offers that most unattainable – and intangible – craving: redemption. Since memorial museums and archives have also undertaken to disseminate this veneration to future generations, the promise of redemption becomes an eternal promise.[12]

The counter-notion of forgetness (distinguished from "forgetfulness" in order to highlight its intentionality and the sense that it might form a deliberate counterpoise to remembrance) is one that proceeds from the basis that remembrance does not result in forgiveness, but in stoking resentment. There has been, and perhaps can be, little that can prove or disprove how our current actions in the area of remembrance or forgetness will impact future actions. In the heat of any calamitous event where matters of life and death are being played out, how heavily might consciousness of the past really bear on those personally involved? Is morality really something that can be learned through history? As much as these questions nag at the heart of humanity, the desire for some basis through which we might avoid repeating our most terrible deeds is inevitable (and indeed, along with atrocity, may equally be a marker of humanity). The usual thinking is that terrible acts start in the mind (in individual psychology and in group-think) rather than as a result of social conditions (indeed, many logically point to the diverse economic, political, and cultural circumstances in which atrocities have occurred to support this idea). If prejudice, broadly defined, resides in the mind, then it is not surprising that education remains the most favored prospect for that ineffable project of changing ideas and actions. The other option – that we are hardwired to fight those who we believe stand against us, and

that we have learned to become ever more effective at doing so – is one that we generally find too dark to bear.

WHAT'S NEXT? PROSPECTS FOR THE CULTURE OF COMMEMORATION

Will memorial museums become a permanent feature of the cultural and political landscape, or might they soon be exposed as a passing trend? Might they become a form of concrete "time capsule" attesting to a fixation with historical atrocity in the two or three decades after the late 1980s – perhaps akin to the museum's role in America's popular fascination with "Egyptomania" during the middle decades of the nineteenth century, or with its enthusiasm for reconstructed colonial villages during the 1920s and 1930s?[13] My own estimation is that they are here to stay, for decades to come, at least. This position is garnered not so much from their current popularity (although indeed, well-publicized, major memorial museums do attract large audiences) but because the political and social conditions that have seen them come into being show few signs of abating. Working with the increasingly accepted maxim that, as Jean Baudrillard puts it, "forgetting the extermination is part of the extermination itself," memorial museums are attributed with a great moral weight, and are even personified as "remembering" entities.[14]

The proliferation of memorial museums can be seen as a self-perpetuating process, at least as their perpetuation as an institutional genre is concerned. Historical omissions (such as Armenian genocide and the Ukrainian Holodomor) are being remedied, and new disasters, such as the December 26, 2004 tsunami are now given the memorialization treatment soon after they occur. Any person, organization, or government that would question any group's "right to memorialize" are viewed as being not just intellectually but morally suspect. While the emergence of cultural-historical representation within the language of "rights" may confuse its judicial-political definition, it has won wide social currency nonetheless. At best, a global field of memorial museums will help to expand peoples' conceptions of historical conflict beyond the traditional container of nation-versus-nation warfare. While it is clear that the amount of time, money, ink, consultation, and media coverage awarded to the World Trade Center Memorial will be far greater than that of Rwandan genocide memorials (to revisit my earlier comparison) this needn't be a depressing prospect for those interested in drawing attention to non-Western struggles: in addition to the formal arrangements of groups such as the International Coalition of Historic Site Museums of Conscience or the International Council of Museums Committee for Memorial Museums, there may be something to the idea that the increasing global practice of visiting memorial museums will spark an interest in those elsewhere. At worst, the growing obsession with identity and memory will mean that global calamities may come under ownership claims by ethno-cultural groups – effectively privatizing history and tipping it towards a zero-sum game competition.

Although in some cases public recognition of an atrocity represents a troublesome prospect for those in power, in others "representation" might serve as a governmental

tactic for the incorporation of lingering animosity within a framework that demonstrates state forbearance. That is, it may be not only politically problematic to fight the creation of a memorial institution, but it can even be politically useful to encourage it, inasmuch as it can provide a forum for historical grievance that may not spill back into the streets of the nation as civic unrest. Narratives of suffering have also proven highly useful in mythologies of national identity, in situations as diverse as atomic victimhood in postwar Japan, the immorality of racially specific laws in post-apartheid South Africa, or a belief in a groundlessly besieged post-9/11 U.S.A. Sensitive sites have also formed a key stage for diplomacy between friendly nations, primarily in the form of state visits that include pledges that never will the affair be repeated. Memorial museums also form key sites that can capitalize on the growth of "cultural tourism." They are advantageous for visitors not only in the way they conveniently condense historical narratives within a single authentic site, but also in the way they impart moral rectitude to those who visit.

Finally, I will conclude with a word about methodology, hoping that this subject will invite further examination by others. The purpose of this book has been to introduce and analyze a genre of museums and commemorative spaces that, although clearly on the rise, has hitherto been dealt with only in a minimal, patchwork fashion. For decades, the academic study of genocide, political terrorism, and atrocity has been dominated by the areas of law, history, political science, and international development studies. Within the diminutive museum studies field, memorial museums have also only been tentatively addressed, despite their rapidly growing number. Nevertheless, there appears to be an emerging scholarly awareness that their aesthetic, political, and moral qualities warrant them a kind of attention different to descriptive surveys that would lump them in as simply a "dark" version of the history museum, or as merely a sinister kind of tourist attraction. Memorial museums are a significantly different and more important proposition for a variety of reasons. To pick out just a few identified in this book: their display of sensitive artifacts and images requires ethical attention to issues of emotional effect; their geographic location is often more critical; they are more directly implicated in political controversy; visitors are often directly situated in relation to the event; memory and testimony have a comparatively enlarged status; their pedagogy has a weightier gravitas. As this cluster of ideas suggests, memorial museums are sites that crystallize a whole raft of issues currently topical not just in museum studies, but in the humanities more broadly.

Indeed, the degree to which memorial museums typically reach out into the world beyond the institutional bounds of the museum sphere make them more of a methodological challenge than the already-interdisciplinary approach of museum studies. One idea in the back of my mind throughout the writing of this book was an urging from Pickering and Westcott that there might emerge some coherent theory for forms of concrete commemoration:

> The study of monuments tends to be energised primarily in the moment of empirical engagement, in teasing out the inter-relation between the monument

and the historical context in which it is embedded. Although theory has sometimes helped to illuminate this task, an attempt to produce a theoretically-based analysis of monuments has not tended to be seen as an interesting task in and of itself.[15]

The issue, I would counter, is not that critics lack interest in producing a theoretical basis for the agglomerated topics involved in any study of museums, memorials, monuments, and historic sites. Rather, the lack of an overarching "theory" should instead be seen as part of the appeal of this topic. The field of memorialization is simply too diverse, and needs to take in too many areas of study – from political ethics to photographic aesthetics, or from architectural design to traumatic disorder – to support a singular or all-encompassing theory. The field of inquiry stands in a fascinating place, difficult to ignore for all its real world challenges, yet not properly established in critical circles. If there appears to be almost as many question marks as periods in this book, it is because for all the points I could resolve, there were many others raised that need to be taken up. My chief ambition, in short, is that this book makes an important contribution in raising the critical profile of this crucial subject.

NOTES

CHAPTER I A VERY DIFFERENT PROPOSITION: INTRODUCING THE MEMORIAL MUSEUM

1. Cited in Matthew Dodd, "Remembrance Days." *New Statesman*, July 29, 2002. Online at: http://www.newstatesman.com/200207290029, accessed July 25, 2007.

2. Blake Gopnik, "Many Words, Little Eloquence," *Washington Post*, May 23, 2004, p. N02.

3. Paul Greenberg, "Monumental Mistake," *Arkansas Democrat-Gazette*, May 30, 2001. Online at: http://www.savethemall.org/media/mistake1.html, accessed July 25, 2007.

4. James E. Young, "Reflections on the Dedication of Berlin's "Memorial to the Murdered Jews of Europe,"" *The Stockholm International Forum on the Holocaust*, conference proceedings (Stockholm, January 26–28, 2000). Online at: http://www.holocaustforum.gov.se/conference/official_documents/abstracts/young.htm, accessed June 5, 2005.

5. Nicolai Ouroussoff, "A Forest of Pillars, Recalling the Unimaginable," *New York Times*, May 9, 2005. Online at: http://travel.nytimes.com/2005/05/09/arts/design/09holo.html?ex=1185508800&en=6e3932b24938e652&ei=5070, accessed July 25, 2007.

6. Cited in Joseph Fishkin, "Anatomy of an Eyesore: Monumental Error," *The New Republic*, September 25, 2000. Online at: http://www.savethemall.org/media/anatomy.html, accessed July 25, 2007.

7. Jay Winter, *Sites of Memory, Sites of Mourning: The Great War in European Cultural History* (Cambridge: Cambridge University Press, 1995), p. 85.

8. Raphael Samuel, *Theatres of Memory. Volume II: Island Stories, Unravelling Britain* (London: Verso, 1998), p. 8.

9. Edward S. Casey, *Remembering: A Phenomenological Study* (Bloomington: University of Indiana Press, 1987), p. 226.

10. See, for instance, James E. Young, 1997, "Germany's Problem With Its Holocaust Memorial: A Way Out of the Quagmire," *The Chronicle of Higher Education* (October 31): B14.

11. James E. Young, 1993, *The Texture of Memory: Holocaust Memorials and Meaning* (New Haven: Yale University Press, 1993), p. 12.

12. For a comparison of German, Polish, Israeli, and American memorials, see Young, *The Texture of Memory*.

13. Young, *The Texture of Memory*, p. 49.

14. J. John Lennon and Malcolm Foley, *Dark Tourism: The Attraction of Death and Disaster* (London: Continuum, 2000), p. 23.

15. Judith Berman, "Australian Representations of the Holocaust: Jewish Holocaust Museums in Melbourne, Perth, and Sydney, 1984–1996," *Holocaust and Genocide Studies* 13.2 (1999): 200–21.

16. Rachel Zoll, "Holocaust Memorials: What's Their Place in Jewish Life?" *Houston Chronicle*, March 23, 2002, p. 6.

17. See Peter Novick, *The Holocaust in American Life* (Boston: Houghton Mifflin, 1999); Hilene Flanzbaum (ed.), *The Americanization of the Holocaust* (Baltimore: Johns Hopkins University Press, 1999).

18. Caroline Wiedmer, *The Claims of Memory: Representations of the Holocaust in Contemporary Germany and France* (Ithaca: Cornell University Press, 1999), p. 35.

19. See Young's discussion of the "countermonument" in *The Texture of Memory*, pp. 27–48.

20. See, for example, Arthur Danto, "The Vietnam Veterans' Memorial," *The Nation*, August 31 (1986): 152.

21. Daniel J. Sherman, "Objects of Memory: History and Narrative in French War Museums," *French Historical Studies* 19.1 (1995): 49–74.

22. Young, *The Texture of Memory*, p. 4.

23. Tiffany Jenkins, "Victims Remembered," *Museums Journal*, May (2005): 22.

CHAPTER 2 THE SURVIVING OBJECT: PRESENCE AND ABSENCE IN MEMORIAL MUSEUMS

1. Jay Winter, *Sites of Memory, Sites of Mourning: The Great War in European Cultural History* (Cambridge: Cambridge University Press, 1995), p. 22.

2. The person giving voice to the shoes is Yiddish poet Moses Schulstein, from "I Saw a Mountain." Translated by Beatrice Stadtler and Mindele Wajsman in Michael Berenbaum (ed.), *From Holocaust to New Life* (New York: The American Gathering of Jewish Holocaust Survivors, 1985), p. 121.

3. James E. Young, *The Texture of Memory: Holocaust Memorials and Meaning* (New Haven: Yale University Press, 1993), p. 132.

4. Quoted in Julia M. Klein, "From the Ashes, a Jewish Museum," *The American Prospect,* 12.3, February 12, 2001. Online at: http://www.prospect.org/cs/articles?article=from_the_ashes_ a_jewish_museum, accessed July 25, 2007.

5. Quoted in Klein, "From the Ashes, a Jewish Museum."

6. Quoted in Klein, "From the Ashes, a Jewish Museum."

7. Klein, "From the Ashes, a Jewish Museum."

8. Daniel Miller, *Material Culture and Mass Consumption* (Oxford: Basil Blackwell, 1987), p. 145.

9. For critiques of the museum's identity card tactic, see, for instance, Andrea Liss, *Trespassing through Shadows: Memory, Photography, and the Holocaust,* (Minneapolis: University of Minnesota Press, 1998), pp. 13–38; Edward T. Linenthal, "The Boundaries of Memory: The United States Holocaust Memorial Museum," *American Quarterly* 46.3 (1994): 406–33; J. John Lennon & Malcolm Foley, "Interpretation of the Unimaginable: The US Holocaust Memorial Museum, Washington D.C., and 'Dark Tourism,'" *Journal of Travel Research* 38.1 (1999): 46–50.

10. Quoted in Dina Kraft, "The New Yad Vashem," *The Australian Jewish News*, March 11, 2005. Online at: http://www.ajn.com.au/pages/archives/feature/feature-2005-07.html, accessed March 21, 2005.

11. See Christian Metz, "The Imaginary Signifier (Excerpts)," in P. Rosen (ed.), *Narrative, Apparatus, Ideology* (New York: Columbia University Press, 1986), pp. 245–78.

12. The New York State Museum. *Recovery: The World Trade Center Recovery Operation at Fresh Kills* (exhibition booklet). (Albany: New York State Museum, 2003). Available online at: http://www.nysm.nysed.gov/exhibits/longterm/documents/recovery.pdf, accessed July 25, 2007.

13. Smithsonian National Museum of American History, "Curator Stories," *September 11: Bearing Witness to History* (2002). Online at: http://americanhistory.si.edu/september11/collection/curators_objects.asp, accessed March 23, 2006.

14. Sarah D. Phillips, "Chernobyl's Sixth Sense: The Symbolism of an Ever-Present Awareness," *Anthropology & Humanism*, 29.2 (2004): 165.

15. See Thomas Laqueur, "Memory and Naming in the Great War," in John R. Gillis (ed.), *Commemorations: The Politics of National Identity* (Princeton: University of Princeton Press, 1994), pp. 150–67.

16. Edward T. Linenthal, *Preserving Memory: The Struggle to Create America's Holocaust Museum* (New York: Columbia University Press, 2001), p. 213.

17. Linenthal, *Preserving Memory,* p. 213.

18. See, for instance, Irina Paperno, "Exhuming the Bodies of Soviet Terror," *Representations* 75 (2001): 89–118; Katherine Verdery, *The Political Lives of Dead Bodies: Reburial and Postsocialist Change* (New York: Columbia University Press, 1999); Bette Denich, "Dismembering Yugoslavia: National Ideologies and the Symbolic Revival of Genocide," *American Ethnologist* 21 (1994): 367–90.

19. Verdery, *The Political Lives of Dead Bodies,* pp. 113, 164.

20. Emile Durkheim, *The Elementary Forms of Religious Life*, trans. Karen E. Fields (New York: Free Press, 1995 [1912]), p. 415.

21. See C. F. Keyes, "Communist Revolution and the Buddhist Past in Cambodia," in C. F. Keyes, Laurel Kendall & Helen Hardacre (eds), *Asian Visions of Authority: Religion and the Modern States of East and Southeast Asia* (Honolulu: Hawaii University Press, 1994), pp. 43–74.

22. See Rachel Hughes, "Memory and Sovereignty in Post-1979 Cambodia: Choeung Ek and Local Genocide Memorials" in S. Cook (ed.),*New Perspectives on Genocide: Cambodia and Rwanda* (New Haven: Yale Center for International and Area Studies Monograph Series 1, 2004), pp. 269–92.

23. Susan E. Cook provides an account of traveling to a school in the Gikongoro district in 2000, where she witnessed numerous bodies preserved with powdered lime, many still with hair and clothing. See Susan E. Cook, "The Politics of Preservation in Rwanda," in Susan E. Cook (ed.), *Genocide in Cambodia and Rwanda: New Perspectives* (Piscataway: Transaction Publishers, 2005), pp. 298–302.

24. Saskia Van Hoyweghen, "The Disintegration of the Catholic Church of Rwanda: A Study of the Fragmentation of Political and Religious Authority," *African Affairs* 95.380 (1996): 394.

25. Van Hoyweghen, "The Disintegration of the Catholic Church of Rwanda," p. 394.

26. AP, "Cambodia Skull Map Dismantled," *CNN World*, March 10, 2002. Online at: http://archives.cnn.com/2002/WORLD/asiapcf/southeast/03/10/cambodia.skulls/index.html, accessed July 29, 2005.

27. Quoted in Editorial desk, "10 Years Later in Rwanda, the Dead are Ever Present," *New York Times*, February 26, 2004, p. A8.

28. Editorial desk, "10 Years Later in Rwanda."

29. Benedict Anderson is quoted in Grant Evans, *The Politics of Ritual and Remembrance: Laos Since 1975* (Honolulu: Hawaii University Press, 1998), p. 120.

30. Associated Press, "Proof of Life: The Process, And Pain, Of Identifying WTC Victims' Remains," September 9, 2004. Available online at: http://www.cbsnews.com/stories/2004/09/09/september11/main642294.shtml, accessed July 25, 2007.

31. Marita Sturken, "The Aesthetics of Absence: Rebuilding Ground Zero," *American Ethnologist*, 31.3 (2004): 313.

32. Kate Connolly, "Jews Angry Over Memorial Plan for Death Camp Tooth," *Daily Telegraph*, May 13, 2005. Available online at: http://www.telegraph.co.uk/news/main.jhtml?xml=/news/ 2005/05/13/wmem13.xml, accessed July 25, 2007.

33. For an account of the importance of the emplacement of Nazi-era railway cars in Holocaust Museums, see Oren Baruch Stier, "Different Trains: Holocaust Artifacts and the Ideologies of Remembrance," *Holocaust and Genocide Studies*, 19.1 (2005): 81–106.

34. Associated Press, "Families Can View Victims' Remains at WTC Memorial," January 5, 2006. Available online at: http://www.sptimes.com/2006/01/05/Worldandnation/Families_can_ view_vic.shtml, accessed July 25, 2007.

35. Jenny Edkins, *Trauma and the Memory of Politics* (Cambridge: Cambridge University Press, 2003), pp. 60–68.

36. Edkins, *Trauma and the Memory of Politics,* p. 68.

37. Notably, the Cenotaph was also a key site where those from the U.K expressed their sorrow for the events of 9/11. See Debra Marshall, "Making Sense of Remembrance," *Social & Cultural Geography* 5.1 (2004): 49.

38. Kristan Hass, "Objects of Memory: Producing, Protecting a Shared Past," *RLG* (1999). Online at: http://www.rlg.org/en/page.php?Page_ID=86, accessed February 23, 2006. In late July 2006 the World Trade Center Memorial Foundation began its radio fundraising appeals with a voiceover that similarly listed everyday tributary items: "soccer cleats, a mixtape, a poem, a brown karate belt, a baseball bat, flowers, a six-pack of beer … these were the things you left." In this instance, spontaneous gestures were invoked to elicit contributions to a permanent memorial. The orator finishes by saying, "we needed one then, we need one now." As such, the fundraising campaign sought to efface differences in meaning and significance between personal tributary items and a large-scale public memorial.

39. Hass, "Objects of Memory: Producing, Protecting a Shared Past."

40. Hass, "Objects of Memory: Producing, Protecting a Shared Past."

41. An online companion to the Atocha train station video walls can be found at: Galería Más Cerncanos, n.d., *Empresa Responsibilidad Social Gabinete de Presna*. Online at: http://www. mascercanos.com/galeria.asp, accessed July 17, 2006.

42. Josie Appleton, "A Very Strange Time Capsule," *Spiked*, March 12, 2002. Online at: http://www.spiked-online.com/Articles/00000002D466.htm, accessed December 12, 2004.

43. Barbara Kirshenblatt-Gimblett, "Kodak Moments, Flashbulb Memories: Reflections on 9/11," *TDR Journal of Performance Studies,* 47.1 (2003): 24.

44. Phillips, "Chernobyl's Sixth Sense: The Symbol of an Ever-Present Awareness," pp. 159–85.

45. Timothy P. Brown, "Trauma, Museums and the Future of Pedagogy," *Third Text* 18.4 (2004): 250.

CHAPTER 3 PHOTOGRAPHIC MEMORY: IMAGES FROM CALAMITOUS HISTORIES

1. Roland Barthes, *Camera Lucida: Reflections on Photography.* trans. Richard Howard (New York: Hill & Wang, 1981), p. 76.

2. See Roger Seamon, "From the World is Beautiful to the Family of Man: The Plight of Photography

as a Modern Art," *The Journal of Aesthetics and Art Criticism* 55.3 (1997): 245–52.

3. See Natalie M. Houston, "Reading the Victorian Souvenir: Sonnets and Photographs of the Crimean War," *The Yale Journal of Criticism*, 14.2 (2001): 353–83.

4. See James Allen (ed.), *Without Sanctuary: Lynching Photography in America* (Santa Fe: Twin Palms, 2000). Images from *Without Sanctuary* were also shown in several museums, including the New York Historical Society (2000) and the Andy Warhol Museum, Pittsburgh (2002).

5. Francis Fralin & Jane Livingstone, *The Indelible Image: Photographs of War – 1846 to the Present* (New York: Harry N. Abrams, 1985), p. 13.

6. See Caroline Brothers, *War and Photography: A Cultural History* (London & New York: Routledge, 1997), pp. 201–17.

7. This chapter deals only with still images, partly because of their preponderance, and partly because it is beyond the scope of my expertise to discuss the moving image. The use of film and video in history museums is a topic that is little explored and deserves scholarly attention. However, this is not the place for it.

8. David L. Jacobs, "The Art of Mourning: Death and Photography," *Afterimage,* Summer (1996): 3.

9. In 2001 the American Association of Museums conducted a national survey which found that 87 percent of Americans find museums to be one of the most trustworthy or a trustworthy source of information. Books are a distant second at 61 percent, and a majority of Americans find print and broadcast media and the Internet to be not trustworthy. See American Association of Museums, "Americans Identify a Source of Information they can Really Trust," (2001). Online at: http://www.aam-us.org/pressreleases.cfm?mode=list&id=21, accessed December 29, 2005.

10. John Tagg, "The Currency of the Photograph," in Victor Burgin (ed.), *Thinking Photography* (London: The Macmillan Press, 1982), pp. 111–12.

11 Marianne Hirsch, "Surviving Images: Holocaust Photographs and the Work of Postmemory," *The Yale Journal of Criticism*, 14.1 (2001): 22–3.

12 Sybil Milton, "Photographs of the Warsaw Ghetto," *Simon Wiesenthal Center Annual* 3 (1986): 307.

13 Hirsch, "Surviving Images: Holocaust Photographs and the Work of Postmemory," pp. 5–37.

14 See Barbie Zelizer, *Remembering to Forget: Holocaust Memory Through the Camera's Lens* (Chicago: University of Chicago Press, 1998). For specific discussion of the Buchenwald image, see her chapter "Holocaust Photography, Then and Now," in Bonnie Brennan & Hanno Hardt (eds), *Picturing the Past, Media, History, and Photography* (Champaign: University of Illinois Press, 1999), pp. 98–121.

15. Ulrich Baer, *Spectral Evidence: The Photography of Trauma* (Cambridge, MA: Massachusetts Institute of Technology, 2002), p. 70.

16. Umberto Eco, "A Photograph," in *Travels in Hyperreality*. trans. William Weaver (New York: Harcourt Brace Jovanovitch, 1986), p. 216.

17. Barbara Kirshenblatt-Gimblett, "Kodak Moments, Flashbulb Memories: Reflections on 9/11," *TDR Journal of Performance Studies,* 47.1 (2003): 3.

18. Andrea Liss, *Trespassing through Shadows: Memory, Photography, and the Holocaust*, (Minneapolis: University of Minnesota Press, 1998), p. 4.

19. Brian Wallis, 2004, "Inconvenient Evidence: Iraqi Prison Photographs from Abu Ghraib," *International Center of Photography*. Online at: http://museum.icp.org/museum/exhibitions/

abu_ghraib/introduction.html, accessed July 2, 2005.

20. Kirshenblatt-Gimblett, "Kodak Moments, Flashbulb Memories: Reflections on 9/11," p. 15.

21. See Hamburg Institute for Social Research, 1995, "Crimes of the German Wehrmacht," Online at: http://www.verbrechen-der-wehrmacht.de/, accessed May 26, 2005.

22. See Samson Madievski, "The War of Extermination: The Crimes of the Wehrmacht in 1941 to 1944," *Rethinking History* 7.2 (2003): 243–54.

23. Susan Sontag, *Regarding the Pain of Others* (New York: Farrar, Straus & Giroux, 2003), p. 77.

24. Ariella Azoulay, *Death's Showcase: The Power of Image in Contemporary Democracy* (Boston: Massachusetts Institute of Technology, 2001), p. 285.

25. This interpretation is provided by Heiki Ahonen, Director of the Museum of Occupations, Tallinn. Email April 6, 2006.

26. Baer, *Spectral Evidence: The Photography of Trauma*, p. 13.

27. Eduardo Cadava, "Words of Light: Theses on the Photography of History," in Patrice Petro (ed.), *Fugitive Images. From Photography to Video* (Bloomington: Indiana University Press, 1995), p. 236.

28. Barthes, *Camera Lucida: Reflections on Photography*, pp. 93–94.

29. See Thierry de Duve, "Time Exposure and the Snapshot: The Photograph as Paradox," 5 (1978): 113–25.

30. Marianne Hirsch "I Took Pictures: September 2001 and Beyond," *The Scholar and Feminist Online*, 2: 1 (2003). Online at: http://www.barnard.columbia.edu/sfonline/ps/hirsch4.htm, accessed September 29, 2004.

31. Fralin & Livingstone, *The Indelible Image*, p. 14.

32. Christian Metz, "Photography and Fetish," in Carol Squiers (ed.), *The Critical Image: Essays on Contemporary Photography* (Seattle: Bay Press, 1990), p. 158.

33. Barthes, *Camera Lucida: Reflections on Photography*, p. 96.

34. Barthes, *Camera Lucida: Reflections on Photography*, p. 96.

35. John Berger, "Photographs of Agony," in *Selected Essays* (New York: Vintage, 2001 [1972]), p. 280.

36. Roger Fjellstrom, "On Victimhood," *Sats: The Nordic Journal of Philosophy* 3.1 (2002): 2.

37. Barthes, *Camera Lucida: Reflections on Photography*, p. 79

38. A lower figure of 12,000 is the official count according to CONADEP, the Commission for Investigation of Disappeared Persons.

39. For a recent interview with Nhem Ein (and interviews with the other few survivors of Tuol Sleng) see Peter Maguire, *Facing Death in Cambodia* (New York: Columbia University Press, 2005). The DK regime was also scopic in the way it enforced intense visual surveillance on its victims. One metaphor often recited by Khmer Rouge officers was that "Angkar [the party] has the eyes of a pineapple." See John Marston "Metaphors of the Khmer Rouge," in May M. Ebihara, Carol A. Mortland & Judy Ledgerwood (eds), *Cambodian Culture since 1975: Homeland and Exile* (Ithaca: Cornell University Press, 1994), p. 107.

40. Kirshenblatt-Gimblett, "Kodak Moments, Flashbulb Memories: Reflections on 9/11," p. 30.

41. Andreas Huyssen, "Present Pasts: Media, Politics, Amnesia," *Public Culture* 12.1 (2000): 27.

42. Michael Rowlands, "Remembering to Forget: Sublimation as Sacrifice in War Memorials," in A. Forty & S. Kuchler (eds), *The Art of Forgetting* (Oxford: Berg, 1999), p. 133.

43. See David Hawk, "The Photographic Record," in Karl Jackson (ed.), *Cambodia 1975–1978: Rendezvous with Death* (Princeton: Princeton University Press, 1989), pp. 209–14.

44. Thomas Roma, "Looking Into the Face of Our Own Worst Fears Through Photographs," *The Chronicle of Higher Education*, 44.10 (1997): B10.

45. Roma, "Looking Into the Face of Our Own Worst Fears Through Photographs," p. B11.

46. Liam Kennedy, "Remembering September 11: Photography as Cultural Diplomacy," *International Affairs* 79.2 (2003): 326.

47. Garance Franke-Ruta, "Missing Sensitivity," *The American Prospect*, March 20, 2002. Online at: http://www.prospect.org/webfeatures/2002/03/franke-ruta-g-03-20.html, accessed March 11, 2005.

48. Cited in Franke-Ruta, "Missing Sensitivity."

49. This was the subject of an online colloquy produced by the *Chronicle of Higher Education*. See *Chronicle of Higher Education*, "Globalization and the Photographic Representation of the Disappeared," *Colloquy Live* (2004). Online at: http://chronicle.com/colloquylive/2003/09/dorfman/, accessed October 2, 2004.

50. Geoffrey Batchen, "Requiem: Capturing the September 11th Terrorist Attacks through Photography" *Afterimage* January–February (2002): 3.

51. Diana Taylor, *Disappearing Acts: Spectacles of Gender and Nationalism in Argentina's "Dirty War,"* (Durham, NC: Duke University Press, 1997), p. 105.

52. Tona Wilson, "Demonstrating in Free Argentina," *Off Our Backs* 14.5 (1984): 1.

53. Noga Tarnopolsky, "Argentina's Slippery Nature of Memory," *Jerusalem Post*, February 13, 2004, p. 6.

54. Taylor, *Disappearing Acts: Spectacles of Gender and Nationalism in Argentina's "Dirty War,"* p. 200.

55. Quoted in Mark Durden, "Eye to Eye," (review article), *Art History* 23.1 (2000): 126.

56. "Representations of Violence, Violence of Representations," *Echo: The Virtual Salon of NYC,* transcript of a telephone interview of Alfredo Jaar by Rubén Gallo. Online at: http://www.echonyc.com/~trans/Telesymposia3/Jaar/Telesymposia3eJaar.html, accessed December 9, 2005

57. Scott McQuire, *Visions of Modernity: Representation, Memory, Time and Space in the Age of the Camera* (London: Sage Publications, 1998), p. 151.

58. Baer, *Spectral Evidence: The Photography of Trauma*, p. 10.

59. Margaret Iverson, "What is a Photograph?" *Art History* 17.3 (1994): 455.

60. Cathy Caruth, *Trauma; Explorations in Memory* (Baltimore: Johns Hopkins University Press, 1995), p. 253.

CHAPTER 4 ROCKS AND HARD PLACES: LOCATION AND SPATIALITY IN MEMORIAL MUSEUMS

1. See, for instance, Suzanne McLeod (ed.),*Reshaping Museum Space: Architecture, Design, Exhibitions* (London: Routledge, 2005).

2. Sharon Macdonald, "Introduction," in Sharon Macdonald & Gordon Fyfe (eds), *Theorizing Museums: Representing Identity and Diversity in a Changing World* (Oxford & Cambridge: Blackwell Publishers, 1998), p. 5.

3. John Urry, *The Tourist Gaze: Leisure and Travel in Contemporary Societies* (London: Sage Publishing, 1990), p. 127.

4. Rob Shields, *Places on the Margin: Alternative Geographies of Modernity* (London & New York: Routledge, 1992), p. 29.

5. Helen Liggett, "City Sights/Sites of Memories and Dreams," in Helen Liggett & David Perry (eds), *Spatial Practices* (Thousand Oaks: Sage Publications, 1995), p. 251.

6. Henri Lefebvre, *The Production of Space* (London: Blackwell, 1991), pp. 38–9.

7. Vito Acconci, "Public Space in a Private Time," (1997). Online at: http://www.kunstmuseum. ch/andereorte/texte/vacconci/vapubl_e.htm, accessed May 11, 2006.

8. Marc de Leeuw, "Berlin 2000: Fragments of Totality – Total Fragmentation," *Parallax* 5.3 (1999): 58.

9. Tristana Moore, "Stones Project Stumbles in Munich," *BBC News* (online), August 13, 2004. Online at: http://news.bbc.co.uk/2/hi/europe/3561860.stm, accessed May 2, 2006.

10. See Clay Risen, "Stone Cold: Eisenman's Abstractions Fail," *The New Republic* (online), May 23, 2005. Online at: http://www.tnr.com/doc.mhtml?i=w050523&s=risen052305, accessed April 11, 2006.

11. Robert Musil is quoted in Marina Warner, *Monuments and Maidens: The Allegory of the Female Form* (London: Picador, 1985), p. 21.

12. Deyan Sudjic, "Engineering Conflict," *The New York Times* (magazine), May 21, 2006, p. 23.

13. I borrow the term, "the scaling of memory" from Derek H. Alderman, "Street Names and the Scaling of Memory: The Politics of Commemorating Martin Luther King, Jr. Within the African American Community," *Area* 35.2 (2002): 163–73.

14. See Simon Robinson, "Through the Door of No Return," *Time* (Europe), June 27, 2004. Available online at: http://www.time.com/time/europe/pilgrim/goree.html, accessed July 25, 2007.

15. See James F. Searing, David Anderson, Carolyn Brown & Christopher Clapham, *West African Slavery and Atlantic Commerce: The Senegal River Valley 1700 – 1860* (Cambridge: Cambridge University Press, 1993).

16. Carolyn J. Mooney, "Where History Meets Memory: A Debate About Slavery on Senegal's Gorée Island," *The Chronicle of Higher Education*, May 23, 1997, p. B2.

17. Both quotes are from Mooney, "Where History Meets Memory," p. B2.

18. Editorial desk, "Row Over Memorial as Clinton Visits Rwanda," *BBC News*, March 25 1998. Clinton's aides may also have had in mind the 1985 Bitburg incident, which involved a Helmut Kohl-staged memorial ceremony at a German military cemetery, during which President Reagan laid a wreath to honor the dead. It was later uncovered that buried there were a number of SS troops. See Jeffrey K. Olick, "What Does it Mean to Normalize the Past: Official Memory in German Politics Since 1989," *Social Science History* 22.4 (1998): 547–71.

19. Allen Feldman, "Political Terror and the Technologies of Memory: Excuse, Sacrifice, Commodification, and Actuarial Moralities," *Radical History Review* 85 (2003): 72.

20. Teresa Meade, "Holding the Junta Accountable: Chile's 'Sitios de Memoria' and the History of Torture, Disappearance, and Death," *Radical History Review* 79 (2001): 133–4.

21. Philip Nobel, *Sixteen Acres: Architecture and The Outrageous Struggle For The Future of Ground Zero* (New York: Henry Holt & Co., 2005).

22. Editorial desk, "Filling the Void: A Memorial by Paul Myoda and Julian La Verdiere," *New York Times Magazine*, September 23, 2001, p. 80.

23. Anne Applebaum, "Tales from the Gulag," *ICON*, Fall (1993): 27.

24. John H. Fund, "Culture of Coercion," *The Wall Street Journal*, February 8, 2006. Available online at: http://www.opinionjournal.com/la/?id=110007935, accessed July 25, 2007.

25. Nanci Adler, "The Future of the Soviet Past Remains Unpredictable: The Resurrection of Stalinist Symbols Amidst the Exhumation of Mass Graves," *Europe-Asia Studies* 57.8 (2005): 1101.

26. Jean Baudrillard, *Simulacra and Simulation. The Body, in Theory* (Ann Arbor: University of Michigan Press, 1994), p. 1.

27. Annie E. Coombes, *History After Apartheid: Visual Culture and Public Memory in a Democratic South Africa* (Durham, NC & London: Duke University Press, 2003), pp. 123–4.

28. Charmaine McEacher, "Mapping the Memories: Politics, Place, and Identity in the District Six Museum," *Social Identities* 4.3 (1998): 505.

29. McEacher, "Mapping the Memories: Politics, Place, and Identity in the District Six Museum," p. 510.

30. See Andreas Huyssen, "The Voids of Berlin," *Critical Inquiry* 24 (1997): 57–81.

31. M. Christine Boyer, *The City of Collective Memory: Its Historical Imagery and Architectural Entertainments* (Cambridge, MA: MIT Press, 1994), p. 21.

32. Karen E. Till, *The New Berlin: Memory, Politics, Place* (Minneapolis: University of Minnesota Press, 2005), pp. 20–1.

33. Till, *The New Berlin: Memory, Politics, Place*, p. 103.

34. Ian Buruma, *The Wages of Guilt: Memories of War in Germany and Japan* (New York: Farrar Straus Giroux, 1994), p. 285.

35. See Tom Gjelten, *Sarajevo Daily: A City and Its Newspaper Under Siege* (New York: Harper Collins, 1996).

36. Stephen Graham, "Postmortem City: Towards an Urban Geopolitics," *City* 8.2 (2004): 167.

37. Graham, "Postmortem City: Towards an Urban Geopolitics," p. 168.

38. Timothy P. Brown, "Trauma, Museums and the Future of Pedagogy," *Third Text*, 18.4 (2004): 257.

39. Annie Coombes, "The Art of Memory," *Third Text* 52 (2000): 50.

40. Also see Vincent Pécoil, "The Museum as Prison: Post-Post Scriptum on Control Societies," *Third Text* 18.5 (2004): 435–47.

41. Michel Foucault, *Discipline and Punish: The Birth of the Prison* (New York: Vintage Books, 1979), p. 172.

42. Tony Bennett, "The Exhibitionary Complex," *New Formations* 4 (1988): 73–102.

43. John Bender, *Imagining the Penitentiary* (Chicago: University of Chicago Press, 1987), p. 21.

44. Duncan Light, "Gazing on Communism: Heritage Tourism and Post-Communist Identities in Germany, Hungary, and Rumania," *Tourism Geographies* 2.2 (2000): 168.

45. There was resistance. See Gediminas Lankauskas, "Sensuous (Re)collections: The Sight and Taste of Socialism at Grūtas Statue Park, Lithuania," *Senses & Society* 1.1 (2006): 29.

46. Sandra Laville, "Wanted for Genocide in Kigali. Living Comfortably in Bedford," *The Guardian*, May 13, 2006. Available online at: http://www.guardian.co.uk/rwanda/story/0,,1773993,00.html, accessed July 25, 2007.

47. Predrag Matvejevic, "This Bridge Between East and West," in Gilles Péqueux and Yvon Le Corre (eds), *Stari Most/The Old Bridge in Mostar* (Paris: Gallimard & Partenaires, 2002).

48. Nerma Jelaci, "Bruce Lee Builds Bridges in Battle-Scarred Bosnia," *The Independent*, September 18, 2005. Available online at: http://findarticles.com/p/articles/mi_qn4159/is_20050918/ai_n15352100, accessed July 25, 2007.

49. Robert Siegel, "Bosnian City's Unique Statue Choice: Bruce Lee," *All Things Considered*, NPR

(audio program). September 13, 2005. Available online at: http://www.npr.org/templates/story/story.php?storyId=4845621, accessed July 25, 2007.

50. William Hubbard, "A Meaning for Monuments," in Nathan Glazer & Mark Lilla (eds), *The Public Face of Architecture: Civic Culture and Public Space* (New York: Free Press, 1987), p. 133.

51. Joe Hagan, "The Breaking of Michael Arad," *New York Magazine*, May 2006, p. 14.

52. Erika Doss, "Death, Art and Memory in the Public Sphere: the Visual and Material Culture of Grief in Contemporary America," *Mortality* 7.1 (2002): 77.

53. Patricia Lowry, "Flight 93 Memorial Emphasizes Contemplation," *Pittsburgh Post-Gazette*, September 13, 2005. Available online at: http://www.post-gazette.com/pg/05256/570287.stm, accessed July 25, 2007.

54. Christopher Hawthorne, "Reading Symbolism in the Sept. 11 Era," *Los Angeles Times*, October 5, 2005, pp. 138–40.

55. Stephen J. Greenblatt, "Ghosts of Berlin," *New York Times,* April 28 1999, p. A29.

56. See, for example, Christopher Benfey, "Monumental Folly," *Slate*, June 16, 2003. Online at: http://slate.msn.com/?id=2084429, accessed June 13, 2004.

57. James E. Young, "Memory and Counter-Memory: The End of the Monument in Germany," *Harvard Design Magazine* 9 (1999): 1–10.

58. Valerie Casey, "The Museum Effect: Gazing From Object to Performance in the Contemporary Cultural-History Museum," *Archives and Museum Informatics, Europe: Cultural Institutions and Digital Technology* (conference proceedings) (Paris: École du Louvre, September 8–12, 2003).

59. Yuichiro Takahashi, "Exhibiting the Past: The Japanese National War Museum and the Construction of Collective Memory," in Peter Eckersall, Uchino Tadashi & Moriyama Naoto (eds), *Alternatives: Debating Theatre Culture in the Age of Con-Fusion* (Brussels: Peter Lang, 2004), pp. 128–9.

60. Barbara Kirshenblatt-Gimblett, *Destination Culture: Tourism, Museums, and Heritage* (Berkeley: University of California Press, 1998), p. 194.

61. Naomi Stead, "The Ruins of History: Allegories of Destruction in Daniel Libeskind's Jewish Museum," *Open Museum Journal* 2.5 (2000).

62. José Luis González Cobelo, "Architecture and its Double: Idea and Reality in the Work of Daniel Libeskind," *El Croquis* 80 (1996), p. 37.

63. For an interesting article on the topic of memory recall through the body, see Jill Bennett, "Art, Affect, and the 'Bad Death': Strategies for Communicating the Sense Memory of Loss," *Signs* 28.1 (2002): 333–51.

64. Friedrich Nietzsche, *On the Genealogy of Morals*, trans. Walter Kauffman and R. J. Hollingdale (New York: Vintage Books, 1989), p. 61.

65. Jenny Edkins, *Trauma and the Memory of Politics* (Cambridge: Cambridge University Press, 2003), p. 39.

66. See Jeff Howard, "New York, New Visions," *WTC Memorial Museum Programming Workshop* (New York: Center for Architecture, September 15, 2005). Document transcript available at: http://search.renewnyc.com/content/pdfs/AIA_Forum_Pres_Transcript.pdf, accessed March 11, 2006.

67. Howard, "New York, New Visions," p. 20.

68. Casey, "The Museum Effect," p. 5.

69. John O'Sullivan, "Preemptive Force," *National Review*, February 4, 2003. Available online at: http://www.nationalreview.com/script/printpage.p?ref=/jos/jos020403.asp, accessed July 25, 2007.

70. Cited in Benjamin B. Brower, "The Preserving Machine: The 'New' Museum and Working through Trauma – The Musée Mémorial pour la Paix of Caen," *History & Memory* 11.1 (1999): 80.

71. Brower, "The Preserving Machine," p. 89.

72. Pierre Sorlin, "Children as War Victims in Postwar European Cinema," in Jay Winter & Emmanuel Sivan (eds), *War and Remembrance in the Twentieth Century* (Cambridge: Cambridge University Press, 1999), pp. 105–6.

73. Cited in Isabelle Engelhardt, *A Topography of Memory. Representations of the Holocaust at Dachau and Buchenwald in Comparison with Auschwitz, Yad Vashem and Washington, DC*. Series Multiple Europes, 16 (Brussels: Peter Lang, 2002), p. 44.

74. Maurice Halbwachs, *On Collective Memory* (Chicago: University of Chicago Press, 1992), p. 146.

75. Michel De Certeau, *The Practice of Everyday Life* trans. Steven Rendall (Berkeley: University of California Press, 1984), p. 108.

76. De Certeau, *The Practice of Everyday Life*, pp. 91–130.

CHAPTER 5 A DIPLOMATIC ASSIGNMENT: THE POLITICAL FORTUNES OF MEMORIAL MUSEUMS

1. David Shipley, "Making a Mockery of Ground Zero," *New York Daily News*, August 21, 2005. Available online at: http://www.nydailynews.com/opinions/2005/08/21/2005-08-21_making_a_mockery_of_ground_zero.html, accessed July 25, 2007.

2. Douglas Feiden, "Another Insult to America's Heritage at Freedom Center," *New York Daily News*, August 21, 2005. Available online at: http://www.nydailynews.com/news/2005/08/21/2005-08-21_another_insult_to_americas_heritage_at_f.html, accessed July 25, 2007.

3. Cited in the International Coalition of Historic Site Museums of Conscience, *Conference Proceedings*, July 24–29, 2003. (New York: Pocantico Conference Center of the Rockefeller Brother Fund, 2003), p. 51.

4. Lower Manhattan Development Corporation, *The International Freedom Center Content and Governance Report* (2005). Online at: http://www.ifcwtc.org/, accessed December 8, 2005.

5. Cited in Debra Burlingame, "Memory Failure: The Great Ground Zero Heist," *Wall Street Journal*, June 8, 2005, p. A14.

6. Others not listed include: the Eleanor Roosevelt National Historic Site, U.S.A.; the Workhouse, England; the Women's Rights National Historic Park, U.S.A.; the Lower East Side Tenement Museum, U.S.A.; the National Civil Rights Museum, U.S.A.; the Japanese American National Museum, U.S.A.; Martin Luther King Jr. National Historic Site, U.S.A.

7. International Coalition of Historic Site Museums of Conscience, "Developing the International Freedom Center, NYC," in *2004 Conference Proceedings* (New York: International Coalition of Historic Sites of Conscience, 2004), p. 30.

8. Burlingame, "The Great Ground Zero Heist," p. A14.

9. Quoted in Joe Mahoney & Douglas Feiden, "Nutty 9/11 Art Nixed," *The New York Daily News*, June 25, 2005, p. A1.

10. Manny Fernandez, "Clinton Says She Opposes Freedom Center," *New York Times*, September 25,

2005. Available online at: http://www.nytimes.com/2005/09/25/nyregion/25clinton.html?ex=1185508800&en=9d57e82b53785975&ei=5070, accessed July 25, 2007.

11. Editorial Desk, "Leveling the Freedom Center," *The New York Times*, September 30, 2005. Available online at: http://www.nytimes.com/2005/09/30/opinion/30fri2.html?ex=1185508800&en=f3870f0078b70ac8&ei=5070, accessed July 25, 2007.

12. Editorial desk, "9/11 Memorial Plans Scaled Down," *BBC News*, June 21, 2006. Available online at: http://news.bbc.co.uk/1/hi/world/americas/5101048.stm, accessed July 25, 2007.

13. Antonius C. G. M. Robben, "How Traumatized Societies Remember: The Aftermath of Argentina's Dirty War," *Cultural Critique* 59 (2005): 120–64.

14. Cited in Robben, "How Traumatized Societies Remember," p. 144.

15. Robben, "How Traumatized Societies Remember," p. 143.

16. Quoted in Larry Rohter, "On Coup's Anniversary, Argentines Vow 'Never Again,'" *The New York Times*, March 25, 2006. Available online at: http://select.nytimes.com/search/restricted/article?res=F20D16F83C540C768EDDAA0894DE404482, accessed July 25, 2007.

17. Kirchner and Cabandié are quoted in Tomás Bril Mascarenhas, "House of Horror," *New Internationalist* 385 (2005). Online at: http://www.newint.org/index.html, accessed June 4, 2006.

18. Rohter, "On Coup's Anniversary, Argentines Vow 'Never Again.'"

19. Quoted in Victoria Baxter, "Civil Society Promotion of Truth, Justice, and Reconciliation in Chile: Villa Grimaldi," *Peace & Change* 30.1 (2005): 124.

20. Teresa Meade, "Holding the Junta Accountable: Chile's 'Sitios de Memoria' and the History of Torture, Disappearance, and Death," *Radical History Review* 79 (2001): 126.

21. Baxter, "Civil Society Promotion of Truth, Justice, and Reconciliation in Chile," p. 129.

22. Baxter, "Civil Society Promotion of Truth, Justice, and Reconciliation in Chile," p. 129.

23. Bangladesh Liberation War Museum, 2004, "Financing of LWM," *Bangladesh Liberation War Museum*. Online at: http://www.liberationmuseum.org.bd/financing_of_lwm.htm, accessed March 2, 2006.

24. International Coalition of Historic Site Museums of Conscience, *2004 Conference Proceedings*, p. 15

25. Edward Kanterian, "Knowing Where the Graves Are: How Romania has Begun to Deal with its Past," *Neue Zürcher Zeitung*, June 24, 2002, p. 6.

26. Kigali Memorial Center, n.d., "Documentation Center." Available online at: http://www.kigalimemorialcentre.org/doccentre/, accessed January 22, 2006.

27. Marc Lacey, "A Decade After Massacres, Rwanda Outlaws Ethnicity," *The New York Times*, April 9, 2004, pp. A3, 39.

28. Ker Munthit, "Healing the Wounds of the Past," *Bangkok Post*, November 24, 2005, p. 5.

29. These statistics are cited in Seth Mydans, "Scarred, Cambodia Seeks to Salve its Trauma," *International Herald Tribune*, February 1, 2006. Available online at: http://www.iht.com/articles/2006/02/01/news/cambo.php, accessed July 25, 2007.

30. Seth Mydans, "Cambodia Profits from Killing Fields and Other Symbols," *The New York Times*, November 6, 2005. Available online at: http://select.nytimes.com/search/restricted/article?res=F00A16FD3F5A0C758CDDA80994DD404482, accessed July 25, 2007.

31. Editorial desk, "The Earning Fields," *The Economist*, May 12, 2005, p. 45.

32. Simon Montlake, "Cambodia's Killing Fields Get Privatized," *Christian Science Monitor*, May 3,

2005. Available online at: http://www.csmonitor.com/2005/0503/p06s01-woap.html, accessed July 25, 2007.

33. Nevatia Shreevatsa, "Memorial Walk," *Hindustan Times*, October 16, 2005, p. 10.

34. Amritha Ballal, Moulshri Joshi, Sanjeet Wahi, Suditya Sinha & Uttiya Bhattacharya, *Bhopal Memorial Competition* (2005). Online at: http://bhopalmemorial.blogspot.com, accessed January 13, 2006.

35. These negative claims are points that the architectural team refutes. See Suditya Sinha's December 12, 2005 letter, "Response to Magazine Outlook Story," quoted in *Architexturez*. Online at: http://portal.architexturez.org/site/groups/bhopal/cont_d/12-12-2005_response, accessed February 5, 2006.

36. See Nikolai Voukov, "Death and the Desecrated: Monuments of the Socialist Past in Post-1989 Bulgaria," *Anthropology of East Europe Review* 21.2 (2003).

37. See Goethe Institute, "Memorial Sites with a Dual Past," *Goethe Institute* (2005). Online at: http://www.goethe.de/kug/ges/ztg/thm/en204290.htm, accessed May 13, 2005.

38. Duncan Light, "An Unwanted Past: Contemporary Tourism and the Heritage of Communism in Romania," *International Journal of Heritage Studies* 6.2 (2000): 154–5.

39. Light, "An Unwanted Past: Contemporary Tourism and the Heritage of Communism in Romania," p. 159.

40. Email communication with Romulus Rusan, Director of the International Center for the Study of Communism. September 26, 2005.

41. In late 2004 former President Ion Iliescu honored the Wiesel Commission report, which detailed the Romanian government's deliberate part in the Holocaust, by dedicating October 9 as Holocaust Day, ending decades of official denial. Iliescu established the Wiesel Commission following an international outcry over comments he made in July 2003 that minimized the Holocaust in Romania. In 2005 investigations began that could lead to Iliescu's trial on a number of charges, including crimes against humanity.

42. Tony Judt, "From the House of the Dead: On Modern European Memory," *The New York Review of Books*, 52.15, October 6, 2005. Available online at: http://www.nybooks.com/articles/article-preview?article_id=18298, accessed July 25, 2007.

43. Quoted in Kanterian, "Knowing Where the Graves Are," p. 6

44. Quoted in Judt, "From the House of the Dead."

45. Quoted in Greg Spencer, "Star-Crossed Museum," *Business Hungary*, 16 (3), March 2002. Available online at: http://www.amcham.hu/BusinessHUngary/16-03/articles/16-03_39.asp, accessed July 25, 2007.

46. John H. Fund, "Culture of Coercion," *The Wall Street Journal*, February 8, 2006. Available online at: http://www.opinionjournal.com/la/?id=110007935, accessed July 25, 2007.

47. Tamás S Kiss, "MJC is not our Future," *The Budapest Sun*, October 21, 2004, p. 8.

48. Author unknown, "Sites of Memory," *European Institute of Cultural Routes*. Online at http://www.culture-routes.lu/php/fo_index.php?lng=en&dest=bd_pa_det&id=00000050 accessed September 20, 2005.

49. Lynn Meskell, "Negative Heritage and Past Mastering in Archaeology," *Anthropological Quarterly*, 75.3 (2002): 558.

50. Quoted in Beverly James, "Fencing in the Past: Budapest's Statue Park Museum," *Media, Culture*

& *Society* 21 (1999): 296.

51. Bernd Musch-Borowska, "Visiting Hitler's Ruins," *Deutsche Welle*, July 20, 2004. Online at: http://www.dw-world.de/dw/article/0,1564,1272100,00.html, accessed October 27, 2005.

52. "Hitler's Bunker A Tourist Site Some Fear Emergence Of 'Nazi Disneyland' at Wolf's Lair In Poland," *St. Louis Post*, October 25, 1992, p. 6.

53. Linnet Myers, "Entrepreneur's Quest Capitalizes on Nazism, Pole sees Profits from Wolf's Lair," *Chicago Tribune*, October 27, 1992, p. 12.

54. Cited in Myers, "Entrepreneur's Quest Capitalizes on Nazism, Pole sees Profits from Wolf's Lair," p. 12.

55. Uwe Neumärker, "The Memorial to the Murdered Jews of Europe in Berlin," *Goethe Institute* (2005). Online at: http://www.goethe.de/kue/arc/dos/dos/zdk/en204106.htm, accessed March 11, 2006.

56. Editorial desk, "Bombs Found at Srebrenica Centre," *BBC News* (international), July 5, 2005. Available online at: http://news.bbc.co.uk/1/hi/world/europe/4651713.stm, accessed July 25, 2007.

57. See Gearóid Ó Tuathail & Carl Dahlman, "The Effort to Reverse Ethnic Cleansing in Bosnia-Herzegovina: The Limits of Returns," *Eurasian Geography and Economics* 45.6 (2004): 451, fn 22.

58. Anes Alic, "Reconciliation Reburial?" *Transitions Online*, July 14, 2003. Online at: http://www.tol.cz/look/TOL/article.tpl?IdLanguage=1&IdPublication=9&NrIssue=1&NrSection =1&NrArticle=10033, accessed February 21, 2006.

59. See Theodor W. Adorno, "What Does Coming to Terms with the Past Mean?" in Geoffrey H. Hartmann (ed.), *Bitburg in Moral and Political Perspective* (Bloomington: Indiana University Press, 1986), p. 128.

60. Daqing Yang, "Challenges of Trans-National History: Historians and the Nanjing Atrocity," *SAIS Review* 19.2 (1999): 133.

61. Daqing Yang, "The Challenges of the Nanjing Massacre: Reflections on Historical Inquiry," in Joshua Fogel (ed.), (Berkeley: University of California Press, 2000), p. 164.

62. Benedict Giamo, "The Myth of the Vanquished: The Hiroshima Peace Memorial Museum," *American Quarterly* 55.4 (2003): 705.

63. Yasukuni Jinja, n.d., *Yasukuni Jinja* (English version). Online at: http://www.yasukuni.or.jp/english/ accessed January 31, 2006.

64. See Daiki Shibuichi, "The Yasukuni Shrine Dispute and the Politics of Identity in Japan," *Asian Survey* 45.2 (2005): 197–215.

65. Quoted in Ian Buruma, *The Wages of Guilt: Memories of War in Germany and Japan* (New York: Farrar Straus Giroux, 1994), p. 224.

66. See Sheldon H. Harris, *Factories of Death: Japanese Biological Warfare, 1932–1945, and the American Cover-Up* (New York: Routledge, 1995).

67. Giselle Portenier (prod.) "Unit 731: Japan's Biological Force," *BBC Two Television (International Correspondent)*, February 3, 2002. Transcript available online at: http://news.bbc.co.uk/1/hi/world/europe/4651713.stm, accessed July 25, 2007.

68. Shane Green, "The Asian Auschwitz of Unit 731," *The Melbourne Age*, August 29, 2002. Available online at: http://www.theage.com.au/articles/2002/08/28/1030508070534.html, accessed July 25, 2007.

69. Li Fangchao, "Germ Warfare Site Bids for World Heritage," *China Daily*, April 19, 2005, p. 3.

70. Seth Kugel, "Preservation: Sure, It's a Good Thing, but …" *The New York Times*, January 15, 2006. Available online at: http://travel.nytimes.com/2006/01/15/travel/15journeys.html, accessed July 25, 2007.

71. Harriet Deacon, "Intangible Heritage in Conservation Management Planning: The Case of Robben Island," *International Journal of Heritage Studies* 10.3 (2004): 313.

72. Deacon, "Intangible Heritage in Conservation Management Planning," pp. 310–11.

73. ICOMOS, "Natchitoches Declaration on Heritage Landscapes," *US/ICOMOS 7 International Symposium at Natchitoches, U.S.* (March 2004). Online at: http://www.icomos.org/usicomos/Symposium/SYMP04/ Natchitoches-Declaration-on-Heritage-Landscapes-3-04.pdf, accessed March 21, 2006.

74. Stephen Kinzer, "Courting Europe, Turkey Tries Some Soul-Cleansing," *The New York Times*, December 4, 2005, Section 4, p. 3.

75. Fergal Keane, "Armenians Say US Failed Them," *BBC News* (international correspondent), January 26, 2003. Available online at: http://news.bbc.co.uk/1/hi/programmes/correspondent/2572667.stm, accessed July 25, 2007.

76. Sean Madigan, "$100 Million Museum Takes Control of Site," *Washington Business Journal*, January 30, 2004. Available online at: http://washington.bizjournals.com/washington/stories/2004/02/02/story3.html, accessed July 25, 2007.

77. Eli Lake, "Hamas to Convert Synagogue into Weapons Museum," *The New York Sun*, September 22, 2005. Available online at: http://www.nysun.com/article/20420, accessed July 25, 2007.

78. Martin Patience, "Row Over Israeli Tolerance Museum," *BBC News* (international correspondent), February 17, 2006. Available online at: http://news.bbc.co.uk/1/hi/world/middle_east/4721336.stm, accessed July 25, 2007.

79. Linda Gradstein, "Israel Debates Site for Tolerance Museum," *Day to Day*, NPR (audio program). September 13, 2005. Available online at: http://www.npr.org/templates/story/story.php?storyId=5231827, accessed July 25, 2007.

80. Amelia Thomas, "Israeli Tolerance Museum Being Built on 'Bad Foundations,'" *Middle East Times*, March 10, 2006. Available online at: http://www.metimes.com/storyview.php?StoryID=20060223-080635-6214r, accessed July 25, 2007.

81. HR 3000, sponsored by Representative Dana Rohrabacher, Senator Claiborne Pell, and Senator Jesse Helms, became Section 905 of Public Law 103–199, which passed unanimously on December 17 1993, and was signed by President Clinton, Speaker Foley, and President pro tem of the Senate, Robert Byrd.

82. Quoted in Meghan Clyne, "D.C. Monument to be Built in Honor of Victims of Communism," *The New York Sun*, December 13, 2005. Available online at: http://www.nysun.com/article/24366, accessed July 25, 2007.

83. Quoted in Meghan Clyne, "D.C. Monument to be Built in Honor of Victims of Communism."

84. Jay Winter, *Sites of Memory, Sites of Mourning: The Great War in European Cultural History* (Cambridge: Cambridge University Press, 1995), p. 93.

85. Abul Taher, "Ditch Holocaust Day, Advisers Urge Blair," *The Sunday Times*, September 11, 2005. Available online at: http://www.timesonline.co.uk/tol/news/uk/article565335.ece, accessed July 25, 2007.

86. See, for instance, Marcel Berlin, "Victims of the Holocaust get a Memorial Day. Victims of Other Atrocities Do Not. Isn't it Time We Dropped the Whole Idea?" *The Guardian*, September 14, 2005. Available online at: http://www.guardian.co.uk/Columnists/Column/0,,1569305,00.html, accessed July 25, 2007.

87. Andreas Huyssen, *Present Pasts: Urban Palimpsests and the Politics of Memory* (Stanford: Stanford University Press, 2003), p. 95.

88. Huyssen, *Present Pasts*, p. 95.

CHAPTER 6 THE MEMORIAL MUSEUM IDENTITY COMPLEX: VICTIMHOOD, CULPABILITY, AND RESPONSIBILITY

1. See R. J. Rummel, *Death by Government* (New Jersey: Transaction Publishers, 1994).

2. John Torpey, *Making Whole What Has Been Smashed: On Reparation Politics* (Cambridge, MA: Harvard University Press, 2006), p. 37.

3. Joseph V. Montville, "The Psychological Roots of Ethnic and Sectarian Terrorism," in Vamik D. Volkan, Joseph V. Montville & Demetrios Julius (eds), *The Psychodynamics of International Relationships. Volume I* (Lexington, MA: Lexington Books, 1990), p. 169.

4. See Roger Fjellstrom, "On Victimhood," *Sats: The Nordic Journal of Philosophy* 3.1 (2002): 12.

5. Quoted in Edward T. Linenthal, *The Unfinished Bombing: Oklahoma City in American History* (Oxford: Oxford University Press, 2001), p. 234.

6. Oklahoma City National Memorial, "Education and Programs," *Oklahoma City National Memorial* (2005). Online at: http://www.oklahomacitynationalmemorial.org/educ.htm, accessed October 27, 2005.

7. Lisa Yoneyama, "Remembering and Imagining the Nuclear Annihilation in Hiroshima," *The Getty Conservation Institute Newsletter* 17.2 (2002): 17.

8. Benedict Giamo, "The Myth of the Vanquished: The Hiroshima Peace Memorial Museum," *American Quarterly* 55.4 (2003): 705.

9. Daniel Seltz, "Remembering the War and the Atomic Bomb," in Daniel Walkowiz & Lisa Knauer (eds), *Memory and the Impact of Political Transformation in Public Space* (Durham, NC: Duke University Press, 2004), p. 131.

10. See Raul Hilberg, *Perpetrators Victims Bystanders – the Jewish Catastrophe* (New York: Harper-Collins, 1992).

11. See, for instance, Alfred Garwood, "The Holocaust and the Power of Powerlessness: Survivor Guilt an Unhealed Wound," *British Journal of Psychotherapy* 13 (1996): 243–58; F. Carmelly, "Guilt Feelings In Concentration Camps Survivors? Comments of a Survivor," *American Journal of Jewish Communal Services* 52 (1975): 139–44; W. G. Niederland, "The Survivor Syndrome: Further Observations and Dimensions," *Journal of the American Psychoanalytic Association* 29 (1981): 413–25.

12. Sharon Todd, "Guilt, Suffering, Responsibility," *Journal of Philosophy of Education* 35 (2001): 600–1.

13. Cited in Julia M. Klein, "From the Ashes, a Jewish Museum," *The American Prospect*, 12 (3), February 12, 2001. Available online at: http://www.prospect.org/cs/articles?article=from_the_ashes_a_jewish_museum, accessed July 25, 2007.

14. W. Michael Blumenthal, "Speech on Receiving the Award of Merit of the Federal Republic of

Germany, 21 June 1999." *Jewish Museum Berlin*. Online at: http://www.juedisches-museum-berlin.de/site/EN/06-Press/05-Directors/01-W-Michael-Blumenthal/speeches/1999_06_21.php?sn=TRUE&list=TRUE&, accessed May 31, 2006.

15. Quoted in David Crossland, "Finishing School for Nazis to Become Museum," *Der Spiegel*, July 24, 2007. Available online at: http://www.spiegel.de/international/germany/0,1518,496026,00.html, accessed July 25, 2007.

16. Henning Süssner, "Still Yearning for the Lost *Heimat?* Ethnic German Expellees and the Politics of Belonging," *German Politics and Society* 22.2 (2004): 1.

17. Charles Hawley, "Is the World Ready for German Victimhood?" *Der Spiegel* (English version), November 4, 2005. Online at: http://service.spiegel.de/cache/international/0,1518,383263,00.html, accessed January 31, 2006.

18. Hans Henning Hahn, Eva Hahn, Alexandra Kurth, Samuel Salzborn & Tobias Weger, "For a Critical and Enlightened Debate About the Past," *Bohemistik*, August 2003. Online at: http://www.bohemistik.de/zentrumgb.html, accessed January 31, 2006.

19. Quoted in Lisa Abend & Geoff Pingree, "Spain's Path to 3/11 Memorial," *The Christian Science Monitor*, July 4, 2004, p. 7.

20. David W. Dunlap, "Alphabetical, Random or Otherwise, Names Are a Ground Zero Puzzle," *The New York Times*, April 2, 2006, Section 1, p. 31.

21. Cited in the International Coalition of Historic Site Museums of Conscience, *2003 Conference Proceedings* (2003), Pocantico Conference Center, July 24–29, p. 31.

22. Sandra L. Richards, "What Is to Be Remembered? Tourism to Ghana's Slave Castle-Dungeons," *Theatre Journal* 57 (2005): 632.

23. Edward M. Bruner, "Tourism in Ghana: The Representation of Slavery and the Return of the Black Diaspora," *American Anthropologist* 98.2 (1996): 295.

24. Chris Keil, "Sightseeing in the Mansions of the Dead," *Social & Cultural Geography* 6.4 (2005): 484.

25. A. V. Seaton, "Guided by the Dark: From Thanatopsis to Thanatourism," *International Journal of Heritage Studies* 2 (1996): 240.

26. Seaton, "Guided by the Dark," p. 237.

27. J. John Lennon & Malcolm Foley, *Dark Tourism: The Attraction of Death and Disaster* (London: Continuum, 2000), p. 16.

28. Lennon & Foley, *Dark Tourism*, p. 119.

29. J. E. Tunbridge & G. J. Ashworth, *Dissonant Heritage: The Management of the Past as a Resource in Conflict* (Toronto: John Wiley and Sons, 1996).

30. Youk Chhang, "The Poisonous Hill That Is Tuol Sleng," *Documentation Center of Cambodia* (2003). Online at: http://www.dccam.org/Tuol_Sleng_Prison.htm, accessed June 12, 2003.

31. Tony Bennett, *Culture: A Reformer's Science* (Sydney: Allen & Unwin, 1998).

32. Cited in *F.A.Z Electronic Media*, "Is It a Memorial or a Playground?" May 20, 2005. Online at: http://www.faz.net/s/Rub9E75B460C0744F8695B3E0BE5A30A620/Doc~E5F6F57D35B0D4BE588433252BEF12242~ATpl~Ecommon~Scontent.html, accessed May 26, 2005.

33. *F.A.Z Electronic Media*, "Is It a Memorial or a Playground?"

34. Quoted in Debbie Lisle, "Gazing at Ground Zero: Tourism, Voyeurism and Spectacle," *Journal for Cultural Research* 8.1 (2004): 11

35. Henri Lefebvre, *The Production of Space* (London: Blackwell, 1991), p. 319.

36. Paul Williams, "The Atrocity Exhibition: Touring Cambodian Genocide Memorials," in L. Wevers & A. Smith (eds), *On Display: Essays in Cultural Tourism* (Wellington: Victoria University Press & Fergus Barrowman, 2004), p. 203.

37. John Taylor, *Body Horror: Photojournalism, Catastrophe and War* (Manchester: Manchester University Press, 1998), p. 40.

38. Craig Murphy, "Genocide Memorial," *Zero Latitude* (2005). Online at: http://craigmurphy.easyjournal.com/entry.aspx?eid=2405287, accessed January 31, 2006.

39. Moris Farhi, "Courage to Forget," *Index on Censorship* 2 (2005): 23–4.

40. Cited in Shaul Krakover, "Attitudes of Israeli Visitors Towards the Holocaust Remembrance Site of Yad Vashem," in Gregory Ashworth & Rudi Hartmann (eds), *Horror and Human Tragedy Revisited: The Management of Sites of Atrocity for Tourism* (New York: Cognizant Communication Corporation, 2005), p. 112.

41. Oren Baruch Stier, "Virtual Memories: Mediating the Holocaust at the Simon Wiesenthal Center's Beit Hashoah-Museum of Tolerance," *Journal of the American Academy of Religion* 64.4 (1996): 840.

42. R. L. Swarns, "Oppression in Black and White: South Africa Museum Recreates Apartheid," *New York Times*, December 10, 2001. Available online at: http://query.nytimes.com/gst/fullpage.html?sec=travel&res=9A06E2DD1F3CF933A25751C1A9679C8B63, accessed July 25, 2007.

43. Lennon & Foley, *Dark Tourism*, p. 158.

44. See U.S. Holocaust Memorial Museum, "Committee on Conscience – Alert, Darfur," *US Holocaust Memorial Museum* (2006). Online at: http://www.ushmm.org/conscience/alert/darfur/, accessed June 4, 2006.

45. Edward Linenthal, *Preserving Memory: The Struggle to Create America's Holocaust Museum* (New York: Columbia University Press, 1995), p. xiii.

46. Cited in the International Coalition of Historic Site Museums of Conscience, *2003 Conference Proceedings*, p. 2.

47. International Coalition of Historic Site Museums of Conscience, 2005, "Intent to Apply for Sites of Conscience Accreditation," unpublished document, p. 6.

48. International Coalition of Historic Site Museums of Conscience, "State Terrorism," International Coalition of Historic Site Museums of Conscience (2006). Online at: http://www.sitesofconscience.org/eng/terrorism.htm, accessed June 2, 2006.

49. Center for History and New Media, George Mason University, "Gulag: Soviet Forced Labor Camps and the Struggle for Freedom," (2006). Online at: http://gulaghistory.org/, accessed June 8, 2006. The online exhibition contains a reasonably comprehensive idea of what was displayed at Ellis Island.

50. Edward Rothstein, "'Gulag,' a Show at Ellis Island, Depicts a Penal System Gone Awry," *The New York Times*, June 7, 2006. Available online at: http://www.nytimes.com/2006/06/07/arts/design/07gula.html?ex=1307332800&en=9fcc3343f66e81a8&ei=5088&partner=rssnyt&emc=rss, accessed July 25, 2007.

51. Carolyn J. Dean, "Empathy, Pornography, and Suffering," *Differences* 14.1 (2003): 89.

52. George Steiner, *Language and Silence; Essays on Language, Literature and the Inhuman* (New York:

Athenaeum, 1967), pp. 156–7.

53. Peter Novick, *The Holocaust in American Life* (Boston: Houghton Mifflin, 1999), p. 121.

54. Dean, "Empathy, Pornography, and Suffering," p. 98.

55. For more on "cosmopolitan memory," see Daniel Levy & Natan Sznaider, "Memory Unbound: The Holocaust and the Formation of Cosmopolitan Memory," *European Journal of Social Theory* 5.1 (2002): 87–106.

56. Michael Humphrey, *The Politics of Atrocity and Reconciliation: From Terror to Drama* (London: Routledge, 2002), p. 6.

57. Jim Holt, "Math Murders," *The New York Times* (magazine), March 11–12 (2006): 11–12.

58. Philip Gourevitch, "Nightmare on 15th Street," *The Guardian*, 'Saturday Review,' December 4, 1999, pp. 1–2.

CHAPTER 7 LOOMING DISASTER: MEMORIAL MUSEUMS AND THE SHAPING OF HISTORIC CONSCIOUSNESS

1. For more see Lawrence L. Langer, *The Holocaust and the Literary Imagination* (New Haven: Yale University Press, 1975).

2. Quoted in Annie E. Coombes, *History After Apartheid: Visual Culture and Public Memory in a Democratic South Africa* (Durham, NC & London: Duke University Press, 2003), p. 91.

3. Hannah Arendt, *Men In Dark Times* (New York: Harvest Books, 1968), pp. 104–5.

4. Reinhart Koselleck, *Futures Past: On the Semantics of Historical Time* (Cambridge, MA: MIT Press, 1985), p. 106.

5. Koselleck, *Futures Past,* p. 215.

6. Mark Selber Phillips, "History, Memory, and Historical Distance," in Peter Seixas (ed.), *Theorizing Historical Consciousness* (Toronto: University of Toronto Press, 2004), pp. 95–7.

7. John Lukacs, *Historical Consciousness: or, The Remembered Past* (New York: Harper & Row, 1968), pp. 1–44.

8. Tony Bennett, *The Birth of the Museum: History, Theory, Politics* (London: Routledge, 1995), p. 166.

9. John Czaplicka, Andreas Huyssen & Anson Rabinach, "Introduction: Cultural History and Cultural Studies: Reflections on a Symposium," *New German Critique* 65 (1995): 10.

10. Jay Winter, *Sites of Memory, Sites of Mourning: The Great War in European Cultural History* (Cambridge: Cambridge University Press, 1995), pp. 9–10.

11. Jonathan Glover, *Humanity: A Moral History of the Twentieth Century* (New Haven: Yale University Press, 1999), p. 1.

12. Berlin cited in Stanley Kober, "Revolutions Gone Bad," *Foreign Policy* 91 (1993): 82; Kerwin L. Klein, "On the Emergence of Memory in Historical Discourse," *Representation* Winter (2000): 138.

13. See Charles S. Maier, "Consigning the Twentieth Century to History: Alternative Narratives for the Modern Era," *The American Historical Review* 105.3 (2000): 812.

14. Koselleck, *Futures Past,* p. 15.

15. Peter Fritzsche, "The Case of Modern Memory," *The Journal of Modern History* 73 (2001): 94.

16. Pierre Nora, *Realms of Memory: The Construction of the French Past.* trans. Arthur Goldhammer (New York: Columbia University Press, 1996), p. 1.

17. Pierre Nora, "Between History and Memory: Les Lieux de Mémoire," *Representations* 26 (1989): 8.

18. See, for instance, Peter Carrier, *Holocaust Monuments and National Memory Cultures in France and Germany since 1989: The Origins and Political Function of the Vél' d'Hiv in Paris and the Holocaust Monument in Berlin,* (New York & Oxford: Berghahn Books, 2005); John Bodnar, "Pierre Nora, National Memory, and Democracy: A Review," *Journal of American History* 87 (2000): 951–63.

19. Tony Myers, "Modernity, Postmodernity, and the Future Perfect," *New Literary History* 32.1 (2001): 34.

20. Key texts that contributed to this "boom" on the topic of war memory include: Martin Evans, Ken Lunn (eds), *War and Memory in the Twentieth Century* (Oxford and New York: Berg, 1997); Dominique Lacapra, *History and Memory after Auschwitz* (Ithaca: Cornell University Press, 1998); Daniel J. Sherman, *The Construction of Memory in Interwar France* (Chicago and London: University of Chicago Press, 1999); Nancy Wood, *Vectors of Memory: Legacies of Trauma in Postwar Europe* (Oxford and New York: Berg, 1999).

21. Kenneth Foote, *Shadowed Ground: America's Landscapes of Violence and Tragedy* (Austin: University of Texas Press, 2003), p. 339.

22. Monty G. Marshall & Ted Robert Gurr, *Peace and Conflict 2005: A Global Survey of Armed Conflicts, Self-Determination Movements, and Democracy* (College Park: Center for International Development and Conflict Management, University of Maryland, 2005).

23. Gregg Easterbrook, *The Progress Paradox: How Life Gets Better While People Feel Worse* (New York: Random House, 2003).

24. Robert G. Moeller, "Germans as Victims? Thoughts on a Post-Cold War History of World War II's Legacies," *History & Memory* 17.1–2 (2005): 152–3.

25. Michael Kammen, "Frames of Remembrance: The Dynamics of Collective Memory," *History and Theory* 34.3 (1995): 250.

26. Erika Doss, "Death, Art and Memory in the Public Sphere: the Visual and Material Culture of Grief in Contemporary America," *Mortality* 7.1 (2002): 70.

27. Edward T. Linenthal, "Violence and the American Landscape: The Challenge of Public History," *OAH Magazine of History* 16 (2002). Online at: http://www.oah.org/pubs/magazine/publichistory/linenthal.html, accessed February 2, 2006.

28. Doss, "Death, Art and Memory in the Public Sphere: the Visual and Material Culture of Grief in Contemporary America," p. 69.

29. See Barbara A. Misztal, "The Sacralization of Memory," *European Journal of Social Theory* 7.1 (2004): 67–84.

30. Misztal, "The Sacralization of Memory," p. 68.

31. Misztal, "The Sacralization of Memory," p. 68.

32. Duncan S. A. Bell, "Mythscapes: Memory, Mythology, and National Identity," *British Journal of Sociology* 54.1 (2003): 66

33. Michael J. Hyde, "The Rhetor as Hero and the Pursuit of Truth: The Case of 9/11," *Rhetoric & Public Affairs* 8.1 (2005): 8.

34. Benedict Anderson, *Imagined Communities: Reflections on the Origin and Spread of Nationalism,* (London: Verso, 1991), p. 205.

35. Stuart Hall, "Framing the Black Subject," *Third Text* 40 (1997): 25.

36. Jeffrey K. Olick & Joyce Robbins, "Social Memory Studies: From 'Collective Memory' to the Historical Sociology of Mnemonic Practices," *Annual Review of Sociology* 24 (1998): 123.

37. Marianne Hirsch, "Surviving Images: Holocaust Photographs and the Work of Postmemory," *The Yale Journal of Criticism*, 14.1 (2001): 9.

38. See, for instance, Arsineh Khachikian, "90th Anniversary Commemorations," *Life in the Armenian Diaspora*, April 28, 2005. Online at: http://www.cilicia.com/2005/04/90th-anniversary-commemorations.html, accessed April 29, 2005.

39. Natalia Melnyk, "Cross and Wheat. Remembering the Manmade Famine: What Kind of Memorial Should be Built?" *The Day* (Ukraine), March 23, 2004. Available online at: http://www.day.kiev.ua/13350/, accessed July 25, 2007.

40. Charles Maier, "A Surfeit of Memory? Reflections on History, Melancholy and Denial," *History & Memory* 5 (1993): 150.

41. Simon Harrison, "Identity as a Scarce Resource," *Social Anthropology,* 7.3 (1999): 243.

42. See Michael Rowlands, "Heritage and Cultural Property," in Victor Buchli (ed.), *The Material Culture Reader* (Oxford & New York: Berg, 2002), pp. 105–14.

43. Hermann Lübbe, *Zeit-Verhältnisse: Zur Kulturphilosophie des Fortschritts* (Graz: Verlag Styria, 1983). For an extended critique of Lübbe's model see Andreas Huyssen, *Twilight Memories: Marking Time in a Culture of Amnesia* (London: Routledge, 1995), pp. 13–36.

44. Quoted in Paul A. Pickering & Robyn Westcott, "Monuments and Commemorations: A Consideration," *Humanities Research* 10.2 (2003): 4.

45. Andreas Huyssen, "Present Pasts: Media, Amnesia, Politics," *Public Culture* 12.1 (2000): 21.

46. S. Hynes, *The Soldiers' Tale: Bearing Witness to Modern War* (London: Allen Lane, 1997), p. 206.

47. Klein, "On the Emergence of *Memory* in Historical Discourse," p. 135.

48. Pierre Sorlin, "Children as War Victims in Postwar European Cinema," in Jay Winter & Emmanuel Sivan (eds), *War and Remembrance in the Twentieth Century* (Cambridge: Cambridge University Press, 1999), p. 105.

49. Paul Feyerabend, *Killing Time: The Autobiography of Paul Feyerabend* (Chicago: University of Chicago Press, 1995), p. 53. I credit Sorlin's "Children as War Victims in Postwar European Cinema" for bringing this passage to my attention.

50. Adam Phillips, "The Forgetting Museum," *Index on Censorship* 2 (2005): 36.

51. Klein, "On the Emergence of *Memory* in Historical Discourse," p. 145.

52. M. Christine Boyer, *The City of Collective Memory* (Harvard: MIT Press, 1994), p. 5.

53. Tiffany Jenkins, "Memorial Museums: Cabinets of Misery," *Spiked*, May 19, 2005. Online at: http://www.spiked-online.com/Articles/0000000CAB4B.htm, accessed June 3, 2005.

54. J. John Lennon & Malcolm Foley, *Dark Tourism: The Attraction of Death and Disaster* (London: Continuum, 2000), p. 21.

55. G. Dann & R. Potter, "Supplanting the Planters: Hawking Heritage in Barbados," *International Journal of Hospitality and Tourism Administration* 2.3–4 (2001): 72.

56. Huyssen, "Present Pasts: Media, Politics, Amnesia," p. 28.

57. Andreas Huyssen, "Monument and Memory in a Postmodern World," in James E. Young, (ed.), *The Art of Memory: Holocaust Memorials in History* (Munich: Prestel Verlag, 1994), p. 12.

58. Marita Sturken, *Tangled Memories: The Vietnam War, the AIDS Epidemic, and the Politics of Remembering* (Berkeley: University of California Press, 1997), p. 17.

59. Germain Bazin, *The Museum Age* trans. Jane van Nuis Cahill (New York: Universe Books, 1967).

60. Noam Chomsky, *9–11* (New York: Seven Stories Press, 2002), pp. 11–12; Geoffrey M. White, "National Subjects: September 11 and Pearl Harbor," *American Ethnologist* 31.3 (2004), pp. 293–310.

61. Harold L. Kaplan, *Conscience and Memory: Meditations in a Museum of the Holocaust* (Chicago: University of Chicago Press, 1994), p. 100

62. David P. Chandler, "The Tragedy of Cambodian History," *Pacific Affairs* 52.3 (1979): 413.

63. David P. Chandler, "Tuol Sleng and S-21," *Searching for the Truth* 18 (2001): 14–21.

64. Robin Pogrebin, "A Leader is Chosen for the 9/11 Museum," *The New York Times*, February 8, 2006. Available online at: http://travel.nytimes.com/2006/02/08/arts/design/08gree.html, accessed July 25, 2007.

65. Saul Friedlander, "History, Memory and the Historian: Dilemmas and Responsibilities," *New German Critique* 80 (2000): 10.

66. Michael Bernard Donals, "Conflations of Memory or, What They Saw at the Holocaust Museum after 9/11," *CR: The New Centennial Review* 5.2 (2005): 73–4.

67. See Maurice Halbwachs, *Das kollektive Gedächtnis* (Enke: Stuttgart, 1967).

68. Ruth Wodak, "History in the Making/The Making of History: The 'German *Wehrmacht*' in Collective and Individual Memories in Austria," *Journal of Language and Politics* 5.1 (2006): 130.

69. Marianna Torgovnick, *The War Complex: World War II in Our Time* (Chicago: University of Chicago Press, 2005).

70. Tony Judt, "From the House of the Dead: On Modern European Memory," *The New York Review of Books,* 52.15 (2005), pp. 12–16.

71. Steven Johnson, "Political Not Patriotic: Democracy, Civic Space, and the American Memorial/Monument Complex," *Theory & Event* 5.2 (2001). Online at: http://muse.jhu.edu/journals/theory_and_event/v005/5.2johnston.html, accessed January 30, 2006.

72. Sturken, *Tangled Memories,* p. 45.

73. Foote, *Shadowed Ground*, p. 174.

74. James E. Young, 1993, *The Texture of Memory: Holocaust Memorials and Meaning* (New Haven: Yale University Press), p. 21.

75. George W. Bush, 2001, "President: The World Will Always Remember September 11," *White House,* Online at: http://www.whitehouse.gov/news/releases/2001/12/20011211–1.html, accessed August 9, 2004.

76. Kammen, "Frames of Remembrance: The Dynamics of Collective Memory," p. 249.

77. Louis P. Hutchins & Gay E. Veitzke, "Dialogue Between Continents: Civic Engagement and the Gulag Museum at Perm-36, Russia," *The George Wright Forum* 19.4 (2002): 73.

78. Sandy Isenstadt, "The Interpretive Imperative: Architecture and the Perfectibility of Memory," *Harvard Design Magazine* 3 (1997): 1–2.

79. Isenstadt, "The Interpretive Imperative," p. 2.

CHAPTER 8 IN CONCLUSION: FIGHTING THE FORGETFUL FUTURE

1. International Council of Museums, "ICOM Statutes," *International Council of Museums* (2005). Online at: http://icom.museum/statutes.html#2, accessed April 12, 2006.

2. Walter Benjamin, *Illuminations* trans. Harry Zohn, ed. Hannah Arendt (New York: Shocken, Harry Zohn, 1969), p. 256.

3. Hannah Arendt, *Origins of Totalitarianism* (New York: Harvest Books, 1951), p. ix.

4. Saul Friedlander, "History, Memory and the Historian: Dilemmas and Responsibilities," *New German Critique* 80 (2000): 10.

5. Christopher Hitchens, "Abu Ghraib Isn't Guernica," *Slate*, May 9, 2005. Online at: http://www.slate.com/id/2118306/, accessed December 13, 2005. My emphasis.

6. Cited in Martin Segger, "Towards a Museology of Reconciliation." Paper written for ICOM ICTOP (International Council of Museums International Committee for the Training of Personnel), May 11, 1998, p. 2.

7. Thomas Keenan, "No ends in Sight" in *Els Limits del museu* (exhibition catalog) (Barcelona: Fondació Antoni Tàpies, 1996), p. 22.

8. Ian Buruma, *The Missionary and the Libertine* (Boston: Faber & Faber, 1996), p. 210.

9. See, for instance, Tom. L. Freudenheim, "Monument to Ambiguity," *The Wall Street Journal*, June 16, 2005. Online at: http://www.opinionjournal.com/la/?id=110006825, accessed September 14, 2005.

10. Mick Hume, "How About a 12-Month Silence," *Spiked*, July 15, 2005. Online at: http://www.spiked-online.com/articles/0000000CAC74.htm, accessed March 12, 2006.

11. Moris Farhi, "Courage to Forget," *Index on Censorship* 2 (2005): 24.

12. Farhi, "Courage to Forget," p. 27.

13. See, respectively, Scott Trafton, *Egypt Land: Race And Nineteenth-Century American Egyptomania* (Durham, NC: Duke University Press, 2004); Steven Conn, *Museums and American Intellectual Life, 1876–1926* (Chicago, University of Chicago Press, 1998), pp. 151–91.

14. Jean Baudrillard, *The Evil Demon of Images* (Sydney: Power Institute Publications, 1988), p. 23.

15. Paul A. Pickering & Robyn Westcott, "Monuments and Commemorations: A Consideration," *Humanities Research* 10.2 (2003): 4.

INDEX